THE HUMAN ANIMAL

in Western Art and Science

THE HUMAN ANIMAL
IN WESTERN ART AND SCIENCE

Martin Kemp

THE UNIVERSITY OF CHICAGO PRESS

CHICAGO AND LONDON

MARTIN KEMP is professor and head of the Department of the History of Art at the University of Oxford.

The University of Chicago Press, Chicago 60637
The University of Chicago Press, Ltd., London
© 2007 by the University of Chicago
All rights reserved. Published 2007
Printed in the United States of America

16 15 14 13 12 11 10 09 08 07 1 2 3 4 5

ISBN-13: 978-0-226-43033-1 (cloth)
ISBN-10: 0-226-43033-2 (cloth)

Library of Congress Cataloging-in-Publication Data

Kemp, Martin.
 The human animal in Western art and science / Martin Kemp.
 p. cm.
 Includes bibliographical references and index.
 ISBN-13: 978-0-226-43033-1 (cloth : alk. paper)
 ISBN-10: 0-226-43033-2 (cloth : alk. paper) 1. Animals in art. 2. Animals—Symbolic aspects. 3. Symbolism in art—Europe. 4. Animals and civilization—Europe. 5. Human-animal relationships. 6. Body, Human—Symbolic aspects. I. Title.
 N7660.K37 2007
 704.9'432—dc22
 2007005014

♾ The paper used in this publication meets the minimum requirements of the American National Standard for Information Sciences—Permanence of Paper for Printed Library Materials, ANSI Z39.48-1992.

If it is dangerous to make man see too much how he is like the beasts without showing him enough of his grandeur, just as it is to make him see his grandeur without showing him enough of his beast-like qualities, so it is even more dangerous to let him ignore one or the other.

Blaise Pascale, 1632–1662

CONTENTS

ILLUSTRATIONS

THE LOUISE SMITH BROSS LECTURES

This book is the first of a series of published lectures at the University of Chicago initiated in April 2000 in memory of Louise Smith Bross. To commemorate Louise's intense commitment to scholarship in the history of art, her family decided to establish in her memory a series of lectures hosted by the university's art history department in the field of European art and architecture prior to 1800. The lectures are to be given every three years by a scholar of international reputation with the expectation that they will be published by the University of Chicago Press. The university's committee for this purpose initially consisted of Professors Charles E. Cohen, Ingrid Rowland, and Joel Snyder. We are grateful to Joel Snyder for all he did on behalf of the university in establishing these lectures.

Louise Smith Bross was born in 1939 and grew up in Lake Forest, Illinois, where she attended the Bell School. She graduated from Miss Porter's School in Farmington, Connecticut, in 1957, and in 1961 received her B.A. in history from Smith College in Northampton, Massachusetts. After she was married and had started a family, she worked as a volunteer at the Art Institute of Chicago and then began graduate studies in art history at the University of Chicago, where she earned her Ph.D. in 1994. Her doctoral thesis, written under the direction of Charles Cohen, was an in-depth study of the architecture, decoration, and patronage of the sixteenth-century church of Santo Spirito in Sassia in Rome; her thesis was a significant contribution to scholarship on late Renaissance Rome. When she joined the faculty of Lake Forest College in 1995, her research had led her to the study of confraternities in Rome and the church of Santa Caterina dei Funari. Her career was cut short by her death in October 1996 from breast cancer. She is survived by her four children, Suzette, Jonathan, Lisette, and Medora, and by me, her husband.

It was said of Louise by an artist-friend that the two most important things for her were first, that she was a mother and second, that she was a scholar. In addition to those central roles, she was active with numerous organizations and had a wide circle of family and friends.

Her family was pleased to learn that the first series of lectures would be given by Professor Martin Kemp on the subject of the human animal in Western art. His four lectures given in April 2000 were highly successful and well attended. The first lecture was delivered to a public audience at the Art Institute of Chicago, constituting a happy point of intersection of two distinguished institutions that meant so much to Louise. We hope that this collaboration between the unversity and the Art Institute will continue to be the pattern for succeeding lectures in the series.

Our family has come to know Martin Kemp not only as a scholar and original thinker but also as a friend. We are delighted that he is the author of the first book to be published in the Louise Smith Bross Lecture Series.

John A. Bross
Chicago, October 13, 2006

PREFACE AND ACKNOWLEDGMENTS

Knowing where to begin in a preface and acknowledgments is often tricky. Here, the choice is obvious and incontestable. The rationale for the existence of this book resides entirely with the Bross family, collectively and in the persons of John Bross and his late wife, Louise Smith Bross. John, who was the moving spirit behind the establishing of the lectures and their publication, has provided support, hospitality, friendship, and patience to degrees that infinitely surpass any reasonable expectation. During my stay in Chicago, he provided me with accommodation in his gracious house, which breathed the warmth of a family suffused by love. Our joint cooking ventures surprised and amused his older children when they visited, and Dolly (Medora) all the time. It was a delight to meet and benefit from the friendship of Suzette, Jonathan, Lisette, and Medora (then still resident in John's Chicago home). I think they will not mind my saying that they present an oasis of old-style courtesy in an encroaching desert of self-interest. Louise I did not meet, but came to know. The energy and force of her personality lived on, and the indomitable courage with which she pursued her life and research when smitten by cancer left an indelible trail of wonder. The presence on the walls of the house of some cleverly selected drawings by Italian masters in the neglected areas illuminated by her research left a tangible memorial of the insight and independence of her taste. To be associated with her is a privilege, tinged only by regret about not having met her when she was alive.

The lectures I gave in Chicago may just about have passed muster as lectures, but were not supported by the research I had anticipated undertaking when I accepted the invitation. They were a long way from being publishable. The eventual publication date of this book tells its own story. I have, in the interstices of my life as a professorial clerk at Oxford, squeezed time to look at the primary sources and directed willing research assistants to ferret out elusive passages of relevant texts and unfamiliar illustrations. The only advantage of the extended timetable has been to be able to reflect more fully on what are the key themes and incidents in the story,

but not alas to fill in the many gaps in my knowledge. The patience of John Bross, Susan Bielstein of the University of Chicago Press, and my literary agents Jim Rutman and Caroline Dawnay has been taxed beyond all reason, but they have never been less than encouraging. John has also been understanding of the inevitable seepage of my material beyond the stated boundary of 1800 given my theme, and that is more marked in the book than the lectures.

Under the sage chairmanship of Joel Snyder, the department of art history provided a welcoming academic home and excellent support in all office matters, not least in assistance with visual material. Joel, into whose research territories I ventured, supplied unstinting support. The librarians in the Special Collections of the University Library dealt with my urgent requests for historic publications and slides with efficiency and unfailing good humor. The city was also a star in its own right. For me Chicago is *the* American city (as far as any such thing can be said to exist in a country of such diversity), though the ability of the wind to blow from all directions at once remains vexing.

A wholly vital component in the completion of the text was the invitation from Tom Crowe to spend three months at the Getty Research Institute in Los Angeles in the spring of 2002. As an engine devoted to art historical research, it is unsurpassed, with all the staff devoted to that end. Charles Salas and his team of assistants made life pleasurable and easy. I was fortunate to be able to draw on the services of Glenn Phillips as my research assistant, who made vital inroads into primary written and visual material. My fellow scholars provided vital knowledge and insights, most notably Kajri Jain whose provision of Kipling sources opened up the area explored in the last part of the book.

In Oxford, my staff has been incredibly helpful and tolerant. Successive administrators, Pamela Romano, Nicola Henderson, Laura Illife, and Rachel Woodruff have made an otherwise unmanageable life more workable than my schedule suggests. Marius Kwint, Geraldine Johnson (from Chicago!), and Katerina Reed-Tsocha assumed unreasonable burdens when I was away completing the book. Martin Porter was my earliest research assistant, funded by the British Academy, and worked very productively on eighteenth-century French sources and on automata. His own book *The Windows of the Soul: The Art of Physiognomy in European Culture* (Oxford University Press, 2005), unfortunately arrived too late to be taken into account here. Aislinn Leconte, during the period when she was working toward her doctorate, worked with great efficiency to see the book from a ragged text with no proper apparatus into a form that could be submitted to the press. I have at various points received sums from the Faculty of Modern History at Oxford to facilitate various aspects of the research. Successive chairs Felicity Heal, Christopher Hague, and John Robertson have been unfailingly supportive. The penultimate thrust to bring the book to publication, above all researching and assembling the complex body of illustrations, has been in part undertaken by Roya Akrami, whose work, like that of Aislinn Leconte, was generously funded by the Bross foundation. The final vital effort in bringing the text and illustrations into good order has been superbly undertaken

by Kelly Wilder, with characteristic commitment and good humor. Uta Kornmeier weighed in with welcome help in the very final stages of the editing.

My colleagues Caterina Albano and Thereza Crowe of Artakt, the small company I set up with Marina Wallace to undertake exhibition making and related tasks, have been exemplary colleagues and friends, taking on tasks that I might well have been expected to perform. Marina, as always, has been a special muse to my endeavors. Margaret, Antonia and Imogen Dalivalle have provided key human dimensions for my life, which can all too easily become insular.

I am particularly grateful to the two readers invited by the press to comment on the book. Rachael DeLue and David Knight both consented to read the text nonanonymously (a practice which I strongly support). Their perceptive and constructive criticisms were well taken, and I can only apologize to them that practical considerations (above all time) did not permit me to make as radical changes as I might have liked in the light of their insights. Professor DeLue drew my attention to a number of necessary clarifications, not least with respect to the position of visual images in a study that had developed increasingly philosophical tendencies. David Knight, more expert in the history of the natural sciences than I could ever hope to be, drew polite attention to a number of shortcomings and to things I should have read and taken on board. I have picked up a series of sources and references from his helpful comments.

Susan Bielstein of the Press has been enthusiastic and patient in equal measure, ably assisted by Anthony Burton and Christa Robbins. Mara Naselli served as a superb manuscript editor, improving the text substantially—even if I resisted a few of the American-style suggestions. I am sure that they, like me, are breathing a collective sigh of relief that the long saga is finally over.

INTRODUCTION: FACING UP TO OURSELVES

We all exhibit a propensity to react to members of the animal kingdom as if they have personalities that we can read from their appearance. We also tend to see individual people as bearing some kind of resemblance to one of our fellow vertebrates, or even invertebrates. The title of this series of studies is to be understood in this double sense—humanized animals and animalized humans. There is rich historical legacy of imagery, which illustrates both sides of this animalistic coin.

On one hand we have the wide vein of animal representation, ranging from compilations of natural history to the illustration of animal fables. It would be easy to disassociate the more obviously humorous, narrative aspects of the animal capers from the "serious" scientific illustrations. But this separation is certainly not valid historically. In the first great printed picture books of animals in the Renaissance, the character and meaning of specific creatures as defined in the bestiaries were of as much concern as what we might regard as more scientific data. And fables, for their part, could serve serious philosophical ends. It might seem the whimsy of legend was progressively expelled from the portals of zoological science, above all in the nineteenth century. The element of "story" in the natural history of animals, however, has continued to exercise a powerful if somewhat covert hold on the imaginations of those who aspire to build up a picture of nature in action. Darwin is a key participant in this respect.

At the more popular level, we can all recall as children the central role that animals played in our developing consciousness of character, behavior, and life-narratives. Children's storybooks are replete with speaking animals, often standing on two legs. How many of us have not possessed beloved stuffed animals, accorded human names and very distinct personalities? It is striking how relatively constant are the virtuous and the villainous amongst the child's cast of animal characters. Teddy bears—improbably, given the irascibility of bears in the wild—have become the most popular repositories of warm feelings and trusty companionship. We expect

to find dogs and cats and small birds to feature strongly among the basically good. Snakes figure hardly at all amongst the virtuous. Foxes, amongst the canines, are not regularly regarded with feelings of trust, whereas badgers, which are at least as keenly carnivorous, generally fall on the friendly side of the divide. Wolves are generally beyond the pale. Certainly for Red Riding Hood. Though for the Romans a she-wolf suckled their legendary founders, Romulus and Remus, and there were persistent legends of wild children nurtured by wolves.

Clearly the actual behavior of the animals in relation to humans plays a powerful role in our instinctive perceptions of their characters. The most sustained relationship that we have enjoyed with any animal is with the horse, the noble beast that for generations bore men in peace and war, pulled wheeled vehicles, and tilled our fields. Only exceptionally does the horse play anything other than a worthy role. Equally, it is difficult to imagine a dairy cow or woolly sheep acting as the villain of the piece (or peace), even less so if they feature in their youthful guises as calf or lamb. Bulls and rams are a different matter. Gender and age are obviously potent factors. On the other hand, some notably violent and unsociable animals regularly play admired roles. Our cherished cats are noted for their ritual slaughter of mice and baby birds. Even the lion is conventionally granted a noble personality, according to a legend of many centuries' standing. There is hardly a building erected by European and many Asian rulers that does not parade lions to represent the potentates' just but fierce virtues. Tigers occupy a more ambiguous position, desirably signifying the high performance of Esso petrol, while not commonly regarded as promoters of peace and harmony. As creatures of the dark, bats are not much liked, in contrast to many birds. Black crows do carry sinister connotations, however, while black and white magpies are notorious thieves.

Inhabitants of the waters are best considered on a case-by-case basis, but tend on balance to evoke distrust, with sharks and octopuses regarded as particularly malevolent. Fishes' eyes are often regarded as unappealing and unsettling, and we often refer to something "fishy going on" when we suspect deceit. Amphibians and reptiles also tend to evoke feelings of revulsion. To describe someone as "reptilian" is certainly not a compliment, and we may suspect that they are likely to be involved in slippery or creepy activities. The aesthetics of touch undoubtedly play a role in stigmatizing such genera of animals. Wetness, sliminess, hardness, and temperature all have roles to play. Someone lacking warmth of emotion is described as a cold fish.

Nonvertebrates as a whole tend not to get a good billing, though snails clearly do much better than slugs. Animals with angular exoskeletons exude an air of aggression, reminiscent of knights in armor. Strangely, such "medieval" insect garb has become one of the stock in trade features for futuristic sci-fi warriors from alien planets. Insects and crustaceans are not fondly regarded as a group. Butterflies are an exception, even when masquerading as caterpillars, as are bees for the most part, but not wasps (unless you own a Vespa scooter in Italy). Spiders are sometimes OK, especially with respect to their arachnid weaving skills, and little "Money Spiders" can be children's favorites, but they more often stimulate strikingly adverse reactions

beyond rational explanation. Even in Britain, where there are no native poisonous spiders, the sight of a big, black specimen that has ascended the waste pipe into a white bath is likely to produce a shudder of dread. Relative size and hairiness are definitely significant factors in defining a spider as threatening.

Ancient legends of the animals, particularly as recorded in bestiaries told of idiosyncratic habits that were frequently read in terms of human meaning. Their legacies are found in popular imagery and sayings like "Hiding one's head in the sand," as ostriches were known to do, which has come to symbolize not facing up to reality. When we manifest insincere grief, we are "crying crocodile tears." The key compilations of fables, by Aesop and Jean de La Fontaine, including many illustrated editions, and the recurrent tales of Reynard the Fox, have typically dressed up salutary lessons for humans in the garb of picturesque stories of talking animals. Reynard's legendary cunning is both a literary topos and related to the well-documented inventiveness of foxes pursued by hunters. As in other territories inhabited by the human animal, many beasts retain relatively constant characteristics, such as the kingly lion, though even he could be satirized as occasion demanded.

Over the ages and across cultures, many different animals have been regarded as sacred, and even as deities. Just to take two examples, monkeys are sacred in Sri Lanka, while cows are accorded divine status in India. The term "sacred cow" has entered common usage to indicate something or someone who cannot be criticized (often implying such status is not altogether warranted). The many Egyptian statues of cats testify to their divine attributes, while combinations of feline and aquiline characteristics in such compound beasts as griffins signify origins and powers beyond those of natural creatures. Generally speaking, creatures fantastically assembled from the component parts of diverse species have served as harbingers of divinity or devilry. Almost all religions that have exploited figurative imagery have developed fantastically confected agents for good or for evil. Human-animal compounds carry a particular frisson, as mermaids, sirens, harpies, centaurs, and satyrs testify.

The perceived character of particular animals, male and female, real and imaginary, is not subject to simple generalization, and once we embark on the assembly of lists it is difficult to know when to stop. A complex and often unstable mesh of cultural factors, knowledge, experience, and deep-seated instincts are involved, collectively and individually. The same creature can play the roles of polar opposites. Many people love birds of all kinds. A few cannot stand the look or touch of feathers. And one of the scariest of all Alfred Hitchcock's masterpieces of filmed unease was *The Birds,* in which flocks of flapping insurgents wreaked mass revenge on humans, as fronted by the lovely Tippi Hedren (fig. 1). The complexity and fluidity of our feelings does nothing, however, to diminish the elemental power of our reactions to each creature in particular circumstances.

The power of a film such as Hitchcock's, addressed to adult audiences, shows that whatever we may have sloughed off amongst our childish things, we retain a very strong instinct to anthropomorphize animals and to build them into our own stories. Domesticated companions are obviously in the front line, but no visitor to

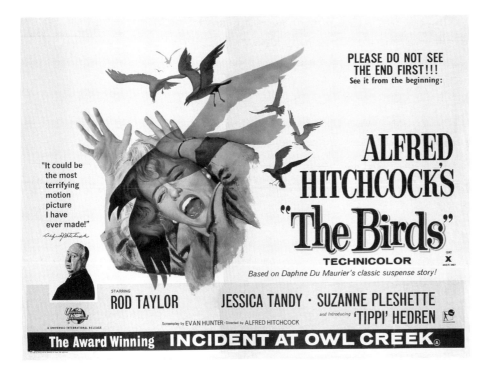

1. Tippi Hedren being attacked in the poster for Alfred Hitchcock's *The Birds*, 1963. Courtesy of the British Film Institute.

a zoo is likely to resist the pull to assign character on the basis of appearance. Even the popular names of some wild animals and, most notably, birds speak of their fancifully assigned roles in human society. The secretary bird, for instance, is all neat precision and high-heeled pertness.

Orwell's exemplary "fairy tale" of revolutionary animals taking over their farm, and the inexorable onset of hierarchies and divisiveness, gains much of the efficacy of its characterization from our instinctual anthropomorphizing. The initial assembly was convened by "old Major, the prize Middle-White boar," now venerable and stout, but still "majestic looking." Of the sketches of the animals, all of whom behave as more or less true to type, none are more finely characterized than the horses:

> The two cart-horses, Boxer and Clover, came in to together, walking very slowly and setting down their vast hairy hoofs with great care lest there should be some small animal concealed in the straw. Clover was a stout motherly mare approaching middle life, who had never quite got her figure back after her fourth foal. Boxer was an enormous beast, nearly eighteen hands high, and as strong as two ordinary horses put together. A white stripe down the centre of his nose gave him a somewhat stupid appearance, and in fact he was not of first-rate intelligence, but he was universally respected for his steadiness of character and tremendous powers of work. . . .
>
> At the last moment, Mollie, the foolish, pretty white mare, who drew Mr. Jones's trap, came mincing daintily in, chewing a lump of sugar. She took her place near the front and began flitting her white mane, hoping to draw attention to the red ribbons it was plaited with.[1]

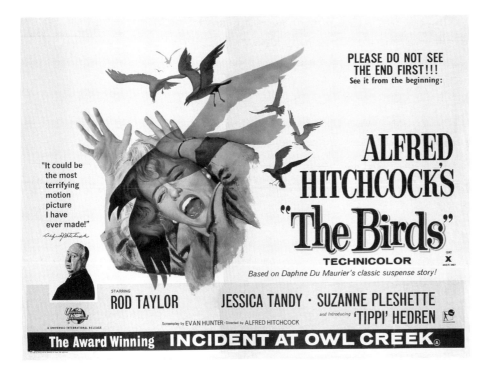

Writing this, as I am, in Los Angeles on the night that the Oscars are awarded, I sense that Mollie would have felt more at home amongst the bejewelled starlets than with the pigs snuffling in their troughs. Though in Orwell's tale it is the pigs that are the cleverest of animals.

At the very end of the book, the pigs are to be discovered forging a self-serving alliance with neighboring humans. Looking into the house at the summit meeting of pigs and farmers, "Clover's old dim eyes flitted from one face to another. Some of them had five chins, some had four, some had three. But what was it that seemed to be melting and changing?"[2] Later, following an argument between Mr. Pilkington and Napoleon, the leading pig, who had been accused of cheating at cards, "Twelve voices were shouting in anger, and they were all alike. No question, now, what had happened to the faces of the pigs. The creatures outside looked from pig to man, and from man to pig again; but already it was impossible to say which was which."[3] This last line of Orwell's novel flips to the other side of our coin; that is to say, to our parade of animalized people.

Sitting in a café in Brentwood, Los Angeles, I notice that someone over there has an aquiline nose. That man beside her has a foxy face. I see a lady who moves like a bird (and maybe eats like one). Continuing in this banal vein, I speculate that she might be a tiger in bed. I am ashamed to find myself thinking in stereotypes. That guy thinks he is cock of the walk. A friend of mine feels that she has physical affinities with a horse. Maybe reincarnation is involved for some. Pioneers of the militant struggle of black people against oppression called themselves the Black Panthers. A military operation is unlikely to be given the code name "turtle dove," although, perhaps given the recent American propensity for military doublespeak, that is now thinkable. A spider-man may be admired for his climbing abilities, even if he is a "cat-burglar," and has recently become a film star, while someone who is a scorpion, with a sting in his tail, is not to be trusted on any account. A sex kitten may rule the silver screen and be an object of desire, certainly on Oscar night in Los Angeles, while a man who is a pig (maybe as applied to a policeman in some parlance) is not nice to know. The names of specific animals are amongst our most frequent terms of approbation and abuse, particularly in the realms of race and gender. Then there are the generalized epithets. Those committing what are perceived as atrocities are stigmatized in a gross way as animals, as beasts (especially when savage or wild), that is to say as essentially inhuman. This is in the face of evidence that humans manage to perpetrate terrible acts on their own kind unequalled in the animal kingdom.

Collectives habitually take animal names that are chosen for their widely recognized appropriateness. American football and basketball teams frequently assume their names and symbols from the ranks of powerful carnivores, airborne or terrestrial. If the chosen animals are vegetarian, they need to manifest famed aggression, like the Los Angeles Rams or Chicago Bulls. It is difficult to think of any macho teams wishing to call themselves the Ducklings or the Mice. Nor would the Rats be well regarded, although the rodents' combative qualities are well known. Aggression is not enough. There must be some perceived virtue as well. British soccer teams are

less richly endowed with animal names than their American counterparts, for a series of historical reasons, but the fighting cockerel of Tottenham Hotspur once stood proudly crowing at the summit of the English game. Sadly not at the time of writing. Spurs's cockerel is also the proud symbol of France as the Gallic cock, though Anglo-Saxons are more likely to stigmatize their continental neighbors as frogs by reference to their eating habits. Powerful individuals, cities, and states pillage the animal kingdom for fearsome or resolute surrogates. The famous battling king of England was Richard Lionheart. Lions and eagles proliferate on heraldic crests, the latter with two heads when symbolizing the mighty Habsburg rulers of European states. A walk around Paris, starting at the Louvre, will uncover a massive pride of sculpted lions, regal and imperial, each exuding a particular sense of French *hauteur*. Even three of Christ's Evangelists are accorded animals, amongst which Mark's winged lion and John's eagle would yield to no secular beast. St. Luke's robust ox is obviously nobody's pussycat, while St. Matthew is accompanied by an angel, who transcends all such beastly matters.

At various historical points, these instincts for animalizing have developed into doctrines of considerable sophistication. From classical antiquity to the nineteenth century the science of physiognomics provided a tool through which we could both rationalize and refine our seeing of faces in terms of birds and beasts. The apparent sanctioning of animal readings of human features by Aristotle lent the tradition considerable gravitas, but it needed more than distinguished ancestry to have persisted so long. Then in the nineteenth century the new sciences of man and nature that aspired to measure, classify, and categorize as their central duty set the human races and types within a spectrum from animals to man. It was a spectrum that had been rendered continuous by Darwin. Evolution, anthropology, ethnography, craniology, eugenics, primatology, and allied sciences redrew boundaries not only between the animal species but also between different kinds of *Homo sapiens* and between apes of differing capacities. In humans the division was between advanced and primitive races, between normal folk and those degenerates who were evolutionary throwbacks to our animalistic past, and between the highly intelligent vanguard of civilized people and the others who had not cast off their lower tendencies.

Degenerate humans were often hairy, heavy browed, and prognathous. Or rather, those with such features were predicted to behave in animalistic ways. My father told me that men with hairy bodies were of low mentality. He was notably smooth. Men exhibiting degenerate "signs" were likely to act brutally, an adverb which, after all, comes from the noun "brute." The brutish "cave-men" of post-Darwinian convention invariably possess coarse mats of bodily hair. In Desmond Morris's *The Naked Ape,* the scientific equivalent in the twentieth century of *Animal Farm,* the central argument is that the stages of embryonic development humans share with apes are terminated by birth before the appearance of overall hairiness and other simian features can set in.

Even for naked apes, the veneer of civilized behavior is always thin. This is the underlying import of William Golding's *Lord of the Flies,* described by the author

himself "as an attempt to trace the defects of society back to the defects of human nature."[4] Not the least operative of Golding's phrases is "back to." He took it as axiomatic that the malign elements fermenting in the closed society of his stranded children were the legacies of our evolutionary past. Published in 1954, eight years after Orwell's *Animal Farm,* Golding's fable assigns a comparably central role to pigs. The cleverest of the boys is the fat Piggy, who is eventually hunted down at the edge of the sea. Struck by a rock dislodged by one of the painted "savages," "Piggy fell forty feet and landed on his back across the square red rock in the sea. His head opened and stuff came out and turned red. Piggy's arms and legs twitched a bit, like a pig's after it has been killed."[5] Earlier, the sustained and brutalizing slaughter of a sow had marked the dominant faction's regression into primitive hunters.

Pink and hairless as they are, pigs have made regular appearance as surrogates for humans. There is a long-standing sense that pigs are brighter than most farmyard animals, despite their grubby habits, and we will later meet a learned pig who became a star performer in the early circus. Perception of their humanoid attributes has recently been given a considerable boost by the use of pig organs for human transplantation. On the other hand, it is not nice to say that someone's house is like a pigsty, implying an environment that reverts to animal standards. Talking of pigs, we may recall that Homer's enchantress Circe transformed Ulysses's men into porcine form, while they nonetheless retained their human understanding. In La Fontaine's ironic recasting of the story, Ulysses's companions, now metamorphosed into a variety of animals, decline the chance to turn back into humans, since they have been able to see the essential nastiness of humankind. In the sixteenth century, Giovanni-Battista Gelli's *Circe* had paraded a succession of metamorphosed humans, all of whom told how they preferred their new state to their previous existence, with the exception of the elephant (formerly a philosopher), who wished to regain the human power of higher reasoning.

In all this, there is a prevailing sense of "higher" and "lower." Someone who does not act virtuously has "fallen" into bad ways. Following the archetypal Fall of Adam and Eve, expelled from primeval paradise into a world riven with sin and the temporal decay of our bodies, the best that their heirs can do is to strive unceasingly to ascend to a state of grace. A "fallen" man descends to the state of the beasts, who do not know better. Indeed, the hierarchy of higher and lower entities in the chain of being created by God placed angels at the top, toward whose virtues humans might aspire if not attain. Electing to become a "fallen angel," like Satan, was the ultimately evil choice. In Western thought, the myth of the Fall when combined with the idea of progress and, eventually, the theory of evolution, produced a three-dimensional schema of vertical and temporal hierarchies distinct from any other culture. What remained implicit in the notion of the Fall was the conviction that humans had been specifically created to be distinct from the animals.

There is also a persistent sense that surrendering to excessive (or any?) sexual desire is to give way to our animal tendencies. What happens in the loins (a term largely reserved for allusions to sexual matters) is seen as remote from the control

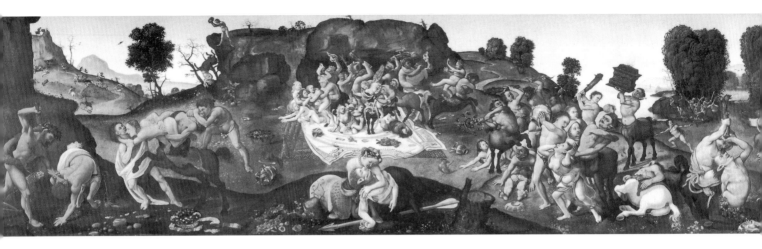

of human intellect and rational judgment. Prostitutes may be described as degrading themselves, and were studied in the nineteenth century for bodily signs of their animal natures. There is no more potent symbol of the rule of our animal parts that the legendary centaur. When Ovid describes how the centaurs ran amok at the wedding of Caeneus and Hippodame, brutally attacking the Lapiths, who are just there to celebrate, it is clear that they are surrendering to their base instincts. What chance do they have when they are at least half animal? Dante characterized the centaurs as essentially sad, sufficiently endowed with higher faculties in their heads to be aware of the baseness of the untamed lusts welling up inexorably from below. In Piero di Cosimo's panel of the *Battle of the Lapiths and Centaurs* (fig. 2), the half-beasts behave bestially, yet they are capable of manifesting worthy sentiments, as in the touching detail of the male centaur dying in the tender arms of the lamenting female.

The very sense of higher and lower is intimately tied into the uniquely upright gait of humans, whose head is lifted toward the heavens. There is something inhuman and degrading in the act of crawling, literally or metaphorically. In the biblical book of Daniel the proud and magnificent Babylonian king Nebuchadnezzar was condemned by God to an animalistic existence on all fours: "he was driven from men, and did eat grass as an oxen, and his body was wet with the dew of heaven, till his hairs were grown like eagles' feathers, and nails like birds' claws."

When we transform ourselves into the two-backed monster during intercourse, or do it "doggy-style," we are not expressing something that is distinctive to our specifically human nature. Literary and popular descriptions of sexual acts are so replete with animal terminology that they do not require listing here. Those moralists who draw up condemnatory codes know this as well as anyone. Carnal acts are condemned. They are of the flesh, which we share with animals, and are not worthy of our elevated minds. The duality of our natures and the pull of the animal is an enduring refrain.

I can think of no instances in which the animal-man or man-animal coin is entirely one-sided. Often, the two sides flip with such rapidity that they seem to be one. The stakes were and are high. The emotional settings for animalized people

2. Piero di Cosimo, *Battle of the Lapiths and Centaurs,* c. 1500–1505, National Gallery, London. Courtesy of the National Gallery, London.

across the ages range from light comedy to profound tragedy. Either way, the theme takes us to the heart of how we define ourselves in relation to those species in nature that come closest to us in biological performance. If we are definitively of a different order from the animals, particularly if they are endowed with no immortal souls and no real feelings, we have an apparent license to treat them as placed on earth to serve our ends. Some extreme Cartesians of the eighteenth century argued that animals were no more than automata whose squeals of pain were simply mechanical responses. If some of our fellow humans are judged on whatever grounds to be little better than such beasts, the implications are all too clear.

As I am, after too long a delay, preparing this text for publication on September 6, 2004, and seeking Internet access, Netscape's "Fun and Games" promises to answer the question, "What kind of dog are you? . . . If you were a Dog, are you more of a Mutt or a timid Chihuahua? Take the Test!" I do not have time to take the test, but its presence on such a global site testifies to the persistence of the anthropomorphizing tendency, a persistence that clearly goes beyond mere cultural convention.

The original quest behind the Bross lectures might be described as a journey through visual images of the human animal, mainly from the "fine arts," set in their intellectual contexts. In other words, it consisted in a kind of "art history plus." In the event, the transition from lectures based around a succession of images to a series of thematic chapters has resulted in a more hybrid form, closer to the history of ideas, but with recurrent recourse to art historical resources. I am aware of a certain uneasy quality in the hybrid, but the unease may in itself be telling. Unlike the written word, a picture or other autonomous representation cannot in itself declare a polemic stance in one direction or another. A picture of a stag ripped apart by savage hounds and witnessed by scarlet-coated riders on fine horses might have been painted for the delight of a regal hunter or to support the campaign to outlaw hunting as brutal. One of the jobs of the visual historian is to locate the image in the context of its making to define the field of attitudes in which it originally operated. However, when the image of the hunt is separated over time from the brief behind its making, an aficionado of the chase is free to bring a different way of looking at the image than someone appalled by blood sports. By contrast, a text on the philosophy of animal rights is likely to parade clearly articulated arguments in favor of a particular point of view, which is unambiguous and with which the author will hope to convince the reader.

The essential fluidity of interpretation built into a visual image is both a strength and a weakness in the history of ideas. The weakness is that an image cannot literally state an idea, framing it as a philosophical proposition. The strength is twofold. A powerful visual image is memorable in a special kind of way, and can remain indelibly with the viewer over a long span of time. Indeed, the ancient "art of memory" relied upon specifically visual triggers to recall words and names, as when items to be recalled were imaginatively secreted in specific locations within a building. The second strength, arising directly from the lack of fixedness of meaning in a visual

image is that we are able to personalize our "stored image" in a way that we gain a special sense of ownership. Amongst literary texts only poetry consistently exhibits this property, and the poet's art, like the painter's, openly relies upon allowing mental space for the audience to complete the image.

The chapters that follow are full of sharply angled stances juxtaposed with images that stand in a variety of relationships to the philosophies behind the stances. The relationships range from illustrative to generic and ambiguous. Even the more direct illustrations stand as very selective translations of the text, at a remove naturally greater in kind than any verbal translation into another language. A complex image presents each viewer with an interpretative field of a particular visual type, and often exhibits a protean potential in the avenues it seems to invite the historian to explore. There is a nice tension in the interpretative strategies that work with images and words, and that this tension stands in a suggestive relationship to the historical and enduring untidiness of human values and communication, individually and collectively.

My starting point lies, therefore, in visual imagery drawn from the Western tradition, mainly paintings, sculpture, drawings, and prints, including some illustrations from what we regard as the particular domain of science. The representations will for the most part be static. Thus film is only a point of reference, not the subject of attention in its own right. This means, sadly, no analysis of the legions of Frankensteins spawned by Mary Shelley's great invention, nor a bloody trail of Draculas inspired by Bram Stoker. Literary works will also feature largely amongst the supporting material, though they move toward the foreground in the postscript at the very end of the book. The *Fables* of La Fontaine are the most conspicuous exception. Above all my choice to limit myself to a certain kind of visual evidence is occasioned by my lack of a rounded cultural knowledge in other artistic territories. I am aware of how much has been lost by confining this project to Western cultures, looking only at non-Western cultures through eyes conditioned by predominantly European viewpoints. In a sense, I have launched a frail paper boat on a river of diverse cultural currents, and the best I can hope is that readers might help it to remain afloat long enough to reach places unknown to me.

Even limiting the scope to evidence that can be related more or less directly to visual images, the territory remains unmanageably vast, chronologically and geographically. My strategy has been to identify the seminal factors in the debates across different eras, largely from the Renaissance to the nineteenth century, and then to concentrate on episodes that appear to vividly reveal how beliefs came to be expressed in visual form. Another factor in the strategy has been to feature episodes in which striking works of art have been conspicuously present. The technique is not so much survey as selective and intuitive sampling. There will be other equally compelling examples, of which I am unaware or about which I am inadequately informed. But one of the benefits of such a rich topic is that the reader has ample opportunity to bring his or her experience and knowledge to bear. I am laying down some features in the provisional map used to guide my breathless journeys between a

few of the towns and villages in the vast landscape. For a more comprehensive view of the historical panorama in written sources from 1500–1800, in Britain at least, the reader can look to Keith Thomas's magisterial *Man and the Natural World.*

Another hazard, caused in part by the range of reference, is not being able to keep abreast of important publications that have emerged in the last three or four years. I am particularly conscious that it would have been good to conduct a dialogue at relevant points with Roy Porter's *Flesh in the Age of Reason,* published in 2003. Some other more recent publications have been erratically raided to keep the references more up-to-date than they otherwise might be. Generally speaking, my text is light in footnotes. I have concentrated on immediate sources and some recent texts that do jobs I cannot.

The text is organized into six thematic essays, each of which contains specific subjects linked by schematic surveys of the intervening territory. Some of the intervening discussions venture from the home ground of the human animal—the account of the four humors is a case in point—but the holistic philosophies of human nature embed fundamental assumptions about humans and animals even when their relationship is not the specific focus. I am also conscious that the same players appear in slightly different guises in successive chapters. This is a consequence of the thematic organization, but it has the advantage that some familiar characters walk reassuringly back onto the stage at various points in the story.

The essays are organized into three parts. The first deals with the paradigms of the constitution of our bodies and minds that persisted from classical antiquity to the eighteenth century. This basis of the theory is granted a relatively extensive outline, since it underpins many of the episodes that feature in later parts of the book. Our visual story, though founded on ancient philosophies, will effectively begin in the Renaissance, when artists began to use their new skills of naturalism to depict characters according to the external "signs" manifested by their temperaments. Each person's constitution was believed to be built upon a four-part base, which was ultimately dependent upon the qualities of the four elements, earth, water, air, and fire. The four basic humors within the body expressed themselves in terms of the four main temperaments. Ideally, one's constitution should be balanced, with no humor predominating, but in practice such balance was rare and impermanent. We all tend to lean toward one of the four temperamental poles—sanguine, phlegmatic, choleric, or melancholic. In extreme cases, someone may lurch into such imbalance and be characterized as insane.

We still use the term "unbalanced" to indicate somebody whose mind we believe to have become temporarily or permanently unhinged. Where the human animal enters the equation is when the temperaments were characterized in terms of those animals that seemed to manifest the qualities that the unbalanced person was exhibiting. The choleric man, for instance, would share the nature of a lion. And the traditional books told us that the lion, as the "King of the Animals," was at once fierce and noble, fearsome and magnanimous, indomitable and wise—the ideal military leader, in fact—though ill-suited for the contemplative life or domestic

tranquility. So deeply embedded were his leonine characteristics that the "signs" of the man's head would parallel those of his feline counterpart. His hair would be vigorous and manelike, his forehead broad and noble, his eyes bright and fierce, and his teeth strong. In this way, the doctrine of physiognomics, which claimed to read the "signs" of the face predictively, is founded upon the conjunction of temperamental medicine and animal characterization. Built into a highly developed theory of character and expression in the seventeenth century, physiognomics and pathognomics (the study of the passing signs of emotions) became the standby of academic painters who wished to tell great human stories. The persistence and coherence of this tradition will take us well into the nineteenth century.

The second part looks at a related theme—dominated by the formulations of Descartes in the early seventeenth century—namely the extent to which humans and animals may be regarded as functioning machines. Whether they are more than that is the key question. Do animals have souls? Are they, in terms of a question that has gained renewed urgency in our age of thinking machines, conscious beings like us, with real feelings? Or are they merely automatic devices? The wonderful automata contrived in the eighteenth century, especially in France, provided evidence that man could make machines operate like animals and perhaps even like people. If it was possible to argue that the animal was a machine, were we merely deluding ourselves not to give due credence to *l'homme machine*—the human being as simply a better kind of device that had developed a sophisticated ability to think of itself as superior? This was of course a godless thought, but it became thinkable in the eighteenth century in the circle of those who followed certain of the implications of Descartes' ideas to what seemed to be their logical conclusion.

Those who opposed the mechanist position based their arguments on traditional foundations. Montaigne made telling use of the ancient and modern accounts of clever animals, who often seemed to possess natural qualities that surpassed those of vain humans. Sage and principled beasts in stories drawn from a range of sources served to put us to shame. Subsequently, La Fontaine, the supreme teller of fables about personality animals—who found his greatest illustrator in Oudry some half a century later—skillfully employed irony to counteract Descartes' characterization of animals as soulless devices. La Fontaine stands as our representative of the enduring tradition of fables. At the same time, the dominant voice in natural history, the Comte de Buffon, was redefining the origins of humans and animals, proposing a scheme that was at once materialist and not overtly Cartesian. His vision of the great age of the earth and the progressive advent and extinction of perfectible species, in which everything arose from material processes, was combined with an absolute belief that humans alone were privileged with souls that could convene with God.

The third part looks at the blurring of the boundaries between the human and the "wild." Initially this occurs in a number of related arenas, without the emergence of any consistent conceptual framework. Most striking in a literary sense are widespread discussions of a few renowned cases of feral girls and boys in the eighteenth and early nineteenth centuries. These strange children of nature seemed to

be devoid of essentially human characteristics and most especially of language, the signal mark of rational beings. Jonathan Swift and Daniel Defoe, authors of the two most celebrated fictions about men thrust into environments outside the norm, were understandably drawn to the spectacle of animalistic children who attracted so much attention from polite society and philosophers alike.

The popular spectacles like the circus, where animals were trained to uncannily perform human acts, and the "freak shows" which displayed human monsters, were not so obviously played out in philosophical and scientific arenas, but the promoters often drew upon scientific-sounding theories to account for the amazing half-human, half-beast creatures they were parading before astonished spectators. They also attracted some learned commentary. These transgressions between the human and the animal provide an important if generally unrecognized setting for Darwin's ideas, when they burst into public consciousness.

Two related areas of scientific speculation complimented the accounts of wild children and public spectacles: the stories of "primitive" (generally hairy) men who inhabited strange territories, remote in either time or place; and the rising science of primatology, in which the anatomy and behavior of varieties of ape were being studied on a more a systematic and comparative basis. The *Homo sylvestris,* the "wild man of the woods" is recurrent actor in both these transgressive mini-dramas. Primitivology and primatology provide more obvious contexts for Darwin.

Darwin's recharacterization of *Homo sapiens* in relation to the species of the animal kingdom brought together the series of scattered philosophical, scientific, literary, and popular trends under the embrace of a great, overarching theory. Darwinian paleontologists' reconstructions of "primitive man," coupled with primatology's increasing sense of the nature of our simian cousins, promised a new kind of natural history for the human race within an evolutionary context. We were beginning to see where we really "came from"—and what we might revert to if we lose a grip upon what it is that makes us civilized.

During the nineteenth century, sustained, even obsessive attempts were made to place the qualitative inferences of traditional physiognomics onto a basis more in keeping with the demands of professional science. Phrenology, the now-ridiculed science of the "bumps" on our crania, possessed many of the attributes of a seriously empirical discipline, linked to the latest ideas about the brain as it developed embryologically in different species. Any science needed a system if it was to be taken seriously, and the more that system was founded on precise measurement, the better. Classifying, counting, measuring, calculating, codifying, and statistical analysis became the order of the day. Ways were needed that could provide a rigorously empirical basis to replace the philosophical assumptions that had underpinned earlier readings of the external signs. The means were provided by geometry and metrical measurements. Geometry was used to plot such features as the angles of human profiles, which came to provide telltale evidence of the relative distance of various races from the apes. The systematic measuring of heads and, to a lesser degree of bodies, provided great data banks for the differentiation of the "races of man"—never to

the detriment of the Caucasians who essayed the theories. The new sciences of anthropology and eugenics, and the refined techniques of psychology, all came to rely upon systematic recording of case studies on a scale such that diagnostic precision could be expected. The new tool of photography promised to be the ideal handmaid of the measuring men.

Bodies of apparently impeccable data were used to show that even within a civilized society it was possible that a degenerate, atavistic individual could all too readily revert to a more primitive state than is socially acceptable. Atavism was defined and diagnostically described in a seemingly rigorous manner by the new sciences of anthropometry and criminology. The feared beast that potentially lies within us was seemingly confirmed by the precise techniques of science.

In the Literary-Cinematic Postscript I pick up on just a few of the later cultural expressions of the human animal to demonstrate the continued vitality and protean adaptability of the motif in artistic and fictional contexts—even in an era when so much science has been applied to the dissection and definition of the constitution and behavior of humans and animals. My tactic is to look at four literary man-animals who exercised a special fascination during the twentieth century. They are Mowgli, the wolf-boy in Kipling's *Jungle Books;* Tarzan, that heroic aristocrat of the jungle as conceived by Edgar Rice Burroughs; Count Dracula, the memorable, blood-thirsty creation of Bram Stoker; and the bestial Mr. Hyde who emerges from within Dr. Jekyll in Robert Louis Stevenson's famous story. All four have enjoyed substantial afterlives in the cinema and beyond. The compelling way that these and similar images of animalistic humans continue to cast their spells over our imaginations testifies to something utterly fundamental about the concept of the human animal.

Finally, with some deference, I "come clean," endeavoring to set out my personal views of the issue that run beneath the surface of the whole book; that is to say how we as a species are related to animals, as seen in the light of the Darwinian revolution. Is the difference between the species that drives cars and those which swing through trees a matter of degree or kind? Or could it be that a difference of degree comes to function as a difference in kind?

PART I

HUMORS, TEMPERAMENTS, AND SIGNS

Fixing the Signs

Although we now commonly use the term "humor" in relation to something that is funny, we do also speak of someone being in a bad humor, and we might more generally inquire about what kind of humor someone is "in." Defining someone's temperament is a common enough thing to do, and we have a sense that those attributes that comprise someone's temperament are deeply built in their constitution rather than passing characteristics. Whether these characteristics arise from nature or nurture, they are not to be readily gainsaid. It is also quite common for the terms that designated the four canonical temperaments in antiquity to be used as contemporary labels. A person who is sanguine is generally seen as well disposed and in a good humor toward things in general or some certain thing in particular. A phlegmatic person is not readily roused, tends to take things very much as they come, and is little disposed to strong reactions even if provoked. Someone who is melancholic (or, more commonly, who is feeling melancholy) suffers from a sadness that goes beyond the routine. The term "choleric" is probably the least current of the traditional terms, though not wholly obsolete. The choleric person is fierce, irascible, and abrupt in action and "bilious." The last adjective, derived, as we will see, from our bodily bile, keys us particularly clearly into the medical basis of the four traditional temperaments, and the humors that underlie them.

Originally the humors were recognized as the natural "juices" essential to the life of things—the vivifying fluids that made dry things moist—such as sap in a plant. The humors of the human body came to be expressed in four temperaments. Blood, yellow bile, black bile, and phlegm manifested themselves respectively in the sanguine, choleric, melancholic, and phlegmatic temperaments to which all humans were variously subject. Animals were confected from the same basic natural ingredients, and some kind of deep affinity might be expected. Since the doctrine underpins virtually all the attempts to define human characteristics in relation to those of

animals, not least through the science of physiognomics, it will make sense here to undertake a reasonably full outline of how the system works, even at the costs of seeming to take some time to reach our main subject.

HIPPOCRATIC PRESCRIPTIONS

The four descriptors of temperament were not mere convention but were locked into a highly developed medical theory of the constitutions of our bodies and minds, and, indeed, more broadly into a theory of everything that extended from the state of our livers to the dispositions of the planets. The basic framework was generally credited to the legendary Greek physician of the fourth century BC, Hippocrates of Cos, whose name survives into current medical practice through the Hippocratic oath, to which aspiring doctors have traditionally been required to adhere. For our purposes, it matters little whether the sixty works in the Hippocratic collection or corpus are credited to Hippocrates himself in whole or in part, or, more especially, whether the key treatise, *On the Nature of Man,* was actually written by him. It is also not our immediate concern to establish to what extent he invented the basic notions or, as seems likely, gave existing concepts their authoritative expression. From our present perspective, it was the attribution of the ideas to such a revered (if shadowy) figure that matters. The major transmission (and transformation) of his conceptual framework was effected by the hugely influential Galen of Pergamum, court physician to Marcus Aurelius in the second century AD.

The Hippocratic treatise *On the Nature of Man* will serve to lay down the basics. The foundation is provided by defining the four elements—earth, water, air, and fire—and their correlation with the seasons by Empedocles in the fifth century BC. Hippocrates begins by denying that man can be a unity—that is to say something composed of one, unified, unchanging substance. Rather, "the body of man has in itself blood, phlegm, yellow bile, and black bile. These make up the nature of his body, and through these he feels pain or enjoys health. Now he enjoys the most perfect health when these elements are duly proportioned to one another. . . . Pain is felt when one of these elements is in defect or excess, or is isolated in the body without being compounded with all the others."[1] The most compelling evidence of the nature of the humors comes from the observation of imbalances. For instance, moist phlegm, the coldest of the humors, "shows itself to be the coldest element by reason of its nature. That winter fills the body with phlegm you can learn from the following evidence. It is in winter that the sputum and nasal discharge of men is fullest of phlegm; at this season mostly swellings become white, and diseases generally phlegmatic."[2] As the seasons succeed each other, so we can witness the rise of blood, being moist and warm, followed by a predominance of yellow bile in summer (warm and dry) and black bile in the autumn (also marked by a decrease in blood as the weather chills), and finally by the phlegm of winter.

To affect cures,

The physician must set himself against the established characters of diseases, of constitutions, of seasons and ages; he must relax what is tense and make tense what is relaxed. . . . Whenever many men are attacked by one disease at the same time, the cause should be assigned to what is most common, and which we all use most. That is which we breathe in . . . But when diseases of all sorts occur at one and the same time, it is clear that in each case the particular regimen is the cause, and that the treatment carried out should be opposed to the cause of the disease . . . and should be by change of regimen. . . . One should . . . carry out treatment only after examination of the patient's constitution, age, physique, the season of the year and the fashion of the disease, sometimes taking away and sometimes adding.[3]

Generally speaking, blood is the most positive of the humors, ideally manifesting a balanced mixture of the four elements, whilst bile and phlegm are particularly associated with illness.

The individual constitution of each person's body manifests its own particular combination of qualities, and each organ exhibits a different composition. The result is a complexity that explains the infinite varieties of human natures, the onset of seasonal illnesses, and the idiosyncrasies of our detailed medical histories.

The set of quotations from *On the Nature of Man* convey how a doctrine that is largely alien to modern medicine is founded upon a judicious mixture of observation, common sense, and general theory. Indeed to have survived as long as it did, it needed to posses compelling explanatory value. It is also helpful to have signaled the nature of the mental framework for the setting of the human constitution within the great whole of the created world, a framework that set the tone for almost all the authorities we encounter in this chapter. The vision is holistic, playing to the idea that the human body is a microcosm or "lesser world" that embodies the fundamental properties of the wider world and the governing actions of the cosmos.

The Hippocratic corpus does not in itself contain a definitive statement of the alignment of the four humors with the four elements or with other components in the four-part schema, including the four ages of man, and it is not altogether clear when the fully developed system was established. In retrospect, we can see that it was Galen's open and influential identification of the humors with the four elements—and their qualities of cold-dry (earth), wet-cold (water), wet-warm (air), and warm-dry (fire)—that paved the way for the elaboration of the system in subsequent centuries. It was certainly known in its canonical form in the early Middle Ages, not least as transmitted in translations of the Islamic philosophers, and was taken over in ever more developed forms in succeeding centuries. By the Renaissance, the outlines laid down by Hippocrates and Galen had been elaborated into a system that embraced all the principle properties of the observable world. It held wide if not unchallenged sway until the eighteenth century and continued to attract adherents even in the nineteenth. Although there were variant alignments, it is possible to draw up a table (fig. 3), which lays out a typical if not absolutely standard rule of four.

SANGUINE	blood	air: warm, moist	morning	spring	youth	Jupiter	Zephyr
CHOLERIC	yellow gall	fire: warm, dry	midday	summer	maturity	Mars	Eurus
MELANCHOLIC	black gall	earth: cold, dry	evening	autumn	later middle age	Saturn	Boreas
PHLEGMATIC	phlegm	water: cold, moist	night	winter	old age	Venus or Moon	Auster

3. Table of the Four Humors.

Although there were variations in the characteristics attributed to each type, we can recognize some more or less constant refrains. Sanguine people tended to be reasonably active, pleasant in demeanor, and generally full of "good humor," while cholerics were prone to hyperactivity and were liable to fly into rages. Phlegmatics and melancholics shared a propensity to lassitude, though the phlegmatic was more docile and somnambulant, while the melancholic was darkly introspective and intermittently creative. Each temperament manifested itself not only in behavior but also in physical characteristics and "complexions," not least in physiognomy and the nature of skin (color and texture). The external "signs" came to constitute a diagnostic kit, which the physician could use in conjunction with other manifestations (such as the color of the urine) to determine the nature of the imbalance affecting a sick person.

That the temperaments also came to be commonly associated with animal types is unsurprising, given, as we will see later, the intimate alliance between medicine and physiognomics, but the specific identifications remained rather variable. The sanguine temperament was variously but not exclusively equated with the horse, the peacock, and the monkey; the choleric by the lion, eagle, and bear; the phlegmatic by the owl, ass, and pig; while the melancholic is denoted by the elk and the sheep. However, regardless of the actual animal chosen, the drift of the exercise is clear. The temperaments traditionally attributed to particular beasts, which are themselves built from the four elements, serve to make them ideal representatives of human natures. Thus the fierce choleric must be represented by a bold and combative animal, while a phlegmatic will be equated with a tranquil browser. However, as we will see when we look at Dürer's *Melencolia I,* even a vigorous and friendly animal like a dog could be overcome by contrary characteristics, just as a sanguine person might fall into a melancholic decline if humeral dispositions are significantly disturbed.

Equally unsurprising, particularly in light of the role of astrology in medicine, is the identification of the temperaments with specific planets. The most noted equation was of melancholy with Saturn, and we still speak of a saturnine disposition with some distaste. Mars was clearly the right god for the belligerent choleric, who is given to martial exploits. Jupiter for the sanguine, and Venus or the Moon for the phlegmatic are perhaps less obvious, but were made to work in the way that the system demanded. At least Jupiter's amorous exploits in various disguises, including his appearance as a swan when he impregnated Leda, demonstrate that lusty blood courses in his veins. And the moon has the cold stillness of the phlegmatic. When

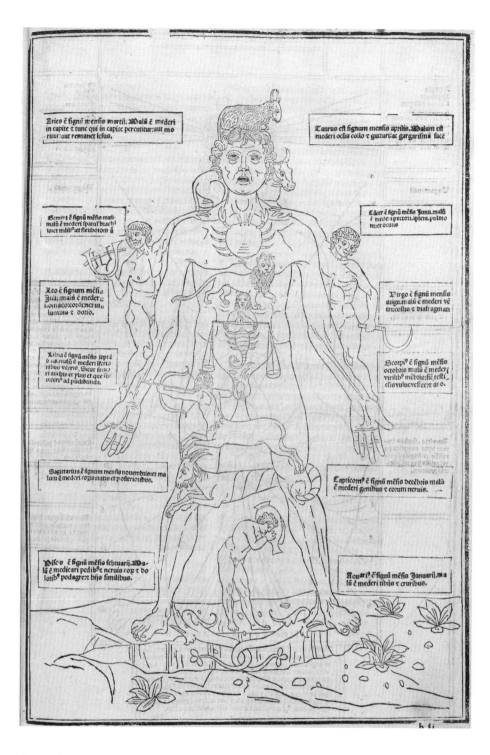

Arico é signū mēsis martii. Walū é mederi in capite τ tunc qui in capite percutitur: aut moritur: aut remanet lesus.

Taurus est signum mēsis aprilis. Walum est mederi oclis collo τ gutturi: ac gargarismū facé

Semini é signū mēsis maii: malū é mederi spatul brachi iser māibʒ: et fleubotom ā

Cācer é signū mēsis Junii. malū é mederi: pectori. ipsēi. pulmo niœt oculis

Leo é signum mēsis Julii. malū é mederi: nōmaco: cordi: neruis lūbis τ dorio.

Virgo é signis mēsis augu. malū é mederi vē tricostūe τ diafragmā

Libra é signū mēsis septēb ris. malū é mederi iscrio ribus vētris. Sicut femo ri anibus et plus et que sūt viseri ad pudibunda.

Scorpi⁹ é signū mēsis octobris malū é mederi virilibʒ mēbris: sic testi clis vuluevescec: τ ano.

Sagittarius. é signum mēsis nouembris: et malū é mederi coxis natio et posterioribus.

Capricom⁹ é signū mēsis decēbris malū é mederi genibus τ eorum neruis.

Pisces é signū mēsis februarii. Wa lū é medicari pedibʒ τ neruis coxτ do loribʒ podagreτ hijs similibus.

Aquari⁹ é signū mēsis Januarii. Ma lū é mederi tibijs τ cruribus.

h ij

these identifications are coupled with assigning the influence of the planets and astrological signs to specific parts of the body, where specific humors held local sway, a further piece of the neat cosmological jigsaw of the microcosm and macrocosm falls into place (fig. 4).

It is understandable that such a potent system should have left an enduring mark on our vocabulary. In addition to the terms already noted, we can also see how the

4. *Zodiac Man* from Johannes de Ketham, *Fasciculo de medicina*, Venice, 1493, The Bodleian Library, University of Oxford. Reference Zodiac Man. RR.x.195.

epithets jovial, loony (or lunatic, from *luna*), and venal allude to the temperaments of the planetary deities. Perhaps the persistence of terms from humeral medicine goes beyond linguistic habit. Its physiological origins have long been refuted, but its insights (real or imagined) are far from dead. Jerome Kagan, the Harvard developmental psychologist, in his book *Galen's Prophecy,* advocates a return to four-part division of personality—timid, bold, upbeat, and melancholy—as corresponding to patterns of brain activity.

As a visual peg on which to hang this pervasive scheme in its historical context and interdependent complexity, we cannot do better than look at the extraordinary (and apparently unique) set of prints of *The Four Seasons* in the History of Medicine Collections at Duke University in North Carolina.[4] Of uncertain origin, and not readily attributable to a known artist, they appear to be of Northern European origin (probably Dutch), and to date from the early seventeenth century. They may originate from the great map-publishers in Holland—mapping, as it were, the human condition as well as the terrestrial and celestial worlds. Artistically, they are somewhat stiff and provincial in style, but in their intricate content and construction they collectively function as a remarkable encyclopedia of the human microcosm in the context of the greater cosmos. The figures, their settings, the diagrammatic components, and the inscriptions are replete with learning and symbolic meaning, ranging from the obvious to the arcane. The cycle is governed by the zodiacal arch over the figures, which displays astrological data for the months and the meteorology of each season. Each print is additionally equipped with strata of superimposed paper flaps, which progressively disclose deeper layers of anatomical knowledge, and with rotating paper "volvelles," movable paper dials that allow the information from the various domains to be systematically permutated. The moving components allow us to dissect the figures step-by-step, and perform astrological calculations to predict the decreed course of our mortal affairs, including the propitious times for bloodletting, travel, and decisive action. Each image is richly endowed with inscriptions based on the *Aphorisms* of Hippocrates, together with moral injunctions and biblical texts. Their full meaning has yet to be unraveled in all its astonishing and eclectic intricacy. A broad outline interspersed with just a few characteristic details will serve our present purposes.

Let us start with *Spring* (fig. 5), which is announced on the scroll held by two swallows. At the center stands a fourteen-year-old youth, flanked by younger siblings. On the right, a young person, apparently female, holds a staff adorned with banners. Maybe she is the youth's future mate. On the left, a baby emerges from a round uterus, which is equated with the earth on the other prints and is matched on the right by an astrological sphere. The children stand on a carpet of spring flowers, while animals in the background munch on new grass. The urine flask held by the young man is labeled "phlegm," which means that the equations appear not to be absolutely standard for the time. If they were, spring's flask would contain blood rather than phlegm, normally a wintry humor. Then as now, doctors could entertain their own variations on generally accepted theory.

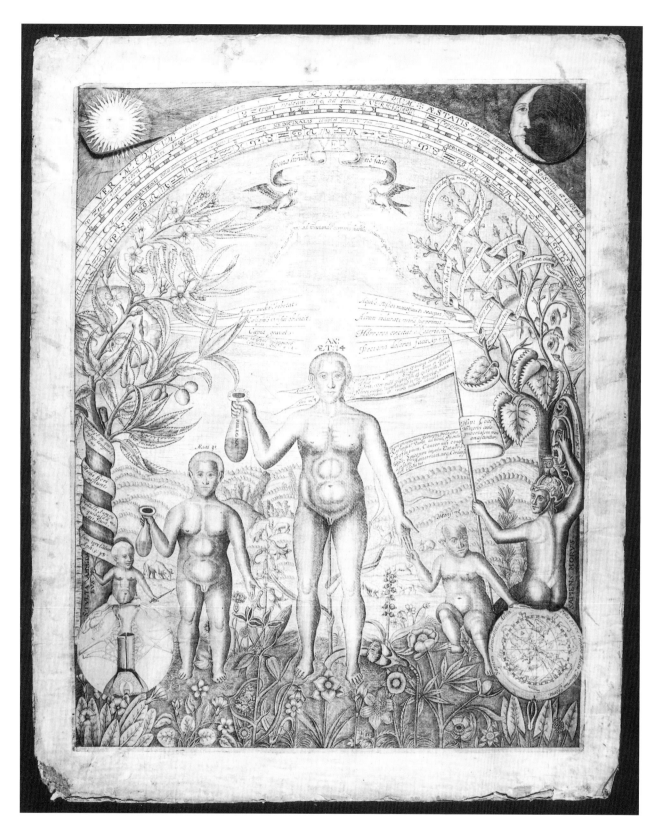

5. *Spring* from *The Four Seasons: Spring, Summer, Fall, Winter.* Four seventeenth-century copperplate engravings (flap anatomies), Europe. History of Medicine Collections, Duke University. Property of Duke University Medical Center Library, Trent Collection, History of Medicine Collections, Durham, NC. Photographer: Bill Gage.

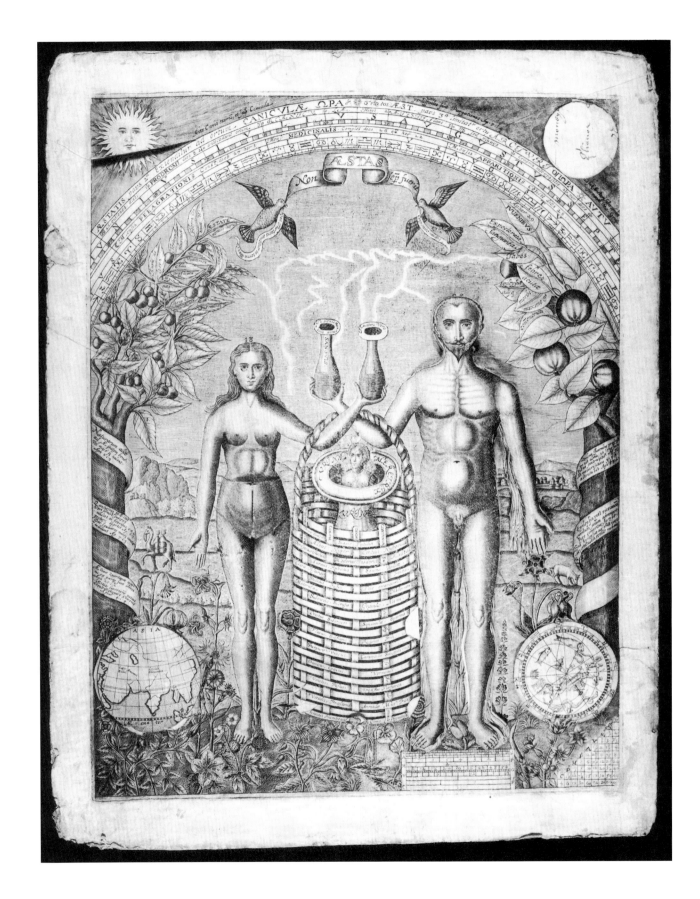

The three subsequent prints are dominated by two adults, one male and one female, inevitably recalling Adam and Eve. The paired trees of life and knowledge on either side of each print underline the reference to Paradise and the Fall. In *Summer* (fig. 6) heralded by two loving doves, the intertwined couple stand before us in their prime. A passing camel hints at heat in the distant landscape, above the globe, which shows Asia. The figures' proportional perfection is underscored by the ruler at their feet and by the ziggurat of proportional numbers (fig. 7). Hinged at the man's head, male anatomy is progressively disclosed in a series of overlapping flaps. The woman's belly opens to display only that part of her which usefully differs from her male partner. Their flasks contain the sanguineous humor. Between them is an elaborate alchemical "basket" containing a vessel from which the head and shoulders of a "distilled" man emerge (fig. 8). The tree on the right is a pomegranate, but the leaves ominously bear the names of diseases.

To announce *Autumn* (fig. 9), the tag is borne aloft by the stork that traditionally delivers infants. The seed implanted by the man's erect penis has borne its fruit in the woman's gravid uterus, replete with a homunculus, as revealed by more hinged flaps. The father's urino-genital system is accessed through the paper doors of his abdomen. The humor is signaled as yellow bile. A lion surveys his domain on the left, while an active elephant is visible in the middle ground between the man's thighs. The globe has been replaced by the schema of the five senses, mingled at the center into one "common sense." The central horoscope (fig. 10) appears to be cast for an inhabitant of Bologna in 1605, though the prints are certainly not Bolognese in style and technique. This is not the least puzzling aspect of the origins of the cycle.

By the time *Winter* has arrived (fig. 11), the man is forty-nine years old—we do well to recall the shorter life expectancy in those days. Balding and somewhat en-

OPPOSITE

6. *Summer* from *The Four Seasons: Spring, Summer, Fall, Winter*. Four seventeenth-century copperplate engravings (flap anatomies), Europe. History of Medicine Collections, Duke University. Property of Duke University Medical Center Library, Trent Collection, History of Medicine Collections, Durham, NC. Photographer: Bill Gage.

TOP

7. Ruler and ziggurat of proportional numbers, detail from *Summer* (fig. 6). Property of Duke University Medical Center Library, Trent Collection, History of Medicine Collections, Durham, NC. Photographer: Bill Gage.

8. Alchemical basket, detail from *Summer* (fig. 6). Property of Duke University Medical Center Library, Trent Collection, History of Medicine Collections, Durham, NC. Photographer: Bill Gage.

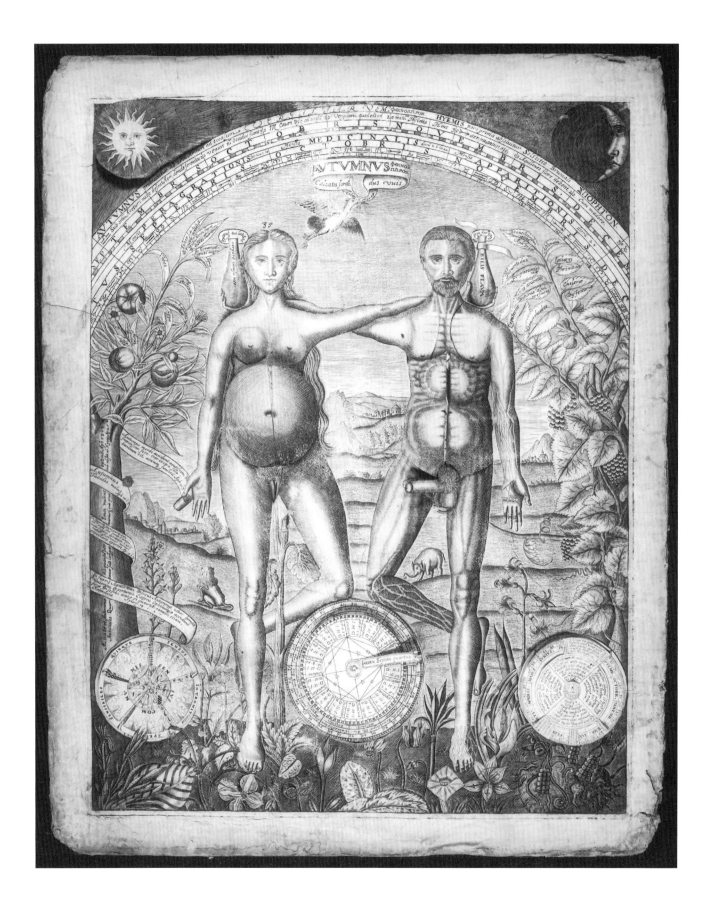

feebled, he turns his back (which is dissected by the raising of successive flaps) on his emaciated and departing partner (anatomized from the side). Emptying her flask of melancholic humor to reveal a skull, and holding a cane topped by another skull, she steps into a fiery but gloomy cleft in a rock dense with fossils. Her face is darkened by the predominance of black bile. Her tree is barren of leaves, while the globe beside the man displays the American continent and sprouts a tobacco plant. It may be the couple's children in the background who press olives and huddle beside a warming fire, stewing food in a cauldron. A tiny figure appears to be planting seeds in the ground. These distant signs of hope are reinforced by the phoenix, holding the central banderole and symbolizing resurrection.

Astrology clearly plays a determining role in the overall scheme, with the fortunes of human life turning inexorably on the wheel of the zodiacal signs. Faith in the rule of the planets over our lives is utterly understandable, given the striking evidence of the moon's ability to shift great bodies of tidal water, and the cyclical governance evident in all aspects of the natural year. Where no known physical mechanism (such as gravity) could be called into account for such action-at-a-distance, it was rational to believe that some kind of invisible influence was at work, transmitted from heavens to earth. The dramatic subjugation of all human, animal, and vegetable life to the cycles of the sun in the passing days and unfolding seasons bore irrefutable witness to the earth's position in the greater scheme of cosmological motions. In this setting, humans and animals are not so much related but are wholly integrated parts of the cosmic system. It is hardly surprising that they manifested profound affinities.

In societies that were still wholly dominated by the vagaries of agrarian cycles, it was sensible to assume to that some hugely complex clockwork was at work and set the seal upon how our lives could be conducted within the world as a whole. There was no reason why humans should prove exempt from the greater patterns of nature. Even today, urban dwellers who are largely insulated from the most extreme effects of the seasons, and able unseasonably to purchase vegetables and fruit of all kinds at any time of the year, are affected in ways deeper than we may commonly credit. The melancholy of the darker seasons, as experienced by sufferers of Seasonally Affective Disorder (appropriately abbreviated SAD), is something to which few are wholly immune, particularly in northern climes where the short hours of daylight do not extend beyond our indoor working day.

OPPOSITE

9. *Autumn* from *The Four Seasons: Spring, Summer, Fall, Winter*. Four seventeenth-century copperplate engravings (flap anatomies), Europe. History of Medicine Collections, Duke University. Property of Duke University Medical Center Library, Trent Collection, History of Medicine Collections, Durham, NC. Photographer: Bill Gage.

TOP

10. Horoscope, detail from *Autumn* (fig. 9). Property of Duke University Medical Center Library, Trent Collection, History of Medicine Collections, Durham, NC. Photographer: Bill Gage.

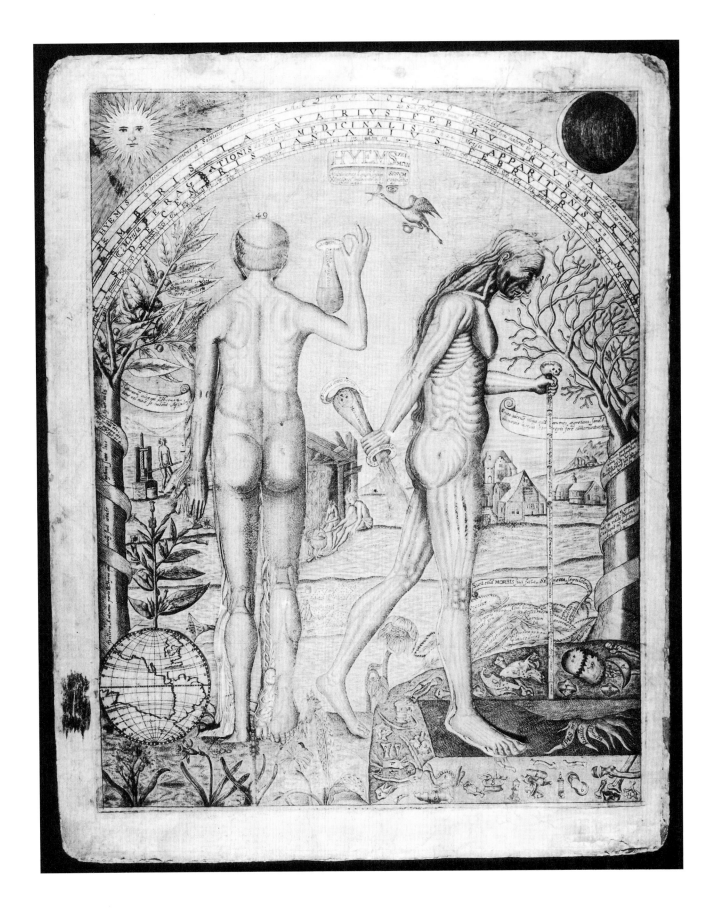

Looking at the *Four Seasons* as a set, we can see how the Hippocratic mottoes locate the knowledge they convey within the compass of the physicians' art. Each component cog in the celestial and earthly clockwork meshes intimately with its neighbors and is an integral part of the functioning whole. The prints are multi-dimensional and interactive machines, serving as computational devices for the great body of philosophical knowledge that the physician needs to possess if he is to undertake proper diagnosis and perform the Hippocratic rebalancing of health. They provide an exemplary visual assemblage of the great bodies of cosmological and earthly knowledge that underpin many of the ideas expressed over the ages.

Amongst examples of "high" art that express the theory of the humors and temperaments in an equally developed if less arcane manner, the prime example has long been recognized as the monumental *Four Apostles* painted by Albrecht Dürer (fig. 12). Presented as his own memorial to his home city of Nuremberg in 1526, and now looming over ranks of spectators in the Alte Pinakothek in Munich, the two great panels clearly represent his supreme artistic testament. The painter himself confessed that "I have bestowed more trouble [on them] than on any other painting."[5]

The great German painter, printmaker, and theorist shared with Leonardo da Vinci, his Italian contemporary, the belief that art should be "universal"; that is to say, one that constructs representations of all forms in nature on the basis of a profound understanding of natural philosophy in all its relevant facets. Indeed, the parallel between the ambitions of the two men is more than coincidence. Not only was it a logical culmination of Renaissance moves to place the visual arts on philosophical basis, but it is evident that Dürer became closely acquainted with some of Leonardo's ideas and drawings on his second visit to Italy in 1505–6.

There can be no doubting Dürer's knowledge of the humors. An avid student of pagan and religious philosophies, he could have turned to his friend Philip Melancthon for an erudite introduction, should any have been necessary. Melancthon, a humanist, author, and Protestant reformer, specifically cited the long account of melancholy provided in the *Problemata,* then firmly believed to be by Aristotle, praising it as a "most sweet doctrine."[6] He specifically attributes a *melancholia generossisima* to his artist friend, a diagnosis with which Dürer himself appears to have concurred.[7] We also have a credible contemporary witness to the direct expression of the doctrine in Dürer's powerful characterizations of the four monumental figures. Johannes Neudörffer, the learned letterer responsible for the Lutheran inscriptions below the Apostles, describes the images presented to Nuremberg as "pictures in oils . . . wherein one may recognise a sanguine, a choleric, a phlegmatic and a melancholic."

On his own account, in his *Four Books on Human Proportions,* Dürer openly adheres to the idea that the planets hold sway over our lives, and refers specifically to the four natures of man, assuming that the reader will be aware of the conceptual framework that lies behind what he is saying: "If you . . . want a treacherous Saturnine picture or a martial one or one that indicates the child of Venus that should be sweet and gracious, so you should easily know, from the aforementioned teachings,

OPPOSITE

11. *Winter* from *The Four Seasons: Spring, Summer, Fall, Winter.* Four seventeenth-century copperplate engravings (flap anatomies), Europe. History of Medicine Collections, Duke University in North Carolina. Property of Duke University Medical Center Library, Trent Collection, History of Medicine Collections, Durham, NC. Photographer: Bill Gage.

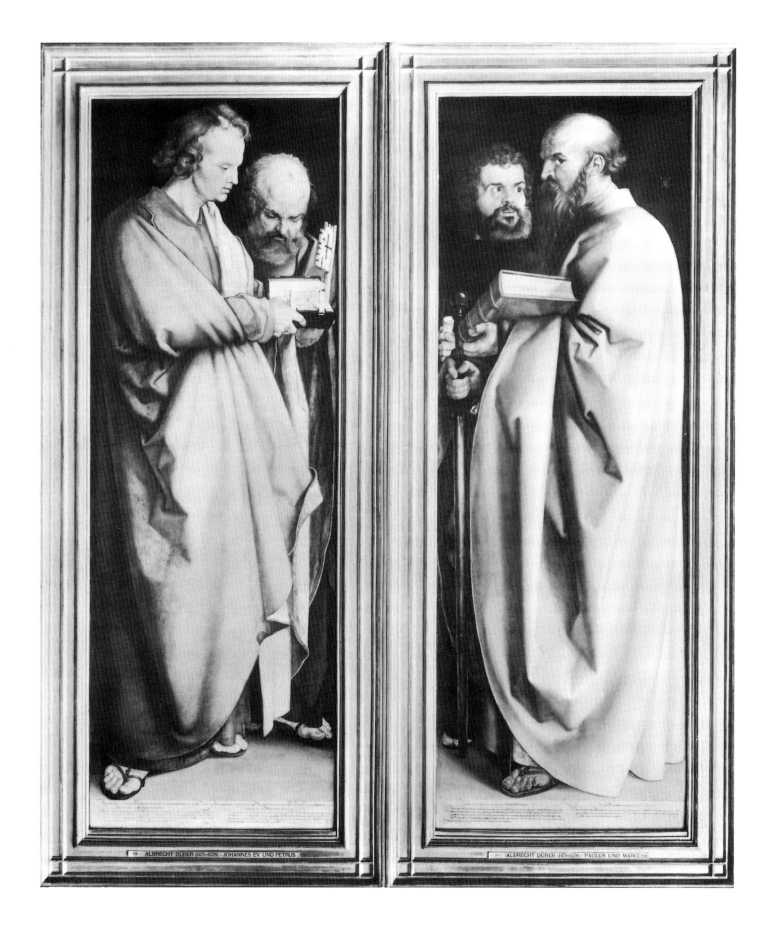

ALBRECHT DÜRER (1471–1528) · JOHANNES EV. UND PETRUS

ALBRECHT DÜRER (1471–1528) · PAULUS UND MARCUS

if you have practised them, what measure and manner you should use for it. For by outward proportions all conditions of men can be described, whether of a fiery, airy, watery or earthly nature. For the power of art, as we said, masters all things."

If we set Dürer's images beside one of the stock texts on the four humors, the broad alignment of his presentation of the four characters with traditional wisdom is immediately apparent. The text is from *On the Constitution of the Universe and of Man,* and it dates from the second or third century AD: "Those governed by the purest blood are agreeable, laugh and joke and have rosy, well-coloured bodies; those governed by yellow bile are irritable, violent, bold and have fair, yellowish bodies; those governed by black bile are indolent, timid and ailing, and with regard to body, swarthy and black haired; but those governed by phlegm are sad, forgetful, and with regard to body, very pale."[8] Although Dürer is not describing quite such a pathological set of signs, which would not be appropriate for Christ's representatives, the sanguine rosiness of the youthful St. John, phlegmatic nature of the elderly St. Peter, the bold character of St. Mark, in the prime of manhood, and the sallow melancholy of St. Paul as he passes into late middle-age are in keeping with the general drift of the anonymous author's prescriptions.

What Dürer has accomplished, however, is to transcend the general conceptions by creating characterizations in which every part of the Apostle's physiognomies and vestments speaks integrally of their deepest natures. St. John's reddish hair, moderately wavy, and the warm glow of his complexion are vividly complemented by the hot redness of his cape, offset by its glowing yellow lining and the complementary green of his underlying robe. To pick up the kind of animal analogy that Dürer would have regarded as natural, he is akin a spirited horse in fine condition, with flowing mane, keen eye, healthy skin, and of good stock. St. Peter is altogether more visually reticent, set back so that little of his grey garment is visible, while his aged and sagging features exude that sense of withdrawal and interiority that is characteristic of many old people. He is wise and imperturbable, like an owl; dignified, grizzled, and solid like Orwell's old boar. St. Mark, though apparently constricted within the rearward space of the right panel, asserts his stern spirit through the bright vigor of his eye, flashing teeth, dark curly hair and beard, and the dogmatic blackness of his costume. His sight is as bright as that of the eagle, legendarily able to look directly on the sun, while the cast of his features is truly leonine. St. Paul, dressed in a striking outer robe that resists definition as a definite color, glances suspiciously from the corner of his eye at the arriving spectator, seemingly more occupied with dark thoughts than open communication, and endowed with a greasy, sallow complexion that does not suggest that he is in the prime of health. The haunted look may evoke that of an elk, the animal that represents the melancholic temperament in Dürer's engraving *The Fall of Man*. The pairing of the Apostles seems to be designed to emphasize contrast, according to the principle of juxtaposing opposites enunciated by Leonardo: in the left panel we see youth set against old age; and boldness is contrasted with introversion on the right.

OPPOSITE

12. Albrecht Dürer, *Four Apostles,* 1526, Alte Pinakothek, Munich. Bayerische Staatsgemäldesammlungen, Alte Pinakothek, Munich.

In one sense, it may seem almost irreverent to disclose the medical pathology of such paragons of divine virtue. But we should recall that they were men, ordinary men, three of them fishermen indeed, imbued with divine spirit through their association with Christ but still subject to the fleshy foibles to which we are all succumb. They stand as representatives of the grand scheme of things on earth, the four-part harmony around which God has organized his creation. Like us they bear witness to our inexorable progress toward death via the four ages. The youthful John, the mature Mark, the middle-aged Paul, and the elderly Peter mark out the march of time, with overt echoes of the cyclical seasons and times of day. But, however much they are part of the earth, they have shown by their deeds that mere mortals can aspire to divine status through the gift of the holy spirit.

Some dozen years earlier, Dürer had already essayed the definitive portrayal of just one of the temperaments in his engraving of *Melencolia I* (fig. 13). There is probably no print by any artist from any period into which so much philosophically coherent detail has been aggregated into a unified whole. The androgynous figure in a heavy and elaborate dress slumps in unhappy contemplation of mental demons seen only by her. Her weighty head is propped on a rigidly clenched fist. We sense that her feathery wings are not about to transport her to a happier place. The plump putto, who may have dozed off in the middle of his lessons or is simply self-absorbed, does not appear to be ready to activate the scene. The woman's wreath of entwined water parsley and watercress—moist plants that promise to counteract the dryness of black bile—have done nothing to relieve the symptom of her dark complexion. A key hangs limply from a strap attached to her waist band, and her moneybag sits unattended in the folds of her skirt. Grasping one leg of a splendid pair of compasses, she shows no sign of taking any informative measurements or of reading the book in her lap. Around her lie the neglected symbols of pure mathematics and the practical geometry of handicrafts. The sphere and the polyhedron, together with the magic number square inset into the wall above her head, seem to speak of unfathomable mysteries rather than rational enlightenment. The truncated cube, in which the basic form is difficult to perceive, presents itself as a disturbingly skewed variation on the regular and semiregular polygons that were becoming well known through Leonardo's illustrations to Luca Pacioli's *De Divina proportione*. The ominous bell, hourglass, and judgmental scales presage a fate to come. We are unclear whether the burst of light and rainbow can be read optimistically, or whether the menacing and tortured "bat" that flags up the name, MELENCOLIA/I, inexorably rules the day. Certainly the scrawny and angular dog, which has not even broken its lassitude to eat properly, suggests that the problem is not of a transient nature.

A clear sense of the erudite climate of ideas in which Dürer's print would have made its full effect can be gained from the account of Saturn/Melancholy in Henry Cornelius Agrippa of Nettesheim's *De occulta philosophia,* first completed in 1510 and published in amplified and elaborated form in 1531. Agrippa's account gives a good flavor of his esoteric elaboration of a theory of everything:

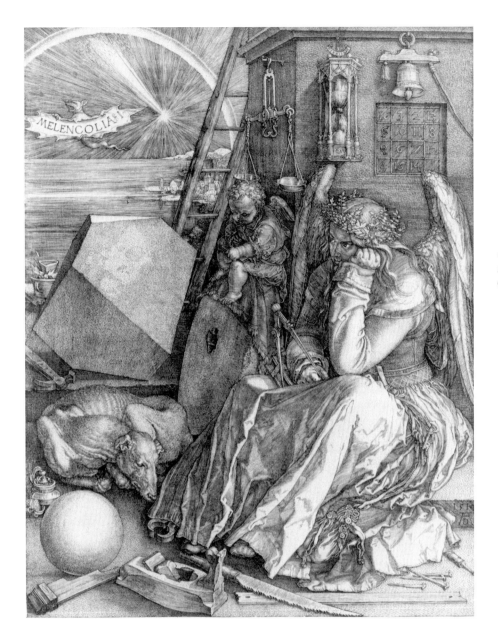

13. Albrecht Dürer, *Melencolia I*, 1514, Ashmolean Museum, Oxford.

Saturn . . . , like the *humour melancholicus* . . . is cold and dry . . . he is the lord of secret contemplation, foreign to all public affairs and the highest among the planets, so he constantly recalls the soul from outward matters towards the innermost, enables it to rise from lower things to the highest, and sends it knowledge and perception of the future. . . . Moreover, this *humour melancholicus* has such power that they say it attracts certain demons into our bodies, through whose presence men fall into ecstasies and pronounce on many wonderful things. The whole of antiquity bears witness that this occurs in three different forms, corresponding to the three-fold capacity of outer soul, namely the imaginative, the rational and the mental. For when set free by the *humour melancholicus,* the soul is fully concentrated in the imagination, and it immediately becomes a habitation for the lower spirits, from whom it often receives wonderful instruction in the manual arts. . . . but when the soul is fully concentrated in the reason, it becomes the

home of the middle spirits; thereby it attains knowledge and cognition of natural and human things; thus we see a man become a philosopher, a physician or an orator . . . But when the soul soars completely to the intellect, it becomes the home of the higher spirits, from whom it learns the secrets of divine mattered, as, for instance, the law of God, the angelic hierarchy, and that which pertains to the knowledge of eternal things and the soul's salvation.[9]

It is easy to see where Dürer's Melancholy resides in this scheme of ascent and descent. Less favorably disposed to the power of the *humour melancholicus* than Agrippa, Dürer has emphasized the lower reaches of this disposition, in which the high intellectual and practical potential of imagination has become paralyzed by insufficiency. In effect, the woman, for all her ostensible cleverness, is rendered to a state no better than the wasted dog. The fact that the dog appears to be the kind of companionable Renaissance greyhound used to chase down prey in aristocratic hunting (as in Dürer's own *St. Eustace*) makes its enervated state even more poignant.

The sympathetic and integral role of animals in the four-part scheme of the "conditions of man" is implied by Dürer's characterization of particular creatures throughout his drawn, printed, and painted oeuvre.[10] In his exceptional engraving *The Fall of Man* in 1504, the temperaments and complexions of different animals are used to underscore the world of humoral imbalances and mortality into which the condemned humans are to be expelled. Like the later *Melencolia I, The Fall of Man* (fig. 14) conjoins his technical virtuosity, Renaissance stylishness, and Northern naturalism in the service of the highest philosophical erudition, theological learning, and human meanings. The animals lurking in the immediate vicinity of the spot on which Adam and Eve are standing appear to be representative of the temperaments, even if they do not actively act out the more overt aspects of their characters—perhaps that would have been too distracting from the main subject. The skulking elk exhibits the melancholy glance that was to characterize Paul; the ox is the very soul of phlegmatic calm; the reproductive prowess of the fecund rabbit qualifies it as a representative of the sanguine disposition (allied with Venus, the goddess of love); and the leonine cat seems to promise martial fierceness once it is aware of the mouse's presence. Looking at Dürer's magical drawing of a *Hare* (fig. 15), very much alive with blood coursing through its veins, we can sense that it would stand as a representative of the sanguineous temperament no less appositely than the rabbit. The inference implicit in the print is that post-Fall pathologies of humoral imbalance condemn the human body to reside in the realm of the unbalanced beasts.

It seems likely that the antidote that Dürer prescribed for deeply pathological melancholy lay not with the bodily remedies of "physic," but with recourse to spiritual things. His engraving of *St. Jerome,* also from 1514 and distributed with *Melencolia I,* illuminates the deep satisfaction that comes from engaging in things pertaining to God.[11] The contentedly writing saint, illuminated as much by inner light as by the beautifully described sunlight streaming though the window, aspires to the third of Agrippa's three states; he engages with "the secrets of divine matters . . . and

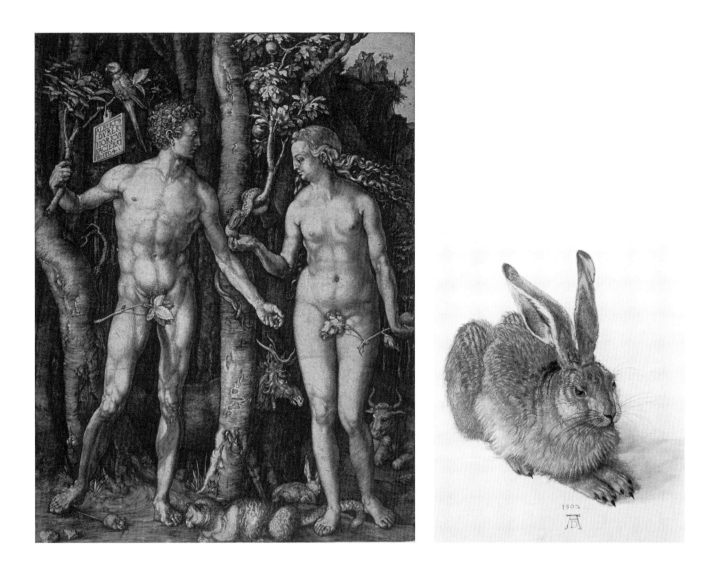

14 . Albrecht Dürer, *The Fall of Man,* 1504, Ashmolean Museum, Oxford.

15. Albrecht Dürer, *Hare,* 1502, Albertina, Vienna.

the soul's salvation." Jerome's benign lion rests comfortably, yet with eyes open just wide enough to detect intruders, while a well-nourished pet dog slumbers peaceably. Whether there was to be a *Melencolia 2,* or even a *Melencolia 3,* is unknown, but St. Jerome clearly represents the productive exercise of *mens* (intellect). He demonstrates how man can most nearly ascend toward the realm of the angels, rather than surrendering to the inner demons that haunt the magnificently troubled woman.

The finest artistic successor to Dürer's great print of melancholic pathology is Lucas Cranach's 1528 painted *Melencolia* (fig. 16); again, the dog is used in a telling manner. Cranach's fashionable lady, as yet less troubled than her predecessor, sits distractedly whittling on a stick, a time-honored way to waste time. The specifically melancholy dog lies indolently on a cushion on the bench immediately below the inscription MELENCOLIA, while his foreground companion, a greyhound like Dürer's, is stirred into irascible and unwanted action by four boisterous putti. In the heavens, the "demons" of whom Agrippa speaks are looming up in a dark cloud that is encroaching on the sunny landscape. The naked witches ride a motley assemblage of

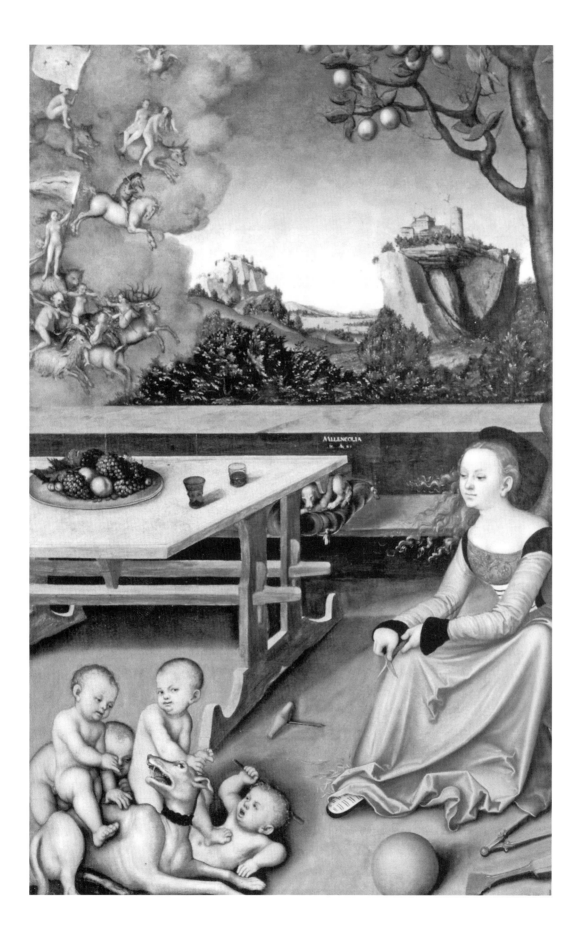

animal steeds, including a bull, wild pig, stag, and goat. The only "normal" mount, a fine white horse, is pointedly ridden by a beaked monster. The implications of the arrival of dark forces are no less potentially sinister than in Dürer's image, but Cranach takes typically playful and courtly delight in devilish things, as in his coquettish Venuses and appealingly wicked Cupids. While not underrating the appeal of Cranach's image, it remains true that no one came close the power of Dürer's vision. The engraving of *Melencolia I* has insinuated itself into our imaginations in the way that few images ever have.

ARISTOTELIAN DIAGNOSES

As we have seen, the descriptions of the appearance of persons with one of the four temperaments in the written texts are somewhat generalized and only go so far in providing visual resources for the artists. The importance of animals in the scheme is readily apparent but somewhat unspecific. Dürer, in particular, succeeds in going far beyond the general prescriptions to endow his characters with very specific physiognomic characteristics, and he uses animals in a telling manner. For this, it is virtually certain that he resorted to a more specifically visual resource, the ancient science of physiognomics, which provided detailed accounts of facial features for different types of character in terms of animal analogies. Like the influential account of melancholy in the *Problemata,* physiognomics could claim a distinguished Aristotelian pedigree.

Just as we used the Hippocratic *On the Nature of Man* to set up the conceptual field within which the theory of the humors operated, so we can look to the Aristotelian *Physiognomics* to set up the tenets of the science of reading human features. No longer regarded as an authentic work of the Peripatetic master, the *Physiognomics* is more plausibly attributed to his close follower, Theophrastus. However, it carried with it the authority and gravitas of an authentic tract throughout the Middle Ages, Renaissance, Baroque, and beyond. As with the Hippocratic text, a series of quotations will provide the basis for an understanding of its cogency, subtlety, and intellectual base.

At the heart of its rationale lies Aristotle's special conception of the soul as the "form" of the body. This is immediately apparent when he discussed animal characters in the first section: "No animal has ever existed such that it has the form of one animal and the disposition of another, but the body and soul of some creature are always such that a given disposition must follow a given form."[12] "Form" in this sense is not merely the physical shape that something has assumed, but the metaphysical formative agency by which substances have been composed, molded, and ordered to become a specific thing.

Later the author develops this theme:

It seems to me that the soul and the body react on each other; when the character of the soul changes, it changes also the form of the body, and conversely. . . . Madness appears

OPPOSITE

16. Lucas Cranach, *Melencolia,* 1528. Private collection on loan to the National Gallery of Scotland.

to be an affection of the soul, yet physicians by purging the body with drugs, and in addition by prescribing certain modes of life can free the soul from madness. By treatment of the body the form of the body is released, and the soul is freed from its madness. . . . It is also evident that the forms of the body are similar to the functions of the soul, so that all the similarities in animals are evidence of some identity.[13]

This profound reciprocity of soul and body means that the soul should be deducible from a person's or animal's physical appearance by those adept at reading the signs. This does not mean that there is a single, easy way to reach physiognomic understanding. All three types of earlier physiognomic theory contain some incomplete truth. The first relies upon straightforward animal analogies; the second classifies humans into different types, especially by race; and the third works by observing pronounced affections and then correlating the observed features in the subject. Theophrastus, if it is indeed he, indicates that a judicious compound of these techniques is desirable. Indeed, if we look at the first technique, simple identification of a facial type with a single animal is too unsubtle: "We have to make our selection from a very large number of animals, and from those that have no common characteristic other than that whose character we are considering."[14] We also have to differentiate between the fixed signs, which speak of enduring character traits, and the more passing effects of particular expressions of the moment. However, he allows that a particular expression, if it becomes persistent and ingrained, can be taken as a sign of something other than fleeting emotion.

Above all, the science is based upon the systematic assembling of empirically verifiable characteristics: "The physiognomist draws his data from movements, shapes and colours, and from the habits appearing in the face, from the growth of the hair, from the smoothness of the skin, from voice, from the condition of the flesh, from parts of the body, and from the general character of the body."[15] As his first instance, he argues that

> A vivid complexion shows heat and warm blood, but a pink complexion proves a good disposition, when it occurs on a smooth skin.
>
> Soft hair shows timidity and stiff hair courage. This is based on observation of the animal kingdom. For the deer, the hare and the sheep are the most timid of all animals and have the softest hair; the lion and the wild boar are the bravest and have very stiff hair.[16]

The formula stiff hair equals courage thus properly obeys the stipulation that the signs of a particular trait should be drawn from data across animal species. As he later emphasizes:

> The characteristics of a brave man are stiff hair, and erect carriage of the body, bones, sides and extremities of the body strong and large, broad and flat belly; shoulder blades broad and far apart, neither very tightly knit nor altogether slack; a strong neck but not very fleshy; a chest fleshy and broad, thigh flat, calves of the legs broad below; a

bright eye, neither too wide opened not half-closed; the skin of the body is inclined to be dry; the forehead is sharp, straight, not large, and lean, neither very smooth nor very wrinkled.[17]

It seems that the signs of a courageous person are to be distinguished from irascibility: "Drawn-back lips are the mark of an acid temper; dark complexion and dry; about the face are wrinkles, and the face is furrowed and fleshless; the hair is straight and black."[18] Presumably, if the author were to be pressed on each count, all these and the other physical characteristics could be aligned with those of groups of animals that habitually display courage, just as the opposite physical attributes of cowards could be recognized in sets of timid creatures.

In this light, it is not hard to see how the physiognomy of animals can be read. To give just two examples:

> The lion of all the animals seems to have the most perfect share of the male type. Its mouth is very large, its face is square, not too bony, the upper jaw not overhanging but equally balanced with the lower jaw, a muzzle rather thick than fine, bright, deep-set eyes, neither very round nor very narrow, of moderate size, a large eyebrow, square forehead, rather hollow from the centre, overhanging towards the brow and nostril below the forehead like a cloud.

Then the bodily characteristics are adumbrated, and he concludes, that we can read the lion's character as "generous and liberal, magnanimous and with a will to win; he is gentle, just and affectionate towards his associates."[19] This is Dürer's St. Mark (and Jerome's pet), to a tee. By contrast, the panther, which is certainly not cowardly and exhibits great physical prowess, looks disconcertingly feminine, with its small head and light limbs. It may be this disjunction that leads the author to conclude that the panther's character "is petty, thieving and, generally speaking, deceitful."[20] Generally speaking, the science of physiognomics is more adept at identifying admirable characteristics in men than in women, who are generally adapted to a very limited range of praiseworthy functions.

The final section of the treatise parades a list of human signs and their most striking animal manifestations, somewhat schematically when compared to the more subtle earlier injunctions. Indeed, it was this list that provided the sanction for the prescriptive formulas that came to dominate popular physiognomics and tended to lead it into later disrepute. The following examples will serve to give the flavor of the diagnostic formulas:

> Those that have thick extremities of the nostrils are lazy; witness cattle.
> Those that have thickening at the end of the nose are insensitive; witness the boar.
> . . .
> Those whose forehead is small are ignorant; witness the pig. . . .
> Those who have sharp, quick moving eyes are rapacious; witness the hawks.[21]

Physiognomic ideas of this kind persisted throughout successive Christian and Islamic cultures. The most substantial espousal of the Aristotelian notions in the Middle Ages came in Michael Scot's *Physiognomics,* part of a trilogy of treatises presented in 1228 to Emperor Frederick II. The British-born philosopher was an important translator of Aristotelian wisdom from Islamic sources—studies in which the learned Frederick was keenly interested—and he became the emperor's favored astrologer. Michael's treatise on physiognomics not only parades the expected prescriptions for the discerning of character from facial features but also deals with wider "physiological" matters, such as conception and child birth, anatomy and the humors, and, more surprisingly, dreams. His astrologically dominated work is very similar to what we have seen in the *Four Seasons.* He adheres completely to the Aristotelian metaphysics of the soul as the form of the body, espousing a fully reciprocal relationship in which the soul responds to the body and vice versa. At the core of Michael's treatise lay a series of Aristotelian diagnoses through which fixed signs can predict character types and prescribed behavior. For a Renaissance representative of this physiognomic tradition, we could not do better than nominate Michele Savonarola of Padua. Grandfather of the fiery and reformist monk, Girolamo Savonarola, who had such a traumatic influence on Florence in the 1490s, Michele was physician to the D'Este Dukes in Ferrara, and a prolific author, if little known today. Amongst his writings on medical and medically orientated themes was a manuscript treatise on physiognomics, which, unsurprisingly, approached the topic through the doctrine of the humors.

When we turn to interpret works of art using the signs of physiognomics as retailed in such treatises we need to exercise some caution. The prescriptions of physiognomy are like the horoscopes in the daily paper—they can be cast so generally that they appear to match what we wish to observe. If, for example, a hero is portrayed by an artist as generally bold in body and expression, as is virtually axiomatic, this hardly provides the basis for equating the portrayal with the physiognomic texts. Ideally, we would like some direct testimony (as was readily available for Dürer) that physiognomic theory was in the minds of those responsible for the images. In the case of Leonardo, it helps greatly that when he lists the fundamental tasks for his projected treatise on the human body, he outlines his intentions to

> describe the grown man and woman, and their measurements and the nature of their complexion, colour and physiognomy. Then describe how they are composed of veins, muscles and bones . . . Then I will show in four expositions the four universal states of man; that it is to say mirth, with various acts of laughing and describe the causes of laughter; weeping in various manners with its causes; contention in various acts of killing, flight, fear, ferocity, boldness and all things pertaining to similar instances; then show work, with pulling, pushing, carrying stopping, supporting and similar things.[22]

He thus adopts a characteristically individual stance, casting the "four universal conditions"—happiness (sanguine or phlegmatic?), sadness (melancholy), boldness

(choleric), and work (phlegmatic or sanguine?)—in terms of definite physical actions rather than medical generalizations. That he was aware of the medical doctrine is shown in the letter he wrote as an "architect-doctor" to the authorities of Milan Cathedral in 1488; in it he declares that "doctors, teachers and those who nurse the sick should be aware of what sort of thing is man, what is health and in what manner a parity and concordance of the elements destroys it; while a discordance of these elements ruins and destroys it."[23] He was also aware, in his own particular way, of the Aristotelian notion of the soul as the form of the body, using it to account for the way that "every painter paint himself"—to cite a time-honored tag.[24] Since the soul forms our mind and body, and our mind forms the work of art, the painted people created by the artist will exhibit an inevitable if undesirable resemblance to their begetter. It's like father and son, mother and daughter.

Leonardo seems to have despised the more dogmatic prescriptions of physiognomics, particularly those connected to astrology and predictive arts, such as chiromancy, since "such chimeras have no scientific foundations."[25] On the other hand, there are systems of signs that have a real physical rationale. As he says in the later compilation known as the *Treatise on Painting,*

> It is true that the face shows some indication of the nature of men, their vices and complexions; in the face the signs that separate the cheeks from the lips, the nostrils from the nose, and the sockets from the eyes, show clearly whether these are cheerful men, often laughing; and those who show such features are men who engage in thought; and those who exhibit parts of the face with strong projections and hollows are bestial and angry men, of little reason; and those who have strongly pronounced lines between their eyebrows are irascible; and those who have transverse lines strongly demarcated across their foreheads are men of hidden or open lamentations; and similar things can be said of many parts of the face.[26]

Leonardo describes here what we might term an inscribed pathognomics; that is to say the muscular inscription of temperamental characteristics on the permanent features of the face, consolidating, as it were, those passing expressions that are recurrently present.

Visually, we can immediately point to a drawing of an obviously bold man in whom leonine characteristics are more than just inferred (fig. 17). In the compelling red chalk drawing at Windsor, a fully frontal view of a characteristic warrior type— memorably termed the "nutcracker man" by Kenneth Clark—is juxtaposed with a more sketchy rendering of a lion's head. The assertiveness of the man's choleric belligerence seems to step over the border into self-parody. Not only does his hair superabundantly exhibit the wiry vitality, which the Greek treatise prescribes, but the wreath of ivy—perhaps an ironic symbol of longevity—assumes an invasive vigor on its own account. The facial features with their exaggerated ridges and furrows are an almost perfect illustrations of the "bestial" and "irascible" characteristics listed in the quotation from the *Treatise on Painting.*

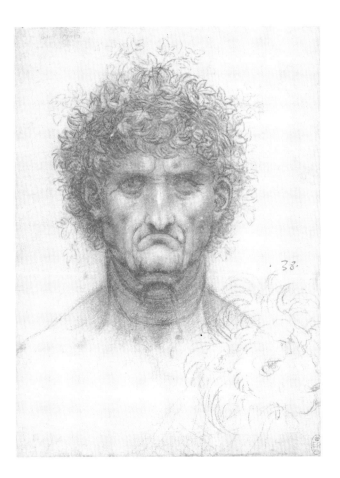

17. Leonardo da Vinci, *Leonine Man*, c. 1504, Royal Library, Windsor, 12502. The Royal Collection © 2004, Her Majesty Queen Elizabeth II.

18. Leonardo da Vinci, *Studies for the Battle of Anghiari*, c. 1503–4, Royal Library, Windsor, 12326. The Royal Collection © 2004, Her Majesty Queen Elizabeth II.

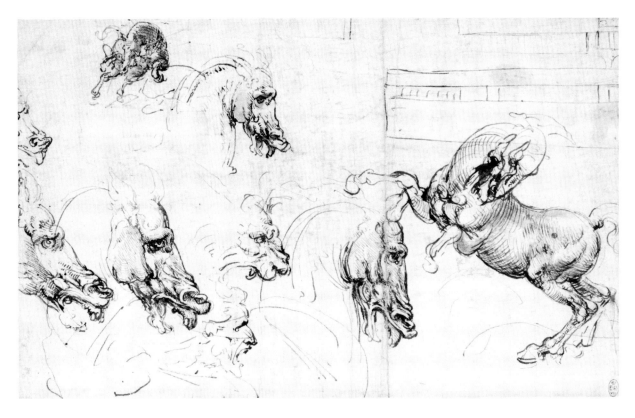

As an artist charged with telling great stories, Leonardo was as much concerned with the signs of passing emotions as with the fixed signs of character. Indeed they necessarily go hand in hand for the figures to express fully what he called *il concetto dell'anima* (the intention [or "impulse" or "pupose"] of their minds).[27] Again, the kinship of man and animal comes into play. Amongst a number of drawings in which he juxtaposes human and animal profiles, the most dramatic is a page of pen studies made during the period of creative ferment when he was designing the *Battle of Anghiari* for the Council Hall of the Florentine Republic (fig. 18). His exploration of horse rage—he was intending that one of the horses in the central knot of fighting Florentine and Milanese should viciously bite its foe—splashes off laterally into parallel sketches of a roaring lion and screaming man. Just as the lithe and graceful *Cecilia Gallerani* (in her portrait now in Cracow), was accompanied by a svelte ermine, so the martial fighting men in the *Battle of Anghiari* were locked into a physiognomic and pathognomic unity with their military horses. This parallelism was not lost on leading Baroque artists who looked either directly or via intermediaries to Leonardo for the principles of vivid characterization. Perhaps the most deeply indebted was Rubens, whose *Lion Hunt* in the Alte Pinakothek exploits exactly the kind of shared bestiality that he appreciated in Leonardo's battle composition.

Alongside such obviously functional studies for narratives, Leonardo produced a huge number of independent sketches of grotesque heads on what appears to be an almost obsessive basis. Few seem overtly to mimic animal types. An exception is the very simian profile in a highly finished sketch at Chatsworth, one of the Leonardo grotesques engraved in the eighteenth century (fig. 19). Others might invite animal parallels, but the achieving of direct animal analogies does not seem to be the prime motive in his studies of such extreme physiognomies. Rather, the animal analogies emerge naturally from the nature of the exercise. As always, Leonardo's results arise from his special blend of observation and *fantasia,* rather than from his adoption of set formulas from tradition.

With two such theorizing artists as Dürer and Leonardo, we are on safe ground in looking at their creations with eyes adapted for physiognomic and pathognomic characterization. Looking at other Renaissance artists, particularly their predecessors, the inference is less secure. This is not the place for a full-scale debate on the prevalence of physiognomics in Renaissance portraiture, narratives, and devotional images, but it would be worth looking selectively at some representative examples of instances in which I intuitively feel that "physiognomic looking" is in order.

Amongst Leonardo's predecessors, the sculptors appear to be those to whom he owed most in characterization of human types. His master, Verrocchio, was the original progenitor of the "nutcracker man," manifested most dramatically in his equestrian statue of *Bartolommeo Colleoni* in Venice. And, before him, Donatello had set the standard for the conveying of particular human personalities

19. Leonardo da Vinci, *Simian Profile,* c. 1494, engraving in After Leonardo da Vinci, *Profile of an Old Woman,* engraving in Conte de Caylus, *Recueil de Teste de caractère & de charges dessinés par Leonard de Vinci Florentin,* no. 6 (original formerly at Chatsworth, now National Gallery, Washington).

in a way that goes beyond simple description. Draw-
ing inspiration from the often startling individual-
ity of Roman portrait busts, Donatello developed
a special line in large-browed, tight-lipped men of
resolute mien. His series of prophets for high niches
in the bell-tower of Florence Cathedral, undertaken
mainly in the second and third decades of the fif-
teenth century, can be read as exhibiting choleric
signs—in keeping with the ire or bile that was stan-
dard for Old Testament preachers. Perhaps the bald
Habbakuk has an air that speaks more of melancholic
angst than choleric ire. The prophet most amenable
to a physiognomic reading is the *Jeremiah* (fig. 20).[28]
Over his stern eyes hangs a "cloudy brow" (to adopt
the Greek formulation). His tight cap of strong hair,
short, rippling beard, and furrowed features, with
the leonine set of his mouth and chin, yield nothing
to Leonardo in the precision with which the cho-
leric temper is defined. Whether the physiognomic
power of Donatello's prophet is a matter of instinct
or learning is a matter of historical intuition.

Remaining in this Florentine sculptural succes-
sion, an equally striking characterization—this time
a specific portrait—is provided in the next century
by Benvenuto Cellini's bronze bust of *Cosimo I de'
Medici* (fig. 21).[29] The Grand Duke of Tuscany is, in
Cellini's own words, portrayed "in accordance with
the noble fashion of the ancients. There is given to
it the bold movement of life, and it is well supplied
with various and rich adornments."[30] Amongst these
"adornments" are large lion masks on the shoulder
of the duke's armor, and a pair of eagles' heads on
his cuirass. The otherwise incongruous dead sheep
is the emblem of the order of Golden Fleece, named
after the legendary feats of Jason. It is notable that an
earlier marble bust of Cosimo by Baccio Bandinelli,
Cellini's bitter rival, is adorned with relief heads of
lions, rams, eagles, bulls, and mastiffs, all animals
noted for their valor.[31] Though it would have not
been decorous to depict the duke with choleric signs
to a pathological degree, it is easy to see how the
emphatically bold characterization conforms to the
physiognomic signs that a warrior-prince would be

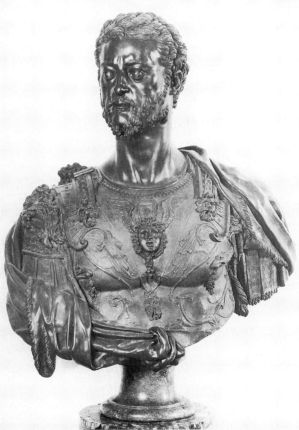

expected to manifest. In this, he far surpasses the rather bland classicism of Bandinelli's portrait head. By the time that Cellini came to make his bust of Cosimo in 1445–47, we may safely assume a relatively widespread acquaintance with the ancient science amongst men and women of letters, not least in Florentine court circles. The fiery and choleric Cellini himself aspired to be a man of letters if not of tranquil learning.

In any event, later in the century artists were provided with a handy visual crib for the characterization of the human animal. In 1586, the polymath Giambattista della Porta published his *On Human Physiognomy,* with plentiful woodcut illustrations and a short, largely formulaic text.[32] The Neapolitan author had emerged precociously in his early twenties with the first edition of *Natural Magic* (1558), an eclectic compilation of science and secrets that retained its popularity even after the advent of more systematic analysis of natural phenomena in the next century. One of the legendary facts that he retails in *Natural Magic,* under the heading of "Sundry Copulations," is mating of humans with diverse beasts.[33]

The twin underpinnings for della Porta's *On Human Physiognomy* are provided by Galenic medicine and the ancient treatise on physiognomics, which he attributes to Aristotle. He follows his Greek predecessor by opening with the general equation of bold men with the lion (fig. 22) and timid women with the panther (fig. 23). His pair of Apollonian and Herculean men (fig. 24) are set beside two "dancing" Venuses, who are delineated with the tapering extremities beloved of Mannerist draftsmen (fig. 25). There follows a parade of double plates (fig. 26), sometimes repeated as he progressively works through what is to be read from each sign of the face. To promote the perceived similarities between specific animals and types of people, it is generally the configurations of animal heads that are pushed in the direction of the human, rather than vice versa. Thus the by-now familiar leonine man is accompanied by a lion that hardly aspires to biological authenticity in figure 22. We are not surprised to find that the head of the choleric exhibits the *nebulosa frons* (cloudy brow). The overhanging brow of the armored "Actiolino, Paduan Tyrant" is aligned with the comparable feature in a hunting dog equipped with spiked collar. Della Porta concludes his text with an account of specific characteristics, noting the beast that corresponds to these, again taking his cue from the Aristotelian author. To our eyes, the juxtapositions of animal and human heads in the rather basic woodcuts are crude—more adapted to the cartoonist's repertoire of stereotypes than to "high" art—but to judge from centuries of successive editions across Europe, his portrayals clearly struck a chord with the book-owning classes. His book operated more effectively in its historical contexts than its modern reputation might suggest.

The second serial illustrator of physiognomics came to the job equipped with an altogether more potent set of skills in observation and representation—skills that raised Charles Le Brun to the dominant position of president in the recently founded French Académie Royale. Le Brun had himself acquired a far wider range of learning than was the norm for a painter, and amassed a notable library of ancient and modern literature. In his leadership of the academy, he advocated a rational

OPPOSITE

20. Donatello, *Jeremiah,* 1420s, Museo dell'Opera del Duomo, Florence.

21. Benvenuto Cellini, *Cosimo I de'Medici,* 1548, Museo Nazionale del Bargello, Florence.

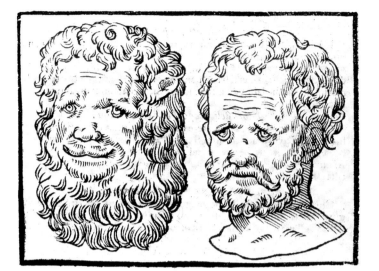

22. Giambattista della Porta, *Heads of Man and Lion*, from *De Humana physiognomia . . .* Libri III (Vici, Josephus Cacchius, 1586).

23. Giambattista della Porta, *Panther*, from *De Humana physiognomia . . .* Libri III (Vici, Josephus Cacchius, 1586).

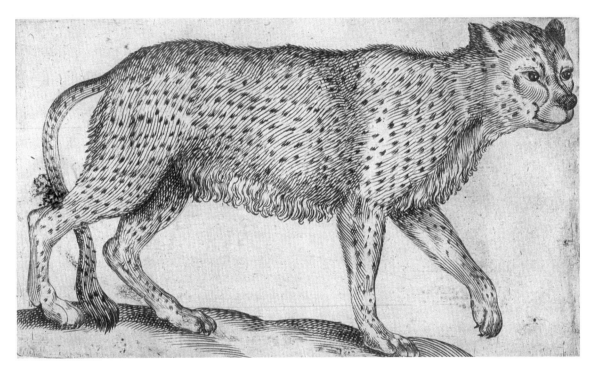

OPPOSITE

24. Giambattista della Porta, *Apollonian and Herculean Men*, from *De Humana physiognomia . . .* Libri III (Vici, Josephus Cacchius, 1586).

25. Giambattista della Porta, *Venuses*, from *De Humana physiognomia . . .* Libri III (Vici, Josephus Cacchius, 1586).

26. Giambattista della Porta, *Head of Dog and Actiolino of Padua*, from *De Humana physiognomia . . .* Libri III (Vici, Josephus Cacchius, 1586).

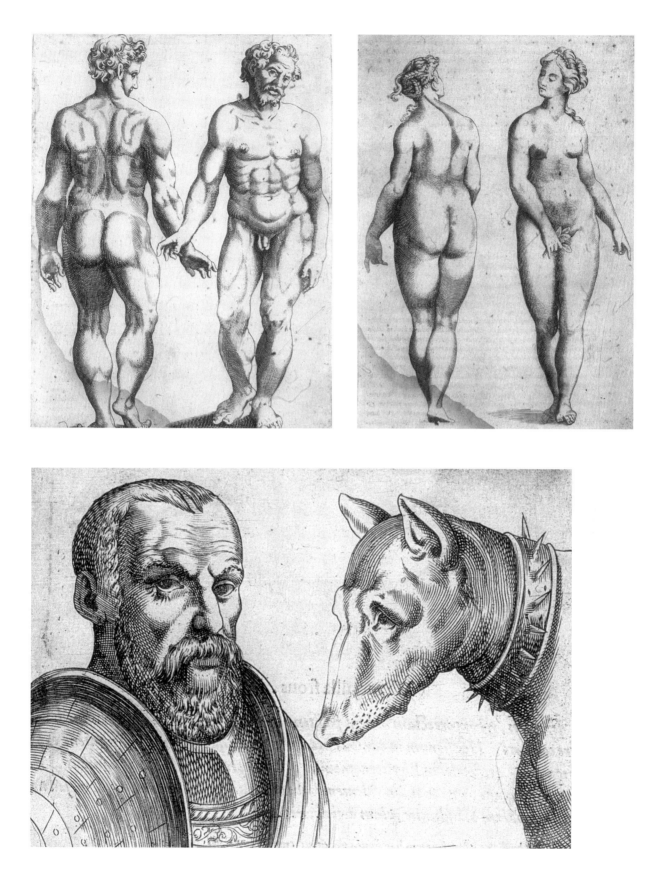

approach to the training and practice of art as a learned discipline. It was as part of such advocacy that he delivered lectures in the late 1660s on physiognomics and pathognomics. His text on physiognomics is now known only through second-hand reports, but splendid drawings have survived from both of his *Conférences*. Those relating to the expressions (pathognomics) were published and successively reissued to great effect. He intended to write an ambitious treatise on physiognomy dealing successively with ancient portrait busts, the anatomy of the head, and the facial features of human and animals—"pointing out the signs which characterise their natural inclination"—though it seems not to have been completed.[34]

Since Le Brun wished to be seen as a lettered painter, it will be fitting to give an outline of the main visual and textual sources for his animal physiognomics. The basic programme of juxtapositions is recognizably inspired by della Porta, but rises to levels of visual cogency far beyond those of his sixteenth-century predecessor. For his animal comparators, Le Brun could fortunately turn to the remarkable stock of exotic beasts in the Royal Menagerie, or even more conveniently, to the extensive drawings made in the Menagerie by his one-time master, Pieter Boel. There is no doubt that he also had recourse to the great sixteenth-century compendia of facts, legends, and pictures of animals published by Konrad Gesner and Ulisse Aldrovandi. He also knew Dürer's publications. And, during his studies in Italy, he may well have encountered the tradition of Leonardo's physiognomies. Della Porta's illustrations were clearly a direct point of reference. His nonvisual sources included, of course, the Aristotelian treatise, and more urgently the ideas being aired in contemporary debates in France about the natures of the human and animal souls (or, rather, whether animals had souls at all). The tone for the debates was set by René Descartes, whose *Treatise on the Passions* of 1649 and *Passions of the Soul* laid the foundation for an enduring strain in French thought. In chapter 4 we will see how his terms of reference dominated disputes about whether animals were mere machines.

When the painter needed to characterize the specific passions he wished to portray in his drawings, he turned to Descartes more regularly than to any other author. He also quoted from Marin Cureau de la Chambre, who published a series of highly relevant treatises in the 1640s: *The Character of the Passions, The Art of Understanding Men,* and *Treatise on the Understanding of Animals.* Later, Cureau became an important protagonist in the Cartesian debates on the animal soul. As a part of his great programme of work to characterize human nature, Cureau planned to reinstate Aristotelian theory on a rather more subtle basis:

> The second rule which they [the physiognomists] draw from the resemblance between man and the animals is . . . dubious, principally in the way in which they use it; for as Aristotle said, there is no man who resembles any animal in every respect, but only in some part, and it is doubtful whether one part can enable a judgement to be made as to the inclination of the whole species. Secondly, as there are few signs belonging to, and peculiar to, one species, and many that are common to several species, if one bases the comparison between a man and an animal on those that are common, the comparison

OPPOSITE

27. Charles Le Brun, *Drawing of Cats' Heads,* C. 1665–70, Cabinet des Dessins, Musée du Louvre, Paris. Photograph: Réunion des Musées Nationaux / Art Resource, NY.

28. Charles Le Brun, *Drawing of Oxen and other Heads,* C. 1665–70, Cabinet des Dessins, Musée du Louvre, Paris. Photograph: Réunion des Musées Nationaux / Art Resource, NY.

29. Charles Le Brun, *Drawing of Man with a Beak-like Nose,* C. 1665–70, Cabinet des Dessins, Musée du Louvre, Paris. Photograph: Réunion des Musées Nationaux / Art Resource, NY.

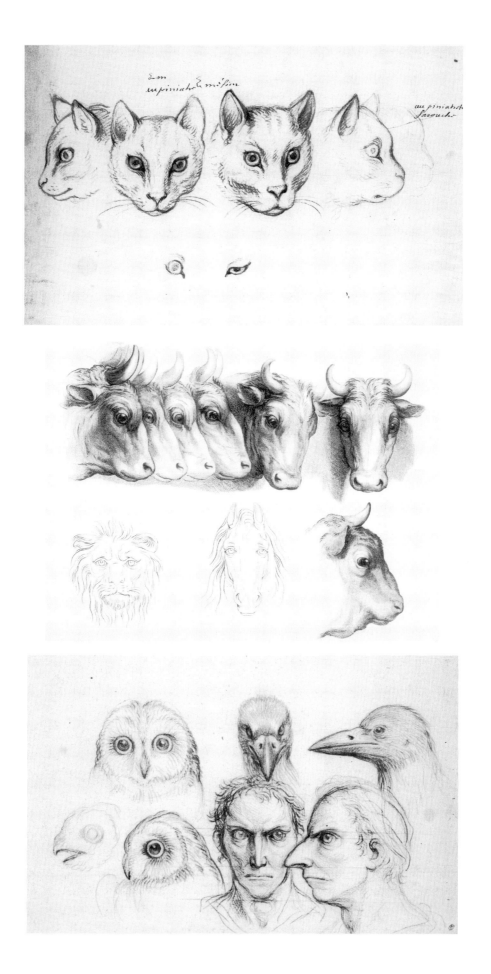

will be defective, and will prove nothing, because it could equally well be made with another species.[35]

The subtleties and qualifications that Cureau recognized in "Aristotle" had proved difficult if not impossible to embrace in pictorial practice, where the message needed to be accomplished with uncomplicated clarity—above all in academic history painting. Those artists and illustrators who had made a close study of animal physiognomics seem to have agreed tacitly with Montaigne, who recognized "the greatest proximity and correspondence" between humans and animals.

Le Brun, for his part, strove to forge a practice that accommodated some of Cureau's criticisms. In his drawn analogies, he does not simply rely on the unitary comparisons of della Porta, but recognizes more subtly that individuals in each species of animal may manifest different characters. In a drawing of five cat's heads (fig. 27), he includes one that is "stubborn and suspicious" (in the center), while that on the right is not only stubborn but also "aggressive." A series of profiles of oxen manifest characters that are "bold," "stubborn," "stupid," and "aggressive," while in unlabelled examples we are left to make up our own mind (fig. 28). In so doing, Le Brun is implicitly positing the kind of portraiture of animals—dependent an animal's unique individuality of feature—which later specialist *animaliers* were to achieve. Similarly, different human heads may all be leonine, without falling into exactly the same mold. It is remarkable how well the analogies work. Even when working around the theme of a man with a beaklike nose, he works deftly with a flexible kind of naturalism and facial geometry that disarms the potential absurdity of the exercise (fig. 29). On the whole, the humans are edged further toward the animal than della Porta was prepared to do, but the sober conviction of Le Brun's draftsmanship often draws his heads back from caricature and parody. Not least, he was able to anthropomorphize his animals in a way that is generally less crude than his predecessors.

In addition to his acknowledgment of internal diversity within animal and human types, Le Brun also contributed in an original manner to the geometry of the human head, to which Leonardo and Dürer had both devoted sustained attention. Le Brun invented a system of cerebral triangulation, the angles of which served as a kind of protractor of character. Since the work of the fixed signs (physiognomics) of the head was not published and has not survived in definitive or complete form, the system of triangulation he applied to animal heads is not easy to follow in all its details (fig. 30).[36] The basic equilateral triangle is composed from vertices in the nostril and ear (or horn). If a line is drawn through the eye and parallel to the side of the triangle that runs downwards from the ear, and cuts the mouth, the animal is a carnivore. If another line is drawn upwards from the eye, perpendicular to the line from the nostril to the ear, and this line cuts the nose rather than the forehead, the animal exhibits "imbecility." As far as we can tell from the surviving material, Le Brun does not appear to have transferred triangulation to the human head, preferring a series of proportional divisions in the traditional manner. Whether he had intended to do so is doubtful, since even the extreme variations on human faces

would not result in the key lines cutting entirely different features in the head. Facial angle appears, therefore, to be a key signifier for Le Brun only in the context of the very wide variations in animal head shapes. In any event, this system, unlike his famed illustrations of human-animal parallels and specific expression, remained little known and apparently uninfluential.

I think it is clear that one specific, historical reason why the analogies work so improbably well is that artists who have been educated to portray the human head, as the noblest element in painting, had acquired a series of effective schemas for, say, the depiction of eyes, which they carried over into their portrayal of animal eyes. Even without a deliberate attempt to anthropomorphize animals, there will be a gravitational force in the ingrained representational techniques that draws animal features in the direction of human.

A more general reason lies in how we recognize faces. No element of our cognitive system is more finely tuned than that devoted to identifying human features. The astonishingly complex system of recognition is devoted to both the generalized "type"—picking up those overall characteristics that denote a face as female or male, young or old, healthy or sick, African or Caucasian, or even Japanese and Korean (for those whose experience of Asian ethnic groups is more extensive than most Westerners')—and to the minute discriminations that differentiate one individual from another. The way that these identifications are accomplished is through the perceptual emphasis upon those features that individually (or in concert) provide the clearest registers of that person's individuality. As I will argue at the end of the next chapter, this process leads toward a form of perceptual exaggeration or "caricature" that inadvertently pushes the mental image in the direction of animal face shapes.

The other system at work in facial perception, which we now know is performed primarily in a different location in the brain, is equally refined. It is dedicated to the detection of expression in terms of the sentiments manifested by someone in even the most fleeting manner. For the narrative artist or portraitist, the elusive task of conveying what thoughts lie within proved to be one of the supreme challenges. We have already touched on one of the ways that Leonardo met that challenge. It is to Le Brun's uniquely influential method to convey the "passions of the soul" that we will now turn.

30. Charles Le Brun, *Triangulation of the Head of a Lion and Proportions of the Head of a Leonine Man*, C. 1665–70, Cabinet des Dessins, Musée du Louvre, Paris. Photograph: Réunion des Musées Nationaux / Art Resource, NY.

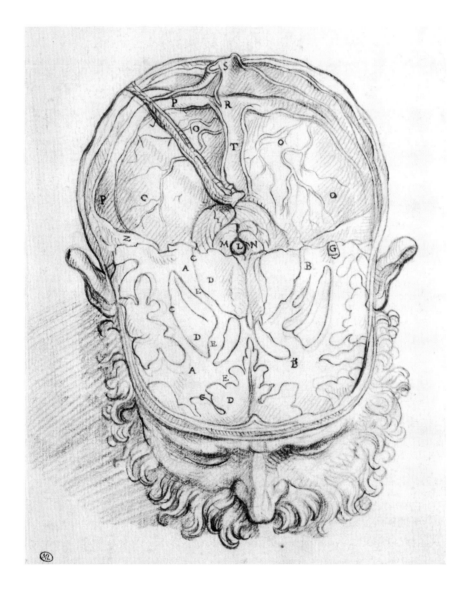

Feelings and Faces

Like his study of the fixed signs, Le Brun's notions of mechanisms of expressions expounded in his *Conférences* are integrally located in the Parisian debates of his time. However, in the face of so many competing views, he espouses a certain kind of practical agnosticism—at least when in addressing his particular audience of aspiring artists: "There are so many scholars who discuss the passions that one can only say what has already been written. Therefore I will not give an account of their opinion on this subject, if only in order to render more understandable what concerns our art, since I believe it is useful to deal with an issue which will benefit young students in painting. What I will attempt to do is to show it as briefly as possible."[1]

We have already indicated that he quoted and paraphrased a number of French authors, whose views were not always entirely in accord. In at least one respect, his ideas were incontrovertibly Cartesian. He draws heavily upon Descartes' conviction that the pineal gland, located centrally under the main brain mass, is literally central to our emotional and intellectual lives. As the only part of the brain that was not divided and bilateral, the pineal gland was identified by the philosopher as the seat of the soul and governor of the passions. In a series of drawings based upon Andreas Vesalius's great *De Humani corporis fabrica* of 1543, Le Brun clearly highlights the location of this key organ (fig. 31). As far as the facial features are concerned, the gland acts like a kind of cerebral magnet, attracting and repelling the features according to its emotional output at any time. It is likely that it also provided a pole for the tilting lines of his facial triangulation.

In the special attention Le Brun gave to eyes, the subject of a particularly brilliant series of studies (fig. 32), he paid due homage to the idea (expressed by Leonardo) that the eyes are the "windows of the soul." His immediate point of reference was probably Etienne Binet's *Essay on the Marvel of Nature and Noblest Artifices* of 1620, a treatise aimed at orators, in which the eighth chapter is dedicated exclusively to the eye. The eyes, Binet wrote, "are a true miracle of nature" as "the interpreter of

OPPOSITE

31. Charles Le Brun, *Horizontal Section of the Human Brain*, C. 1665–70, Cabinet des Dessins, Musée du Louvre, Paris. Photograph: Réunion des Musées Nationaux / Art Resource, NY.

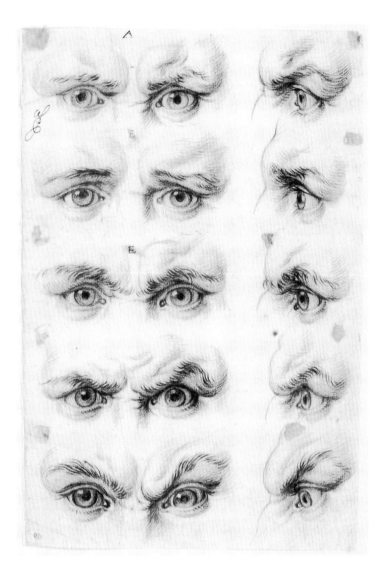

32. Charles Le Brun, *Studies of Eyes*, C. 1665–70,
Cabinet des Dessins, Musée du Louvre, Paris.
Photograph: Réunion des Musées Nationaux /
Art Resource, NY.

the soul and its mirror." "Love, hate, fury, piety, revenge shine forth from them."[2]
Encouragement indeed for the ambitious artistic portrayer of human nature!

Le Brun's visual codification of the configurations of eyes and other features
came together in images of such emotional states as despair (fig. 33) and astonish-
ment (fig. 34). In his striking demonstration of the desperate man, the whole face is
engulfed by a conflagration of emotion, affecting the flaming hair no less than the
convulsed forehead. The two illustrated examples show how Le Brun used both ful-
ly rendered studies and, as in the illustration of astonishment, line diagrams marked
with proportional divisions. In total, his demonstrations were designed to equip art-
ists and spectators with a shared natural grammar of human emotion, more universal
than written language. Such general legibility of expression was essential for the
narration of the grand "histories" that stood at the pinnacle of academic art. First
published at the end of the century, his illustrations were then repeatedly reissued
as exemplars for any artist who wished to emulate Leonardo's ambitions to portray
each painted actor according to *il concetto dell' anima*. Le Brun, in his own grandilo-

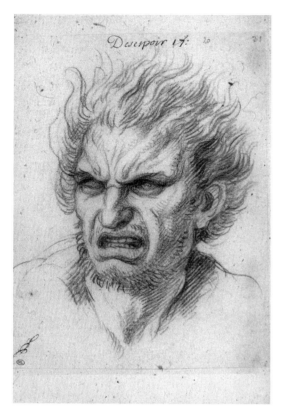

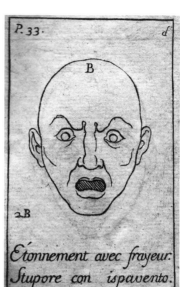

33. Charles Le Brun, *Extreme Despair*, from *Conférence de Monsieur Le Brun . . . Sur l'expression générale & particulière,* 1694, p. 95.

34. Charles Le Brun, *Astonishment with Fear,* from *Sur l'expression générale & particulière,* 1694, p. 33.

35. Charles Le Brun, detail of running man from the center of *The Battle of Arbela,* c. 1668, Musée du Louvre, Paris. Photograph: Réunion des Musées Nationaux / Art Resource, NY.

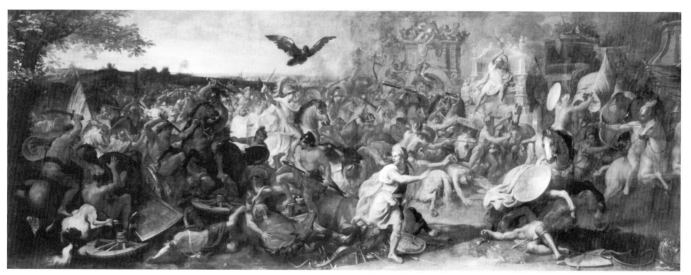

quent narrative paintings now corralled obscurely in an upper room of the Louvre, again acts more subtly in practice than the formulas might suggest. However, it is possible to recognize the template that lies behind the characterization of particular figures in situations of extremis (fig. 35).

The overtly prescriptive texts and illustrations of della Porta and Le Brun provide for the historian a potent way of looking at period images. This way of looking extends from the general understanding of how emotions were read and

communicated in a particular culture to the direct interpretation of works by individual artists. This is not to say that we should indiscriminately apply the way of looking to images from cultures we know to have been interested in physiognomics. In the absence of direct evidence of an artist's personal engagement with physiognomics, we need to exercise judicious intuition as to its strict applicability. We are best advised to look for instances where a particular artist was involved in a sustained manner in techniques of characterization. We can generally tell when an artist has been devoting special thought to the communicative sinews that connect the artwork and spectator, resorting to special strategies to draw our minds (and by implication our bodies) empathetically into the configurations that the artist intends. In other cases, we may suspect that we are dealing with a common undercurrent of nonverbal expression in a given culture rather than precise prescriptions.

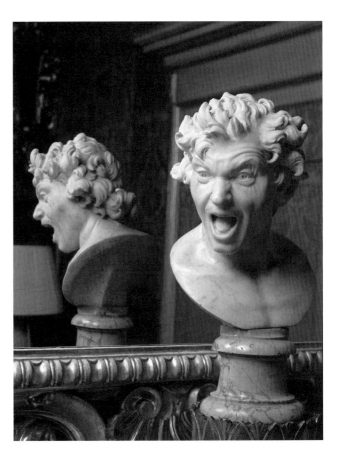

Amongst artists who span the era between della Porta and Le Brun, I will discuss just two giants of expressive communication, Gianlorenzo Bernini and Rembrandt. Readers may on their own account be able to suggest equally good candidates for physiognomic reading.

Our two exemplars were both involved in flashy demonstrations of their prowess in portraying extreme expressions early in their careers. Bernini, precocious son of an accomplished carver, was the greatest master of living faces in marble, and early in his career in 1622, he undertook what may be regarded as two demonstration pieces, the *Anima Dannata* and *Anima Beata* (figs. 36 and 37).[3] Without bodily postures or hand gestures, he is able to use the expressive heads to tell us all we need to know about the contrasting fate of the figures on the day of judgment. As is so often the case, virtue is less visually engaging than vice. The blessed lady, with uplifted eyes and restrainedly open mouth expresses the translation of her soul into a state of spiritual rapture. The man con-

demned to perpetual torment—perhaps for having descended to the level of the beasts—is altogether a different matter. Bernini miraculously translates what Leonardo and Michelangelo could accomplish in the warm medium of red chalk into cold marble. Full of extremity and visual noise, his damned soul nonetheless shares something of the self-conscious knowingness of an actor. Is it only in retrospect that we seem to discern a tongue-in-cheek quality, not altogether different from a cult horror movie, which produces a special kind of delicious terror? I suspect that we should not push this line of interpretation too far, since we know that the context was unquestionably serious. The two souls were made in 1619 or shortly thereafter at the instigation of a Spanish prelate attached to the Vatican, and the Spanish Catholics were renowned for their humorless fervor.

Rembrandt's comparable experiments, undertaken on a much smaller scale and in the more modest medium of etching, are no less potent—not least because we realize that they are self-portraits (figs. 38 and 39).[4] Undertaking such studies from oneself is an advantage, because such extreme expressions can be held only momentarily, and it is easier for the painter himself to recreate the expression over and over again rather than asking a sitter to do so. David Hockney has recently argued that painters who wished to represent transitory expressions with the greatest accuracy and vividness could have resorted to some kind of "camera" (lens- or mirror-based) to sketch features rapidly in a posed model.[5] We can sense the relish with which Rembrandt creates such a challenging power of communication within the small compass of a series of tiny plates. Again, there is a self-conscious delight in the virtuoso's ability to play on our emotional response to extreme expressions. I think there can be little doubt that Rembrandt, the greatest master of rendering living faces in material pigments, was alert to the teachings of physiognomics, which would

OPPOSITE

36. Gianlorenzo Bernini, *Anima Dannata,* 1619, Spanish Embassy, Rome, Italy, Joseph Martin / The Bridgeman Art Library.

37. Gianlorenzo Bernini, *Anima Beata,* 1619, Spanish Embassy, Rome, Italy, Joseph Martin / The Bridgeman Art Library.

BOTTOM

38. Rembrandt, *Self-Portrait with a Startled Expression,* 1630, etching, Ashmolean Museum, Oxford.

39. Rembrandt, *Self-Portrait with Agonised Expression,* c. 1630, etching, Ashmolean Museum, Oxford.

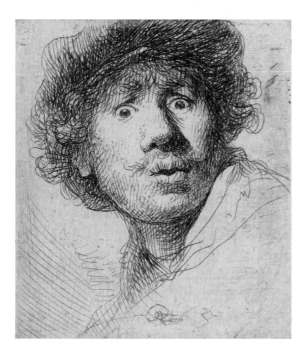

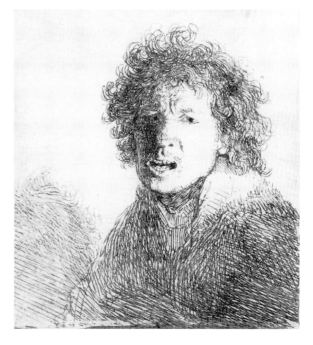

certainly have been a tool in the academic kit of his master, Lastmann, who specialized in "histories" with somewhat formulaic expressions. However, Rembrandt knew (like all great communicators) that artistry and intuition had to take over where formula ended.

These two examples of extreme expressions exploit what came to be called pathognomics; they transcended the normal limits of decorous behavior because they clearly stand in the tradition that related the expression of unbridled emotion to our animal natures. The Leonardesque parallel with roaring beasts is a perpetual undercurrent. There is something animalistic in baring a snarling set of teeth. Even smiling with a toothy grin would have been regarded as indecorous, especially amongst ladies, before the twentieth century. We may observe in passing that the term "unbridled" is itself an equine metaphor, implying that our emotions are no longer "reined in." This is both a popular image and related to a philosophical metaphor, current in Neoplatonic circles and derived from Plato's *Phaedrus,* in which the soul is seen as a fiery steed that needs to be disciplined through reason and moral rule.

Where that rule breaks down, the fabric of rationality is threatened, both individually with respect to society as whole. Few artists before the Romantic period had any opportunity (conceptually or in practice) to create works on the subject of what happens when monsters of the mind emerge from their dark hiding places during the "sleep of reason." The phrase is taken from the frontispiece of Goya's *Los Caprichos,* in which animalistic portrayals abound, as we will see. Jerome Bosch is the obvious exception, but his knowing microcosms of infinitely inventive devilry are not quite what I mean. I am thinking of something more obviously "inner," as expressed in outer mechanics of the face. In this sense, there is one prime candidate, the eccentric eighteenth-century sculptor, Franz Xaver Messerschmidt.

Messerschmidt had embarked on a career in Vienna during the 1760s that appeared to be destined for untroubled success.[6] As a highly accomplished sculptor specializing in portraits, he undertook a series of prestigious commissions in Habsburg court circles. His style evolved from full Baroque to more sober classicizing naturalism, always with a strong sense of the individuality of each sitter's features as symptomatic of their personality. In 1769 he was enlisted as a teacher at the academy. But there were troubling signs. In 1774, the Prince Kaunitz was reporting that the sculptor "has for three years suffered from some confusion in his head [and] . . . has strange bees in his bonnet"—a nice animal metaphor. Increasingly disillusioned with his life in Vienna, Messerschmidt retreated via Munich to Bratislava (Presboug), where the strange "madman-genius" became a kind of visitor attraction.

The best firsthand account comes from his confidant, Friedrick Nicolai, who was convinced that his friend was "an extraordinary genius."[7] There has been a recent tendency to downplay Nicolai's account, but it is so detailed and carefully observed as to give us confidence in his veracity. He reports that the choleric sculptor was haunted by bouts of melancholy. Messerschmidt "was a man of fiery passions, yet he had a great longing for solitude. In Vienna he had fallen in with people who boasted of some secret knowledge, of contacts with invisible spirits and of powers over the

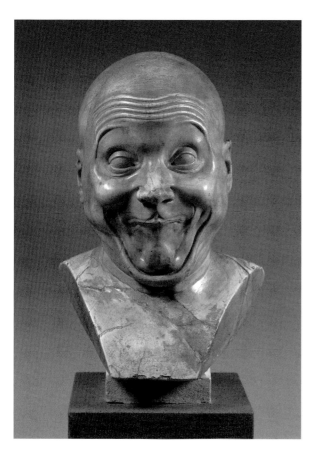 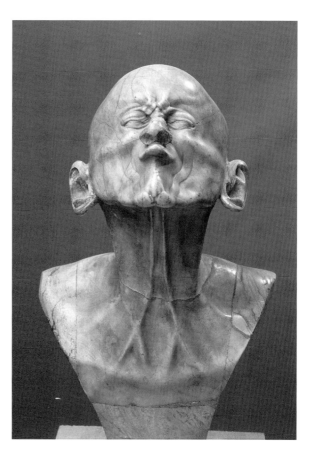

forces of nature." The sculptor came to be assaulted by such spirits, above all by the "spirit of proportion," which inflicted tortures on specific parts of his body. The antidote was for Messerschmidt to pinch himself sharply in the area invaded by the spirit, at the same time forming a fixed grimace specific to the pain at that point in his body. He seems, perhaps in the face of paranoid delusions, to have been exercising a weird form of chiropractic therapy.

Why should the spirit of proportion, ostensibly the artist's friend, have been driven to such viciousness? The answer lay in the artist's own elaborate and esoteric studies of human proportions, based not least on an "old Italian book on human proportions" (probably an Italian edition of Dürer) and a drawing of an Egyptian statue. The intrepid sculptor had apparently tapped into the ultimate secret of ancient Hermetic wisdom, fully divining secrets that the spirit of proportion had jealously concealed from earlier investigators.

Where this odd figure becomes more than a passing case for retrospective psychoanalysis is that he immortalized his "remedies" in sixty-four sculptures of specific grimaces, forty-nine of which survive in various media, mostly in lead. The faithful Nicolai described how, "every half minute he [Messerschmidt] looked into the mirror and with the greatest accuracy he pulled the face he needed." The results are very compelling (fig. 40), their technical accomplishment testifying to the kind

40. Franz Xaver Messerschmidt, *Intentional Grimace in the Form of a Manic Grin*, c. 1775–80, Museum of the City of Vienna. Osterreichische Galerie, Belvedere Vienna.

41. Franz Xaver Messerschmidt, *Intentional Grimace with a Beak-Like Mouth*, c. 1775–80, Museum of the City of Vienna. Osterreichische Galerie, Belvedere Vienna.

of rational control that allowed him to continue to produce sober busts on commission, even while suffering from the malign spirit's shocking ministrations. Given his friendship with Anton Messmer, pioneer of "animal magnetism," it seems likely that the spirit's assaults were seen as being of a specifically "electrical" nature.

The busts do not for the most part make direct reference to animal analogies, but do proclaim a "primitive" alliance between the "electricity" of the body and a mind pushed beyond reason. They stand in a long tradition, dating back to the Middle Ages, of heads distorted in ways that make them look inhuman. Some of his heads, with beak-like noses, specifically conjure up images of birds. Most extraordinary are the so-called Beak Heads (fig. 41), in which lips adopt configurations like duck bills. They exude an unsettling sense of wrenching strain, as the features are stressed disproportionately to limits beyond normal human endurance. This agonized exercise in facial anguish was by implication to be followed by blessed relief as the agony of overextension subsided. They seem to invite us to imagine the thwarted spirit of proportion departing (albeit temporarily) with a high-pitched scream of defeat.

THE TRADITION REVITALIZED

By the mid-eighteenth century, the tradition of physiognomic texts and illustrations led by della Porta and Le Brun was apparently lumbering into quiescence, with little new to be seen. It was, however, to be revitalized, largely by two men, the inventive artist-theorist, William Hogarth, and the chaotic encyclopedist of human faces, Johann Caspar Lavater.

Hogarth's revivification of physiognomics came in the context of his reform of "lowly" genre painting into a vehicle for moral "histories" that spoke of the human condition no less effectively than the great narratives favored in the academies. A mastery of physiognomics was a valuable part of this enterprise. There is hardly a narrative by Hogarth that does not invite physiognomic reading (fig. 42). In plate 2 of *A Harlot's Progress,* for example, the faces of her rich Jewish "protector" and young black servant register astonishment, as she kicks over the tea table to cover the escape of her young lover in the background.[8] Her facial expression is characterized in a way that is at once coyly seductive and devious. Her pet monkey, draped in what may be the sash of her dress and scampering out of the way of the falling crockery, underscores the message that monkey business is going on.

The twin keys to Hogarth's physiognomic literacy lay in two special associations: medical men and the theatre. His documented relationships with medical institutions and with physicians, surgeons, and those charged with caring for the insane, are well established.[9] A particularly relevant instance of his engagement with medical matters is his satirical contribution to the huge controversy stirred up by Mary Toft, the "Rabbit Woman," who duped prominent doctors into believing that she gave birth to rabbits, mostly in fragmentary form (fig. 43).[10] Hogarth, as always, stood on the skeptical side of the debate. In a more serious vein, his large paintings of *The Pool of Bethesda* and *The Good Samaritan* for the staircase in St. Bartholomew's

OPPOSITE

42. William Hogarth, plate 2 from *A Harlot's Progress,* 1732, Ashmolean Museum, Oxford.

43. William Hogarth, *Mary Toft, the "Rabbit Woman,"* 1726, Ashmolean Museum, Oxford. Courtesy of Glasgow University Library, Department of Special Collections.

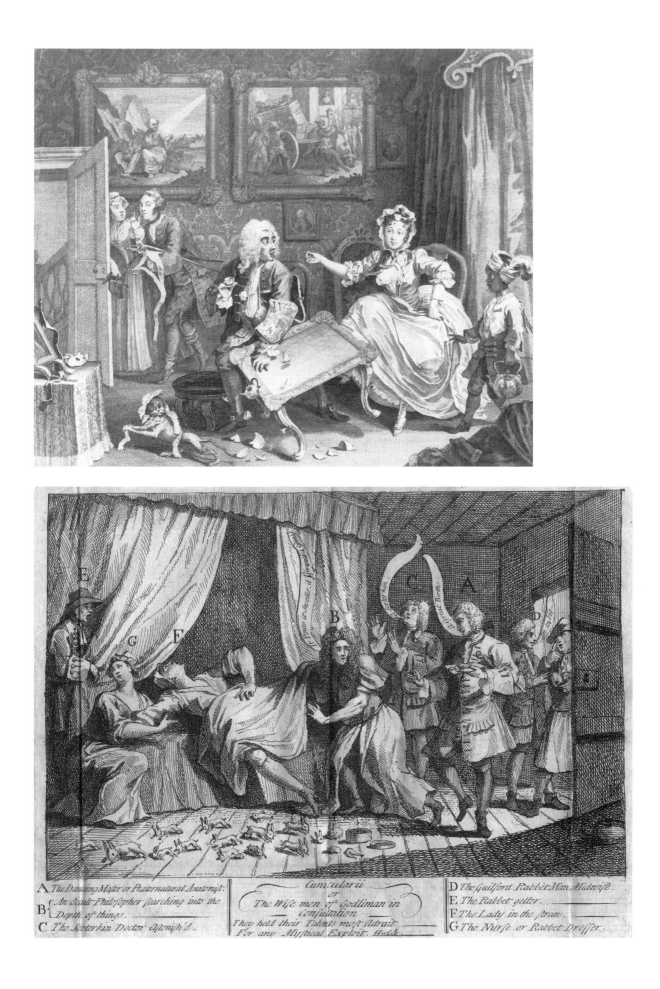

A. *The Dancing Master or Preternatural Anatomist.*

B. *An Occult Philosopher searching into the Depth of things.*

C. *The Sooterkin Doctor Astonish'd.*

Cunicularii
or
The Wise men of Godliman in Consultation

They hell their Talents most Adroit For any Mystical Exploit. Hudib.

D. *The Guilford Rabbet-Man Midwife.*

E. *The Rabbet-getter.*

F. *The Lady in the straw.*

G. *The Nurse or Rabbet-Dresser.*

Hospital in London show that he was fully conversant with diagnostic criteria of the period. His narrative paintings and prints, in which the folly of leading players leads inexorably to sickness and insanity, demonstrate a knowing grasp of how the paraphernalia and procedures of contemporary "Physic" could be used to found a new kind of medical iconography within modern "histories."[11]

The compound plates in Hogarth's ingenious *Analysis of Beauty* articulate how line expresses the telling contours in the human face, amongst other things, including corsets! (fig. 44). He confirmed that "the face is the index of the mind."[12] We need to be mindful of Hogarth's caution that "there are so many different causes which produce the same kind of movements and appearances of the features" as to resist simple formulation.[13] However, he is sure that just readings of character can be made. The animalistic Silenus, as known in ancient sculpture, provides a case in point: "Human nature can hardly be represented more debased in the character of Silenus . . . where the bulging-line . . . runs through all the features of the face, as

44. William Hogarth, plate 1 from *Analysis of Beauty,* 1753. Ashmolean Museum, Oxford.

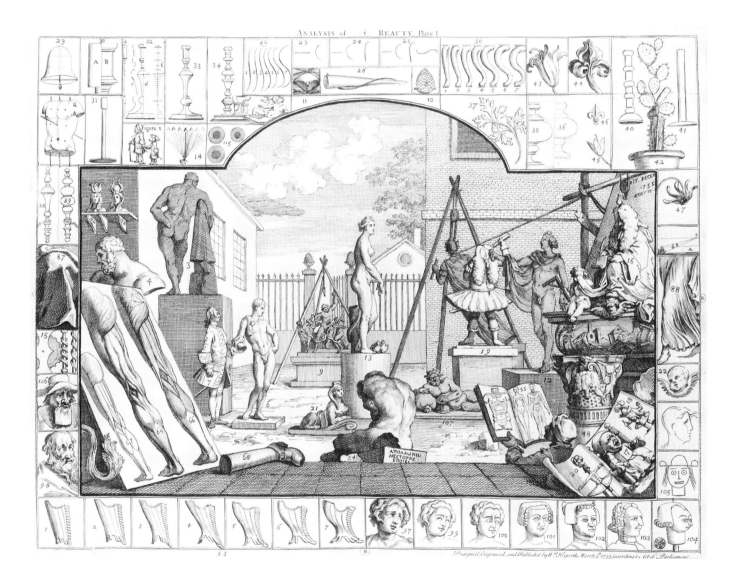

well as in other parts of his swinish body: whereas in the satyr of the wood, though the ancients have joined the brute with the man, we still see preserved an elegant display of serpentine lines, that make it a graceful figure."[14] He refers the reader to the sculpture of the reclining drunk—podgy like a swine—at the base of Venus's pedestal. The "bulging-line" is on the right of the sequence in the uppermost margin at center left. Hogarth's famously curvaceous "Line of Beauty," wound around a cone above the center of the lunette, is the very essence of suave appeal. The line presents a kind of abstract physiognomy of beauty extracted from the natural world, above all from humans perceived to exhibit the highest grace. Lumpy and dissonant lines speak of an outer and inner ugliness.

Lumpy profiles abound when Hogarth parades massed ranks of physicians' faces for our wry scrutiny in *The Company of Undertakers* (fig. 45). The print is cast satirically in the form of a mock escutcheon. In upper part, separated by the wavy line or "nebuly" that he has adopted from heraldry, are Joshua Ward (inventor of a famed pill of questionable merit), Mrs. Mapp (a notorious bone-setter), and John Taylor (an itinerant and flamboyant oculist).[15] Below these noted doctor-quacks

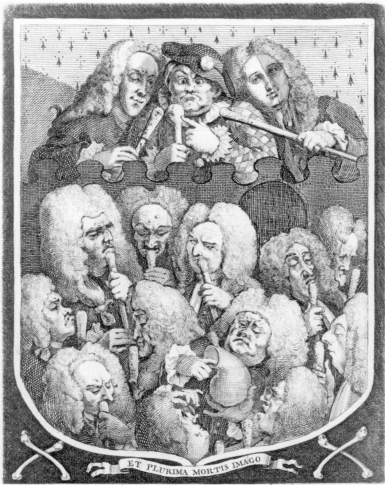

45. William Hogarth, *The Company of Undertakers,* 1736, Ashmolean Museum, Oxford.

are physicians who operated in more institutional contexts, though they are hardly rendered in more flattering guises, sniffing like dogs at canes topped with supposedly disinfectant mixtures of herbs. Here Hogarth knowingly exploits both the fixed signs of their unappealing physiognomies and the pathogmonics of their arrogant and stupid expressions. Profile, *profil perdu,* and full-face all make telling contributions to the caricatured ensemble.

Amongst Hogarth's many medical acquaintances was Dr. James Parsons, secretary of the Royal Society, and a well-respected author. The two lectures he delivered to the society on "Human Physiognomy Explain'd" in the Crounian series on Muscular Motion were duly published in the *Philosophical Transactions* for 1746.[16] Criticizing Le Brun for his failure to pay attention to the specific anatomical mechanisms, Parsons strove to describe the action of particular muscles, "the sole Agents" of facial expression. When discussing how to portray desire, he specifically pointed to Hogarth's *Danaë,* now unfortunately lost, while Hogarth for his part followed the doctor's emphasis on the muscles:

> It is by the natural and unaffected movements of the muscles, caused by the passions of the mind, that every man's character would in some measure be written in his face, by that time he arrives at forty years of age, were it not for certain accidents which often, though not always, prevent it. For the ill-natured man, by frequently frowning and pouting out the muscles of his mouth, doth in time bring those parts to a constant state of the appearance of ill-nature, which might have been prevented by the constant affection of a smile.[17]

Parson's illustrations are consciously less "artistic" and more systematically analytical than Le Brun's drawings. *Scorn and Derision* (fig. 46), for example, shows how much more specific he is than Le Brun in picking out facial motions that express the action of individual muscles. It is an indication of the international respect accorded to Parsons's "scientific" approach that his illustrations were taken over by Buffon in his *Histoire naturelle.*

Hogarth's links with the stage and those who wrote and performed for the theatre are also so well established as to need no further documentation here.[18] Where physiognomic theory comes to the fore is in the interplay between contemporary acting practice and the rhetorics of expression developed by history painters, such as Le Brun. The didactic poem the "Art of Acting," published in 1746 by Aaron Hill, who had attempted to establish an academy for tragic acting, was replete with Le Brun's formulas. In fact Hill also aimed his message at "Painters, Sculptors, and Designers: But adapted in particular, to the Stage."[19] By the naturalistic standards of today's acting

46. James Parsons, *Scorn and Derision,* from *Human Physiognomy Explain'd,* in *Philosophical Transactions of the Royal Society,* 1746.

we would find the exaggeratedly held poses and formulaic facial expressions on the Georgian stage to be hugely contrived. (This is not make any judgment about the levels of contrivance actually needed to make something on the stage appear "natural.") There is little doubt that the supreme exemplars of painted storytelling exercised a considerable impact on "high" drama. Raphael's Tapestry Cartoons of the *Acts of the Apostles,* proud possessions of the British monarchs, were routinely cited as ideal models for characterization and expression (fig. 47 a, b). Le Brun's sets of expressions were available in a number of English editions and plagarizations from 1701 onwards and Hogarth specifically commended his "common drawing-book, called Le Brun's *Passions of the Mind.*"[20]

47. Benjamin Ralph after Raphael, heads representing Awe, Surprise and Gratitude, Agony, Mental and Corporeal, and Awe, the Tapestry Cartoons of the *Acts of the Apostles*, from Benjamin Ralph, *The School of Raphael,* 1759, plates 6 and 7. The Bodleian Library, University of Oxford. Reference Johnson b.76.

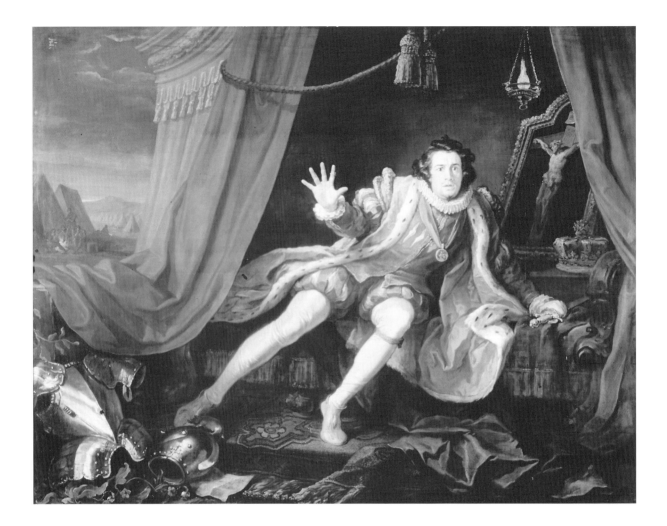

All this ensures that the system of gesture and facial expression in Hogarth's *Garrick as Richard III* of 1746 (fig. 48) should come as no surprise.[21] The dominant Shakespearean actor and producer of his day is pictured at the moment when the usurping king, in his battle tent ready to don his armor, has awakened in horror from a nightmare prophetic of his fate—or rather at the extended moment in which he communicates the import of his fear to his audience. Garrick was credited with the introduction of a more realistic style of conveying emotions, but he necessarily had to use grand gestures to stir the hearts of those in the remoter regions of the large theatres in which he played. There is no problem in recognizing the way that Hogarth has followed the Le Brunian instruction that the horrified person should start violently backwards with hands uplifted and fingers widespread. The facial expression shows that Hogarth's depiction of Garrick's features has been informed by Le Brun's prescription in *Horror* (fig. 49). Hogarth eschews its more extreme effects—no doubt wishing to avoid overly distorting the required likeness in his portrait of the actor. His desire to compose

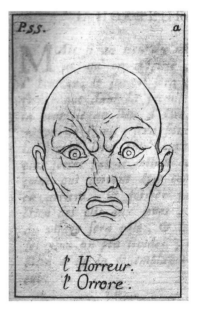

a dramatic narrative in the grand tradition and the actor's desire to emulate the grand sentiments of history painting merge in a shared intent.

Hogarth's hugely successful prints served to promote his example and his inventions across Europe. He reinforced the growing trend, represented in France by Jean-Baptiste Greuze and then by Louis-Leopold Boilly, to elevate genre subject to the level of history through the adoption of rhetorical strategies from "history painting." But the most spectacular legacy of Hogarth in the late eighteenth century is found in far-away Spain with the satirical prints of Francisco de Goya.

Completed in 1799 at the height of his work for the Spanish Royal court, Goya's first series of prints, *Los Caprichos,* turns a remorselessly cynical eye on the traditional practices of Spanish society. The tone is set by an image of the sleeping artist assailed by bat-like creatures of the night, the "Monsters" whose reign is unleashed, as the caption indicates, by the "Sleep of Reason." From his reformist and Enlightenment stance, Goya uses an unrivalled range of techniques and imagery to excoriate the unenlightened mores of contemporary Spain. A nice example is *What a Sacrifice* (fig. 50), in which an innocent young woman is tearfully traded to a lecherously repulsive suitor, whose satyr-like features, humped back, and ape-like legs are hardly offset by his implied wealth.[22] Like Hogarth, Goya knows how to use the "physiognomic" rhythm of bodily contour to characterize both the participants and the situation.

OPPOSITE

48. William Hogarth, *David Garrick as Richard III,* 1746, National Museums Liverpool (The Walker).

49. Charles Le Brun, *Horror,* from *Sur l'expression générale & particulière,* 1694, p. 55a.

BOTTOM

50. Francisco de Goya, *What a Sacrifice,* from *Los Caprichos,* 1799, Ashmolean Museum, Oxford. Courtesy of Glasgow University Library, Department of Special Collections.

51. Francisco de Goya, *All Will Fall,* from *Los Caprichos,* 1799, Ashmolean Museum, Oxford. Courtesy of Glasgow University Library, Department of Special Collections.

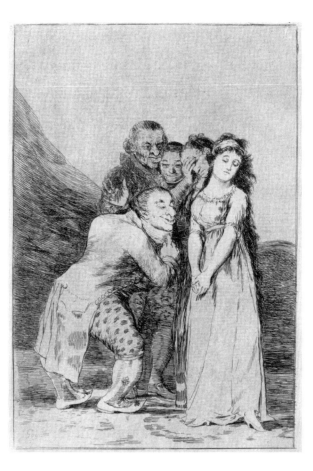

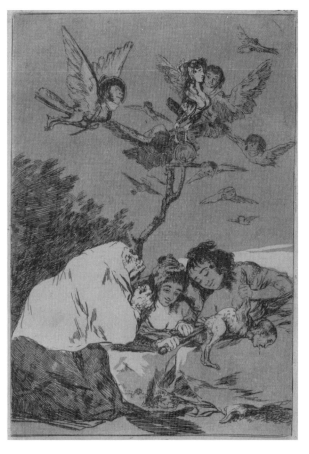

Elsewhere amongst the eighty prints in *Los Caprichos,* animal imagery is overtly involved. In *All Will Fall* (fig. 51) a busty bird attracts hopeful males like moths to a flame.[23] The feathery suitor nearest the temptress bears features much like those of Goya himself. What the eager men fail to observe is that the object of their lust is perched precariously on the unstable ball of fortune, or rather ill fortune. Below, an expectant old woman—an "old crow" in our parlance—prays for another to fall as the result of having his wings clipped by insatiable desire. The two younger women obscenely give a plucked cock a good stuffing. Like all great visual satirists, Goya both despises the superstitions and foibles that lead people astray and relishes the visual delights that corruption affords. Goya's involved savagery not only goes beyond Hogarth but also surpasses all earlier artists, with the possible exception of Jerome Bosch, whose sixteenth-century fantasies of devilish practices were well represented in the Spanish Royal Collection.

In one way, the second of our designated revivers of physiognomics, the Swiss pastor Johann Caspar Lavater, can be set within the same Enlightenment context as Hogarth and even the more radical Goya. He was aspiring to establish physiognomics as a key science of everyday life. The artist to whom he probably felt closest, the Swiss Daniel Nikolaus Chodowiecki, was very much a Hogarthian moralist of modern life. Lavater sets out with the highest purposes proclaiming his quest to understand human countenances to be a religious mission. This is because there is an indelible "Harmony between Moral Beauty and Physical Beauty." He is attempting nothing less than the "study of the human heart." He also trumpets his intention to surpass those "who only pilfered from Aristotle" rather than going to Nature. Thus it is that he asks, "is not Painting a Science? And yet, how narrow are its bounds!"[24]

In a series of volumes issued from 1772, with translated editions and anthologies in most European languages, Lavater offered what proved to be a highly popular blend of rudimentary medical science, classical learning, Christian moralizing, philosophical commonplaces, and instinctive prejudice, larded with an ingenious pillage of images from historical and modern art. His method was to accumulate different kinds of "evidence." First came observations of people's faces and behaviors, drawing upon his own accounts and those of others. These were supported by ideas taken from the human sciences, especially humoral medicine. He was also alert to the exciting new ideas in natural history being promulgated by Buffon and others, adopting them selectively to serve his own cause. Finally, Lavater drew repeated attention to the lessons of the great artists in their theories and practice, particularly the physiognomic acumen of contemporaries Chodowiecki and fellow Swiss Henri Fuseli, who rose to become president of the Royal Academy in London. In his illustration of Fuseli's erotically charged *Daughter of Herodias* (fig. 52), St. John's "sublime" countenance, even as a severed head, is contrasted with Salome's seductively flawed sensuality. Particular historical painters are seen to exemplify different classes of expression—Raphael the noblest and Rembrandt the "passions of the vulgar." Lavater's main emphasis is upon physiognomics, but he does devote some attention to expression, drawing heavily upon Le Brun, not least because

52. Johann Caspar Lavater, illustration of Henri Fuseli's *Daughter of Herodias,* from *First Physiognomical Fragments,* 1775–78.

he believes that pathognomic signs can be induced as acquired features during the course of life.

The result is a loose mix of empiricism and theory, which aggregates detailed effects without any real attempt to demonstrate causes. Given the episodic character and rambling structure of his theories and observations, it is not for nothing that the original title of his four-volume compilation published in 1775–78 was *First [or "Preliminary"] Physiognomical Fragments.*

In Lavater's review of his predecessors, he sternly criticizes della Porta for producing human types that are not credible, and for using animals too remote from humankind. Indeed, Lavater rejects the idea that a human head can really resemble that of a lowly beast in any meaningful sense. "A man who in the forehead and nose should resemble the profile of the lion, assuredly would not be an ordinary person; but I question whether that character can be completely found in a human face."[25] In place of such traditional ideas, he aspires to produce a mathematical foundation of an irrefutable kind—apparently unaware of Le Brun's unpublished system of triangulation. His immediate point of inspiration was probably Dürer's system for the geometrical transformation of human heads. Lavater supposes that, "Were we able to draw correctly the profiles of men and animals, could we compare them

mathematically—we should come in time to deter-
mine with certainty the just proportion of their fac-
ulties."[26] His goal was "to calculate and determine
the forms of heads according to the principle of
Physics and Mathematics."[27]

In practice there are few instances in which La-
vater endows his analysis of profiles with anything
like a really geometrical base (fig. 53). I suppose that
he might have claimed the minute reading of tiny
differences in the contours of the head—above all
the forehead—as a kind of instinctual mathematics.
A typical key to two of the figures in the illustrated
plate of mathematical profiles reads:

> [fig. e] his judgement rises almost to penetration.
> My conjecture is founded on the acute bone
> of the eye, and the exact contour of the chin,
> which supports . . . a turned-up nose of such
> a form.
> [fig. f] I perceive not here any great depth of
> judgement, but calmness of reason, circum-
> spection, candour, love of order and persevering activity.

Looking at a profile in another plate, he sees "folly only, because the frontal sinus
terminates in a point."[28] He proliferates these kinds of judgments with abandon. It
seems that the malign "spirit of proportion" that had so tortured Messerschmidt
remained quiescent in the face of Lavater's muddled efforts to unravel the math-
ematical secrets of the human constitution.

Lavater devotes substantial space to the analysis of what he hopes are authentic
images of the famous and infamous. For instance, he analyses profile images of Hei-
degger on his deathbed (fig. 54) and one taken from his death mask for what they tell
us about the philosopher's qualities. Lavater is aware that some images convey better
levels of information than others. One of the profiles is drawn more "correctly," and
exhibits "far more shrewdness." "In this case there is more truth, energy and wis-
dom," as might be expected of a renowned thinker.[29] Later, Johann Joachim Winck-
elmann, the great authority on ancient art, is disconcertingly judged to be "destitute
of proportion." However all is not lost. "Not withstanding the faults that disfigure
this head, we shall discover in it the character of a great genius."[30] However, looking
at a supposed bust of Seneca (fig. 55), the ancient philosopher, the effect is so "harsh,
inflexible, intractable" that he doubts the traditional identification of this famous
image.[31]

Women, as is standard in physiognomics, do not fare well. One plate (fig. 56),
shows "two women with all the weakness of their sex."[32] The older looks "as if she

TOP

53. Johann Caspar Lavater, *Geo-
metrical Analysis of Profiles,* from
First Physiognomical Fragments,
1775–78.

OPPOSITE

54. Johann Caspar Lavater,
Heidegger on His Death Bed, from
First Physiognomical Fragments,
1775–78.

55. Johann Caspar Lavater, *Bust
of Seneca,* from *First Physiognomi-
cal Fragments,* 1775–78.

56. Johann Caspar Lavater, *Two
Women,* from *First Physiognomical
Fragments,* 1775–78.

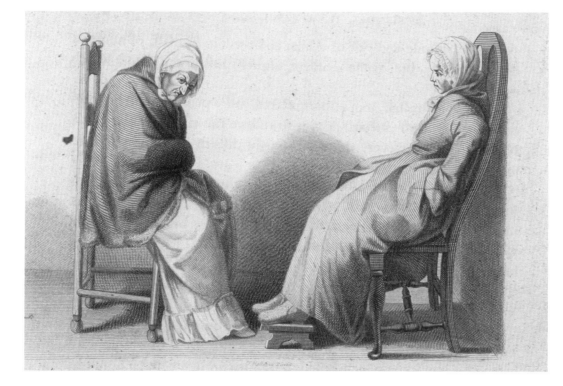

were calculating the amount of the physician's fees," but in spite of her apparently unpromising demeanor, the Swiss pastor concludes that she is likely to be "an excellent mother and good housewife." The younger shows that she is "the best creature in the world" though "her faculties limit her to the ordinary things in life."

However scathing Lavater is of any individual character, he is reluctant to formulate any direct equation with animals. He is utterly committed to the maintenance of an impermeable boundary between Man, who stands at the divine summit of creation, and mere beasts. Comparing, for example, the signs of a rabbit to those of a human, Lavater clearly sees evidence of the rabbit's "lasciviousness, stupid and timorous gluttony. How opposite in every sense, is this from to the profile of man, to his erect and majestic form!"[33] The context for his forceful advocacy is the evidence emerging from the natural sciences of the "higher" animals' closeness to man. To help sustain the traditional separation, Lavater selectively cites evidence from the new science of comparative anatomy: "the generic difference between man and animals is obviously manifested in the bony system," above all in skulls.[34]

He was well aware that some apes were being hailed by pioneering primatologists as very adjacent to humans, perhaps even continuous with them:

It is well known that of all animals, the Monkey approaches nearest to the human form—and yet what distance between the monkey and man!—But the more enormous this distance is, the more is man bound to rejoice at it. . . . Of all the different kinds of monkeys, there is hardly any except the Orang-outang and the Pitheco which have a marked resemblance to man; all the others are sensibly below the human form. . . . Those who take pleasure in degrading man to the level of the brute, exalt the Orang-outang to the level of man.[35]

However, in reality, "the [newborn infant] will sooner rise to the dignity of angels, than the [newborn Orang-outang] to the dignity of man."[36] Those who pretend to describe "man in a state of nature" are summarily dismissed: "Much has been said of 'man in a state of nature'—but where shall we find him in that state? It no more exists than a 'Natural Religion' without revelation."[37] In theology, as in all moral and social matters, Lavater is a staunch traditionalist.

In the final analysis, the tell-tale sign that speaks irredeemably of the true nature of the human spirit is the profile of the forehead: "In vain will you look any where but in man, for that large and elevated forehead which gives so much dignity to his physiognomy, and that stately arch which seems destined to serve him for a crown."[38] In this, he is almost certainly drawing upon the ideas of Petrus Camper, whom we will encounter as a major player in chapter 6, in company with the more radical authorities whose ideas Lavater is so keen to combat.

However, for all this emphasis on the baseness of all animals, it is still possible to apply the abstract rules of physiognomics to them, since every species "has attached to it certain lines which are fixed and invariable."[39] For example: "The character of tame animals . . . is marked by long irregular lines. . . . The structure of these heads

seems to indicate no other end of existence, but repose and peaceful enjoyment. . . . [for example] the curved line extending from the bone of the eye to the nostril, is the indication of patience."[40] Like Le Brun, he also recognized that varieties of character and corresponding physiognomy are apparent within a single species of animal. More surprisingly, there are still signs of the old Aristotelian analogies lurking in his system, albeit updated in light of studies by Camper and others: he notes that the "Nomade Tartar" or Calmuck exhibits the "flat forehead and sunk eyes" that "generally pass for signs of cowardliness and rapacity." The Tartar's forehead, in particular, bears clear "resemblance to that of a monkey."

Above all, when reading Lavater, it is not possible to demand methodological consistency, even less any philosophical logic linking observation to cause. What is reasonable to expect are ingenious judgments colored by unshakeable moral and theological principles. There is the bonus of much quirky vitality in his writing, and a feast of images often engraved to a very high standard. Admired and sometimes derided, there is no doubt that Lavater's volumes attracted widespread attention. I suspect that he was more influential on the way that people looked at paintings, sculpture, and prints than most professional writers on art. The appeal of his illustrations and his entertaining texts undoubtedly injected fresh life into what was a flagging genre, even for those that felt he had exceeded his brief. His most important legacy resided in the work of the cartoonists and caricaturists who achieved such public prominence in the nineteenth century. This is true above all with the greatest of them all, Honoré Daumier.

Daumier was of course more than a caricaturist. I am not just referring to his paintings, which combine economy of means and depth of expression in equal measure, but to the graphic work itself, which transcends the normally transient nature of the cartoonist's trade. That he drew directly upon physiognomics, not least for a system of reference that much of his audience could be expected to recognize, is not in doubt. Looking at the *Interior of the Omnibus* (1839), we have no difficulty in recognizing the porcine nature of the oaf on the left (a pork butcher by profession!). He intrudes into the space of the resentful lady who anxiously leans away from the lurch of the drunken man next to her (fig. 57).[41] This lithograph, like so many in Daumier's career, was issued within a series published in the new Parisian journal *La Caricature,* and in the illustrated newspaper *Le Charivari.* The titles of these series convey the sense that Daumier and his contemporary caricaturists were involved in a kind of systematic natural history of the bizarre creatures in human society: *Types of Paris* (in which the *Omnibus* appeared), *French Types, Physiognomic Gallery, Tragical-comical Physiognomies, Parisian Emotions, Course in Natural History* . . . This was the age of classifying everything, separating and comparing, defining difference and establishing links. As Balzac had said in the foreword to his *Comédie humanie,* "society makes of man, according to the environment in which his activity is exercised, as many different species as exist in Zoology."[42] Allowing for a rather loose use of the term "species," this view of the biological adaptation of humans to diverse environments stands very much in the tradition of Buffon and Georges Cuvier.

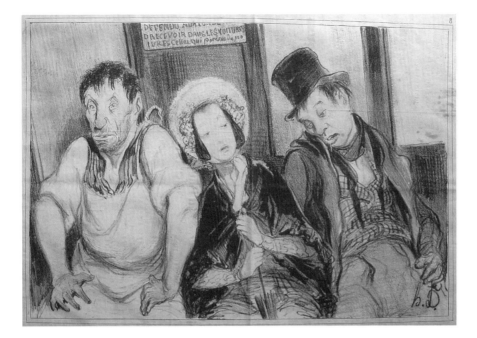

57. Honoré Daumier, *Interior of the Omnibus,* 1839, Ashmolean Museum, Oxford. © www. daumier.org.

It was in this pseudobiological but comedic spirit that Daumier's publisher, Daniel Aubert, issued a series of volumes between 1839 and 1841 entitled *Physiologies,* illustrated by his team of house artists and devoted to various taxonomic categories of French people: lawyers, poets, bathers, lechers, and so on. One enterprise, which had begun life as an illustrated essay in *Le Charivari,* became in 1841 a big book on human creatures, knowingly entitled *The Parisian Museum. The Physiological, Picturesque, Philosophical and Grotesque History of all the Strange Beasts in Paris and the Suburbs, Made to Follow the Works of M. Buffon,* with 310 illustrations by a number of artists, of which 130 were by Daumier himself. A set of four lithographs by Daumier issued in *Le Charivari* in 1836 placed an orangutan in the midst of human situations, with predictable confusion as to who was the ape. When we look at two prints in Daumier's *Physiognomic Gallery* (1836–37), we have no difficulty in recognizing the fishy nature of the *Lover of Oysters* (fig. 58) as he eagerly sucks the living mollusks from their hard shells, while the man who discovers while he is shaving that his wife has died looks like a startled pussy cat (fig. 59).[43]

The extraordinary parade of teeming characters in Daumier's later prints generally make less overt and direct reference to traditional physiognomics, but the infinitely inventive way he is able to exploit hundreds of variations in the shape of forehead, nose, eyes, mouth, and chin testify to a subtlety of physiognomic diagnosis beyond even Lavater's fertile imagination. The world of art, like that of lawyers, provided a particularly rich vein of eccentrics. His numerous essays on the pomposity of painters, sitters, and spectators testify repeatedly to a kind of folk physiognomics, in which we as posing actors play a knowing role. To be the possessor of a striking profile was something of which to be proud, even to the point of absurdity (fig. 60).[44] The lady author in her expensively framed portrait turns heavenwards in fervent search of inspiration for her "moody book." She explains to the prim young

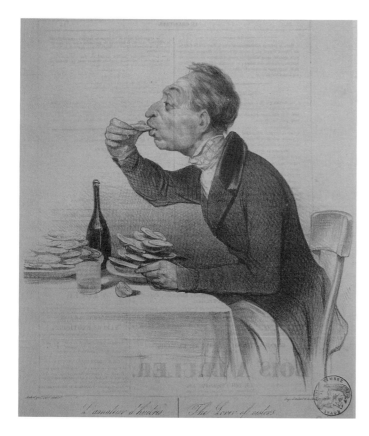

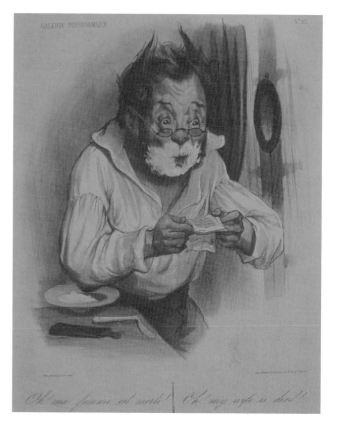

58. Honoré Daumier, *Lover of Oysters*,
from *Physiognomic Gallery,* 1836–37,
Ashmolean Museum, Oxford. © www.
daumier.org.

59. Honoré Daumier, *Man Learning of
the Death of His Wife,* from *Physiognomic
Gallery,* 1836–37, Ashmolean Museum,
Oxford. © www.daumier.org.

60. Honoré Daumier, *The Artist Has
Caught Me at the Moment I Have Written
My Moody Volume,* 1844, Ashmolean
Museum, Oxford. © www.daumier.org.

man that "the eyes came out quite well but the nose is not sorrowful enough!" Perhaps she harbors hopes that romance might erupt in the right circumstances.

THE PHOTOGRAPH

The new photographic image-makers of his day were also, as we might expect, one of the subjects of Daumier's wry gaze, and he himself was immortalized by the new art. Yet his own art remained largely untouched by the invention that was revolutionizing the portrayal of the bourgeoisie. The telling role of judicious exaggeration in his drawn images was heightened rather than diminished in the face of the frozen faithfulness of the studio portrait. Whatever the cutter of silhouettes, painter of miniatures, the peddler of cheap drawn likeness, or the reproductive engraver might fear from the new medium, the integrity and utility of Daumier's physiognomic art of communicative distortion was unaffected.

Photography was, however, to revolutionize the science of the face in other key areas. In chapter 6 we will see the exploitation of the photograph as a diagnostic tool in criminology. In the context of our present concerns, it is the study of pathognomics that was affected to the most striking degree.

In the light of the nineteenth-century aspiration that any proper science should reveal the fundamental mechanisms behind a phenomenon, the kind of undemonstrable connection between cause and effect that had persisted in the works of Le Brun and Lavater was clearly no longer sustainable. What was needed, as Parsons and Hogarth had recognized, was a systematic way of connecting specific emotions with the actual mechanisms of the face. The mechanisms in the complex mask of muscles had been progressively disclosed by anatomists such as the Scottish surgeon, Charles Bell, whose important book on *The Anatomy and Philosophy of Expression* in 1806 set new standards for the treatment of facial mechanisms, receiving due if critical attention from Darwin.

The trick was to pass beyond the shallow empiricism of simply observing facial expressions and to correlate muscular action with what could be discovered about the emotions of the subject. That trick was seemingly performed by Guillaume-Benjamin Duchenne de Boulogne. It was unveiled to the public in his 1862 treatise, *Mechanism of Human Physiognomy,* which is amongst the most remarkable of all the early photographically illustrated books.[45]

Like so many of his contemporaries, Duchenne believed that photography is as "truthful as a mirror."[46] Given the traditional idea that the face was the mirror of the soul, he now seemed to be in possession of a device that provided an unparalleled reflection of innermost feelings. Indeed, he described his photographs of expressions as the "orthography of the physiognomy in motion," in which each muscle separately manifested a "movement of the soul."[47] To define the muscles that corresponded to emotions was no small task; no less than fifty-three emotions were to be codified.

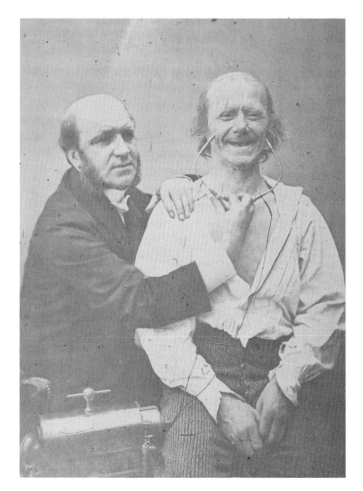

61. Guillaume-Benjamin Duchenne de Boulogne, *Activation of Facial Muscles with Electrodes,* from *Mechanism of Human Physiognomy,* 1862, plate 13, The Bodleian Library, University of Oxford. Reference 16665 d.14.

Working as a doctor at the Salpêtrière in Paris, the hospital that housed mentally disturbed patients, he began in 1856 to photograph inmates to record their expressions.[48] In order to identify the individual role of each of the many muscles in the intricate web of the face, he used a "Volta-Faraday Apparatus" equipped with two electrodes to animate any given muscle electrically. His research involved the application of these electrodes to male and female volunteers in order to precipitate the expressions, which arose from the contraction of a particular muscle or muscle group (fig. 61). For example, activation of the "grand zygomatique" produced a joyous expression, was therefore identified as the "muscle of joy."[49] An elderly man proved to be the perfect subject for Duchenne's purposes, blessed with limited cutaneous sensitivity, a strongly lined face, and lack of fat. With the assistance of Adrien Tournechon (brother of the famous Parisian photographer, Nadar), he produced a series of emphatic images that rival anything in the drawn manuals of expression.

Duchenne was well aware of the tradition in which he was operating, founded by Leonardo and Michelangelo as artist-anatomists. He openly compared his images to the paintings of such masters of expression as Caravaggio and Rembrandt, and offered them as exemplars for those practicing the "plastic arts."[50] The final section

of the book consists of a "Partie Esthetique," in which he provides analyses of exemplary antique sculptures (fig. 62), and sets up little erotic dramas of women photographed in various emotional states. In spite of his insistence on reductive analysis, he recognized how the combined actions of more than one muscle could express elusive and paradoxical blends of emotion, even to the extent of simultaneously manifesting "terrestrial love" and "celestial love."[51] Despite proclaiming the instrumental objectivity of his electric device and the impersonal scrutiny of the camera's eye, Duchenne was still locked into the subjectivity that typified earlier attempts to codify expressions. The scientist's definition of the subject's emotional state remains that of the observer. While his experiments displayed a particular emotion, the subject could not be shown to be actually experiencing that emotion at the time of the making of the image.

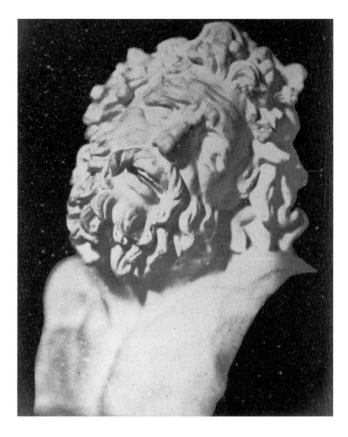

62. Guillaume-Benjamin Duchenne de Boulogne, *Laocoön,* from *Mechanism of Human Physiognomy,* 1862, The Bodleian Library, University of Oxford. Reference 16665 d.14.

The other major contributor to the photographic study of expression was Charles Darwin, whose earlier books seemed to be taking part in a competition to see how far he could go without resorting to pictures. Impressed by Duchenne's results, he sought and obtained permission to use some of the French doctor's photographs in his *The Expression of the Emotions in Man and Animals* (1872). Perhaps one of the least well regarded of Darwin's books in terms of "hard" science, it is one of the most revealing of instincts, which were generally suppressed in his more deliberately dry texts. The pictures play a prominent role in this respect.

Darwin's interest in the subject is entirely understandable. Even without accepting the simple analogies for fixed signs promulgated by della Porta, it was clear that human expressions were shared to notable degrees with those of animals. The fact that certain terrifying events can "make our hair stand on end" is an obvious example, though it hardly seems to play a crucially functional role in the survival of our species. What Darwin aspired to was to understand the ancient roots of expressions and their cultural transmigration in the light of evolutionary theory and natural selection. Above all he sought the link between cause and effect that had eluded all earlier commentators: "No doubt as long as man and all other animals are viewed as independent creations, an effectual stop is put to our natural desire to investigate as far as possible the causes of expression. . . . With mankind some expressions, such as the bristling of the hair under the influence of extreme terror, or the uncovering of the teeth under that of furious rage, can hardly be understood except on the belief that man once existed in a much lower and animal-like condition."[52] Indeed, the

expression of human emotions was not the reason why the muscles had evolved: "every true or inherited movement of expression seems to have had some natural and independent origin. But, when once acquired, such movements may be voluntarily and consciously employed as a means of communication."[53] The result is that some actions of the muscles result from the direct and spontaneous reaction of the nervous system, while others are the result of acquired habits and their consciously expressed antitheses.[54] There is a strong hint here of the ideas of Condillac, the eighteenth-century French philosopher, whom we will encounter in chapter 5.

But the question remained. How to gather and record data on a nonarbitrary basis? Darwin was well aware of the traditional handbooks generated by artists and nonartists, but was not impressed. Few of the existing texts shed any useful light on how to proceed in a scientific manner. For instance, he cites Le Brun on "Fright" to demonstrate the "surprising nonsense that has been written on the subject."[55] One solution was to circulate questionnaires to correspondents around the world, some thirty-six of which were returned. From this all too small comparative sample, he provisionally concluded that "the same state of mind is expressed throughout the world with remarkable uniformity," in spite of all the obvious cultural differences in the languages of gesture.[56]

Another potential solution lay in photography, which, as Duchenne claimed, promised to bypass the mediating hand and eye of the artist. Photographs also had the merit of allowing an expression to be scrutinized for a longer period than was possible though direct observation of human and animal subjects. Darwin declared, "I have found photographs made by the most instantaneous process the best means for observation, as allowing more deliberation."[57] He augmented Duchenne's photographs with ones he collected from various other sources, and, most notably, with images taken at his instigation by Oscar Rejlander (fig. 63), the famed stager of photographic tableaux in emulation of history painting. Rejlander's subjects were actors, skilled in the kind of conscious communication through expression and gesture that he recognized as especially human. The results are hardly less stagy than Hogarth's *Garrick,* even though acting styles had become less fixedly rhetorical by the mid-nineteenth century. When photographs were not available for a variety of reasons, as was generally the case with animals, specialist illustrators were deployed, including the German-born master of animal narratives, Joseph Wolf (fig. 64).[58] Wolf, who became the leading illustrator of natural history in Britain, was also a long-term Royal Academy exhibitor, submitting a series of well-regarded oil paintings of creatures interacting dynamically with often-hostile environments. He also produced popular illustrations of what may be called "animal capers"—as we will see later. His illustration of the cat with arched back, bared teeth, glaring eyes, and bristling hair places the traditional artistry of the *animaliers* in the service of Darwin's understanding of the functionality of the cat's behavior in reacting to a threat.

What the engagement of Rejlander and Wolf in Darwin's enterprise shows is the extraordinary difficulty of extracting the study of expression and the emotions from its traditional context of artistic representation. The visual tone of the volume

Tab VI

1

2

3

4

Photogravure by V. Brooks, Day & Son.

as a whole also provides a revealing insight into the more instinctive and emotional engagement of Darwin with the affinities of humans than with other creatures. Access into this side of Darwin, which is generally scrupulously concealed behind the biologist's controlled prose, is provided by his *Biographical Sketch of an Infant,* in which he recorded the emergence of emotional signs in his son William:

> *Anger.*—It was difficult to decide at how early an age anger was felt. . . . When about ten weeks old, he was given some rather cold milk and he kept a slight frown on his forehead all the time that he was sucking, so that he looked like a grown-up person made cross from being compelled to do something which he did not like. . . . When eleven months old, if a wrong plaything was given him, he would push it away and beat it; I presume that the beating was an instinctive sign of anger, like the snapping of the jaws of a young crocodile, just out of the egg, and not that he imagined he could hurt the plaything.[59]

Fig. 16. *Cynopithecus niger,* in a placid condition. Drawn from life by Mr. Wolf.

Fig. 17. The same, when pleased by being caressed.

When he took William as a two-year-old to the Zoological Gardens, Darwin was fascinated by his son's instinctive reaction of fear to the larger caged animals, which he had not previously seen: "We could in no manner account for his fear. May we not suspect that the vague fears but very real fears of children, which are quite inde-

pendent of experience, are the inherited effects of real dangers and abject superstitions during savage times?"[60]

Darwin's *The Expression of the Emotions* may be regarded simultaneously as the last great act in the traditional succession instigated by the Renaissance artists, and as the clearest signal that new methods were needed if science was to make any inroads into the problem of pathognomics. There was of course, no problem for artists in continuing to exploit and develop the repertoire of time-honored devices for conveying emotion. To cite only one example of the migration of long-standing motifs into film, we can clearly see in the figure screaming on the precipitous steps of Odessa in Sergei Eisenstein's *Battleship Potemkin* that the potency of recognizable signs is undiminished (fig. 65). Indeed, the great Soviet filmmaker acknowledged Leonardo was a source of inspiration.[61] This example is helped by our visual habits—but are they just habits?

Histories of art and contemporary science gravitate toward divergent answers. Art historians are inevitably concerned with contextual specifics, those aspects of images that differ in a way that may be taken as characteristic of a particular culture (however defined) or of their individual makers. On the other hand, the sciences that bear most directly in questions of facial recognition and expression—experimental psychology, cognitive science, neurology, and aspects of the behavioral sciences—

OPPOSITE

63. Oscar Rejlander, *Helplessness and Indignation,* from Charles Darwin's *The Expression of the Emotions in Man and Animals,* 1872, plate 6, The Bodleian Library, University of Oxford. Reference 189 f.73.

64. Joseph Wolf, *Niger Macaque Placid and Pleased,* from Charles Darwin, *The Expression of the Emotions in Man and Animals,* 1872, The Bodleian Library, University of Oxford. Reference 189 f.73.

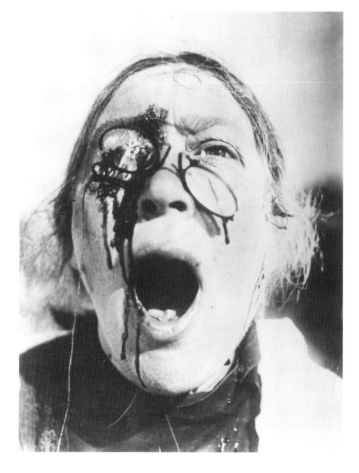

65. Figure screaming on the steps of Odessa in Sergei Eisentein's *Battleship Potemkin,* 1925. Courtesy of the British Film Institute.

are for the most part concerned with shared mechanisms in relation to basic signs. During the all-too rushed course of the present chapter, we have been constantly encountering the way that cultural specifics seem to compose endlessly new variations on old biological tunes. But to gain a grip on the cultural and scientific aspects of expression, neither the scientific or cultural approach is sufficient unto itself.

With respect to pathognomics, it seems likely that the balance struck by Darwin between innate mechanisms and acquired cultural signs is about right, though I suspect that the division between "innate" and "acquired" is too schematic a form of shorthand for what actually happens. Nothing "innate" arises fully formed and realized, while nothing acquired operates arbitrarily in the relation to underlying mechanisms that are a function of the brain's biology. And, however much we may be able to determine the neurology and physiology through which expressions are generated and decoded, the complexity, subtlety, and speed of the system through which we react to what we see in someone else's face remains awesome. The variety of cultural expressions is indescribably incredible.

Darwin's contention that there are communicative mechanisms of facial expression that are shared across cultural boundaries is increasingly finding support from contemporary research, though his set of six basic types of emotion is likely to be much too small. Above all, recent investigators are confirming the extraordinary intricacy and speed of the systems that both produce and understand expressions. At the Autism Research Centre in Cambridge University, Simon Baron-Cohen and his team have been working with a set of 412 emotions, boiled down from a total of 1,512 identifiable emotion words.[62] Paul Ekman at the University of California is entering the same subject via the mechanisms. He has identified forty-three specific muscle movements—"action units"—that produce at least 10,000 facial configurations, which typically appear for only fleeting fractions of a second in real life.[63] The net result is an instinctual communication system of such eloquent subtlety, nuanced complexity, and perceptual instaneity that any kind of verbal formulation is bound ultimately to fall short.

Neuroscience has also shown how the mechanisms of facial recognition, integral to traditional physiognomics, are located in a different region of the brain from that which does most work in recognizing expressions. In our present context, the key question is, how have those mechanisms delivered our strange propensity to animalize human faces and to humanize animal faces? Let me float a hypothesis, or rather some linked hypotheses.

The way we operate recognition of individual faces, often on the basis of tiny differences in form and in the context of the constant mobility of facial features, is by stabilizing and exaggerating those aspects that differentiate one person from another. Thus, to express it at its crudest, someone whose nose is long and pointed will be registered within the complex nexus of recognition signs as having a very pronouncedly different nose from some kind of reference norm. The process of exaggeration is that which gives rise to caricature. It is effective and economical, able to handle huge numbers of nuanced variations through the permutation of a series

of relatively basic shapes. This is not to say that we store people's faces as imprinted caricatures, but that caricatures play toward one aspect of the intricate webs of memory functions that are involved in facial recognition. The result of the "caricatured" mnemonic for someone's pointed nose is to draw the totality of that person's face toward that of a bird or animal stored in our memory. But which bird or animal?

The answer to this question must lie in how we recognize animal faces, which is mainly (though not exclusively) concerned with identifying types rather than individuals. This process (which also comes into play when we are identifying which ethnic group someone belongs to), plays toward standardization. The heads of fishes, for example, are drawn toward the stock prototype of fishiness, birds to the norm of bird type. It is these ur-fish and ur-birds that children typically draw, and that adults tend to draw if asked to depict a bird or fish head without a particular species being specified. According to our interest at any one time, and according to our experience and expertise, we can also refine and differentiate our typological categories in a highly flexible way. Sometimes we do to animal faces exactly what we generally do to human ones, and emphasize the differences within a given category. How many of us, I wonder, would be able to say accurately how flat an owl's beak is compared to a crow? I would guess that we overexaggerate the difference. At other times, we blur all bird profiles into a general type, a kind of ur-bird's head. If asked to draw a bird's head, I suspect we would all generate something similar and archetypal.

If this is true, it suggests that our tendency to elide human and animal physiognomies is a by-product of complex mechanisms that we acquire (from nature and nurture) to perform vital functions in the differentiation of faces and types in the human and animal worlds. As such, it is not particularly useful, but neither is it a disadvantage in evolutionary terms. It just happens. But to call it a by-product is to underrate its ubiquity and huge cultural potency. It has provided generations of image-makers with ways of making mute representations speak of protagonists' characters and feelings. It has fueled Leonardo's representation of people, and, as we will see, Oudry's animal stories. It provides us with exploitable sources of artistic expression and innocent amusement, though also, as we will see, with potentially powerful underpinnings for prejudice.

On a shelf beside my computer is card sent by friend. It shows an anonymous artist's copy of the head of a horse from Raphael's *Expulsion of Heliodorus* from the Vatican Stanze (fig. 66). Out of its context in Raphael's narrative, we do not know to what the horse is reacting. However, its flaming mane, starkly staring eye, open mouth, and drawn-back head speak incontrovertibly of fear. Le Brun rides again.

66. Birthday card, 2002, after Raphael, detail of horse's head from *Expulsion of Heliodorus,* Vatican , Stanza d'Eliodoro, taken from an anonymous painting in Christ Church Picture Gallery, Oxford.

PART 2

SOULS AND MACHINES

From Meaning to Mechanism

Strength
The lion is never afraid, but rather, with a bold spirit in fiery combat with a multitude of hunters, always seeks to injure the first one who injures him.

[The Ermine]
The ermine on account of its moderation does not eat more than once a day, and, in order not to stain its purity, it would rather let itself be captured by hunters than choose to flee into a filthy lair.

Fable
The oyster being laid out with other fish in the house of a fisherman near the sea, pleads with the rat to take it to the sea. The rat, who has designs to eat it, made it open itself, and as he bit it, the oyster squashed his head as it closed. The cat came in and killed the rat.[1]

Leonardo da Vinci

The epigraph above shows three typical examples of Leonardo's animal tales: in one the animal is emblematic of a quality; the second characterizes the virtues of a particular creature; and the third is a very short fable of duplicity and its just rewards. Such characterizations stood in a long tradition, as he well knew. It seems that three versions of Aesop's *Fables* were in his library, one in French, one in verse, and one presumably in vernacular prose. He also possessed *L'Acerba*, by Cecco d'Ascoli, a poet-astrologer, and Pliny's famed *Natural History*, the ancient source for much of what was believed about exotic and legendary beasts. Where Leonardo differed from earlier compilers is that he could draw animals with consummate mastery.

By Leonardo's time, animals had come to assume extensive roles in a range of literary and visual genres, often playing parts that transcended their ostensibly low stations. Bestiaries, compilations of facts and fancies about real and chimerical animals, took their cue from the *Physiologus* of the third century AD. These compilations had accorded different animals particular roles and meanings in the great Book of Nature, which stood beside the Book of Scripture as a repository of truth. The *Physiologus* was less like an encyclopedia of natural history, as we would understand

it, and more like a huge collection of short stories or fables that narrated the manifold wonders of God's creation. Adam had named the animals; Noah ensured that none of God's creatures should be lost to posterity during the Flood; and they all must therefore have significance for us, even those that served no ostensible human purpose. Otherwise, what was the point of an animal like an ant, which did not obviously provide for any human necessities? For Leonardo, the ant was an exemplar of prudence because it killed its stored seeds to stop them from germinating. We will later see Montaigne expanding on exactly this exemplar.

The meanings accorded to species were embroidered and modified as occasion demanded. They could perform heraldic roles on banners and shields. They could stand as embodiments of some positive or negative quality in emblem books, though this was also true of inanimate objects. Mythology, fable, legend, and symbol existed in a continuous spectrum with what we would regard as natural history. Biology in our sense did not exist, either as a name or as a discrete practice. Real and fantastic animals were cataloged with the same levels of seriousness and wonder as ones that were available for ready witness.

We have no reason to feel superior to those who believed in the existence of unicorns and dragons. Given common knowledge of such familiar creatures as horses and lizards, descriptions and images of unicorns and dragons must have seemed less improbable than those of giraffes and rhinoceroses. We all have to take many things on trust, accepting that pictures of things we have not seen testify to real things or events. When Europeans or Americans show their children a picture of the extraordinarily implausible duck-billed platypus, they take it on trust that the Australian animal does exist. When a deep-sea camera in a submersible that ventures to depth inaccessible to people shows us the wonders of the deep, we take it on trust that the images are not faked—though some have questioned whether men really did land on the moon and send back those flickering pictures. We have to trust much of what we are told and what we are shown because we simply do not have time or the opportunities to check everything.

Leonardo's drawings will provide a visually compelling point of entry into this chapter, which juxtaposes in very selective manner two starkly polar themes: the anthropomorphized animal of fable and legend; and the soulless animal, separated absolutely from humankind by divine decree. The centerpiece will be the debates around the "animal-machine" of the eighteenth century, which prevailed until around 1800, when, as we will later see, new factors began to predominate.

AN ARTISTIC BESTIARY

Leonardo's sheet of drawings of cats at Windsor (fig. 67) serves beautifully to illustrate the continuity between real and imagined. No one can doubt that the lying and crouching cats at the right of the page (as a left-hander, Leonardo tended to begin on that side) are based upon observation. The enfolded cat with upraised face and "smile" of warm contentment just below center right will be recognizable to any cat

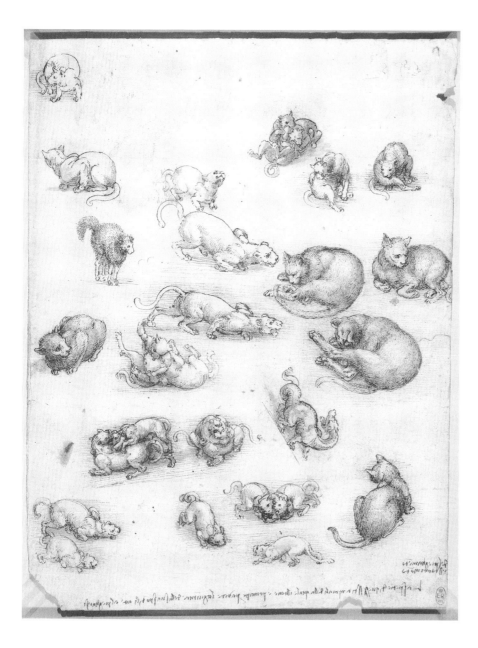

67. Leonardo da Vinci, *Studies of
Cats and Other Animals,* c. 1513,
Royal Library, Windsor, no.
12363. The Royal Collection ©
2004, Her Majesty Queen Eliza-
beth II.

owner. The cats grooming themselves toward the upper right also ring true, through
their poses were more fleeting than those of the resting animals. The creatures in
stalking posture, with front legs sharply bent and chest pressed to the ground, are
clearly based on seen motions but develop into imagined variants that look more
like the big cats than domestic ones. The pairs of wrestlers are entirely true to the
spirit of how cats move, but their frozen poses can only be the products of memory
and artifice. The little hairy variant above center on the left is generally cattish, but
appears less of a portrait than an invented demonstration of the arched-backed and
spiked-hair posture of alarm and deterrence illustrated by Wolf for Darwin. Is the
creature at the very top of the page on the left a mouse or rat? The beast to the lower
right of center, drawn on its own piece of diagonally orientated ground, is certainly

neither. It is a curly-tailed dragon, drawn with an "observational" conviction not inferior to that in all but the static cats.

The sheet of studies may well have been part of his enterprise to "write a separate treatise describing the movements of animals with four feet, among which is man, who likewise in his infancy crawls on all fours." He specifically noted at the bottom of the sheet: "On bending and extension. This animal species, of which the lion is the prince, because the joints of its spinal chord are bendable." Perhaps the generic *principe* was a more natural title for the "king of the jungle" in Leonardo's mind, since he was unacquainted with monarchies until the last years of his life.

The ermine in his written bestiary was also drawn and painted by Leonardo. It was less generally familiar than the cat but certainly known in the circles of his princely patrons. Its winter coat provided the most luxurious and exclusive of furs, and an ermine trim came to carry specific connotations of nobility. A small sketch enclosed in the round border of an emblem (fig. 68) shows the fastidious ermine hesitating fatally before a morass and falling prey to a kneeling hunter. As an emblem, the ermine (portrayed on an emphatically large scale) appears in the gracious portrait of Cecilia Gallerani, the young mistress of Ludovico Sforza in Milan (fig. 69). Its presence may well serve a double function, making a humanist play on her name and the Greek for ermine (*galee*) and alluding rhetorically to her ermine-like fastidiousness. In so signaling Cecilia's virtue—presumably her purity rather than her dietary habits—Leonardo has been able to transcend traditional emblematics. The ermine's refined bearing, bright eyes, and immaculate coat act compellingly as visual metaphors for the kinds of qualities that the court poets lauded in the duke's favorite. Cecilia was a lady of good birth and high accomplishments in her own right. The ermine—svelte aristocrat amongst weasels, stoats, and ferrets—served as an appositely fair emblem for such a gracious luminary of the Milanese court.

In a similar vein, two drawings proclaim legends of the unicorn, an animal said to frequent India. In one marvelously economical little sketch (fig. 70), the unicorn stoops to purify a pool of polluted water with its medicinal horn. In the other (fig. 71), a seated lady points knowingly at a docile unicorn tethered by collar and lead. As Leonardo tells us, "From the pleasure it [the unicorn] takes in fair maidens, it forgets its ferocity and wildness. Setting aside its suspicions, it goes to the seated maiden and falls asleep in her lap, and the hunters in this way capture it."[2] The hunt of the unicorn, a royal beast, was a popular subject in word and image. It was portrayed in two magnificent sets of tapestries, one of which is the Cluny Museum in Paris and the other in the Cloisters of the Metropolitan Museum in New York. The Cluny series, probably woven in Brussels around 1500, culminates in the demure

68. Leonardo da Vinci, *The Ermine and the Hunter,* c. 1489, London, Clarke Collection. Reproduction by permission of the Syndics of the Fitzwilliam Museum, Cambridge.

OPPOSITE

69. Leonardo da Vinci, *Portrait of Cecilia Gallerani,* c. 1490, Czartoryski Muzeum, Cracow, Poland.

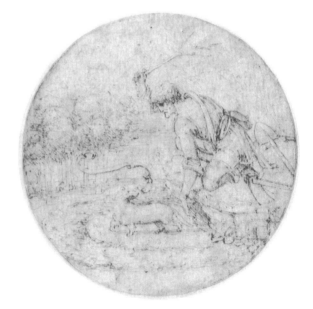

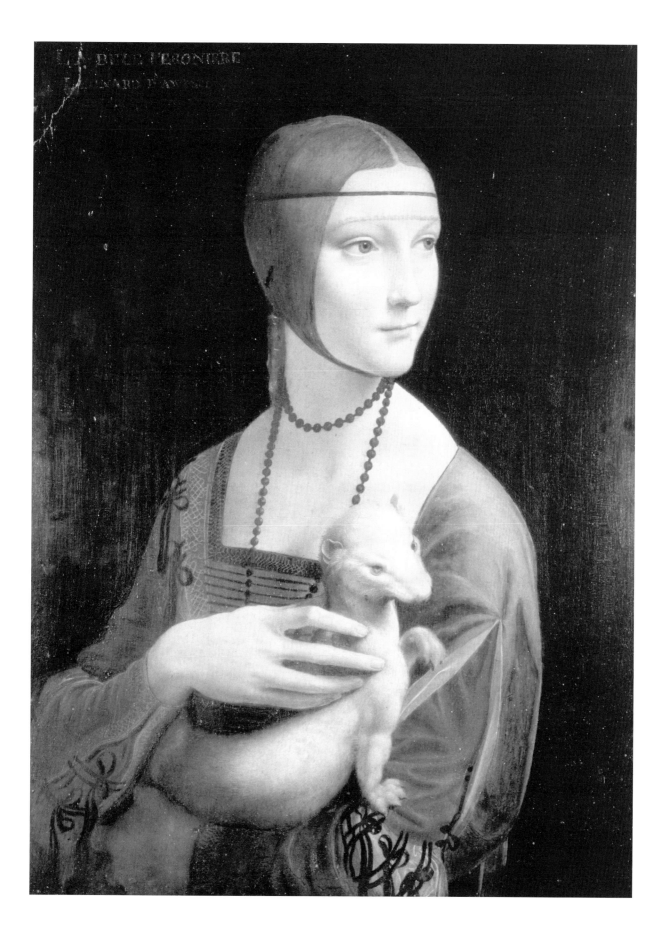

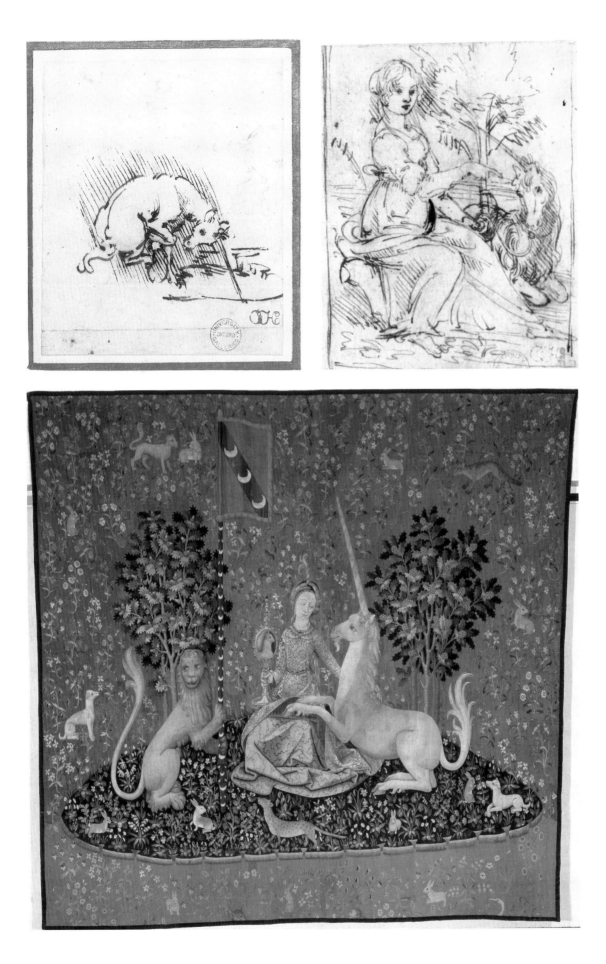

virgin accomplishing what the bold hunting-men always failed to do (fig. 72). To accord such powers to a virgin invited obvious religious analogies with Mary, the mother of Christ.

Lest we should think that such legends persisted only in storytelling and not within the purview of serious natural histories, it will be salutary to look at the system used to explain animals in the greatest zoological encyclopedia of the sixteenth century, the *Historia animalium* by Konrad Gesner, serially published between 1551 and 1587. He opens each of his comprehensive entries with a discussion of the creature's names in Hebrew, Greek, Latin, and European vernaculars, correlating information from a wide range of authorities to understand the etymology of the names and whether the various authorities were indeed referring to the same beast. Then follow accounts of the features that allow the animal to be identified and its morphology. Next come its nutrition, the manner and season of its generation, its enemies, its life in its natural setting, and its position in relation to man, most especially any uses it may have. The last section undertakes a comprehensive trawl of literature that tells of the cultural history of the animal—its lore, symbolic meanings, allegorical significance, its appearances in poetry, and any other recorded role it has performed in the life of the imagination and the book of nature.

Gesner adopts an overtly critical stance toward his many sources, not least Pliny's extravagant accounts, and he strives to portray specimens from life whenever he can. But, inevitably, Gesner has to take the accounts of many exotic and rare animals on trust. Thus, amongst the real animals, we find that the ibex (fig. 73), the astrological Capricorn, is depicted in a spirited and convincing woodcut (even its precipitous leap exaggerates its ability to cope with its mountain habitat). On the other hand, Gesner felt bound to provide an account and picture of the legendary satyr (fig. 74), since it was granted such prominence by Pliny and other classical authors. Gesner's satyr, unlike those of Renaissance and Baroque artists, is definitively a quadruped, equipped with clawed forepaws and birdlike rear feet. In keeping with the humanoid qualities attributed to it by the ancients, the satyr is endowed with a human face and pointed mane of a beard. As such, it takes its place in the extensive ranks of monstrous races and animals with human faces that haunted the European imagination in the Middle Ages. With the discovery of the Americas, the traditional monsters of the East were amplified with accounts of wondrous monsters that could not but be taken on trust by most residents of the Old World, who had no chance to see for themselves.

Wherever we look at the portrayal of known animals in the Italian Renaissance in art or science, they speak implicitly or explicitly of the well-known "stories" that were to be retailed by Gesner. In keeping with the strategy in the first chapter, I will select just two illustrations, again from the sculptural tradition. The first takes us back to Donatello, that most potent signaler of temperaments. One of his most famed sculptures in his own day was the *Marzocco,* the lion of St. Mark (fig. 75), which was a central symbol of Florence's cherished and resolute independence in the face of outside threat. At least three lions had been kept in captivity in Florence

OPPOSITE

70. Leonardo da Vinci, *Unicorn Purifying Water,* c. 1478, Ashmolean Museum, Oxford.

71. Leonardo da Vinci, *Sketch of a Unicorn with a Maiden,* c. 1475, Ashmolean Museum, Oxford.

72. *Virgin and the Unicorn* from Unicorn Tapestries, c. 1500, Cluny Museum, Paris. Photograph: Réunion des Musées Nationaux / Art Resource, NY.

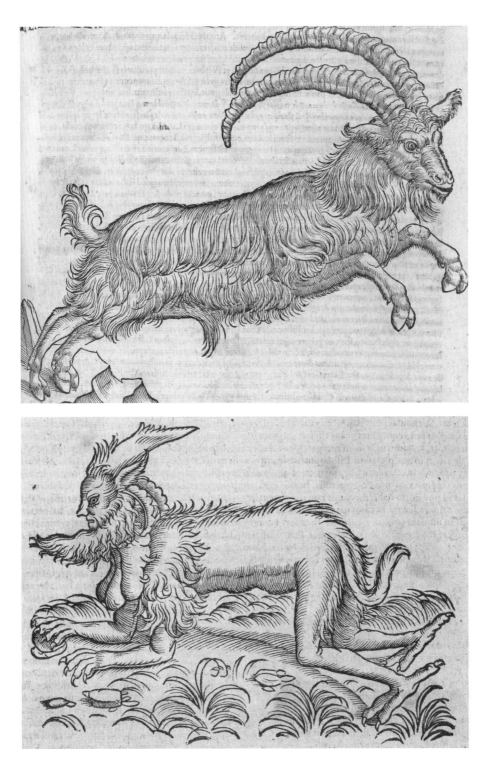

in the fifteenth century. The diarist Luca Landucci records one that arrived in 1487, amongst other creatures given to Florence by the Sultan of Egypt. Landucci and the anonymous author who continued his diaries describe how a number of animals, including lions, bears, bulls, and stags, were let loose together in public spectacles to see what they would do to each other.[3] The lions, as happened in other such combats

75. Donatello, *Marzocco,* 1419, Museo Nazionale del Bargello, Florence.

set up in European courts, generally failed to act spontaneously in a fully bestial manner, showing little inclination to attack at random to satisfy human spectators. Landucci's lion did, however, commit one act of savagery, when it killed a boy in 1487. This incident aside, it is possible that the beast's comparative restraint served to reinforce the idea of the regal dignity of the lion, which would exercise its full might only when warranted.

Donatello's noble beast, sculpted in 1418–20 from sandstone, stood for years on the staircase leading to the Sala del Papa in Santa Maria Novella, which had been

designed to impress the visiting pope, Martin V.[4] In 1812 it was moved to the *rhing-hiera* (raised platform) built into the base of the government palace, the Palazzo de' Signori (now Palazzo Vecchio), where it replaced a lion that had stood there from at least the fifteenth century. Resting a grand foot on a shield adorned with the Florentine Lily, Donatello's lion exudes that air of indomitable majesty and contained *fortezza* we know from its legends. Like the Florentine state, the lion was seen as a just but ferocious ruler when roused. That its physiognomy is leonine goes without saying, but it is possible to discern in the cast of its features (especially when placed beside the *Jeremiah* [fig. 20]), that Donatello has deliberately played to the more universal values in its character that cross species boundaries, above all into those men in whom the choleric disposition finds positive rather than pathological expression. Dürer's *St. Mark* comes to mind as an exemplar of noble choler and martial potential.

The second of our witnesses comes from the Medician court culture of the sixteenth century, which provided the setting for Cellini's bronze portrait of the duke. The dominant sculptor of the younger generation was a naturalized Fleming, Giovanni Bologna (Jean de Boulogne), who came to master the figure style *all'antica* in a way that had been regarded as the prerogative of the Italians. Alongside his great

76. Giambologna, *Monkey,* c. 1570, Musée du Louvre, Paris. Photograph: Réunion des Musées Nationaux / Art Resource, NY.

Ovid's much translated and illustrated *Metamorphoses* tells many tales of how the gods transformed humans into animal, vegetable, and mineral form. Their metamorphosis is not necessarily a debasement but often occurs as an opportune reembodiment of someone who has reached a point of extremis in their human guise. A popular if tragic example concerns the story of Actaeon, the hunter. Moving stealthily through the forest with his hounds, Actaeon chances on a pool and grotto where the divine Diana and her nymphs are bathing naked. His punishment for sampling these forbidden visual fruits is to be transformed into a stag and to suffer death in the jaws of his own hounds. In one sense, many of Ovid's narratives seem central to our theme, and we will shortly encounter again the doomed Actaeon. However, for all the inventive delight of his tales, they are actually of limited relevance here, since he does not really deal with humans as animals while they are still in human guise, nor with animals who subsequently behave in human ways. That was not his purpose.

During the course of the later Renaissance, the standard point of reference for humanoid beasts was provided by Ulisse Aldrovandi. One of the splendidly illustrated volumes he published in the later sixteenth century was the *History of Monsters*.[14] Popular creatures of enduring legend, like the horrid *Harpy* (fig. 79), assume such convincing visual form that the contemporary viewer had difficulty in discrediting their existence. Serial repetitions of such images in later books only served to establish the humanoid prodigies ever more firmly in nature's pantheon of the weird and wonderful. Compelling "evidence" of such creatures was provided by the grotesquely confected specimens of shriveled mermaids and other marvels, cunningly assembled from diverse animal and even human parts. They were made for display in "cabinets of curiosities," of which none was more distinguished than Aldrovandi's. His collection, like many later museums, did not remain immune from such wondrous fakes.

The final genus in this summary roll call of Renaissance man-beasts comprises the wild, hairy, and monstrous races in remote places and times, those primitive creatures who are clearly human in basic form but appear not to have risen decisively above the level of the beasts. The "hairy men" will be given their due in chapters 5 and 6.

AN INVERTED WORLD

Leonardo, Dürer, and the other masters of animals stood in a long and enduring tradition of study from classical antiquity and even earlier. We could continue to illustrate revealing instances of animals exploited as vehicles for big truths across

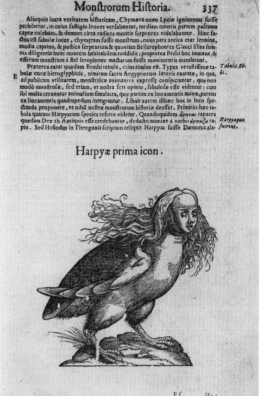

79. *Harpy*, from Ulisse Aldrovandi's *History of Monsters*, 1599–1662, The Bodleian Library, University of Oxford.

carries obvious phallic connotations. But satyrs, like the centaur, are more ambiguous than mere animals. They are endowed with a ratio of humanness, approaching half, and are accorded humanoid heads, which presumably house humanoid brains. They are, therefore, not devoid of consciousness of their base condition and are capable of comprehending moral value. This humane and human view is most clearly expressed by the unfailingly individualistic Piero di Cosimo, whose *Wounded Nymph* in the National Gallery in London depicts a stooping satyr or faun ministering tenderly to a recumbent nymph who has been struck down by an arrow.[12] Piero's views of centaurs, as we have seen (fig. 2), are equally sensitive to the dilemma posed by their dual nature, in keeping with the view that our own constitutions are little less dual than those of the overtly composite creatures.

Dürer's image feeds off this duality. The amply-breasted woman is not obviously threatened by her companion, and relaxes contentedly in the rustic setting with her plump child, who does not appear to exhibit satyr-like features. The implication is that the woman is living in a state of nature with the satyr, who has, we presume, sired the child. There is an almost palpable sense of nostalgia for an age of innocent concourse between humans and creatures, in which the satyr's carnal appetites have found expression—to the mutual satisfaction of himself and the woman. The realm may be devoid of higher spiritual dimensions, but it is hardly paraded as despicable. Such subtlety is the exception rather than the rule. It is more normal for the man-animals of the late Middle Ages and Renaissance to be viewed as unambiguously negative. When Lucas Cranach, for example, portrays the *Werewolf* in his turbulent woodcut around 1512 (fig. 78), we are left in no possible doubt that the bestial man-creature who commits such terrible atrocities, and goes on all fours like Nebuchadnezzar, is utterly despicable.[13]

There was of course one great text, revered in the Renaissance, which dealt in a predominantly benign way with people transformed into animals.

take for the head that of a mastiff or a hound, the eyes of a cat, the ears of a porcupine, the nose of a greyhound, the brow of a lion, the temples of an old cock and the neck of a turtle.[9]

This method, as well as providing a recipe for monstrous conviction, also corresponded to the notion of *fantasia* in the medieval system of faculty psychology with which he was acquainted. A key aspect of fantasy (or imagination) was combinatory, that is to say taking sensory impressions of diverse kinds and mingling them in new compounds. We find this process consciously exploited in Chrétien de Troyes' twelfth-century romances on Arthurian themes. What Leonardo adds to the traditional brew is his supreme ability to represent the natural components in a combined whole with an immaculate sense of their structure and function.

However, it is not perhaps in his own surviving graphic oeuvre that we find the highest realization of this method, but in that of his spiritual cousin, Dürer. The German's engraving of *Knight, Death and the Devil,* dated one year before the *Melencolia I* and *St. Jerome* and very much associated with them, depicts a steadfast warrior in armor on a fine charger.[10] He is assailed ineffectually by a two-person rabble of monstrous beings. The monsters are at once inventively grotesque and superbly naturalistic. Looking at the devil—that strange creature developed from non-Biblical and generally non-Christian precedents—we can recognize the snout of a boar, horns of a ram, ears of an ass, some generically crustacean protuberances, and a set of feline claws. Death is cast in the form of a human figure in advanced state of putrefaction, implying that the human body after its soul has departed is a residue of pure baseness. His cranium is surrounded by a corona of writhing snakes, and he rides a lethargically melancholy horse. Man's two most faithful companions, the horse and the dog (now fit and active) share the knight's fixity on the way ahead. It seems possible that the knight's Christian virtue means that the terrible yet comic beings are invisible to him and his fellow travelers. But we see them.

It is again Dürer, not Leonardo, who best introduces us to the two other genuses of man-beast in the Renaissance. The first is the type of creature, inherited above all from classical mythology, who is part man and part animal. They were many in number: sirens, sphinxes, harpies, mermaids, centaurs, satyrs. Even compounded creatures that did not possess recognizably human members, like griffins, were often designed within a humanoid framework, standing on two legs with head aloft and using their forefeet as hands. For the most part, the composites are not a virtuous band. Just one of these, the satyr, will have to stand as representative for them all. Dürer's engraving of a male satyr in a wooded setting with a woman and child will serve our purposes well (fig. 77).[11] The satyr, cloven hoofed, hairy in his lower parts, and endowed with an unusually conspicuous pair of horns, is clearly not predisposed toward untrammeled virtue. As a favored companion for the drunken Bacchus, the satyr can stand as a representative of licentiousness, and often signals the release of the sexual appetites that inhabit men's loins. His goatish genitals promise a special level of bestial lust. Dürer's satyr is blowing on a rustic chanter, which

OPPOSITE

77. Albrecht Dürer, *The Satyr Family,* 1505, 11.5. x 7.1 cm, Clarence Buckingham Collection, The Art Institute of Chicago. Photography © The Art Institute Chicago.

78. Lucas Cranach, *Werewolf,* woodcut, 1512, Ashmolean Museum, Oxford.

figures in marble and seductively melodious statuettes in bronze, Giambologna cast series of marvelously vivacious and characterful animals. One of the motifs in his animal bronzes, a horse being attacked by a lion, was made in direct emulation of a famed marble group that had survived from Roman antiquity, and which found later echoes in the works of George Stubbs (as we will see).[5] More often, his works stood on their own as astonishing fresh remakings of living creatures, as Giambologna exploited the malleability of clay and wax to transmute the qualities of a living being into the final sculpture. The bronze of a monkey (fig. 76), for example, exhibits a fearful demeanor of such natural spontaneity as to demonstrate that the sculptor had studied the real animal.[6] Its fresh naturalism prevents Giambologna from slipping into the anthropomorphic sentimentality that so often beset the representation of monkeys.

Given the perceived characters and meanings of animals, it was possible to combine them into their own kinds of "histories" or allegories, paralleling the portentous narratives that involved human actors and conveyed great truths. Again, Leonardo provides a fine visual example of this kind of visual *fantasia*. The precise interpretation of his *Allegory of the Wolf and the Eagle* is still not entirely settled, but it is not difficult to see the way it was meant to be read. The eagle is an imperial bird, suitably crowned and standing magisterially on a terrestrial globe. Taking his lead from the glorious rays that radiate from the eagle's breast, a stooping wolf uses a compass to navigate unerringly toward the eagle's terra firma. The wolf is clearly setting out his course according to the eagle's star. The tree-mast (punning on *albero*) appears to be an olive, symbolic of peace. My suspicion was that the allegory refers to the "Concordat" of 1515 between the French king, Francis I, and the Roman pontiff, Leo X. Francis was at this time aspiring to become Holy Roman emperor—hence the eagle—while the wolf had famously suckled the founder-infants of Rome, Romulus and Remus.[7] More recently the allegory has been linked with the revival of interest in the fiery Dominican preacher, Girolamo Savonarola, who had dominated Florence for a few years before his execution in 1498.[8] But whatever the specific interpretation, the way the animals play their allegorical roles is evident, as is their relative status. The regal eagle bows before no one, and the wolf is guided subserviently. This would suggest that the image was made for Francis, in whose court Leonardo was to serve, rather than for the pope—or, at least, that it was made for someone who wished to see the pope in less than flattering light. After three years of service at the Vatican, Leonardo left in 1516 for Francis's court at Amboise.

As we saw with his little dragon on the sheet of cats, Leonardo was also adept at using his grasp of animal morphology to give convincing graphic reality to a creature that was a product of his *fantasia*. Indeed, he specifically recommended that a confected creature should be composed from naturalistic parts:

You know that it is impossible to fashion any animal without its individual parts, and that each of these in itself will bear a resemblance to those of other animals. Therefore if you wish to make your imaginary animal appear natural, let us say it was a serpent,

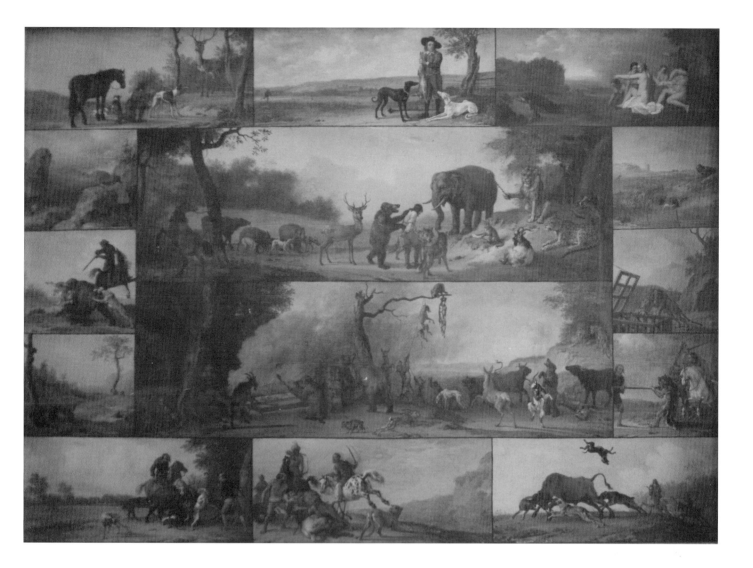

the centuries to today, though this is not an option within the compass of this book. Again, one must stand for many. The one in this case is amongst the most remarkable of all animal "histories" from any period. It is a plural narrative painting in the Hermitage, St. Petersburg, generally called *The Life of the Hunter* but more appositely entitled something like *The Hunted Animals' Revenge* (fig. 80). The subject exists in its own subgenre of the "world turned upside down," in which the normal hierarchies are inverted for the sake of both comic effect and (potentially) deeper meaning. Such inverted worlds were the particular province of the burlesque and the carnival; they were often featured in popular prints, but were less familiar in the "Fine Arts." The artist of the picture was that specialist master of Dutch animal life, Paulus Potter, famed for his engaging portraits of agricultural creatures. It dates from around 1650. The arrangement—twelve scenes around a central field—is also unusual in a painting, and is more common in prints on social topics.[15]

As an animal painter, Potter found it expedient to enlist the assistance of Cornelis van Poelenburch, a noted virtuoso of sexy mythologies, when he wanted to

80. Paulus Potter, *The Life of the Hunter,* c. 1650, The State Hermitage Museum, St. Petersburg.

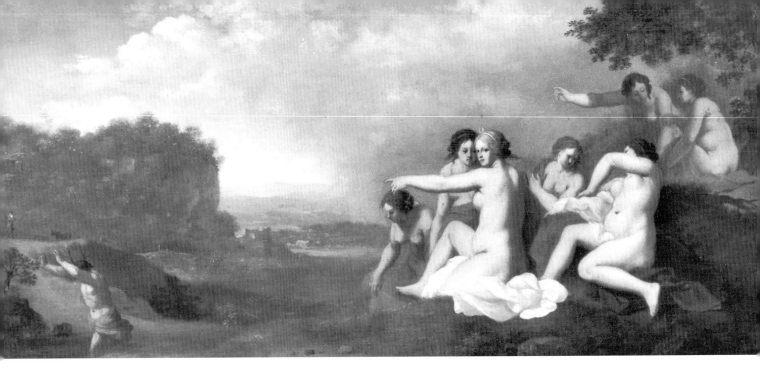

include a story with nude figures depicted in accordance with the "ancient manner." The subject of his colleague's narrative insert at the upper right is Ovid's story of Diana and Actaeon (fig. 81), which we have already summarized. The monogram "CP" testifies to Poelenburch's intervention. This ancient story of the hunter and the hunted sets the tone for the other narratives in the ensemble, most of which are set either explicitly or implicitly in the contemporary world. It will be helpful to give a brief account of each episode in the mosaic, in an order that reflects the drift of the allegory as a whole.

At top left, the mythology is matched by a sacred history, depicting St. Hubert (or Eustace), who saw a vision of the Crucifix between a stag's antlers when out hunting. In the center at the top, between the sacred and mythological histories, is a pastoral portrait of a hunter holding a dead hare and accompanied by two calm greyhounds. The three lateral scenes on either side depict types of hunt. On the left are narratives of the hunting of mountain goats and a bear, and the trapping of monkeys. On the right, we see the capturing of rabbits with a white-coated ermine, the snaring of a leopard and a wolf hunt. The rectangular scenes along the base illustrate hunts of a boar, lions, and a bull. The combat is not all one-sided. The larger beasts make some of the dogs suffer: the bear has a writhing dog locked in its jaws; the boar is putting up a stiff fight; and a dog is thrown by the mighty bull, spiraling into the air. Moreover, a man is assaulted by a lion after his horse has been brought down. In all cases, however, we may be reasonably confident that the final triumph in the violent confrontations belongs to the hunters and their accomplices.

The scenes of hunting can be related to the popular existing genre of hunting pictures, tapestries, and related prints, though Potter's own firsthand studies of landscape, flora, and fauna raise his depictions above the merely conventional. The narratives are for the most part easy to read. Two warrant more detailed

81. Cornelis van Poelenburch, *Diana and Actaeon,* detail from Paulus Potter's *The Life of the Hunter,* c. 1650, fig. 80, The State Hermitage Museum, St. Petersburg.

explanation, since they related to animal legends. The monkeys in the lower of the three small narratives on the left are betrayed by their propensity to "ape" what men do. Having spied on the hunters when they were washing and pulling on their boots, the monkeys do the same with footwear and a bowl deliberately left by the men. Unknown to the monkeys, the hunters have laced the water with quicklime, which cements their eyelids closed, and weighted the boots with lead. Disabled, the monkeys become easy prey. The central story on the right shows a leopard that has been lured outside its lair in search of its stolen cubs. There it finds a mirror in an open cage, and mistaking its reflection for one of its lost cubs, leaps into the cage, the lid of which is released by a rope and snaps down on the entrapped beast. Both legends were conveniently available to Potter in prints after drawings by Jan Stradanus, the Flemish artist who worked in Medicean Florence at the court of Cosimo I.

The two panoramic scenes in the central field tell a quite different story. In the upper register, a bound and crestfallen hunter, devoid of coat and hat, is ushered forward by a bear and two wolves, and is to be held to account by a tribunal of animals. The regal lion, brandishing a scepter, presides over proceedings. The wise elephant, mountain goat, leopard, lioness, and fox (who appears to be acting as clerk of the court), clearly accord with the lion's sage judgment. The most appropriate punishment is death by roasting. In the lower scene, while onlooking animals dance and shout for joy, the hunting dogs—treacherous to their kind—are strung up from the branch of a dead tree. A goat and boar baste the hunter, who is spit-roasting nicely over a flaming fire. A monkey is bringing more fuel for the eager flames. The hunter's gun lies impotently on the ground at the feet of the goat.

Clearly there is much to enjoy in Potter's rich parade of events, portrayed with consummate bravura, and we can all enjoy the ironies of the world turned upside down. But so remarkable is this elaborate picture *in toto* that we must suppose special circumstances lay behind its genesis. It appears virtually certain that it is a political allegory, like Leonardo's *Allegory of the Wolf and the Eagle*. In one of the prints of the animals' revenge, which provide the closest precedent for the mosaic of images, the moral is inscribed as "Rulers who are too severe turn respect into hatred." The animals, in this light, stand for the subjects of a ruler, normally subjugated and docile but potentially capable of taking revenge in the face of cruelty. The apparent context in Holland for the moral of Potter's picture was a power struggle between the young Prince Willem II and the States of Holland over the prince's wish to maintain a big army with foreign mercenaries. Hostile pamphlets refer to Willem as a "tyrant and a bully." In 1650, the prince suddenly succumbed to smallpox. During the infancy of Willem's son, born eight days after Willem's death, a ruler was needed, and the most likely choice was Count Johann Maurits, a man of experience and wisdom, remembered internationally today as the builder of the Mauritshuis, which houses a magnificent gallery of paintings.

The calm and judicious hunter of the single hare in the central scene at the top, who looks directly out at the spectator, has been convincingly identified as a portrait of Johann Maurits. In the distance on the left, a man with a spear is running toward

him, we may imagine to bring news of his invitation to lead Holland. In the event, no such invitation was forthcoming and the post of Stadholder was left open. In this light, the upper scenes make good sense. Maurits himself decorously and knowingly invites us into the picture as events run their moralizing course. He is positioned between the saint, arrested in his hunt and kneeling before the vision, and the importunate Actaeon—both traditional histories of great religious and moral import. In both, the hunter is subject to imperatives greater than himself and to the pleasures of the chase. Whether Maurits was the direct commissioner of the painting, as is possible, it was clearly designed and rapidly executed to stand as a kind of allegorical manifesto, speaking of his intention to rule with moderation.

What we cannot tell from this inversion of the order of things in the natural world, as in the other more orthodox examples we encountered earlier in this chapter, is where animals and humans were actually seen as standing in the greater scheme of the Book of Nature. Using beasts to make points about human affairs was not the same as saying that animals were essentially like humans. They might convey big meanings, but this in itself did not affect their essential status in the order of things. Whether animals had souls, whether they possessed self-awareness and true feelings, and whether they could enter paradise were not issues that were readily expounded through such visual representations. Their bigger messages were directed toward social and political issues. The question of status was essentially a theological matter.

CARTESIAN MACHINES

Broadly speaking, the prevailing Christian view of animals in the Middle Ages and Renaissance was, despite divergences of opinion, predicated on an unshakeable central belief that human beings, possessors of divinely implanted souls, were fundamentally different from the whole of the animal kingdom. Animals were subservient to humans, and were placed in nature for human purposes. After the Deluge, God had specifically decreed that "the fear of you and the dread of you shall be upon every beast of the earth, and upon every fowl of the air, upon all that moveth upon the face of the earth, and upon all the fishes on the sea, and into your hand they are delivered. Every moving thing that liveth shall be meat for you."[16] How they were actually treated in practice was a matter of taste and practicality rather than primarily of theological imperative. Someone might develop and profess a strong feeling for animals, like St. Francis or Leonardo (who probably became a vegetarian), while others could treat them callously. In the context of his time, it is unsurprising that Vesalius should display a pig on a vivisection board (fig. 82), emulating Galen, without a glimmer of conscience. Treating domestic and agricultural animals badly was both decried and counterproductive, while the other hosts of flying, walking, climbing, creeping, slithering, burrowing, and swimming creatures were regarded as fair game for the human predator and interpreted as signs provided by God.

Throughout the Middle Ages and Renaissance, considerable philosophical effort was devoted to the separation of the soul and mind of humans from those of

82. Andreas Vesalius, *Pig on a Vivisection Board,* from *De Humani corporis fabrica,* 1543, The Bodleian Library, University of Oxford.

animals. The prevalent Aristotelian system of locating the faculties of the mind in the ventricles of the brain was designed, not least, to distinguish between the seats of those powers that were shared with beasts and those (above all reason and conscious recollection) that were unique to humans, courtesy of God's gift at the time of Creation. Animals might be regarded as having souls, but at best theirs were material, nonmoral, irrational, lacking consciousness, and inseparable from their organic bodies, while the human soul was immaterial, moral, rational, conscious, and immortal, capable of existence after the death of our bodies. Animal souls had appetites, instincts, and passions; human souls possessed powers of reason that could exercise control over unbridled desires. However, if our rational faculties lapsed, our animal instincts would rule unchecked, and we would behave like beasts. Philosophers of a more Platonic bent in the Renaissance were much attracted to Plato's elegant metaphor for this dualistic state of affairs. In his *Phaedrus,* Plato characterized the human soul as a chariot drawn by two winged horses, one comely and obedient and the other brutish and unruly. The charioteer was engaged in a perpetual struggle to bring his contrasting steeds under harmonious control.

This theologically pervasive dualism was granted new physiological and philosophical cogency in the seventeenth century by the hugely influential writings of René Descartes, whose notion of the pineal gland as the site of the soul was noted when we were looking at the *Conférences* of Charles Le Brun. As Descartes argued in his *Traité des passions de l'âme,* published in 1650, the year of his death, this gland in animals strengthens motions but not emotions (which were, in their true sense, exclusively human). It was this central organ that transmitted the "animal spirits" distilled in the heart and motivated the bodily mechanisms. It was evident that animals were capable of motion, reacting to stimuli and apparently expressing "feelings," much as can be witnessed in humans. Does this therefore mean that "higher" animals have souls, located in their pineal glands? Descartes' answer was no, an answer driven by the theological imperative that man alone possessed an immortally divine soul. The soul of animals was distilled from blood and refined animal spirits, capable of moving and reacting, but devoid of consciousness and reason, incapable of truly elevated sentiments and lacking any immortal entity that was autonomous from their material bodies. Animals were in essence machines. It was only to children and

naive people that they *appeared* to think and react in the way that we do. They were not really "feeling" beings in our human sense.

A key argument in his *Discourse on Method* (1637) comes from his observations of automata, those increasingly sophisticated inventions that appeared to ape human and animal motions:

> If there were such machines with the organs and shape of a monkey or of some other non-rational animal, we would have no way of discovering that they were not the same as these animals. But if there were machines that resembled our bodies and if they imitated out actions as much as is morally possible, we would always have two very certain means for recognising that, nonetheless, they are not genuinely human. The first is that they would never be able to use speech . . . [a mechanical body] could not arrange words in different ways to reply to the meaning of everything that was said in its presence, as even the most unintelligent human being can do. The second means is that, even if they did many things as well as or, possibly better than any one of us, they would infallibly fail in others. Thus one would discover that they did not act on the basis of knowledge, but merely as a result of the disposition of their organs.[17]

According to legend, Descartes himself constructed a mechanical "daughter," a feat that was regarded, so the dubious story goes, as black magic.

Descartes acknowledged that in some arenas animals were capable of feats beyond those of humans. Flying birds are an obvious example. And no hunter on foot could keep pace with a greyhound. But, just as a clock is an instrument that can step out the march of time better than any human brain, so such animals are merely superb machines, with specific organs uniquely adapted for specific roles but devoid of reason and true feelings.

The idea of the body as a magnificent machine was not of course new. Leonardo had argued that the body was "such a marvel of artifice" that the soul departs from it only with "great wailing and lamentation.[18] He had specifically undertaken diagrammatic analyses of such features as the muscles of the arm and neck, and the action of the jaws in terms of levers and fulcrums. And, looking at the mechanism of the hand (fig. 83), it is easy to understand his awe. This "instrument of instruments" as it was termed in the Aristotelian tradition, stood in a hierarchy of cerebral and bodily functions: the hand served the intellect, as the intellect served the soul.[19] It was this marvelous tool, with its reciprocating thumb and system of interpenetrating flexor tendons that Dr. Tulp was demonstrating to his awed audience in Rembrandt's famous *Anatomy Lesson* (fig. 84). Nicholas Tulp will later reappear as a pioneer of primatology, and he was one of the medical authorities to whom Julien Offray de La Mettrie looked. La Mettrie will shortly feature as the most extreme of the mechanist Cartesians. Such a natural instrument as the hand, invented by God, set the ultimate standards for machines invented by humans. Descartes accepted the general view that such standards would never be fully attainable in practice by the human engineer. What was new in Descartes' philosophy was a cogent analysis of why the

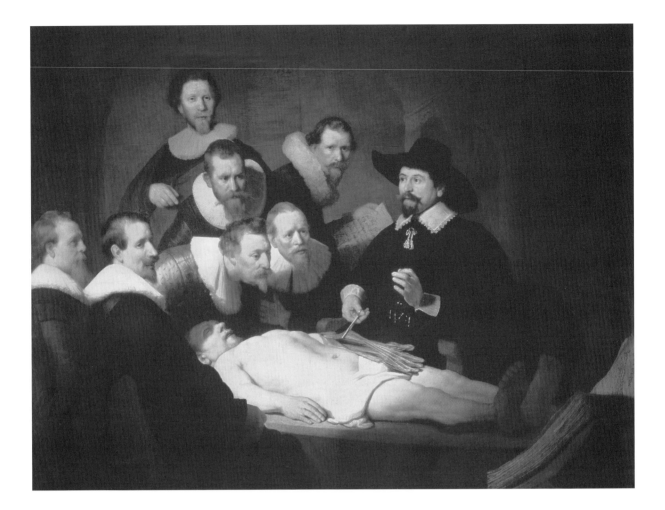

84. Rembrandt, *The Anatomy Lesson of Dr. Tulp*, 1632, Maritshuis, The Hague, The Netherlands / The Bridgeman Art Library.

animal-machine was theoretically possible and why the animal-machines of nature did not possess a true soul, in spite of appearances, whereas man definitely did.

In Descartes' system of nature, the potential for the human being to be absorbed within the world of pure mechanisms is, in retrospect, obvious, as Descartes himself was aware, and he went to considerable pains to shut down this alarming prospect. If animals merely *appear* to react in a soulful manner, why should humans not be presenting the same illusion to themselves? A key philosophical argument is that we are uniquely conscious beings, aware of our own thoughts, and, indeed, of our ability to think. But there were more fundamental theological premises that trumped all other arguments. While God, the Creation myth, and the promise of Paradise remained inviolable premises for human existence, there could be no serious doubts about the unique nature of the human soul.

However, the unthinkable did begin to be thought in the succession of Descartes.[20] For one truly radical thinker in the next century, La Mettrie, the answer to the heretical proposition that man is a machine was thinkably yes—humans can be shown incontrovertibly to be the greatest of all machines but not necessarily the possessors of autonomous and divine souls. This sensational conclusion was the

prime goal for La Mettrie's notorious *L'Homme machine* in 1748.[21] Written by the French physician-philosopher while in intellectual exile in Holland and published anonymously in Leiden, *L'Homme machine* is full of the latest anatomical and physiological learning, but does not quite qualify as a book on either, nor as a concerted philosophical discourse. Rather it is a materialist polemic, cast in the form of an extended pamphlet by a physician with a taste for philosophical debate. La Mettrie's anonymity was short-lived. *L'Homme machine* assured its author's notoriety, a reputation that survived as much through hearsay as from direct knowledge of what he had actually written.

La Mettrie is a complex, beguiling, and ironic writer whose wry and acerbic views can all too easily be caricatured in a brief summary. I hope that some relatively extensive quotations will help him speak for himself. He also serves, given the extremity of his literary stance, to frame the whole debate about the nature of animals in the sharpest possible terms, and it is worth citing his arguments in some detail.

Let us begin where he takes up the clock analogy: "The human body is an immense clock, constructed with so much artifice and skill that if the wheel that marks the seconds stops because of dust or derailment, the minutes wheel continues turning, as does the quarter hour wheel, and all the rest."[22] However, the failure of the main-spring to drive the mechanism is fatal: "is not the narrowing of a few veins enough to destroy or suspend the force of the movement of the heart, as in the mainspring of a machine?" Unsurprisingly he is much attracted by the potential of clockwork automata to emulate living beings, citing the famous mechanical flute player and duck of Jacques Vaucanson, which we will encounter later in this chapter.[23]

The essential difference between the human and animal automaton is the perfection of the human anatomy and physiology: "Man is to apes and the most intelligent animal what Huygens's planetary pendulum is to a watch by Julien le Roy."[24] Le Roy, master horologist, was renowned for mechanisms that compensated automatically for changes in temperature.

The full range of emotional reactions is also attributable essentially to mechanism:

Let us consider the details of these springs of the human machine. Their actions cause all natural, automatic, vital and animal movements. Does not the body leap back mechanically in terror when one comes on an unexpected precipice? And do the eyelids not close automatically at the threat of a blow? And, as I said before, does not the *pupil* contract automatically in full daylight to protect the retina and enlarge to see in the dark? In winter, do pores of the skin not close automatically so that the cold does not penetrate into the vessels? Does the stomach not heave automatically when irritated by poison, a dose of opium, and all emetics? Do the heart, arteries and muscles not contract automatically when one is asleep, just as when one is awake? Do the lungs not automatically work continually like bellows? Do not the sphincters of the bladder, *rectum,* etc. close automatically? Does the heart not contract more strongly than any other muscle, so that the

erector muscles raise the rod in man, as they do in animals who beat it on their stomachs, and even in children who have erections if that part is excited? This proves, let me say in passing, that there is in this member an extraordinary spring that is little known and produces effects that have not yet been well explained, despite all the enlightenment of anatomy.[25]

Clearly he felt he was on especially strong ground when pointing to the fact that human and animal penises both behave as if they have a mind of their own. He is even ready to propose a specific physiological explanation for the "motive principle of the whole body and of cut up parts." He argues "that it very clearly resides in what the ancients called the *parenchyma,* that is to say, in the very substance of the parts, excluding the veins, the arteries, the nerves, in a word, that in the organization of the whole body, and that consequently each part contains within itself springs whose forces are proportionate to their needs."[26]

Further extending the march of the machine, La Mettrie turns his attention to our emotional and intellectual faculties that seem on the surface to separate us from the animal-machine:

> But there is another more subtle and marvellous force, which animates everything. It is the source of all our feelings, pleasures, passions, and thoughts: for the brain has its muscles for thinking, as do the legs for walking. I mean that impetuous autonomous principle that Hippocrates calls *enormon* (soul). This principle exists and has its seat in the brain at the point of origin of the nerves, through which it exercises its rule over all the rest of the body. It is the explanatory principle that all can be explained, even to the surprising effect of maladies of the imagination.[27]

Even our ability to deduce natural law can be attributed to the extraordinary powers of our mechanism: "a well-constructed animal to whom one has taught astronomy, can predict an eclipse, just as it can predict recovery or death after it has studied in the school of Hippocrates and had experience at the bedside of the sick. On the basis of these observations and truths, we come to attribute the admirable power of thinking to matter, without being able to see the connection between the two, because the subject of this attribute is essentially unknown to us."[28] What is definite is that we cannot use the argument from mechanism to assume any necessary separation between humans and animals, other than by degree of ingenious design. Superior human reason does not provide evidence of essential difference. La Mettrie insists that "the excellence of reason does not depend on its *immateriality,* a big word empty of meaning, but from its power, extent, and clear-sightedness."[29] He is equally scathing about any resort to "spirituality," a comparably vacuous term, to effect any separation between humans and animals.

The logical conclusion seems to be that no such thing as immaterial or spiritual soul is required in explaining what we can observe of men and animals in their shared world. In his treatise on the soul, *Histoire naturelle de l'âme* (1745), La Mettrie

had already floated the idea that the nature of what we call soul would yield its secrets to anatomical and physiological investigations. But in the final analysis, even in *L'Homme machine,* he slips away from dogmatically asserting that there is no such thing as immortal soul:

> We cannot say whether all machines and animals perish utterly or take on another form after death, because we know absolutely nothing about it. But to claim an immortal machine is a chimera or a *being of reason* is to reason as absurdly as caterpillars, who, on seeing the cast-off skins of their fellows, bitterly deplore the fate of their species that seems to them to be in the process of annihilation. . . . Not even the cleverest among them could ever have imagined that he must turn into a butterfly. It is the same with us. Do we know any more of our end than of our beginning? Let us submit ourselves, therefore, to an invincible ignorance on which our happiness depends.[30]

This stance on the inevitable incompleteness of human understanding relates closely to the ideas of Pierre Gassendi. In the face of such ultimately irresolvable doubts about the metaphysics of the soul, La Mettrie is nonetheless convinced that the actual behavior of animals and humans on earth can be adequately explained through physical phenomena, radically extending Descartes' fundamental insight that animals are machines. However, this does not mean that Descartes, actual characterization of animals' faculties was wholly accurate. It is evident that animals, as La Fontaine had insisted, do share fundamental human qualities. They are endowed with "a structure similar to ours, which performs the same acts, has the same passions, the same sorrows, the same pleasures, more or less acute according to the empire of the imagination and the refinement of the nervous organization."[31] Imagination becomes the central faculty, as a natural attribute of the cerebral mechanism, and its collective attributes comprise what we call "soul." The vital "spring" of human imagination, teeming with ideas and feelings, can occasion the highest insights of genius and the noblest of passions, but it is not essentially different in nature from that in animals.

Even an engagement with and understanding of natural law is shared with animals: "Nature has created us uniquely to be happy—yes, every one of us from worm who crawls to the eagle who loses himself in the clouds. For this cause nature has given all animals some share of natural law, more or less refined for the needs of the well-tuned organs of each."[32] La Mettrie cites, as evidence, the apparent remorse of the famous "wild girl of Châlon in Champagne" when faced with the charge that she had eaten her sister. This remorse demonstrates the indelible "imprint" of natural law in all souls, however apparently base.[33] Memmie, the wild girl, will concern us in more detail later.

During the course of his brisk intellectual journey, La Mettrie attacks established opinions with uninhibited vigor. He cites a wide range of evidence from modern medicine, but is scathing about most existing philosophical stances. He berates named authorities who should have known better, including those from whom he

drew vital information about the latest physiological and anatomical ideas. Amongst those who are on the receiving end of his qualified approval are Nicolas Malebranche, who had tried to mediate between Cartesian reason and theological reason, Thomas Willis (from whom he learnt much), who defined the corporeal soul as shared with animals and the rational soul as man's immortal gift, and Charles Perrault, physician, architect, and pioneer of animal anatomy, who advocated a diffuse body-soul. The person with whom he might seem to be least in potential dispute, Georg Stahl, the physician and chemist who regarded the vitalizing *anima* as inseparable from the body and not as an independent soul, comes in for a typical beating for getting his physiology wrong. Even the unrivalled Dutch authority on the human body, Herman Boerhaave, whose writings La Mettrie had translated and edited, had missed the essential point that the ultimate source for motion was generated within the body itself. By missing this point, Boerhaave had to invent all kinds of ingenious but unnecessary explanations.

The only major international authority to emerge wholly unscathed is Baron Albrecht von Haller, whose fundamental research on the motive powers of nerves and muscles provided La Mettrie with crucial evidence about the mechanisms of vital forces in the body, without recourse to the mystical spirits of traditional physiology. La Mettrie's opening eulogy of the "two-fold son of Apollo, illustrious Swiss gentleman, . . . learned physician, even greater poet," caused some embarrassment to Haller, who was understandably concerned to distance himself from the heretical author of *L'Homme machine*.

In all this, we have to issue a word of caution. There is no doubt that La Mettrie is writing for effect, openly acting as the "devil's advocate" in the face of theological and philosophical orthodoxy. There is an overt relish in his extremism, which is not necessarily tongue-in-cheek but certainly exudes a certain kind of irony. Behind his apparently materialist dogmatism lies an elegant uncertainty. But, even if pervaded by irony, the fact that the thoughts have been thought is shocking enough. And he had undoubtedly hacked down large areas of philosophical deadwood along the way.

MONTAIGNE'S ALTERNATIVE

La Mettrie's inflammatory theories stood, as he had no reason to doubt, far outside accepted and generally acceptable ideas. For those who wanted an alternative point of reference to the Cartesian stance about animals that had inspired La Mettrie, the sixteenth-century essayist Michel de Montaigne provided the most attractive and enduring source of inspiration, providing a series of arguments and exemplars that were reworked well into the nineteenth century. During the course of the very complicated debates around the Cartesian view on animal souls, it was Montaigne who provided the most effective point of reference, both for those who wished to oppose Descartes' prescriptions and for the "soft Cartesians" who were prepared to permit more scope to animal reasoning and feelings than the mechanized view of animals would allow.[34]

Aristocrat and landowner, Montaigne espoused his philosophy and theology disarmingly in his *Essays,* in which his own special style of worldly wisdom is used to frame arguments that would tax any "professional" philosopher. His most substantial and influential treatment of the animal question came, unexpectedly, in his *An Apology for Raymond Sebond,* an extended essay in defense of the Spanish philosopher's *Natural Theology,* originally composed in Toulouse around 1430 and translated by Montaigne himself in 1568. Montaigne's strategy presents the most effective alternative to those of Descartes and La Mettrie if the close relationship between humans and animals was to be sustained without abandoning faith in the Christian soul. He effectively unseats man from his lofty perch and raises animals to the ranks of the learned.

As far as humans are concerned, according to Montaigne,

Man is the most blighted and frail of all creatures, and, moreover, the most given to pride. This creature knows and sees that he is lodged down here, among the mire and filth of the world, bound and nailed to the deadest, most stagnant part of the universe, in the lowest story of the building, the furthest from the vault of heaven. . . . Yet in thought, he sets himself above the circle of the Moon, bringing the very heavens under his feet. The vanity of this same thought makes him equal himself to God; attribute to himself God's mode of being; pick himself out and set himself apart from the mass of other creatures.[35]

Our arrogance leads us to impute dumbness to animals, when we have no way of accessing their thoughts or understanding their communications: "When I play with my cat, how do I know that she is not passing time with me rather than I with her?" Eager to pose sharp questions, Montaigne proceeds to ask, "Why should it be a defect in the beasts and not in us which stops all communication between us?"[36]

In the absence of the animals telling us how clever they are, Montaigne presents us with an extended litany of animal achievements, based on natural observations—his and those of earlier authorities—and above all on a host of stories of particular animals who have shown special sagacity. The prudent ant, already encountered in Leonardo, makes its appearance under the category of "household management": "Corn does not always stay dry and wholesome but gets soft, flabby and milky, as a step towards germinating and sprouting anew; to stop it tuning to seed-corn and losing its nature and properties as grain in store for future use, ants gnaw off the end that does the sprouting."[37] In many categories animals are demonstrably the equal of man or even superior. Montaigne assembles an impressive list, including housebuilding (swallows); the arts (the weaving spider and musical nightingale); the provision of natural clothing and armaments, the obtaining of food even when very young, acuteness of sense, natural nobility (the lion and horse, perhaps inevitably); medical treatment (citing legends such as goats that treat spear wounds with dittany); weather forecasting, demonstrating omens and portents, loyalty (especially the fabled dogs belonging to ancient masters); gratitude, companionship, dreaming, and

beauty. On the other hand, there are plentiful examples of when men individually and collectively behave in ways that are worse than is ever observed in the animal kingdom, particularly with respect to how they treat their own kind.

Elephants, traditionally wise and possessed of prodigious memory, are seen as especially "close to human capacities," to such a degree that "there is a greater degree of difference between one man and another than between some men and some beasts." A story is told to illustrate this point: "An elephant driver in a private household in Syria used to steal half the allotted rations at every feed. One day the master himself wanted to attend to things. He tipped into the elephant's manger the right measure of barley, as prescribed. The elephant glared at its driver, and, with its trunk, set half the ration aside, to reveal the wrong done to it."[38]

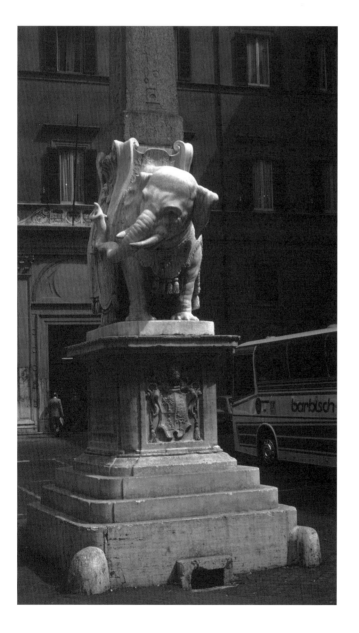

85. Gianlorenzo Bernini, *Elephant and Obelisk,* 1666–67, Rome, Santa Maria Sopra Minerva.

It is also evident that "elephants have some notion of religion since, after ablutions and purifications, they can be seen waving their trunks like arms upraised, while gazing intently at the rising sun . . . they stand rooted in meditation and contemplation."[39] We may recall the dignified and sage demeanor of the elephant in Paulus Potter's narrative. Indeed, the whole of the Dutch painter's canvas has a very Montaignean feel about it. The elephant, renowned not least for their role in Hannibal's army, as Montaigne acknowledges, made a spectacular appearance in Baroque Rome in Gianlorenzo Bernini's *Elephant and Obelisk* (fig. 85).[40]

The Egyptian obelisk carried by the elephant was unearthed beside Santa Maria Sopra Minerva in Rome to much excitement, and the Jesuit sage, Athanasius Kircher, was charged by Pope Alexander VII with deciphering the ancient hieroglyphs. Bernini, for his part, was required to design a piazza, at the center of which the life-size elephant stoically bore its stony burden. The legendary attributes of the elephant—strength, patience, wisdom, and their religious intuitions—famous from Pliny's description, make the beast suited to stand before a Christian basilica. One of the inscriptions very much captures this spirit: "Let every beholder of the images, engraved by the wise Egyptian and carried by the elephant, the strongest of beasts, reflect this lesson: be of strong mind; uphold steadfast wisdom." Bernini's mighty porter, based on studies of an elephant that had arrived in Rome in 1630, exudes a suitable air of grave resolution. It is possible that the motion of its trunk, arched toward his flank, alludes to the way in which Pliny's elephants sprinkled themselves with water in the purification rite at the River Amilo during the new moon.

Montaigne's diverting stories and arguments were not such as to impress a hardnosed Cartesian, but his strategy of showing the baseness of man and the amazing performance of animals struck a sustained chord over the centuries, both emotionally and theologically. Post-Fall, neither Catholic nor Protestant had good reason to feel so naturally virtuous and superior to beasts, after all.

By this time, the reader may feel that this Cartesian business is all very well. But how if at all are the doctrines in these disputes expressed in art and visual imagery? After all, a follower of La Mettrie could look at a painting of an animal narrative by Jean-Baptiste Oudry (fig. 104) and see the actors as simply performing their soulless routines according to mechanical dictat—however vivaciously and movingly—just as a follower of Montaigne could see in the animals behavior a confirmation of their essential closeness to humans. In that such paintings were entering a wide interpretative field, such different ways of looking are obviously operational in their historical context. But the historian surely wants something more concrete as a purposeful interpretative strategy for looking at animal art in eighteenth-century France. Oudry and his depiction of stories from the *Fables* of La Fontaine will concern us in the next chapter. For the moment I want to enter the world of represented animals by a more surprising but obviously germane route; that is to say via the world of automata, which provided Descartes and La Mettrie with concrete evidence that their philosophical models might assume real form.

Automata had a long history, if not through the survival of actual devices at least through some celebrated texts.[41] The inevitable point of reference for Renaissance and post-Renaissance ambitions was Hero (or Heron) of Alexandria of the first century AD, often seen as the inventor of the first steam engine.[42] His *Pneumatics,* which contained accounts of his wonderful devices, not least a veritable flock of singing birds, was frequently reprinted in early modern Europe in Greek, Latin, and vernacular translations. The other major source of inspiration came from the Islamic inventor in the thirteenth century, Al-Jazari, whose mastery of clockwork mechanisms took the West a long time to surpass. Accounts of amazing automata and their seemingly miraculous feats from Antiquity and the Middle Ages probably gained much in the telling, but the accounts do testify to an enduring fascination with the rivaling of nature. The famous portfolio of Villard de Honnecourt in 1235 parades automata associated with Roger Bacon and Albertus Magnus, particularly their renowned talking heads. One of the devices illustrated by Villard (fig. 86) claims to tell us "how to make the eagle face the Deacon while the Gospel is being read," though the actual operation of the rotational mechanism is difficult to understand.[43]

A notable acceleration in the invention of ever more complex automata occurred in the European Renaissance courts, often in connection with elaborately staged celebrations for marriages or triumphal entries. The astronomer Regiomontanus (Johann Müller of Königsberg) made a fly of iron and an artificial eagle for the Emperor Maximilian. Peter Ramus says that the imperial bird flew to greet the emperor on his entry into Nuremberg on June 7, 1470.[44] We have no idea of precisely how it worked, but its legend survived into the writings of Giambattista della Porta and Pierre Gassendi. In a similar vein, Leonardo contrived a mechanical lion to greet the French king, Francis I, on behalf of the Florentines on his entry to Lyons in July 1515. It regally advanced a few paces toward the king before opening its breast to reveal an array of lilies, the *fleur-de-lys,* the flower that was heraldically shared by the Florentine state and the French monarchy. The manuscripts of Renaissance engineers such as Francesco di Giorgio, Leonardo's colleague, testify to the efforts they were expected to put into the contriving of courtly machines and automata. Leonardo himself left clear hints of his resentment at the time devoted to such ephemeral things. We know something of the range of automata with which Leonardo was involved, including a spring-driven carriage (probably for festivals) and, perhaps, some kind of robotic figure.[45] In a sense, his project for a great *uccello*—the "bird" or flying machine—stands at the height of the automatist's ambition to remake nature. In this case, the motive power and "soul" of the machine was to be provided by human agency. Leonardo's stated aspiration to emulate the designs of God, in whose inventions nothing is superfluous and nothing is lacking, provides the general underpinning for the most philosophically aware of the makers and patrons of automata.

86. Villard de Honnecourt, *Mechanical Devices, including a Revolving Eagle,* Portfolio, c. 1230, Bibliothèque Nationale. Photograph: Foto Marburg / Art Resource, NY.

Miniaturization was also a running motif. Brilliantly crafted sailing ships (*nefs*), with elaborate components and miniature figures driven by tempered steel springs became a favorite genre for princely collections. Such devices flourished spectacularly alongside other modern instruments in the growing culture of the *studiolo* and *wunderkammer,* those often eccentric forerunners of the modern museum. The contents and scope of cabinets of curiosities varied widely from collector to collector, but there was an increasing attempt to provide them with a universal reach—as microcosms of knowledge—which testified to their owner's learning and status. Natural things (*naturalia*) made by God stood tellingly alongside mechanical inventions (*artificialia*) contrived by men. Unsurprisingly, Rudolf II in late sixteenth-century Prague, who assembled the most diverse and brilliant of the early *wunderkammern,* was a keen acquirer of automated devices of the most ambitious kind.[46]

In print, Agostino Ramelli's *Diverse and Artificial Machines,* published in Paris in 1588, set the standard for subsequent anthologies. The greatest contrivers of ingenious devices and "divers engines" became figures of international renown, not least

87. Salomon de Caus, *The Cave of Orpheus,* from *The Causes of Moving Forces,* 1615.

Salomon de Caus, born in Dieppe, who pursued a peripatetic career in the courts of Austria, England, Bohemia, and France. His *The Causes of Moving Forces* (1615), described and illustrated a rich treasury of automata and mechanized spectacles in gardens. In one, a hydraulically animated Orpheus works his musical magic on an assembled company of pacified animals (fig. 87). De Caus's treatise played a significant role in directing Descartes' thought toward the construction of a human automaton.[47] In Britain, the pioneer of empirical science Francis Bacon testified in his *New Atlantis* in 1627 to the marvels of "Salomon's House or the College of the Six Day's Works," the aim of which was to discover "the knowledge of Causes and secret motions of things" in order to "imitate . . . all articulate sounds and letters."[48] Such was the obvious novelty of the newer devices that they provided testimony (as did modern firearms) to the decisive surpassing of the revered "Ancients."

It is the convergence and often symbiotic relationship between the sheer ingenuity of such wondrous devices and the elaboration of mechanistic philosophies in the wake of Descartes that draws automata into our present story. The automaton becomes, in effect, a philosophical machine, offering both diverting entertainment, as it always had, and a focus for discussions on the nature of the created world. Was it possible, as Descartes had abstractly speculated, to make a machine that was fully the equal of an animal or even a human? As a thought experiment, the building of such a machine was useful in itself, whether to prove that animals or humans could ever be equaled by a man-made device, or vice versa. As with artificial intelligence in

the twentieth century, the theorists' speculations ran in advance of the technological capacities. In Edinburgh in 1709, Robert Stewart published *An Essay for a Machine of Perpetual Motion,* in which he introduced his subject through the idea of a "notional Embrio" and looked at how mechanical systems might be designed to bring it about (fig. 88). Inevitably, his ingenious system of gearing, like any other set of mechanical components, could not solve the problem that significant quotients of the power would be consumed by friction and other detrimental forces.

It was in France that we first see clearly that the implications of actual, manufactured automata were taken up in philosophical circles. The key inventor in this respect was Jacques Vaucanson, whose status as a master of mechanical devices led to his appointment in 1741 as director general of the country's silk weaving industry. In this capacity he strove unsuccessfully to devise and introduce a mechanical weaving machine. His first exhibited automaton was the *Flute Player,* completed 1737 (fig. 89).[49] The flautist, in the form of a faun, was five and a half feet high, seated on a rock, and placed on a substantial pedestal. It was based directly on a marble faun by the sculptor Coysevox in the Tuileries in Paris. Those wishing to delight in this marvel of artifice could do so for the entry fee of an *écu de trois livres.*[50]

88. *Gearing for the Perpetual Motion Machine,* from Robert Stewart's *An Essay for a Machine of Perpetual Motion,* 1709, The Bodleian Library, University of Oxford. Vet.A4 e.3159.

89. Jacques Vaucanson, *Flute Player, Tabor-Pipe Player,* from *An Account of the Mechanism of an Automaton,* 1737.

In his contemporaneous publication, *Le Mécanisme du flûteur automate . . .* (translated as *An Account of the Mechanism of an Automaton; or Image Playing on the German Flute*), Vaucanson boasts of his "profound researches into the physics and anatomy of the flute." The "lungs" consisted of three sets of bellows, while the mechanisms of levers that enabled the faun to play his tunes were driven by a rotating drum punctuated by studs.

Continuing in this musical vein, Vaucanson constructed *Tabor-Pipe Player,* which he claimed "out-does all our Performers on the Tabor-Pipe, who cannot move their Tongue fast enough to go thro' a whole Bar of Semi-Quavers, and strike them all."[51] While the boy blew with varied pressure into his pipe, which he fingered with his left hand, he beat the drum with his right. The challenge was not simply the devising of an ingenious mechanism to perform actions that looked natural but to produce a kind of "physiological machine" that functioned in a way analogous to the human respiratory system. Throughout his career, Vaucanson harbored an unrealized Cartesian ambition, to build an artificial man, not least to learn about the working of human systems for medical purposes. Neither he, nor his best equipped competitor, the surgeon Charles-Nicholas Le Cat, realized this ultimate dream, or came close to doing so.

His most cherished "Machine, or Automaton" he described as a "Duck, in which I represent the Mechanisms of the Intestines which are employed in the Operations of Eating, Drinking and Digestion," the workings of which may be recorded in some illustrations and photographs of doubtful status (fig. 90).[52] The bird was set up to bite grain greedily from a spectator's hand and to drink with gurgling noises. The food was allegedly passed into the "chemical laboratory" of the stomach, where it was seemingly "digested," before being eventually expelled from the duck's body in a suitably processed state. As well as this striking demonstration of bodily functions, Vaucanson testifies that the anatomy of the bird's flapping wings was precisely observed from life. In order to prove that no fakery was involved, Vaucanson proudly allowed spectators to view the elaborate mechanics, much of which was contained in the large pedestal of each piece. One observer described how "during the time that this artificial animal was eating grain from someone's hand, drinking and splashing the water brought to him in a vase, passing his excrements, flapping and spreading his wings and imitating all the movements of a living duck, everybody was allowed to look in the pedestal."[53] The duck, or an imitative version of it, seems to have survived in a degraded state into the late nineteenth century, when it was photographed. Two of those who

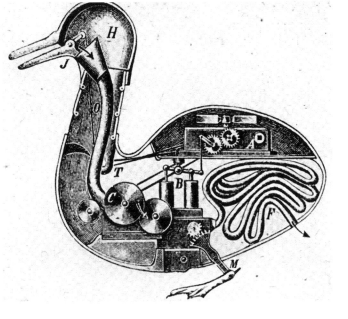

90. Jacques Vaucanson, *Mechanism of the Duck's Intestines,* from *An Account of the Mechanism of an Automaton,* 1737.

inspected it claimed that no digestion actually took place, and that what was egested was not what had been ingested. In any event, contemporaries did not doubt that Vaucanson's bird was a supreme example of mechanical ingenuity and an enduring paragon for the artificial construction of a natural creature.

Vaucanson's remarkable set of "living" machines went on tour, including a successful appearance at the King's Theatre in London's Haymarket in 1743. It is amusing to think about the Digesting Duck competing for public attention with Garrick in Shakespeare. In fact the contest was not between vulgar entertainment on one hand and high art on the other. The automata, however entertaining, were philosophical machines. Vaucanson ensured that his invented bodies took their place in the highest realms of intellectual life in France by presenting them for scrutiny at the Academie des Sciences, which offered its approbation for devices that were both ingenious and thought provoking.

The eighteenth century was the golden age of the automaton. The Droz family, originally from Switzerland, enjoyed a flourishing business in London from 1773 and well into the nineteenth century. Big money was involved. The Comtesse de la Motte acquired "an automaton bird which sang and beat its wings and which she had acquired in exchange for a diamond worth 15,000 livres."[54] For a sumptuously rich patron, owning a mechanical bird of extraordinary rarity and monetary value was clearly better than possessing the real thing. Some idea of the visual magnificence of the feathery machines is conveyed by James Cox's *Swan* at Barnard Castle

91. James Cox, *Swan*, 1773, the Bowes Museum, Barnard Castle, Teesdale, County Durham, England.

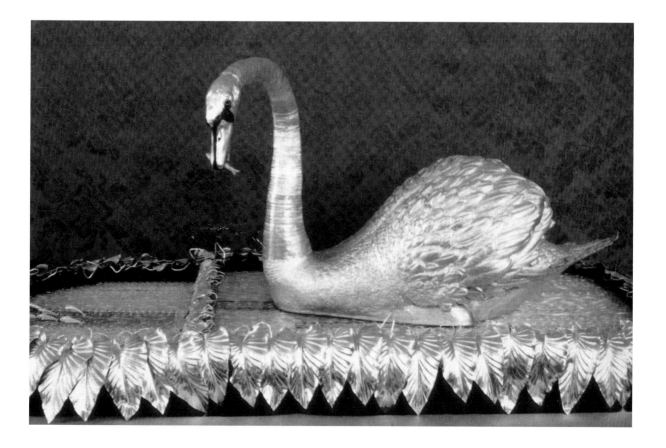

(fig. 91) and his peacock clock with a gorgeously speading tail in the Hermitage at St. Petersburg.[55] Cox staged renowned displays of automata, clockwork, and jewelry in Spring Gardens at Charing Cross in London, including machines that were up to sixteen feet in height. For his 1772 exhibition of twenty-three automata, including dragons and elephants, he charged the grand entrance fee of ten shillings and six pence, later reduced by a half to a quarter of a guinea.[56] As we will see, this is also the era of the birth of the circus and the "perfecting" of performing animals, which could undertake truly "human" feats. The public boundaries between machine, animal, and human were becoming visibly permeable in an unprecedented way in these other arenas.

92. Jean-Siméon Chardin, *Bird-song Organ,* 1751, Musée du Louvre, Paris. Photograph: Réunion des Musées Nationaux / Art Resource, NY.

Even real birds could learn from machines. Bird-song organs became popular in Paris in the eighteenth century. In one of Jean-Siméon Chardin's paintings, known

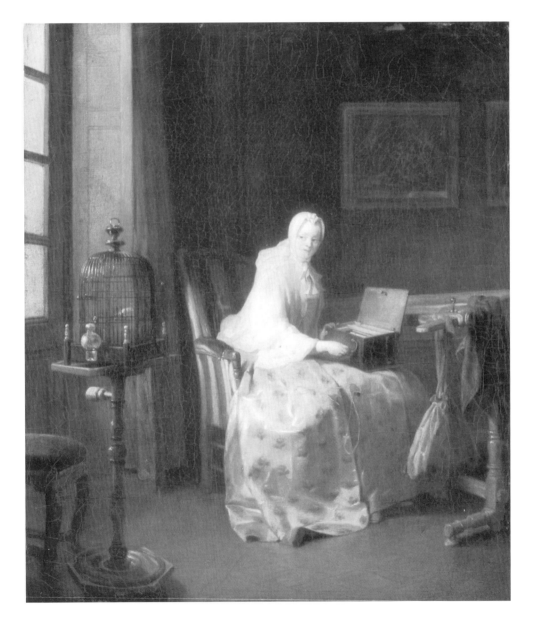

in a number of versions (fig. 92), a finely attired lady turns the handle of an organ that would have played noted tunes of the day.[57] The aim was to teach her canary to sing in a tutored manner. Chardin, that most cunning maker of pictorial devices that delude us into believing that they contain more naturalistic detail than is actually present, seems to be consciously playing on the theme of nature, artifice, and imitation. The reticent irony in his picture of the lady and her canary becomes more overt in his series of images of the monkey-painter, the veritable ape of nature (fig. 93).[58] Monkeys became very popular subjects for automata in which they do human things like playing music and smoking actual cigarettes (fig. 94). The invention apes the monkey, and the monkey apes the man.

An answer to Descartes' well-founded objection that an automaton could never be flexibly responsive seemed to be provided by Wolfgang von Kempelen's *Chess*

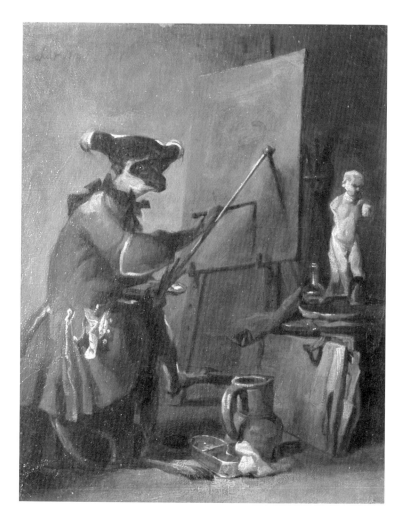

93. Jean-Siméon Chardin, *The Monkey Painter*, 1740, Musée des Beaux-Arts, Chartres.

94. *Monkey Smoker*, c. 1880, Musée National, Collection de Galéa, Monaco.

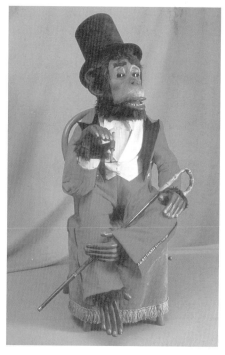

Player.[59] A philosophically minded Hungarian nobleman who had become a prominent state official in the Viennese court of Empress Maria Theresa, he gained renown as an inventor of pumps for draining salt mines and more generally as a water engineer. His chess grandmaster sat behind a substantial cabinet of machinery, which the demonstrator willingly displayed to the spectators by opening a succession of doors (fig. 95). The life-size player was richly attired in a Turkish costume, a fashionably exotic garb that may have alluded to the transmission of chess to the West via the Middle and Near East. The mechanical chess player made a stunning debut at the empress's court in 1770, and was intermittently revived by von Kempelen to astound visiting grandees and to undertake tours across Europe.

Its prowess was such that it convinced many discerning observers that it could literally play chess in response to the unexpected moves made by an opponent. Its record against skilled players was very impressive, and it even made visible signs of disapproval when any of its human adversaries attempted to cheat. One Parisian observer claimed that the *Chess Player* "is to the mind and eyes what M. Vaucanson's flute player is to the ear."[60] Von Kempelen's own seriousness as a philosopher and inventor ensured that it inhabited an intellectual environment beyond that of mere showmanship. His treatise on *The Mechanism of Speech in the Light of the Description of a Speaking Machine* (1791) made serious claims about the language capacity of animals.[61] Like Montaigne he believed that animals have their own kind of language, accompanied by ideas and species of reasoning. He was even prepared to believe

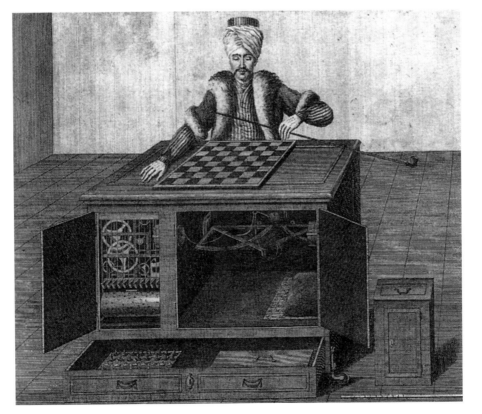

95. Wolfgang von Kempelen, *Chess Player,* 1770, from Carl G. von Windisch's *Inanimate Reason; or circumstantial account of that astonishing mechanism . . . ,* 1784, The Bodleian Library, University of Oxford.

that animal language extends as far as expressing their passions, desires, and interior agitations. If the animal-machine was capable of far more than the hard Cartesians believed, why should a machine not play chess?

After von Kempelen's death in 1804, the apparatus was restored by the inventor Johann Maelzel, who constructed both automata for shows and utilitarian devices such as artificial limbs. It was under Maelzel's aegis that the Turk rose to the apogee of its public fame, particularly in the wake of a widely reported encounter with Napoleon. Tours to Britain and America followed, and it eventually settled with the rest of the showman's mechanical entourage in Philadelphia. It finally perished in a fire of 1854. But its legend lived on. In 1926 it even inspired a feature film, *Le Joueur d'échecs et le Baron von Kempelen* by Henry Dupuy-Mazuel and Reymond Bernard.

International reactions to the Turk varied widely, driven not least by each commentator's stance on the philosophical issue of the man-machine. Humanist skeptics tended to speculate that a living player must be concealed inside the cabinet, even though the spectators were apparently allowed to see right through the cabinet's packed mechanism of wheels, levers, and drums. Those disposed to believe in the potential of machines for performing elaborate mental tasks were prepared to credit the chess player with a kind of machine intelligence. Amongst those captivated by the machine's capacities were Charles Babbage, the pioneer of calculating machines, and the scientifically minded author of mechanically motivated horror stories, Edgar Allan Poe.

How did it work? During the final years of its existence, it was openly acknowledged that the Turk relied upon the magician's skills of illusionism, akin to those at work in the enduring illusion of the lady sawn in half. The key lay in the cramped repositioning of a hidden player as the doors of the cabinet were opened and closed in a strict sequence. The chess player, although it was mechanically ingenious, was not so much a supreme automaton in the tradition of Vaucanson and Droz but more a product of prestidigitation in which the skilled illusionist invites us to believe our eyes, even when they utterly deceive our reason.

One of the enduring problems of the clockwork model for animals no less than humans concerns the origins of the force that set it in motion. All such mechanisms required an external agent—most typically the hand that turned the key to wind the spring. But natural organisms did not literally need winding up and did not run down (at least until old age and death). Where was the equivalent of the spring? New discoveries in the late eighteenth and early twentieth centuries seemed to provide a likely answer. When in 1781 Luigi Galvani used an arc of two metals to twitch a dead frog's leg into electrical motion, the secret of locomotion and maybe even of life seemed to be at hand. Although Alessandro Volta later recognized that the electricity resided in the arc rather than the frog, Galvani's "animal electricity" seemed the prime candidate to be identified as the mysterious ingredient, which infused inanimate compounds with the vital powers of life. Thus it was in 1818 Mary Shelley's Frankenstein constructed an apparatus to galvanize the "spark of life into the lifeless thing." But outside fiction, the actual experiment had only been performed on

an animal. Then Andrew Ure, a Scottish chemist, sensationally used electricity to induce some signs of life in the corpse of an executed criminal, much to the consternation and revulsion of his audience.[62] The implication was that a supreme automaton equipped with the organic equivalent of Volta's "pile" (or battery) could indeed achieve the semblance of human life if not life itself.

In retrospect, we can see how the seventeenth- and eighteenth-century causes célèbres of the automatists' art helped lay down the terms of an enduring dispute. On one side stand the hard materialists; on the other a loose coalition of those who adopt more qualified views, either on pragmatic or spiritual grounds. A nice example of the eruption of the La Mettrian debates in the twentieth century is provided by the polemical book published in 1927 by Joseph Needham, *Man a Machine: In Answer to a Romantical and Unscientific Treatise Written by Sig. Eugenio Rignano & Entitled "Man Not a Machine."*[63] Needham, who achieved renown as the leading historian of Chinese science and technology, stood firmly in the camp of those who believe in the ability of modern science to understand all that there is to understand about the constitutions of humans and animals. More recently, the advent of "thinking" computers has produced a new focus for the arguments, but the basic ideas and instincts that fuel them have not changed. The potency of the intuitive dimension—what we instinctively believe about the nature of the human being—should not be underrated in determining our stance on these issues. The feeling that people must be more than mere machines, based on our daily experience of the complexity of lived lives, is a powerful motivation behind many attempts to combat hard materialism. The related feeling that the animals we know and love must be more than automata is often held equally strongly. It is this feeling that provides the starting point for the next chapter, where we will witness the obstinate survival of the world of meaning and character that we encountered with Leonardo.

Fable and Fact: La Fontaine and Buffon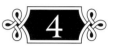

The lion cannot justly be branded with cruelty, since he acts from necessity, and kills no more than he consumes; while the tiger, the wolf, the hyena, and many other inferior species, such as the fox, the martin, the polecat, the ferret, &c. delight in slaughter, and seem rather to gratify their rage than their hunger.

Georges-Louis Leclerc (Comte de Buffon)[1]

This epigraph comes from the supreme natural historian, the Comte de Buffon. The restrained character of the noble beast is the stuff of legend and fable. The fable as an enduring literary genre was the prime vehicle for the telling of affecting stories of animals' deeds, good and bad. The greatest ever allegiance between a great writer of fables and a major artist came when Jean-Baptiste Oudry embarked on his huge project to illustrate the fables of Jean de La Fontaine. Their allegiance was in no way impeded by the fact that the writer died before the artist was born. Their shared enterprise is representative of one of the great literary and visual traditions, fully meriting extensive coverage in its own right. In this chapter we will also see that Buffon, the "scientist," shares more with this literary tradition than might be expected.

LA FONTAINE, OUDRY, AND THE FEELING ANIMAL

Von Kempelen's double role as a maker of automata and theorist of animal language very directly confirms the continuing role of automata in the Cartesian debates. A more general testimony to the way that automata were a key point of reference for anyone concerned with the animal-man-soul issue is provided by the great writer of fables, Jean de La Fontaine. He tells us that "there was hardly a *solitaire* who didn't talk of automata. They administered beatings to dogs with perfect indifference, and made fun of those who pitied the creatures as if they had felt pain."[2] The audible protest of animals apparently "suffering" were taken to be of no more account than

the noises of striking clocks—an obvious reference to the Cartesian topos. Unsurprisingly, this doctrine was taken as sanctioning vivisection. La Fontaine's reference to the *solitaires* refers to a group of philosophers and educated laymen who chose to associate themselves with or actually retreat to Port-Royal, which had originally been established as a convent of nuns in the vicinity of Versailles (Port-Royal-des-Champs), with a second house in Paris in the Faubourg Saint-Jacques (Port-Royal-de-Paris). Associated with Jansenist ideas, the Port-Royal was also a locus for debates on Cartesian topics, though it was not specifically a hotbed of Cartesian doctrine.[3] Antoine Arnauld, one of the most famous and influential *solitaires,* was a strong supporter of Descartes, while another, the prominent Duc de Liancourt, refuted the idea of the *bête-horloge* (beast-clock) with a story of a particularly intelligent dog, which would have appealed to Montaigne.[4]

La Fontaine, for his part, did not participate in the disputes in a sustained way as a philosopher, but his renowned *Fables* contributed effectively, both implicitly and

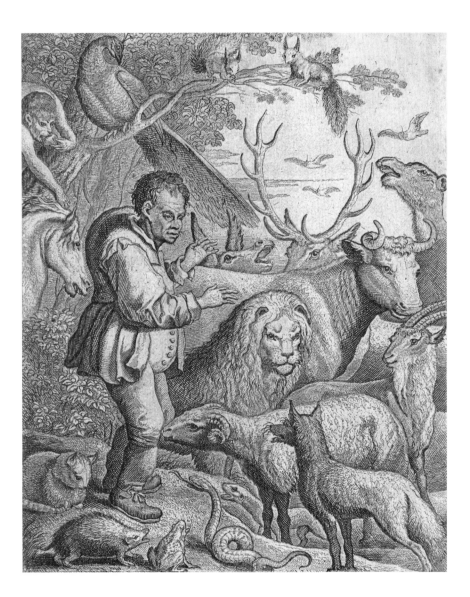

96. Francis Barlow, British (1626–1702), frontispiece from *Aesop's Fables* (Amsterdam: Etienne Roger, 1714), 1666. Etching and engraving. 25.8 x 19.5 cm (sheet). Fine Arts Museums of San Francisco, Achenbach Foundation for Graphic Arts, 1963.30.38638.1.

OPPOSITE

97. Francis Barlow, British (1626–1702), illustration from *Aesop's Fables* (Amsterdam: Etienne Roger, 1714), 1666. Etching and engraving. 25.8 x 19.5 cm (sheet). Fine Arts Museums of San Francisco, Achenbach Foundation for Graphic Arts, 1963.30.38638.

explicitly, to the vitality of the anti-Cartesian case. For us there is the added bonus that he was the source of inspiration to Oudry, the greatest animal artist of the eighteenth century. Of all the illustrators of the *Fables,* it is Oudry who most perfectly realizes their outer and inner dimensions.

By the last quarter of seventeenth century, when La Fontaine was active, there was a long tradition of illustrated fables, above all those of Aesop, which remained the touchstone for all subsequent authors. Of the many illustrated editions of Aesop, the volume published in 1665–66 by Francis Barlow, English animal painter and draftsman, is notably effective in our present context. The frontispiece (fig. 96) shows Aesop, misshapen according to legend, and in the company of his cast of characters. He is deeply versed in their world of behavior and meaning, as the accompanying verse informs us.

> See here how Natures Book unclasped lies,
> Whose pages Aesop reads with Piercing eyes,
> Who with Apologues from beasts deriv'd,
> Tells man they for his conduct were contriv'd.

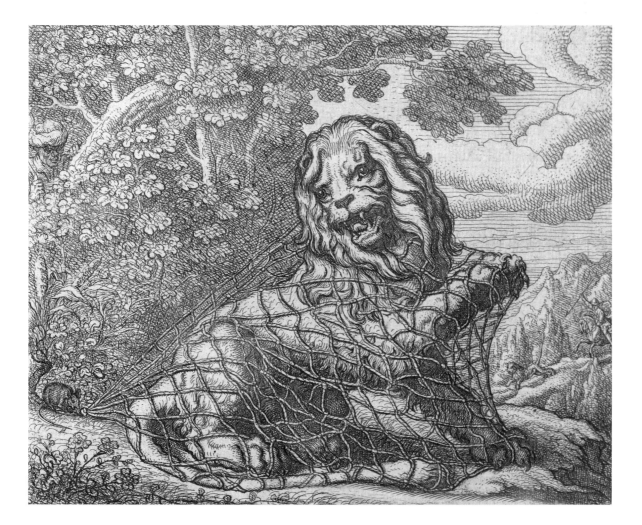

Aesop's very popular story of the mighty lion ensnared in an enveloping net (fig. 97) is very much in keeping with La Fontaine's tastes. Unable to release himself, in spite of all his proud strength, the lion has to depend on the nibbling prowess of the tiny mouse to free himself before the hunters arrive.

Of the lesson-teaching animals, the cunning fox, eagerly prominent in the foreground of Barlow's frontispiece, enjoyed a special fame. The wily ruses of Reynard the Fox, ubiquitous hero of medieval beast-lore, featured in all the main European literary traditions. The tales center around his summoning by the Lion King to answer charges brought by Isengrim the Wolf, his slow-witted butt, and other of his "victims." The diffusion and popularity of the tales relied on the way that they came to provide a vehicle for social satires, often of a pointedness that was less readily expressed in direct political writing. The clever and sometimes devious fox regularly appeared in moralizing and satirical medieval carvings, such as wooden misericords in choir stalls. It is on this didactic tradition of lessons from the world of nature that La Fontaine's *Fables* depend.

The best point for us to enter the fabulous world of La Fontaine along a specifically Cartesian path is where he himself directly addresses the philosopher. The context is the noted salon of Madame de La Sablière, of which the author was a permanent member from about 1673 to his death in 1696. Here La Fontaine could benefit from the company of literati such as François Bernier, from whom his later editor says he "took good lessons in physics."[5] Some idea of the terms of reference in the debates in such salons can be gained from an amusing if somewhat discouraging anecdote told by Vigneul Marvile, who recounts what happened when La Fontaine came to dinner. The company of the writer proved to be disappointingly unrewarding,

> because during all the time that La Fontaine remained with us, he seemed to us to be nothing but a machine without a soul. We threw him in a carriage and said goodbye to him forever. Never have I seen a group of people so surprised, and we turned to each other and said "how can a man, who knows how to render spiritual the lowest beasts in the world, and make them speak the most beautiful language that one has ever heard, have a conversation so dry, and yet, for a quarter of an hour, cannot bring the spirit to his lips and let us know that he is there?[6]

Marvile's companions were apparently presented only with a Cartesian machine. They were unable to reconcile their experience with La Fontaine's own conviction that a fable (and by implication its author) must possess both a body and a soul—the fable being the body, the moral the soul. Fortunately La Fontaine was not always so mute. His *Discourse to Mme de La Sablière* (1675), testifies eloquently both to his familiarity with the animal-machine debate, and his ironic scepticism about the Cartesian stance.[7] Indeed, by entitling his extended poem-letter *Discours,* he seems to be deliberately alluding to Descartes' *Discours de la méthode*. His hostess is addressed as Iris, radiant goddess of the rainbow and mistress of percipient vision.

La Fontaine opens with praise for the light and learned air of Mme de La Sablière's eclectic salons (here quoted with minor changes from Elizur Wright's eccentric and sprightly nineteenth-century translation):

> Wit, science, even trifles grace
> Your bill of fare; but, for that matter,
> The world will not believe the latter.
> Well, leave the world in unbelief.
> Still science, trifles, fancies light as air,
> I hold, should mingle in a bill of fare,
> Each giving each its due relief;
> As, where the gifts of Flora fall,
> On different flowers we see
> Alight the busy bee,
> Extracting sweet from all.[8]

For the fablist there was always a great precedent in conveying profound truths in disarmingly entertaining vehicles, namely the *Fables* of Aesop. In describing the life of his Greek predecessor, La Fontaine tells how the native wit, commonsense, and experiential wisdom of the former slave repeatedly confounded the arguments of learned philosophers. Through his praise of Aesop, La Fontaine in effect paraded his own claims to be taken seriously: "he taught true wisdom and taught it with far greater art than those who give definitions and rules."[9]

In Mme de La Sablière's salon, the big contemporary issue of the animal soul was very much on the table, and even La Fontaine, the writer of "trifles," might aspire to treat of such a thing:

> Thus much premised, don't think it strange,
> Or in any way beyond my muse's range,
> If even my fables should enfold,
> Among their nameless trumpery,
> The traits of a philosophy
> Far-famed as subtle, charming, bold.
> They call it new—the men of wit;
> Perhaps you have not heard of it?
> My verse will tell you what it means:—
> They say that beasts are mere machines;
> That, in their doings, everything
> Is done by virtue of a spring—
> No sense, no soul, nor notion;
> But matter merely,—set in motion,
> Just such the watch in kind,
> Which joggeth on, to purpose blind.[10]

Although the "vulgar people" think the animals feel genuine emotions, Descartes has shown otherwise.[11]

> Hear how Descartes—Descartes, whom all applaud,
> Whom pagans would have made a god,
> Who holds, in fact, the middle place
> 'Twixt ours and the celestial race,
> About as does the plodding ass
> From man to oyster as you pass—
> "Of all the tribes into being brought
> By our Creator out of nought,
> I only have the gift of thought."
>
> We were by older science taught
> That when brutes think, they don't reflect.
> Descartes proceeds beyond the wall,
> And says they do not think at all.[12]

As his own counterweight to the ironically retailed Cartesian stance, La Fontaine tells the atmospheric and heart-rending story of a stag hunt, which reveals, in a way reminiscent of Montaigne, the valiant strategies adopted by a stag at bay. The stag's cunning is in its own way not less than that of a beleaguered political leader:

> . . . in the forest, when, from morn
> Till midday, sounds of dog and horn
> Have terrified the stag forlorn;
> When he has doubled forth and back,
> And labour'd to confound his track,
> Till tired and spent with efforts vain—
> An ancient stag, of antlers ten;—
> He puts a younger in his place,
> All fresh, to weary out the chase.—
> What thoughts for one that merely grazes!
> The doublings, turnings, windings, mazes,
> The substituting fresher bait,
> Were worthy of a man of state—
> And worthy of a better fate!
> To yield to rascal dogs his breath
> Is all the honour of his death.[13]

The implication is that the new kind of philosopher, in his bookish study and experimental laboratory, does not have access to aristocratic insights into the world of beasts, since he has obviously never been on a hunt to experience the stag's true character.

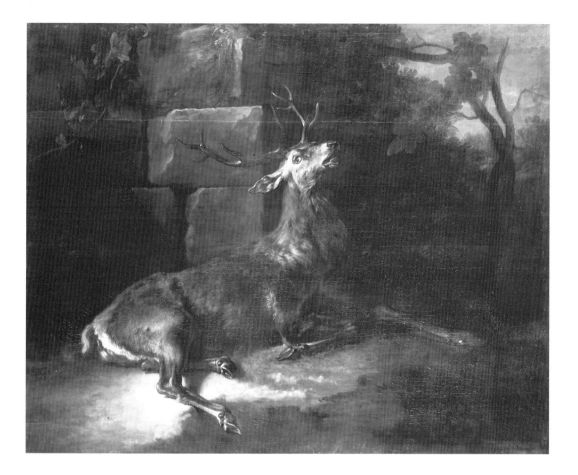

98. Jean-Baptiste Oudry, *Stag in a Forest*, c. 1735–38, Staatliches Museum Schwerin. Photograph: Elke Walford.

A perfect illustration of the sentiment La Fontaine wanted to evoke was provided by Oudry some fifty years later. In 1728, the painter was commanded to follow Louis XV's royal hunt in order to depict its progress. The first of his large paintings depicted its climax in Saint-Germain-en-Laye. It took two years for the grand painting to be finished, as the first of a series of great "histories" of the king's hunt.[14] Oudry's rhetorically staged narratives pit the majestic monarch, calmly in command, against the most regal of beasts, hunted to its last breath. The desperate beast often plunges into the cold waters of lakes and rivers, pursued by eager hounds, having long bucked the odds with a heroism that would have befitted the doomed hero of a classical tragedy. A painting of a single stag, apparently in a situation of physical and mental extremis like the exhausted ancient stag of La Fontaine's narrative (fig. 98), is full of the pathos normally reserved for pictures of great human dramas.

La Fontaine follows his telling narrative of the hunted stag with the relatively familiar story of the partridge that, on seeing her young in danger, pretends to have a broken wing in order to divert the attentions of the hunters and the dog (fig. 99). As the hunters head in her direction, she flees, emitting that most human of sounds, laughter:

> And when the partridge danger spies,
> Before her brood have strength to rise,

She wisely counterfeits a wound,

And drags her wing upon the ground—

Thus, from her home, beside some ancient log,

Safe drawing off the sportsman and his dog;

And while the latter seems to seize her,

The victim of an easy chase—

"Your teeth are not for such as me, sir,"

She cries,

And flies,

And laughs the former in his face.[15]

LA PERDRIX.Fable CLXXXIX.
Discours a M.^e de la Sabliere. I.^{re} Planche.

99. After Jean-Baptiste Oudry,
The Dog and the Partridge, from
Jean de La Fontaine's *Fables
Choisies,* 1755–59, The Bodleian
Library, University of Oxford.

Next, La Fontaine turns to the natural history of new, far off worlds, where the humans live in a profound ignorance. By contrast to the rude peoples of these remote regions, who dwell in poor huts, the "castors" or beavers exhibit a remarkable genius for physical and social engineering:

> For animals are dwelling there
> With skill such buildings to prepare
> As could on earth but few men.
> Firm laid across the torrent's course,
> Their work withstands its mighty force,
> So damming it from shore to shore,
> That, gliding smoothly o'er,
> Their work, as it proceeds, they grade and bevel,
> Or bring it up to plumb or level;
> First lay their logs, and then with mortar smear,
> As if directed by an engineer.
> Each labours for the public good;
> The old command, the youthful brood
> Cut down, and shape, and place the wood.
> Compared with theirs, e'en Plato's model state
> Were but the work of some apprentice pate.[16]

In the face of such evidence, La Fontaine is simply not prepared to countenance what the Cartesians tell him:

> Now that the skilful beaver,
> Is but a body void of spirit,
> From whomsoever I might hear it,
> I would believe it never.[17]

We will encounter the constructional gifts and well-regulated society of the beaver again in Buffon's great compendium of natural history.

La Fontaine also tells his hostess of some foxlike animals, the warlike Ukrainian "boubaks," who live on the Polish borders. They exhibit a special level of military prowess, honed by long experience of war:

> And with more skill no war hath been,
> By highest military powers,
> Conducted in this age of ours
> Guards, piquets, scouts, and spies,
> And an ambush that hidden lies,
> The foe to capture by surprise,

And many a shrewd appliance

Of that pernicious, cursed science.[18]

"What," he finally asks (and answers), would Descartes "say to facts like these? Why, as I've said, that nature does such things in animals by means of springs." But, whatever the philosophers may claim, the ultimate truth in such matters lies beyond our human understanding:

And, speaking in all verity,

Descartes is just as ignorant as we;

In things beyond a mortal's ken,

He knows no more than other men.

In addition to the *Discourse,* La Fontaine dedicated a complex tale of animal altruism to his hostess. It involves a rat, raven, gazelle, and tortoise, and serves to demonstrate how, in the face of man's barbarous hunting, "Four animals, in league compact, / Are now to give our noble race / A useful lesson in the case."[19] Gathering for a communal meal, the friends find that the gazelle is missing. The raven flies off and finds "the poor gazelle entangled in a snare" (fig. 100). Hastening to the spot, Grey Rongemail the rat gnaws through the entrapping bonds, releasing his companion. The returning hunter deprived of his prey, alights on the slow-moving tortoise, and thrusts it into his sack. The raven then alerts the gazelle, who (like the partridge) lures the hunter away by pretending to be lame while the rat again uses his dental prowess to chew through fabric of the sack. Once the tortoise is free, the gazelle dashes off, and the hunter is deprived of his meal, even the meager fare of the tortoise. Each animal has played its role in confirming the bonds of feeling that cement their mutual society in the forest. It was evident that

Grey Rongemail the hero's part should play,

Though each would be as needful in his way.

He of the mansion portable awoke

Sir Raven by the words he spoke,

To act the spy, and then the swift express.

The light gazelle alone had had th' address

The hunter to engage, and furnish time

For Rongemail to do his deed sublime.

Thus each his part perform'd. Which wins the prize?

The heart, so far as in my judgement lies.[20]

The natural conclusion to be drawn from the edifying tales that La Fontaine offers to Madame de La Sablière is that animals genuinely demonstrate true feelings, "good sense," learn from experience, and exhibit an altruistic sense of community.[21] However, he does not believe that there is ultimately no separation to be made

100. After Jean-Baptiste Oudry, *The Rat Releasing the Gazelle,* from Jean de La Fontaine's *Fables Choisies,* 1755–59, The Bodleian Library, University of Oxford.

between humans and animals, since humans have been divinely endowed with a special "spirit":

> . . . in the beasts of which I speak
> Such spirit it were vain to seek,
> For man its only temple is.
> Yet beasts must have a place
> Beneath our godlike race,
> Which no mere plant requires
> Although the plant respires.[22]

Humans are endowed with the "double treasure" of two souls, one of which is essentially material and is shared with the beasts, while the other is uniquely divine:

The one the soul, the same in all
That bears the name of animal—
The sages, dunces, great and small,
That tenant this our teeming ball;—
The other still another soul,
Which should to mortals here belong
In common with the angel throng.[23]

La Fontaine is not writing philosophy, but he is taking up a philosophical position. It is clear that he has given very careful thought to the stories for presentation to his learned hostess, deliberately including some examples that stand outside the stock legends of animal cleverness. The references to Plato and Descartes openly signal a level of high philosophical reference. The stance he adopts is not that of a hard Cartesian, but neither does he go quite as far as Montaigne. He charts a course that seems to share much with the new styles of scientists, such as Gassendi and Bernier (Gassendi's chief pupil), and with Marin Cureau de la Chambre, whom we have already encountered as a source of inspiration for Le Brun.[24]

As a member of the same salon, La Fontaine cannot but have discussed such questions with François Bernier, whose *Epitome of the Philosophy of Gassendi* did much to make his master's views accessible.[25] Bernier accorded animals an "understanding approaching that of reason," and Pierre Gassendi himself had given them "some species of reason," which proceeded from their imagination. Although Gassendi agreed with Descartes that animal souls were irredemably coporeal, he placed them above the condition of base materiality, granting them a special subtlety and mobility that endowed them with mental attributes and feelings of quite an extensive kind, though never aspiring toward the most elevated kinds of human reason. Perhaps La Fontaine comes closest to Cureau de la Chambre, who saw the "Sensitive Soul" of animals as fully capable of imagination, instinctive knowledge and reason in forming mental images, which the soul can combine, separate, and subtract, making judgments and learning from experience.[26] Where the animal soul fell short of man's was in its lack of powers of abstract reasoning and in its inability to predict of future events beyond what could be deduced retrospectively through experience. In more general terms, La Fontaine's unwillingness to believe that human reason could provide ultimate solutions to all questions is consistent with the Gassendi-Bernier stance on the conditionality and incompleteness of human knowledge.

Even if the shifting complexities of the debates on animal and human reason in this period make precise alignments between La Fontaine and the philosophers hard to define, it is clear that he openly strove to locate his moral tales in a camp that lay far outside the enclave of the doctrinaire Cartesians. That animals were genuinely clever and had real feelings seemed impossible for La Fontaine to doubt. In telling his vivid and accessible animal stories, he inevitably resorted to anthropomorphism, allowing his animals to speak and enact other human traits. This cannot but prejudice any sense that animals' intelligence and communication should best be defined

strictly on their own terms, as Montaigne had argued, rather than seeing them as operating in a quasi-human way. But we should remember that he is a skilled literary artist working within a long-standing literary genre, and not a writer of logical tracts.

The engraved illustrations reproduced here are taken from Jean-Louis Regnaud de Montenault's extremely grand edition of La Fontaine, published in four volumes in 1755–59. The prints were based on the drawings of Oudry.[27] Unfortunately the story behind their genesis and publication is not as simple as it looks at first sight. It was between 1729 and 1734, at a time when Oudry was painting the *Death of a Stag* and was engulfed by Royal duties, that Oudry undertook the complete series of 276 illustrations of the *Fables*. From the dates on the drawings, it appears that he drew them in order, but we cannot be sure of his motivations in undertaking such a grand enterprise. Charles-Antoine Jombert, the scholarly editor of the texts of the new edition believed that

> They were his [Oudry's] recreation; he composed them for his own pleasure, in those moments of choice and fantasy where an Artist most vividly seizes the ideas of his subject, and gives free reign to his genius. It was in this way, without even thinking about them, that he formed the repertoire and collection of compositions which, subsequently, formed the original of most of the canvases that lined the walls of the Academy's salon, which were so admired by the Public, and which can be found all over the King's private residences as well as in the Cabinets of Curiosities.[28]

If that is so, it would be a remarkable labor of love.

Jombert is certainly right in stating that Oudry exhibited and sold numerous paintings of La Fontaine subjects, starting in 1720 if not earlier and continuing them as a hugely successful line for salon exhibits and as tapestry designs. A notable example is the life-size *The Lion and the Spider,* painted in 1732 and later sold to the king of Sweden for the very handsome sum of 1,000 livres (fig. 101).[29] He characteristically kept a copy, which he offered unsuccessfully to the Duke Christian Ludwig II of Mecklenburg-Schwerin for the more modest price of 250 livres. The fable tells how even the regal lion may be brought low by the humble gnat, a typical moral tale of pride before a fall, but with a twist in its tale:

> "Go, paltry insect, nature's meanest brat!"
> Thus said the royal lion to the gnat.
> The gnat declared immediate war.
> "Think you," said he, "your royal name
> To me worth caring for?
> Think you I tremble at your power or fame?
> The ox is bigger far than you;
> Yet him I drive, and all his crew."
> This said, as one that did no fear owe,

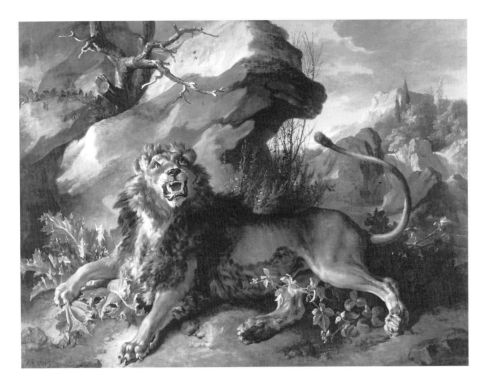

> Himself he blew the battle charge,
> Himself both trumpeter and hero.

The gnat dives on to his opponent, inflicting multiple bites on the lion until it is driven to distraction. Enraged and tearing at its itching hide, the lion thrashes around frantically until exhausted. To the gnat goes the victory. But the victor's celebrations are premature. A spider has formed a nearby web . . .

> The gnat retires with verdant laurel.
> Now rings his trumpet clang,
> As at the charge it rang.
> But while his triumph note he blows,
> Straight on our valiant conqueror goes
> A spider's ambushing to meet,
> And make its web his winding-sheet.

The double moral emphasizes that the mightiest does well to fear the puniest, while someone triumphant in one great battle may unwarily run straight to his death in an apparently lesser or unseen hazard.

Compared to the same subject in the engraved edition (fig. 102), the painted lion is given the starring role, desperately scouring his itching hide on a thistle and bramble, and it is his glance that brings the spider and his fatal web into meaningful play. In the illustration, the spider's web is accorded a more prominent position and is closer to us than the lion, with whose face we cannot fully engage. The gnat's fate

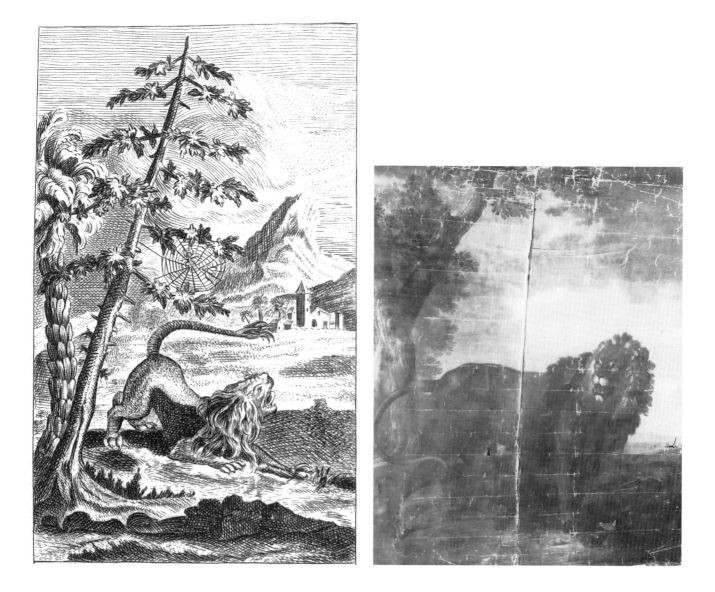

becomes literally central. Finally in 1752 Oudry painted a large canvas of a life-size lion on its own, which entered the collection at Schwerin and survives in a battered state (fig. 103).[30] This exceptional late work does not illustrate the fable, but stands more directly as a surrogate for the real specimen of the lion. Even here, the "portrait" of the lion exudes a sense of individual character, perhaps more thoughtful and reserved than the stereotype would demand.

The great set of drawings for the *Fables* had been sitting in Oudry's studio for more than fifteen years, when they were sold to Montenault who was preparing a definitive and sumptuous edition of La Fontaine. A few of the drawings had already appeared in print, but the series as whole remained unpublished. Montenault persuaded the banker Darcy and one of his colleagues to help finance the very costly venture. Oudry designed a frontispiece for the work in 1752, but did not live to see it completed. The 276 illustrations played a key role in Montenault's ambition to make

102. After Jean-Baptiste Oudry, *The Lion and the Spider,* from Jean de La Fontaine's *Fables Choisies,* 1755–59, The Bodleian Library, The University of Oxford.

103. Jean-Baptiste Oudry, *Lion* (before conservation), 1752, Staatliches Museum Schwerin. Photograph: Elke Walford.

his edition one of the most magnificent books ever published. As Jombert pointed out, there had been illustrated editions before, but nothing to equal the images by the "Peintre du Roi" and professor at the Académie Royale, who was veritably the "La Fontaine of Painting." Previous readers of the *Fables* were deprived the "talent and brush of M. Oudry, who is alone capable of expressing their passions with the colours and nuances which the fiction demands."[31] "Nobody," Jombert declared, "knew better how to make the animals act and talk than he did in his canvases, and particularly in the designs which accompany this work."

Jombert claims that Oudry's drawings had been hidden away in a cabinet and would have been lost had he not discovered them, and had not M. Cochin, the Censeur Royal, and Permanent Secretary of the Royal Academy, used his famous talents to bring them into printed form.[32] Some financial figures will give an idea of the speculative nature of the undertaking. The four volumes were offered on a subscription basis, at 206, 252, and 288 livres for three different qualities and sizes of papers.[33] The subscription closed on June 30, 1755, just a couple of months after the death of Oudry, after which the price rose to 300, 348, and 400 livres respectively. The huge costs ate into Montenault's resources, and the fourth volume was only published as the result of a donation of 80,000 livres from the king himself. The Royal "Privilege" that was necessary for all books gave Montenault a monopoly on the publication of the La Fontaine for thirty years. Publishers and booksellers faced a fine of 3,000 livres if they were caught selling other editions. Montenault acquired the right not only to publish this version of the text in any form, but also to publish the illustrations at any size and separately. The complex publishing history of successive editions and issues of Oudry's illustrations confirms that the entrepreneur did all he could to take advantage of his monopoly.

The publisher placed Cochin *fils*, from a family of printmakers, in charge of the making of the illustrations. Charles-Nicolas Cochin was more than an engraver. From his position as secretary of the Royal Academy, he had become a powerful authority on all matters artistic, theoretical, and practical. A large team of engravers was assembled, almost fifty in total. Oudry's original drawings were made in pen and wash with white heightening, on blue-green paper. Cochin thought it necessary to adapt them for the engravers, considering the originals but "slight and fluid sketches in first draft in Chinese ink on tinted paper, in which the figures are incorrect and very uncertain." Thus he felt that he had "to rework them" in a more fully resolved form.[34]

Although one commentator writing in the *Mercure de France* in July 1756 decried the intervention of Cochin, the illustrations have been widely admired as one of Oudry's greatest achievements.[35] In reality, they vary greatly in the quality of their engraving (with Cochin's amongst the more accomplished), and even the best of the plates cannot be considered as entirely faithful renderings of the original drawings. Although Oudry designed the frontispiece in 1752, he seems not to have been actively involved in the whole project. Perhaps he did not like what he saw when some of the prints were exhibited in advance at the salon in 1753.

The illustrations, even in their engraved form, serve La Fontaine wonderfully. They fully accord with the literary verve and philosophical tenor of the author's vision. This is not the same as saying Oudry was consciously working within an intellectual framework to demonstrate that animals possessed feelings and reason. We are remarkably short of anything that would help us construct an intellectual biography of this supremely professional and productive painter and master of tapestry design. I think the safest we can say is that he was exploiting a full range of Le Brunian techniques in recounting the histories of the animals, particularly in those large-scale canvases and tapestries that overtly rivalled the productions of the academic history painters. An especially clear instance is the pair of leopards he painted at the Royal Menagerie in 1741 (figs. 104 and 105).[36] Oudry, writing to the duke of Mecklenberg-Schwerin in 1750 tells of the origins of the series that he was offering to sell and of which the leopards were part:

> These are the principal animals of the Royal Menagerie, all of which I have painted from nature by order of His Majesty and under the direction of Monsieur de La Peyronie, His surgeon, who wished to have them engraved, to form a suite of natural history for His Majesty's botanical garden. I have painted these pictures with great care, they were left with me at the death of Monsieur de La Peyronie.[37]

Although the painter indicates that the animals were a royal commission, the surgeon seems to have taken the lead throughout, and the project lapsed on his death in 1747.

The male leopard is described by the painter as "un tigre [*sic*] masle en colère," that is to say suffering from a bout of choleric ill-disposition. The phlegmatic female, by contrast, is "in tranquil attitude." We know that the basic poses were caught in incredibly lithe and eloquent line sketches dashed down in a few instants, while the paintings fizz with brilliant brushwork and coloristic vitality. The pose of the male and his facial agitation speaks of his bilious disorder, while the female exhibits the timidity that the Aristotelian text and della Porta prescribed as typical of the leopard. It is as if Oudry's pictures are in dialogue with the historic texts on physiognomics, saying, in effect, that it is the female leopard who exhibits the feminine characteristics, not the male, which can be as fierce as a lion.

Like Le Brun, Oudry recognized that different characters existed within the same species of animal such that they could be portrayed as distinct individuals. Indeed, the characterful paintings he undertook of Louis XV's hunting dogs, apparently in the king's presence, were specifically described as "portraits." The compound of individuality and expression in Oudry's animals was consonant with animals having their own kinds of animal soul, their own kind of reason, temperaments and real feelings. Their bodily and facial dispositions reflect *il concetto dell'anima* in Leonardo's sense. Whatever stance we attribute to Oudry, the artistic skills he inherited and developed came from a grand tradition designed to express high moral truths, general and individual. He was aiming for what is popularly called "a speaking likeness"

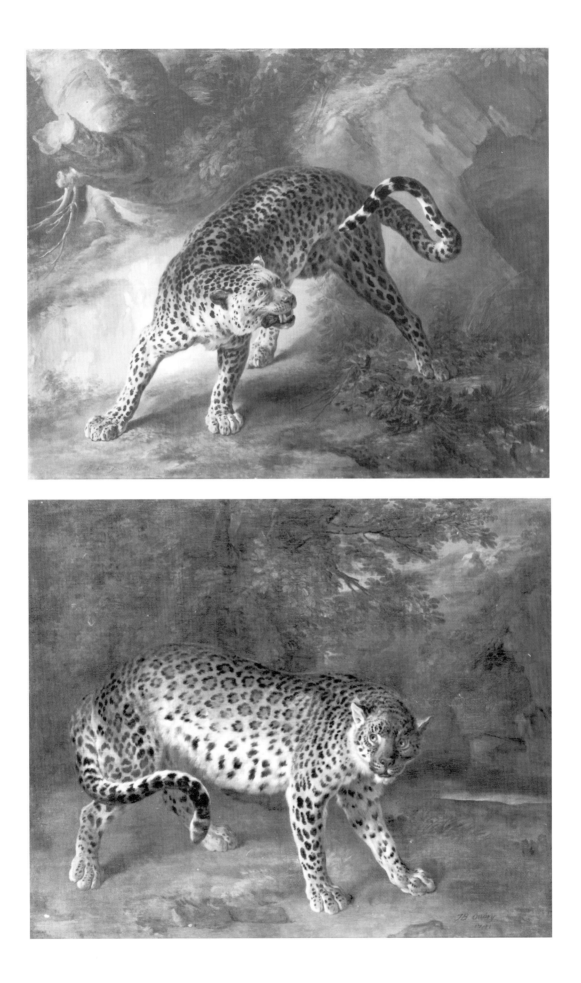

of each beast. By applying the skills of the history painter to La Fontaine's animal stories, his images and the author's words achieved a remarkable harmony in their characerization of the sentiments and reason exhibited by beasts.

There is abundant evidence that contemporary commentators sensed this was the case. Writing of the *Tiger and Two Mastiffs* in the salon of September 6, 1739, Le Chevalier de Neufville de Brunaubois Montador fulsomely praised the way that "these three animals have an inconceivable expression. They truly inspire a mute terror, and the ears of our inner spirit comprehend the furious animals' accents of rage." The animals' emotions spoke directly to him. They look so real in the Chevalier's eyes that he might feel tempted to touch them, if it did not seem so dangerous.

La Font de Saint-Yenne, reviewing the salon on August 25, 1746, delighted in the "actions of these animals and the terrifying expression of their fury, which is no less admirable than the artistry of his brush in the decisive and fiery touch of his canvases." In the December issue of the *Mercure de France* in 1749, an ode to Oudry paid particular attention to his *Stag Hunt:*

> When you trace the image of a stag at bay,
> Its deathly eyes, its tears, are for me a language
> Which casts pity into my responsive soul.
> And this illusion is so alive and strong,
> Just as I see the movements of hounds,
> Relentlessly carried by fury,
> So I hear their very cries.

It was precisely this ability to move the spectator to empathetic emotion, transcending "muteness" of the painted image, that Oudry had brought to the genre of animal painting from the academy's traditions in high art.

BUFFON AND THE HISTORY OF NATURE

We have noted how the legends of the animals in the bestiaries and faunas of the Middle Ages and Renaissance were replete with both beasts and behaviors that we would regard as "fabulous." Perhaps we might expect to find a quite different tenor in scientific natural history in the "enlightened" eighteenth century. When we read the *magnum opus* by the greatest of all the natural historians from the period of Oudry and Vaucanson, we certainly encounter a powerful emphasis upon material processes and direct observation, but we also find that the spirit that animated Montaigne and La Fontaine is still very much present. The natural historian in question is the Comte de Buffon (Georges-Louis Leclerc), and the key publication is his thirty-six-volume *Histoire naturelle,* the first three volumes of which appeared in 1749, and the final in 1788, the last year of his life.[38]

To understand how Buffon regarded animals, it makes sense to look first at the broader framework of his great vision of the earth and the advent of its inhabitants.

OPPOSITE

104. Jean-Baptiste Oudry, *Male Leopard,* 1741, Staatliches Museum Schwerin. Photograph: Elke Walford.

105. Jean-Baptiste Oudry, *Female Leopard,* 1741, Staatliches Museum Schwerin. Photograph: Elke Walford.

At the heart of his vision lay the idea that the teeming variety of life on earth arose through processes that were physical and natural, rather than put into motion by the hand of God, and required vast developments over far longer periods than had previously been allowed. His published figure for the age of the earth was 74,832 years (approximately), but he had privately countenanced that it could be as old as many millions of years.

Whatever the age of the earth, extensive time was needed to accommodate the seven major phases Buffon defined in his *Epochs of Nature* in 1779. During the first epoch, the hot earth was torn from the fiery sun and the moon from the earth. The second saw the congealing of the mountains. As the earth cooled during the third epoch, the waters condensed and provided the habitation for marine creatures. The fourth was characterized by vast volcanic activity, earthquakes and erosion, which reshaped the surface of the globe. Animals make their appearance during the fifth epoch. The continents separated from each other in the sixth. It is only in the final epoch that humans come to rule the earth. The fossil record bore witness to the existence of enormous creatures that were unable to survive as the earth progressively cooled. As these great changes occurred, adaptation came into play. Those creatures and newly arrived humans that survived had acquired new characteristics that allowed them to flourish in new conditions. The first humans, living in an era of greater heat, were black, but gradually adapted to a range of climates. Human rationality and the use of language lead to a mastery of nature, which is being further extended through developed scientific and technological understanding.

Buffon's great vision of how the world has come about set the stage for the discipline of natural history during at least the next hundred years. He identified what were to become the key issues in biology during the nineteenth century, namely change and continuity in species over long spans of time.

> The greatest miracle is not exhibited in the individual. It is in the successive renovation, and in the continued duration of the species, that Nature assumes an aspect altogether inconceivable and astonishing. This faculty of reproduction, which is peculiar to animals and vegetables; this type of unity that always subsists, and seems to be eternal; this generative power that is perpetually in action, must, with regard to us, continue to be a mystery so profound, that we shall probably never reach the bottom of it.[39]

In retrospect, it seems that Buffon's temporal conception and his clear sense of the adaptation of species to changing environments is leading in the direction of a theory of evolution. However, he takes it as given that the species itself is inviolable as the fundamental unit. One species does not change into another. Change takes place adaptively within the integrity of the species, and by the successive appearance and disappearance of species.

As an accomplished mathematician, physicist, chemist, and cosmologist, Buffon recognized that the extraordinary variousness of nature resisted the neat ordering that

was applicable to the more precise sciences. Indeed, he was suspicious of the kind of classificatory precision that Linnaeus was proposing. His emphasis is therefore upon detailed accounts of what can be known about each species. Since all species (including humans) arose through natural processes, proper explanantion required a meticulous scrutiny of all aspects of their lives within their environments. The task for the natural historian is clear and comprehensive, embracing procreation, gestation, birth, number of offspring, nurture, instincts, habits, diet, the procuring of food, hunting methods, cunning, character, and achievements.

When Buffon characterizes an individual species, he typically begins with a homily about what is to be understood about broader issues of nature and humanity from that particular animal's place in the greater scheme of things. There is often a kind of "moral" to be drawn from each animal's performance, and those animals that manifest some advanced behavior can be assessed according to social and psychological criteria. Some extended excerpts from his very long account of the lion (fig. 106) show how he reads significance into the book of nature. The passages that follow are taken from the translation by the noted Scottish physician William Smellie:

> Accustomed to measure their strength with that of every animal they [the lions] meet, the habit of conquering renders them terrible and intrepid. Being ignorant of the power of man, they are not afraid to encounter him. Having never experienced the force of his arms, they hold them in defiance. Wounds enrage, without terrifying them. They are not disconcerted even by the appearance of numbers. A single lion of the desert often attacks a whole caravan; and if, after a violent and obstinate engagement, he finds himself fatigued, instead of flying, he retreats fighting, always opposing his face to the enemy. Those lions, on the other hand, who dwell in the neighbourhood of the towns or villages of India or Barbary being acquainted with man, and the power of his arms, have lost their native fortitude to such a degree, that they fly from the threatening of his voice, and dare not attack him. They content themselves with seizing small cattle, and even fly before the women and children, who make them indignantly quit their prey, by striking them with clubs. . . .
>
> This change, this softening in the temper of the lion, indicates that he is susceptible of the impressions he receives, and that he must possess a docility sufficient to render him tamable to a certain degree, and to admit of a species of education: And history informs us, that lions have been yoked in triumphal cars, and conducted to the battle or the chase. . . . As his movements are impetuous, and his appetites vehement, we ought not to presume that they can always be balanced by the impressions of education. It is dangerous, therefore, to allow him to want food too long, or to irritate him unnecessarily. Bad treatment not only enrages him, but he remembers it, and seems to meditate revenge, in the same manner as he remembers and requires benefits received. Here I might quote a great number of particular facts, some of which appear to be exaggerated; but the whole, when combined, are sufficient to prove, that the anger of the lion is noble, his courage magnanimous, and his temper susceptible of impressions. . . .

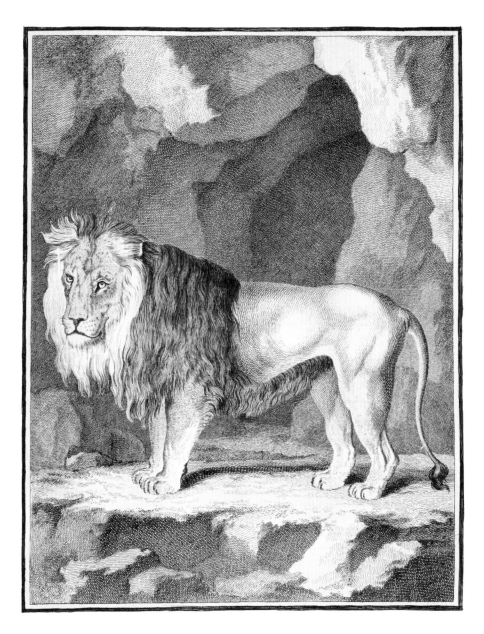

106. Comte de Buffon (Georges-Louis Leclerc), *Lion*, from *Histoire naturelle,* 1749–89, The Bodleian Library, Oxford.

The lion cannot justly be branded with cruelty, since he acts from necessity, and kills no more than he consumes; while the tiger, the wolf, the hyaena, and many other inferior species, such as the fox, the martin, the polecat, the ferret, &c. delight in slaughter, and seem rather to gratify their rage than their hunger.

The external appearance of the lion detracts not from the noble and generous qualities of his mind. His figure is respectable, his looks firm and determined, his gait stately, and his voice tremendous. His bulk is not excessive, like that of the elephant or rhinoceros. He is not gross and unwieldy, like the hippopotamus or the ox, nor too contracted, like the hyaena or the bear, nor lengthened to deformity, like the camel. The body of the lion, on the contrary, is so well poised and proportioned, that it may be regarded as a perfect model of strength combined with agility.[40]

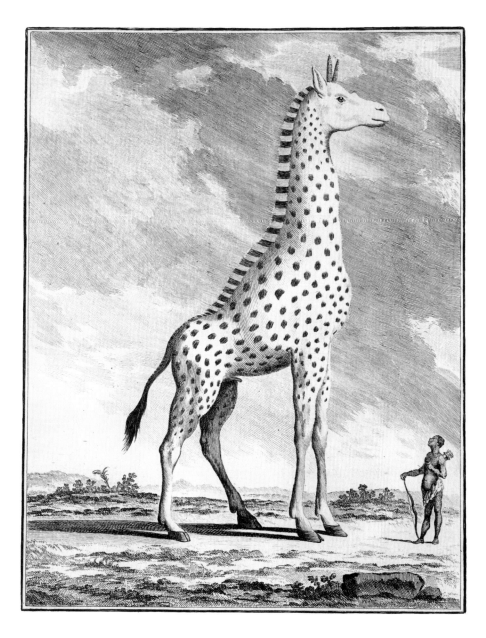

107. Comte de Buffon, *Giraffe*,
from *Histoire naturelle,* 1749–89,
The Bodleian Library, University
of Oxford.

Buffon's account of the temperament and physical characteristics of the lion is fol-
lowed by substantial accounts of other aspects of the lion's natural history, laced
with extensive citations of authorities past and present, much in the manner of
Gesner and Aldrovandi.

By contrast with his essay on the noble lion, Buffon's account of the giraffe or
camelopard (fig. 107) opens with a dubious billing:

> The camelopard is one of the most beautiful and largest quadrupeds: without being nox-
> ious, he is at the same time extremely useless. The enormous disproportion of his legs, of
> which those before are double the length of those behind, prevents him from exercising
> his powers. His body has no stability; he has a staggering gait; and his movements are

slow and constrained. When at liberty, he cannot escape from his enemies, nor can he serve man in a domestic state.[41]

Some of Buffon's most engaged reflections are occasioned by those animals that perform acts of architecture or engineering. The constructional prowess of the beaver (fig. 108), lauded by La Fontaine, occasions a particularly powerful analysis. Again, relatively extended quotation is necessary to give a flavor of Buffon's style:

> The beavers afford, perhaps, the only subsisting monument of the antient intelligence of brutes, which, though infinitely inferior in principle to the human intellect, supposes common projects and relative views; projects which, having society for their basis, and, for their object, a dike to construct, a town to build, or a republic to found, imply some mode of making themselves understood, and the capacity of acting in concert. The beavers are said to be, among quadrupeds, what the bees are among the insect tribes. There are in Nature, as she now appears, three species of societies, which must be examined before we can compare them: The free society of man, from which, next to God, he derives all his power; the constrained society of the larger animals, which always flies before that of man; and the necessary society of certain small creatures, which, being all produced at the same time, and in the same place, are obliged to live together. An individual, solitary as he comes from the hand of Nature, is a sterile being, whose industry is limited to the simple use of his senses. Even man him-self, in a state of pure nature, deprived of the light and assistance of society, neither produces nor constructs. Fertility, on the contrary, is the necessary result of every society, however blind or fortuitous, provided it be composed of creatures of the same nature. From the necessity alone of desiring to approach or to avoid each other, common movements arise, from which there often results a work, that has the air of being concerted, managed, and executed with intelligence. Thus the works of bees, each of whom, in a given place, such as a hive, or the hollow of an old tree, builds a cell; the works of the Cayenne bee, or fly, who not only makes the cells, but the hive that is to contain them, are operations purely mechanical, and imply no intelligence, no concerted project, no general views; they are labours which, being the produce of a physical necessity, a result of common movements, are at all times, and in all places, uniformly executed in the same manner, by a multitude, not assembled from choice, but united by the force of nature. Hence, it is not society, but numbers alone, which operate here. It is a blind power, never to be compared to that light by which all society is directed. I speak not of that pure light, that ray of divinity, which has been imparted to man alone. Of this the beavers, as well as all the other animals, are most assuredly deprived. But their society, not being a union of constraint, but proceeding from a species of choice, and supposing at least, a general concert and common views in its members, implies likewise a certain degree of intelligence, which, though different in principle from that of man, produced effects so similar as to admit of comparison, not, indeed, to the luminous society of polished nations, but to the rudiments of it, as they appear among savages, whose union and operations can alone, with propriety, be compared to those of certain animals.

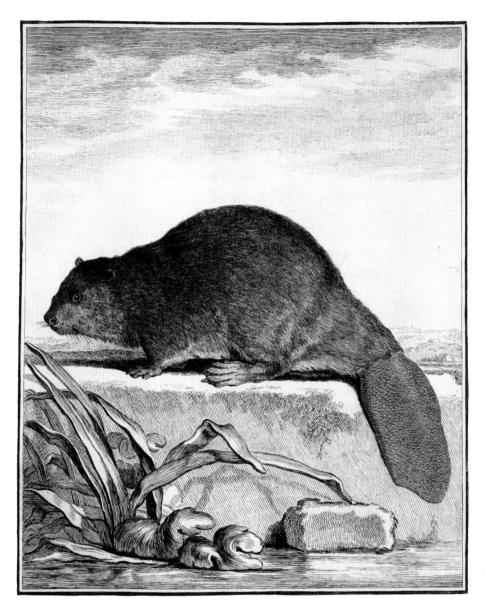

108. Comte de Buffon, *Beaver,*
from *Histoire naturelle,* 1749–89,
The Bodleian Library, University
of Oxford.

 Let us, then, examine the product of each of these associations; let us see how far
the art of the beaver extends, and to what the talents of the savage is limited. To break
a branch, and to make a staff of it, to build a hut, and to cover it with leaves, for shelter,
and to collect hay or moss, and to make a bed of these materials, are operations common
to the animal and to the savage. The beavers build huts, the monkeys carry staves, and
several other animals make commodious and neat houses, which are impenetrable by
water. To sharpen a stone by friction, and make a hatchet of it, to use this hatchet for
cutting or peeling the bark off trees, for pointing arrows, for hollowing a vessel, or for
slaying an animal in order to clothe themselves with its skin, to make bow-strings of its
sinews, to fix the sinews to a hard thorn or bone, and to use these for needles and thread,
are actions purely individual, which man in solitude may perform without the aid of
others; actions which solely depend on conformation, because they suppose nothing

but the use of the hand. But, to cut and transport a large tree, to build a village, or to construct a large canoe, are operations, on the contrary, which necessarily suppose common labour and concerted views. These works are the results of infant society in savage nations; but the operations of the beavers are the fruits of society already matured among those animals; for it must be remarked, that they never think of building, but in countries where they are perfectly free and undisturbed.[42]

Whenever possible, Buffon follows the tradition of Gesner in citing his own firsthand observations. In this case he was able to observe a Canadian beaver that he kept for twelve months. Its behavior confirmed his conviction that an animal's freedom to live in its proper social context is all-important.

It is somewhat melancholy, and even plaintive; but has no violence or vehemence in its passions. Its movements are slow, and its efforts feeble; yet it is seriously occupied with a desire of liberty, gnawing, from time to time, the gates of its prison, but without fury or precipitation, and with the sole view of making an opening for escape. In other matters, it seems to be extremely indifferent, forming no attachment, and neither wishes to hurt nor to please. In these relative qualities, which would make him approach to man, he seems to be inferior to the dog. . . . If, then, we consider this animal in a state of nature, or rather in a state of solitude and dispersion, he appears not, by his internal qualities, to rise above the other animals. He has not the genius of a dog, the sense of an elephant, the craftiness of the fox, &c.

However, in their natural societies, they achieve something very remarkable. In rivers or brooks, where the waters are subject to risings and fallings, they build a bank, and, by this artifice, they form a pond or piece of water which remains always at the same height. The bank traverses the river, from one side to the other, like a sluice, and it is often from 80 to 100 feet long, by 10 or 12 broad at the base. This pile, for animals of a size so small, appears to be enormous, and supposes an incredible labour. But the solidity with which the work is constructed, is still more astonishing than its magnitude as the water subsides.[43]

This is followed by an incredibly detailed account of the beaver's constructional methods, in which Buffon endeavors to filter out the more improbable details from reports he cannot verify or that have been given by unreliable witnesses.

When we turn specifically to the illustrations, which were not the least glorious part of Buffon's huge enterprise, we can see how well they are tuned to his written portraits. Their drawing was largely the responsibility of Jacques Eustache de Sève, who devised a neat system of simple yet characterful portrayals of single adults on a foreground stage against economically evocative backgrounds. The result is more visually interesting than the bare portrayal of a specimen, and gives some sense of a specific habitat without attempting to dramatize the presentation or provide a fully "ecological" setting. The lion is the very embodiment of Buffon's description: "the external appearance of the lion detracts not from the noble and generous qualities

of his mind. His figure is respectable, his looks firm and determined, his gait stately. The body of the lion, . . . is so well poised and proportioned, that it may be regarded as a perfect model of strength combined with agility."[44] Standing stoically at the entrance to its rocky lair, the male lion has the clear-eyed look of a sternly benevolent monarch. The giraffe, by contrast, assumes a notably stupid expression. De Sève makes less of the beaver, whose physiognomics present less potential within the traditional framework, and whose greatest attributes are not inherent in its relatively modest appearance. However, it may be possible to sense the beast's intelligence in its bright eye and the power of its compact body.

Even such a high-achieving animal as the beaver is explicable as a product of the processes of nature. A material account of the origin of all created things is adequate to explain historically the origin of animals in all their awesome wonder and variety. In this, he retains a strong echo of the hard Cartesian standpoint:

> What a variety of springs, of powers, and of mechanical movements, are included in that small portion of matter of which the body of an animal is composed! What a number of relations, what harmony, what correspondence among the different parts! How many combinations, arrangements, causes, effects, and principles, all conspiring to accomplish the same design! Of these, we know nothing but by their results, which are so difficult to comprehend, that they only cease to be miraculous from our habits of inattention and our want of reflection.[45]

Viewed from this standpoint, man is the best of machines: "Man, if we estimate him by his material part alone, is superior to the brute creation only from the number of peculiar relations he enjoys by means of his hand and of his tongue; and, though all the operations of the Omnipotent are in themselves equally perfect, the animated being, according to our mode of perception, is the most compleat; and man is the most finished and perfect animal."[46]

In retrospect, it is easy to think that Buffon has set up all the conditions for God to be rendered irrelevant. None of the physical processes he uses to account for the origins of the living world and the achievements of its living creatures require the hands-on intervention of God. This charge of godlessness was explicitly made in 1751 in an anonymous publication, *Lettres à un Amériquain sur l'Histoire naturelle, générale et particulière de Monsieur de Buffon* (Letters to an American on the natural history . . . of M. de Buffon), which originated with René-Antoine Ferchault de Réamur, a pious academician and expert on insects.[47] Citing the famous geometrical bees, Réamur maintained with Montaigne that animals could posses a "genius" in their own right, and that to dismiss them as mere machines was to debase God's Creation as described in Genesis. Yet Buffon openly adheres to the idea of an omnipotent Creator whose presence is everywhere apparent in the conception of the system. The argument from design—namely that the awesome "handiwork" evident in the macrocosm and microcosm necessarily presumed a supreme intelligence at work—was shifted from the Biblical act of divine Creation, in which everything was literally

made as it is now, to a more conceptual position in which God's providence was expressed through processes he alone could have set up. It was part of this providence that humans emerged as rational and social animals, capable of evolving language, the capacity that separates us definitively from the beasts. Man can be said to have a "natural history," and social animals to have an "anthropology." We will later see how close Buffon allowed primates to approach the human. But when everything is weighed up, he maintains unshakeable convictions that man is not just a superior animal, and no animal can aspire to the condition of man. Above all, only man is the privileged recipient of "that pure light, that ray of divinity" that raises his thoughts heavenwards. Humans alone possess immortal souls.

What Buffon's stance helps us recognize, looking back over the incidents covered to date, is the almost unchallenged primacy of the argument from design. Whether the animals and humans were identified as sharing in God's gifts of rationality and emotions, or as machines constructed according to varied levels of ingenuity, the existence of a transcendent designer was not in serious question. Even La Mettrie hesitated to assert that the ultimate cause of natural things was demonstrable in his machinist philosophy. Nature in the profoundest sense remained purposeful as an expression of divine intention. What was to be decided was whether God had determined an absolute boundary between man and beasts. Most took that boundary as self-evident. The arrival in the next century of Darwinian natural selection, however, rendered the very premises of the fierce eighteenth-century debate largely obsolete.

PART 3

GOING APE

Beastly Boys and Admirable Animals

The eighteenth century increasingly witnessed the blurring of the comfortably demarcated borders between humans and animals. This was happening more or less simultaneously in a series of fields. By the late eighteenth century considerable bodies of evidence were accumulating but were far from being brought together under the embrace of an overarching theory. The advance troops of the new evolutionary regime were, in effect, massing on a number of fronts, but were not yet visibly gathered together as a single army with an organized battery of arguments under a single command.

Previous chapters have borne witness to the mechanist challenge of the "human machine" in its most extreme form, and the delusory rise of the automaton to chess-playing competence. Against these examples were pitted the intelligent and soulful animals of Montaigne and La Fontaine. Finally, Buffon, operating in a framework that was neither overtly Cartesian nor anti-Cartesian, offered a materialist view of the origins of humans and animals, while proffering accounts of clever beasts that retained many of the traits in which the humanizers had delighted.

We will turn now to a series of "preludes" to Darwin. We should note that this inquiry is not a determinist history in which a series of imperfect steps march toward some inevitable truth unrealized by earlier contributions. These preludes involve a series of incidents in which the boundaries between humans and animals seemed to be transgressed, sometimes in a worrying manner. First, we will encounter the troubling cases of wild or feral children who seemed to be human beasts. Then we will look at some selected cases from the circus and the freak show. In the former, educated beasts seemed capable of performing humanlike feats beyond what was assumed possible. In the latter, a series of unfortunate human curiosities were paraded as if they were beasts in a zoo.

Finally in this chapter, we will introduce the dynamic view of nature advocated by Georges Cuvier, which conducted a demonstrable dialogue with artists'

characterizations of animals in their natural settings, particularly in French Romantic painting and sculpture.

BEYOND WORDS: THE WILD CHILDREN

Stories of young children who through misfortune find themselves in the wild, bereft of parents and insulated from human society, appear in many cultures. In such circumstances animals necessarily play the nurturing role, providing milk in infancy and training the maturing boys and girls in the ways of the wild. Various animals feature as foster parents. Wolves are probably the most recurrent, perhaps because of their pack instinct, which suggests that they are highly social beasts, at least amongst themselves. In Western cultures, wolves achieved a special status as nurturers through the story of the twins, Romulus and Remus, traditionally regarded as the founders of Rome (and thus directly responsible for all that ensued). As babies they were cast into the Tiber by their hostile uncle, and their cradle washed up on shore. The foundlings were nourished and nurtured by a she-wolf. An ingenious Renaissance variant on the story of the Roman brothers is found on the medal of the mercenary general Niccolo Piccinino, by the founding genius of the medallists' art, Antonio Pisanello. On the reverse of the medal a splendidly characterized griffin, half eagle and half lion, suckles two robust infants (fig. 109). The inscription identifies them as Niccolo Piccinino, whose profile portrait is on the obverse, and Braccio di Montone, under whom Niccolo had learnt his trade as *condottiere*. The beast's mighty collar, inscribed PERVSIA, reminds us that the griffin is the heraldic beast of Perugia, where the two commanders were born. The boys have, as it were, suckled at the breasts of their native city, imbibing the martial valour of its fierce beast.

Outside the world of legend, wild children only feature substantially in the written record in the eighteenth century. It was in the context of the kind of debates we encountered in the previous chapter that they became the subjects of sustained scrutiny by educated society.[1] A few key cases were documented extensively in the quest for evidence about the nature of humans and beasts, particularly in the context of language acquisition. Peter the Wild Boy and Memmie the French wild girl will serve as our main case studies, while our major witnesses are Daniel Defoe, Jonathan Swift, James Burnett (Lord Monboddo), and Etienne Bonnot de Condillac. In both case studies, it is difficult at this distance to disentangle truth from fiction, but I think it likely that both children suffered from more or less severe autism, and had been abandoned by their distressed parents.

The "Wild Boy" had been found in 1726 as a teenager in the woods near Hanover, where he became a cause célèbre in George I's court, before being shipped to London and placed in the keeping of Dr. Arbuthnot, Scottish physician and man of letters. Unable to speak, beyond a few monosyllabic words, Peter, as he was named, became both an object of philosophical scrutiny and a popular sensation (fig. 110). He was subject to lively controversy in the culture of pamphlets that flourished in eighteenth-century London. It is not surprising that the indefatigable journalist

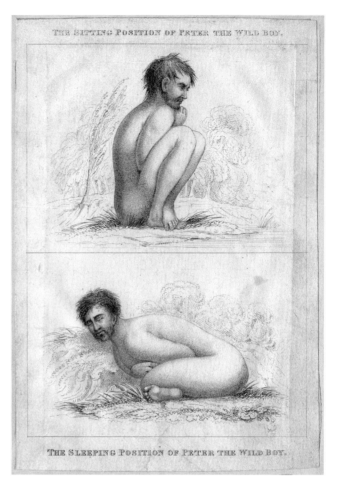

Daniel Defoe became involved. His pamphlet of 1726 bore the trumpeting title, *Mere NATURE Delineated: on A BODY without a Soul. Being OBSERVATIONS Upon a Young FORRESTER Lately brought to Town from GERMANY. With Suitable APPLICATIONS. Also a brief Dissertation upon the Usefulness and Necessity of FOOLS, whether Political or Natural*.[2] Defoe was convinced that Peter was demonstrably "in a State of Mere Nature, and that, indeed, in the literal sense of it." Without the benefits of civilized nurture over the years, Peter remained an animal-machine, devoid of words, divorced from acts of naming, and accordingly without ideas. The wild boy remained locked into an unrealized state in which his essential humanity had not emerged, because of the lack of beneficial shaping influences over his raw soul: "Mere Nature receives the vivifying influence in Generation, but requires the Help of Art to bring it to the perfection of living. The Soul is plac'd in the Body like a rough Diamond, which requires the Wheel and the Knife, and all the other Arts of the Cutter, to shape it, and polish it, and bring it to shew the perfect Water of a true *Brilliant*. . . . the soul, unpolish'd, remains bury'd under the Rubbish and Roughness of its own Powers."[3]

The background for this interpretation is the widespread eighteenth-century conviction in the formative power of advanced human society, in which the directed

109. Antonio Pisanello, *Reverse of the Medal of Niccolo Piccinino*, c. 1441 Museo Nazionale del Bargello.

110. *Peter the Wild Boy*, c. 1726 British Library, London. National Portrait Gallery, London.

experience of enlightened nurture was essential for the development of a truly civilized being, one who is raised above the state of nature. The development of language is the key, not only for the communication of values and knowledge but for the very act of thought itself: "Words are to us, the Medium of Thought; we cannot conceive of Things, but by their names . . . we cannot muse, contrive, imagine, design, resolve or reject, nay, we cannot love or hate, but in acting upon those Passions in the very Form of Words . . . we have no other Way for it."[4]

In this light, Defoe's Robinson Crusoe, on his desert island, is secure in his civilized instincts, since they have been ingrained by nurture, while the erstwhile cannibal, Man Friday, can only realize part of his human potential through contact with the culture of the European castaway. In fact, Friday's special potential could be read through his physiognomy, which does not conform entirely to that of a "savage": "He had a very good countenance, not a fierce and surly aspect, but seemed to have something very manly about his face; and yet he had all the sweetness and softness of a European in his countenance, too, especially when he smiled. His hair was long and black, not curled like wool; his forehead was very high and large . . . His face was round and plump; his nose small, not flat like the negroes, a very good mouth, thin lips, and his fine teeth well set, and as white as ivory."[5] A key apsect of Friday's civilizing is his learning of English, while Peter's lack of language signaled a more animalistic state.

Amongst the pamphlets and commentaries on Peter, two anonymous contributions take a notably independent stance: *It Cannot Rain but It Pours* and *The Most Wonderful Wonder that Ever Appear'd to the British Nation*.[6] In both, Peter's presence in London society is used to turn our perceptions upside down. Rather than portraying Peter as the uncivilized beast in a rational world, we are shown human society for what it is—a farrago of hypocrisy, stupidity, and vicious behavior under a thin veneer of gentility. Once we see the true manner of human duplicity, the animals appear the very soul of rationality—echoing the refrain from Montaigne. Jonathan Swift appears to be the most likely author of the two exceptional pamphlets. We know that he "saw the Wild Boy, whose arrival has been the subject of half of our Talk this fortnight."[7] He reported that the boy "is in the keeping of Dr. Arbuthnot, but the King and Court were so entertained with him, that the Princess could not get him till now. I can hardly think him wild in the Sense that they report him." Arbuthnot, who patiently used encouragement and chastisement in an endeavor to civilize Peter—to no great effect—was a friend of Swift. The pamphlets' inversion of the given order is wholly characteristic of the author of *Gulliver's Travels*, published in exactly the same year as the advent of Peter.

The period during which Gulliver is marooned on the island of the Houyhnhnms is full of resonances with the spectre of the wild children. The intrepid traveler's first encounter is with the Yahoos, who are humanoid yet behave bestially. "Their Shape was very singular and deformed," to such a degree that Gulliver "never beheld in all my Travels so disagreeable an Animal, nor one against which I naturally conceived so strong an Antipathy."[8] They were hairier than Gulliver himself, though not as

hair-covered as apes, with brownish skin and clawed feet. They climbed trees "as nimbly as a Squirrel." Later he makes detailed observations of one Yahoo:

> I observed, in this abominable Animal, a perfect Human Figure, the Face of it indeed was flat and broad, the Nose depressed, the Lips large, and the Mouth wide. But these differences are common to all Savage Nations, where the Lineaments of the Countenance are distorted by the Natives suffering their Infants to lie groveling on the Earth, or by carrying them on their Backs, nuzzling with their face against the Mother's Shoulders. The Forefeet of the *Yahoo* are different from my Hands in nothing else, but the Length of the Nails, the Coarseness and Brownness of the Palms, and the Hairiness on the Backs.[9]

By contrast the Houyhnhnms are morphologically similar to horses but are endowed with supreme rationality and gentility, far superior to the attributes of the modern Britons. Gulliver comes to understand that their whinnies comprise an eloquent language, which he strives to learn. Montaigne would have approved. It is with great reluctance that Gulliver tears himself away from the civilized society of the higher horses to return to the company of the British Yahoos who inhabit his own corrupt world of politics (fig. 111).

111. Sawrey Gilpin, *Gulliver Taking Final Leave of his Master, the Sorrel Nag, and the Land of the Houyhnhnms,* 1786. Courtesy of the Bridgeman Art Library.

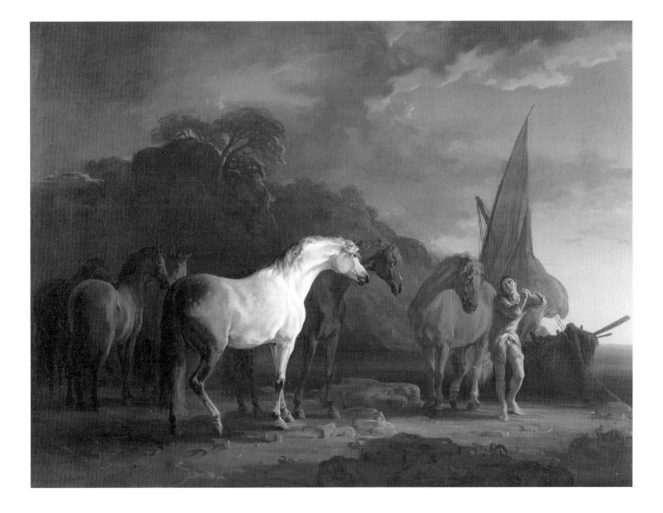

The second eighteenth-century star in the firmament of wild children is the French girl who was accorded the very fancy name of Marie-Angélique Le Blanc, but was more familiarly known as Memmie.[10] In 1731 a group of villagers in the region of Champagne were startled by the frightening apparition of a savage girl of nine or ten who emerged from the woods bearing a club. She was taken up by the Viscount d'Epinoy at Songi, and, like Peter, she became a hot topic of conversation in the salons of the well-to-do and an object of scientific and popular curiosity. Her initial behavior was unquestionably uncivilized: on entering the viscount's château, she seized on some uncooked birds that the cook was preparing and started tearing at the flesh with her teeth. She also skinned a dead rabbit with her bare hands and devoured it raw.

She became the subject of a monograph by Mme Hecquet, the *History of a Young Savage Girl found in the Woods at the Age of Six* in 1755. Her firsthand account of Memmie's discovery and progress was translated into English in 1768 by William Robertson, clerk to James Burnett, the Scottish lawyer and philosopher. Burnett, who inherited the title of Lord Monboddo in 1787, provided the preface for Robertson's translation, in which he stated that the philosophical implications of Memmie's history are entirely clear. The reader is invited to "observe with amazement the progression of our species from an animal to wild, to men such as we. . . . He will discover another state of our nature even beyond that in which this girl was, however near it may seem to the original, I mean the state before language was invented."[11] Burnett's attitude shares much with Defoe's, but he blurs the boundaries between reason and sensation in a way that Defoe does not. He points out that "superior faculties . . . are . . . *adventitious* and *acquired,* being only at first *latent powers* in our nature, which have been evolved and brought into exertion by degrees. . . . The *rational* man has grown out of the mere *animal,* and that *reason* and *animal sensation,* however distinct we may imagine them, run into one another by such insensible degrees, that is as difficult, or perhaps more difficult, to draw the line betwixt these two, than betwixt the *animal* and the *vegetable.*" Hecquet, having reviewed Memmie's characteristics, comes to the anthropological conclusion is that the wild girl is actually an Eskimo—a case of a relatively unknown race providing a taxonomic repository for the otherwise unclassifiable.[12] This was not a conclusion that Burnett was inclined to take seriously.

Peter and Memmie are philosophically reassessed by Burnett in his magnum opus, *Of the Origins and Progress of Language,* published in six volumes in 1773–79. His great study is now less widely read than other major works of the Scottish Enlightenment, but it exercised a considerable international impact at the time. Burnett had the opportunity to study Peter and Memmie firsthand, the latter on a visit to Paris 1665, where he also inspected stuffed specimens of the orangutan in Buffon's Jardin des Plantes. We will see later that the orangutan had become renowned for its humanoid qualities. Burnett also observed two living orangutans in London, and was more impressed by their potential for civilized behavior than he had been by Peter's. Since language acquisition was the key moment in the "ascent" of humans from the primitive condition in which they arose, Burnett can set Peter, the orangutan, and

Memmie in a continuous sequence in the great chain of being. Peter is silent and bestial; the orangutan is clearly sociable and may posses some potential for speech, while Memmie proved susceptible to civilizing and language instruction to some degree. The orangutan itself might even be considered as a kind of man, stranded in nature, outside society, and therefore devoid of speech.

In a comparable way, Condillac used the evidence of wild children to support his arguments about what separates humans from beasts, and what unites them. The arguments were rehearsed in his seminal *Essay on the Origin of Human Knowledge* in 1746.[13] He specifically cited evidence from Christian Wolf about a Russian wild boy: "In the forests between Russia and Lithuania a boy of about ten, who lived among the bears, was found in 1694. He gave no sign of reason, walked on hands and feet, had no language, and formed sounds that had nothing in common with human sounds. It took a long time before he could utter a few words, which he still did in a very barbarous manner."[14] The boy could not remember anything about his former state, which does not surprise Condillac, since the acquisition of language and consciously accessed memory are utterly interdependent. He explains that

A child raised among bears has only the use of the first [kind of sign, to be outlined below]. It is true that we cannot deprive him of the cries that are natural to each passion, but how would he suspect that they are suited to become signs of the sentiments he feels? If he lived among other people he would so often hear them utter cries similar to his that sooner or later he would connect their cries with the sentiments they are intended to express. The bears cannot offer him the same occasions; their roar does not offer sufficient analogy with the human voice. In their own intercourse, the animals probably connect their cries with the perceptions of which they are signs, but this is what this child did not know how to do.[15]

In this sense, the bears within their own natural society are in advance of the displaced boy.

Condillac's theory of understanding and consciousness entailed three grades of signs in the world of animals and humans. The first sign, mentioned above, comprises "accidental signs, or the objects that some peculiar circumstances have connected with some of our ideas so that those ideas may be revived by them."[16] The second consists of "natural signs, or the cries that nature has established for the sentiments of joy, fear, pain, etc." The third and highest level is provided by "instituted signs, or those that we have ourselves chosen and have only arbitrary relation to our ideas." The first is associational without reflection, while the second is automatic in the first instance, even if it can be instituted culturally. The third relies upon the ability to recall things at will, according to our conscious control over imagination, memory and processes of signification.

Within this framework, Condillac asserts that "animals do not have memory and . . . they only have an imagination which they cannot direct. They represent something absent to themselves only to the extent that the image in the brain is closely

connected with the present object. Recognizing signs of predators or where food may be available is dependent on experience, but "animals cannot, like us, by themselves and at will recall the perceptions that are connected in their brains." They depend on "instinct" not on conscious control. And it is a consideration of the nature of instinct that leads Condillac to a conclusion that challenges the whole of the Cartesian inheritance on animal souls: "Some have placed instinct next to or even above reason; others have rejected instinct by taking the animals for pure automatons. Both opinions are equally ridiculous to say no more. The similarity between animals and us proves that they have a soul. The difference between us proves that it is inferior to ours. . . . The operations of the animal soul are limited to perception, consciousness, attention, reminiscence, and to an imagination which is not at their command, whereas our possess additional operations."[17]

These "additional operations" are signaled above all by a man's ability "to attach ideas to signs he himself has chosen" which is accompanied by the formation of memory.[18] And it is only when "memory has been acquired" that a human being "begins to achieve mastery of his own imagination and to give it a new exercise, for by the assistance of signs he can recall at will." The limited capacities of animal souls are proved by the fact that many of them possess bodies that exhibit anatomical features that could potentially be used for speaking. Man is therefore wholly distinct as the language-making animal, but there is an essential continuity between the powers that human and animal souls endow in their bodies. This essential continuity was to become increasingly apparent in a number of arenas as the century progressed.

PUBLIC SHOWS:
LEARNED PIGS, NOBLE BEASTS, AND HUMAN BRUTES

During the later eighteenth and nineteenth centuries, the staging of public spectacles underwent a huge expansion, fuelled not least by the rising wealth, educational level, leisure, and travel ambitions of the growing middle class. The human animal in many guises was a prominent actor in many of the spectacles. The circus, museum-style collections, "freak shows," zoological gardens, and traveling menageries all tapped into the rich vein of animalized humans and humanized animals.

The advent of the modern circus was predicated on a variety of earlier public and aristocratic entertainments, but at its center was the science and art of horsemanship. If anyone is to be recognized as the founder of the circus it is Philip Astley, formerly sergeant major in the Light Dragoons, who was fully versed in the military schooling of horses.[19] The schooling entailed teaching the animals to operate in situations of extremis that took them far beyond their natural realms and perceived temperaments. Astley's first establishment was a "riding school" in Lambeth, founded in 1768. In his book *The Modern Riding Master,* published in 1775, he tells us in the introduction that we must in effect be a physiognomist of horse character if we are to chose a suitable companion. Anyone selecting a horse must look above all at the windows of the horse's soul, seeking a creature possessed of "Eyes bright, lively,

resolute and impudent; that will look at an Object with a Kind of Disdain. We may discover by the Eye his Inclination, Passion, Malice, Health and Indisposition; the Eye is the most tender Part of the Frame."[20]

Astley's commercial enterprise grew into a rounded public spectacle, staged in specially constructed "amphitheaters," not only in London but also in Paris and Dublin. The rival Royal Circus was inaugurated in 1782, taking its name from the Roman arena in which chariot races and other public spectacles had been mounted. The trained horse at the heart of new circuses was literally a creature of man, and did not transcend its nonhuman nature without our instruction. Astley proclaimed in his "Prologue on the Death of a Horse" in 1768 that the performance of a horse "playing dead" demonstrated "how brutes by heaven were design'd / To be in full subjection to Mankind."[21] After feigning death, the recumbent horse rose to its hoofs on being exhorted to serve a famous contemporary general, who had distinguished himself in the wars against France.

What was possible if beasts were granted human education proved to be increasingly remarkable—at least in staged performances. There was, in the competitive environment of all kinds of public entertainment, an unceasing demand for novelties. Humanized animals were trained to perform more and more improbable feats. Thus the "Little Learned Military Horse" in 1770 performed such tricks as firing a pistol, "as if he understood every word."[22] He was in turn trumped by Billy, the "Little Speaking Horse" in 1799. A rope-dancing monkey, General Jacko, took breakfast in uniform with Mme de Pompadour (a suitably attired dog), and rode a "richly caparisoned" dog in a "Triumphal Entry" in 1785.

The leading intellectual was the "Learned Pig," which (or who) enjoyed a stellar career in 1784–88, speaking with the assistance of letter cards, undertaking mind-reading, and performing card tricks.[23] For many, the clever beasts were mere diversions, but, given the range of people attracted to the circus, which began as a relatively up-market spectacle, there were those who were to set thinking in print. Sarah Trimmer, for one, was alert to the implications of the Learned Pig's achievements when she wrote her moralizing children's stories: "'I have,' said a lady who was present, 'been a long time accustomed to consider animals as mere machines, actuated by the unerring hand of Providence, to do those things which are necessary for the preservation of themselves and their offspring; but the sight of the Learned Pig, which has lately been shown in London, has deranged these ideas and I know not what to think.'"[24] The pig features with other of Astley's star performers (including General Jacko riding a large dog) in Samuel Collings's satirical engraving, *The Downfall of Taste and Genius or The World as it Goes* in 1785 (fig. 112). Astley's surging rabble of human and animal performers throw the muses of the arts into disarray, trampling books by Shakespeare and Pope underfoot—a comment on the way that the circus was considered to be subverting public taste. Painting and sculpture have both gone down in the onslaught.

Complementing the educated animals were the really wild beasts, particularly the exotic species from Africa and elsewhere that became increasingly popular in the

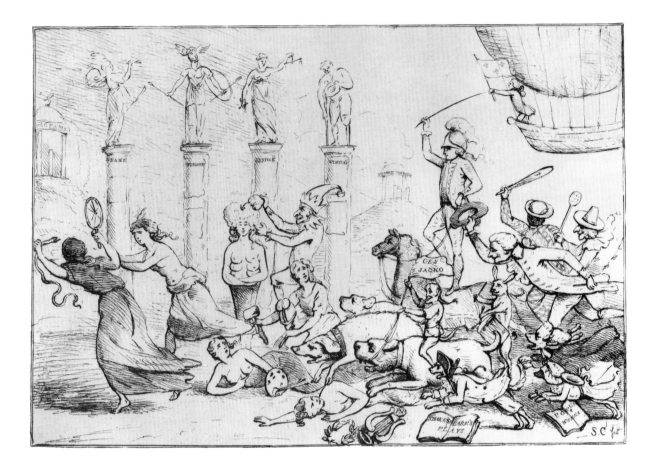

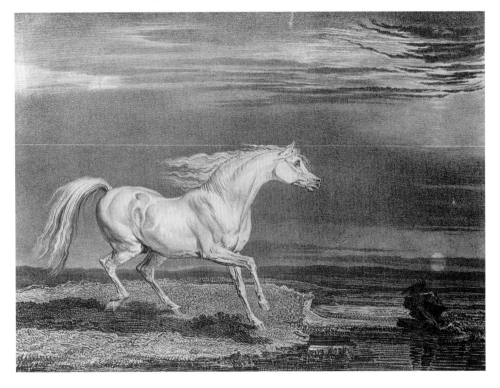

nineteenth century. Horses could play both roles, tame and wild. The "hippodra-ma" became a favorite genre, featuring daring and cacophonous tales set in extrava-gant locations, replete with equestrian combats and burning castles.[25] The horses, not the humans, were the star actors, emulating Keene and Kemble in their Le Bru-nian expressions, which extended from untamed fury to civilized obedience. The horse, spectacles were the very epitome of Romantic drama, particularly as they were made progressively more wild and exotic to retain public interest.

In 1822 *The Life, Death and Restoration of the High-Minded Racer* told the mov-ing life-story of the champion's degrading slide from admired thoroughbred to the knacker's cart. Finally, the neglected hero was rewarded after death by a place in the "Grand Palace of ннодумнs."[26] Five years later, the manager of Astley's staged a stirring combat of "Ferret Horses," which fought "as when in a Wild Ungovern-able State of Nature."[27] If we look at the wild, high-spirited horses of James Ward in England (fig. 113) or Theodore Géricault in France, it is not hard to see how cir-cus and "high art" were expressing a shared sensibility, in which the horse was ef-fectively standing as a surrogate for those untamed dimensions in our own nature that seemed increasingly evident as a constitutional fact. The published print after Ward of Napoleon's famous charger, Marengo, named after one of the emperor's victories, precisely captured the nervous sensibility admired in a high-bred horse. The training of such "wild" animals to behave in a disciplined manner was in effect a mirror of the proper education of humans.

The surviving visual legacy of the early circus, like that of the theater, gives only a partial idea of the power of the visual spectacle that captivated audiences around 1800. Some sense of the visual dramas that enticed the audiences—and a good idea of the way that circus drew upon "high culture"—is provided by Astley's poster for a staging of *Mazeppa* (fig. 114), the violent poem by Lord Byron. The show was first produced in 1831 under the famous manager and performer Andrew Ducrow (John Astley had died in 1820). The image on the poster shows the Polish nobleman strapped to the back of a fiery Ukrainian steed, the punishment meted out by the regal husband of his lover.

OPPOSITE

112. Samuel Collings, *The Downfall of Taste and Genius or The World as it Goes*, 1785.

113. James Ward, *Marengo, Napoleon's Charge at Waterloo*, published by Robert Ackermann, 1824. Courtesy of the Bridgeman Art Library.

> "Bring forth the horse!"—the horse was brought;
> In truth, he was a noble steed,
> Who looked as though the speed of thought
> Were in his limbs; but he was wild,
> Wild as the wild deer, and untaught,
> With spur and bridle undefiled—
> 'Twas but a day he had been caught;
> And snorting, with erected mane,
> And struggling fiercely, but in vain,
> In the full foam of wrath and dread
> They bound me on, that menial throng,
> They loosed him with a sudden lash—

114. Astley's poster for *Mazeppa,* 1824. Image courtesy of the Harvard College Library.

Away!—away!—and on we dash!—
Torrents less rapid and less rash.[28]

Wild horse and helpless rider stampede crazily onwards, through seemingly interminable hazards. The specific moment depicted is when Mazeppa's onrushing horse emerges from a river.

With glossy skin, and dripping mane,
And reeling limbs, and reeking flank,
The wild steed's sinewy nerves still strain
Up the repelling bank.
We gain the top. A boundless plain
Spreads through the shadow of the night,
And onward, onward, onward, seems,
Like precipices in our dreams.
Above flies an ominous vulture awaiting its feast of carrion.[29]

While bearing its human burden through hideous tortures, the horse instinctively returns to its homeland, where it collapses dead. Mazeppa, himself more dead than alive, is slowly nursed back to life by the peasants who had found him. Through subsequent acts of valour he rises to become a Ukrainian prince. Mazeppa's horse, from the exotic land of the Cossacks, is characterized by Byron as a wild beast, unbroken for human riders; yet it possesses a natural nobility and heroism fit for Mazeppa himself.

Even the more apparently staid world of public museums participated in the nineteenth-century parade of the exotic, the primitive, the wild, the untamed, and the semihuman—perhaps not surprisingly given the antecedents of the museum in the cabinets of curiosities of the Renaissance and Baroque eras. Frequently anthropological material and splendid artifacts from exotic societies were placed in museums or sections of museums centered on Natural History rather than in those devoted to the "Fine and Applied Arts" in the Western sense. This could even apply to such products as Chinese and Japanese painting and calligraphy. It was certainly the case with the majority of the artistic productions of "natives" and "Negroes."

Probably the most extraordinary of the nineteenth-century "Cabinets," in the light of our present concerns, was assembled by Charles Waterton, traveler, natural historian, collector, taxidermist, pioneer of nature reserves, Catholic mystic, aristocratic Yorkshireman, and all-around eccentric.[30] During the first two decades of the century, Waterton lived and traveled extensively in South America, particularly in Guyana. The specimens he brought back to Walton Hall, his family seat, were subjected to taxidermy that aimed both to preserve the external features of the animals and to reinstate their living demeanor. What is surprising about the collection now housed in Wakefield Museum is that it contains some confected monsters, akin to those in earlier cabinets such as Aldrovandi's. Waterton's monsters were self-conscious and ironical. Two were satirical: a porcupine weighed down with a tortoiseshell and assaulted by lizard-devils represents "John Bull and the National Debt" (which amounted to £800); while a "Noctifer," compounded from an eagle owl, a bittern, and a partridge, symbolized "the Spirit of the Dark Ages, unknown in England before the Reformation"—a typically anti-Protestant sentiment.[31]

The most unsettling of Waterton's taxidermy fantasies was the mounted bust of a strange humanoid with a vague resemblance to an Eskimo, which he labeled

as *The Nondescript*—using the established term to denote something new to science and that lay outside the descriptive categories of stock taxonomies (fig. 115). Waterton's varied statements about the origins of this strange specimen served as a deliberate tease, although in his *Wanderings in South America* in 1825 he indicated that it was a virtuoso demonstration of his transformative skill as a taxidermist: "If I have succeeded in effacing the features of a brute, and putting those of a man in their place, we might be entitled to say that the sun of Proteus has risen in our museums . . . we can now give to one side of the skin of a man's face the appearance of eighty years, and the other that of blooming sixteen."[32] The human visage was in fact made from the skin of a howler monkey. Waterton is in effect setting himself up as a kind of Dr. Frankenstein of taxonomy, able to reconfigure natural species and even to cheat time. *The Nondescript,* like so many of the taxonomy-breakers of the nineteenth century, fascinated because of its very ambiguity.

115. Charles Waterton, *The Nondescript,* Wakefield Museum, c. 1820–25. Courtesy of Wakefield MDC Cultural Services.

OPPOSITE

116. *The Living Aztecs,* c. 1885, Ringling Museum of the Circus, Sarasota, Florida. Ronald G. Becker Collection of Charles Eisenmann Photographs, Special Collections Research Center, Syracuse University.

Alongside these displays of weird beasts and semihuman creatures ran a demeaning parade of real human oddities. These were the human "freaks" who seemed, like the feral children, to have descended into the base realm of animal existence—or, in the case of "primitive races," not to have risen from their lowly state. The sorry history of traveling shows, often consisting of a single malformed or retarded individual traveling from place to place with a "keeper," is a long one. Again, I will select examples in which scientific curiosity was openly invoked. The two I have chosen are from the arena of the great American showman, Phineas Taylor Barnum. This is to be followed by a brief glance at zoos and traveling manageries.

Although we now think of Barnum as the founder of a great and enduring circus, his most cherished enterprise was the American Museum, founded in 1841 when he purchased an existing museum in New York City. The old setup was revitalised to become a fashionable family entertainment in which living human oddities played a prominent role beside other curious things. In this, Barnum was picking up an eighteenth-century fashion for parading living freaks and the even longer tradition of displaying deceased human "monsters" in museum-style collections of curiosities.[33] The atmosphere cultivated by Barnum compounded sensation, education, and popular science. The star attractions included an Albino family, two "Living Aztecs," the "Swiss Bearded Lady" and the "Fat Highland Boys."[34] The "Living Aztecs" were a microcephalic brother and sister, of small stature and strange appearance who were endowed with a fabricated history that claimed them to be survivors of a sacred race worshipped in the ancient Aztec kingdom. They were hailed in the press as rare "specimens of a dwindled, minikin race" (fig. 116). They also attracted serious ethnographic attention. On a visit to London in 1853 they were introduced

to the royal family and paraded before the Ethnographic Society. Further royal and imperial audiences followed in Paris, Prussia, Bavaria, Holland, Hanover, Denmark, Austria, and Belgium, with concomitant public and scientific interest. There was a sense in which those involved with the human sciences were only too keen to discover firsthand surviving links with the distant past of primitive societies.

The most striking career amongst all the human exhibits was that of William Henry Johnson, a microcephalic black man under five feet tall, who was born in the United States around 1840.[35] Whatever his real origins, which were effectively suppressed, he was certainly not captured by intrepid explorers searching on the River Gambin for gorillas, as was publicly proclaimed. Originally exhibited as "What Is It" (and more succinctly known as "Zip"), Johnson survived the closure of Barnum's American Museum to star in circuses until the 1920s. In 1860, reacting with opportunistic speed to the sensation caused by Darwin's *The Origin of Species,* the American museum publicized him as "The Man-Monkey" who is "a most singular animal, which, though it has many features and characteristics of both the human and the brute, is not, apparently, either, but, in appearance, a mixture of both—the connecting link between humanity and brute creation."[36] The literature issued by the museum exploited a consciously scientific tone:

> When first received here, his natural position was on all fours, and it has required the greatest care and patience to teach him to stand perfectly erect . . . When he first came his only food was raw meat, sweet apples, oranges, nuts etc., of all of which he was very fond; but he will not eat bread, cake, and similar things . . . the formation of the head and face combines both that of the native African and of the Orang Outang . . . , he has been examined by some of the most scientific men we have, and pronounced by them to be a CONNECTING LINK BETWEEN THE WILD NATIVE AFRICAN AND THE BRUTE CREATION.[37]

The press propagated the myth, with the *New York Tribune* confirming that "it seems to be a sort of cross between an ape species and a Negro."[38] Photographs by Mathew Brady (fig. 117), whose adjacent studio helped to establish him as the favorite photographer of the museum, show Johnson kitted out in a monkey suit, holding a pole and with a supporting landscape, in exactly the manner favored for the illustration of advanced primates by Buffon and others, as we will shortly see.

It is easy to be disgusted by the exploitative culture that took commercial advantage of children and adults with unusual attributes. However, some of the unfortunates appear to have relished the attention and benefited financially. Johnson seems to have cooperated willingly in the suppression of his origins, sustaining his apparent inability to speak, keenly protecting his status as the leading freak and actively furthering his own lucrative career as circumstances changed in the entertainment industry.

The comparable parading of trained animals in the circus nowadays evokes wider unease than in past eras. It is difficult to generalize about the training of animals, since some of the more commonly domesticated creatures, such as the dog, seem to

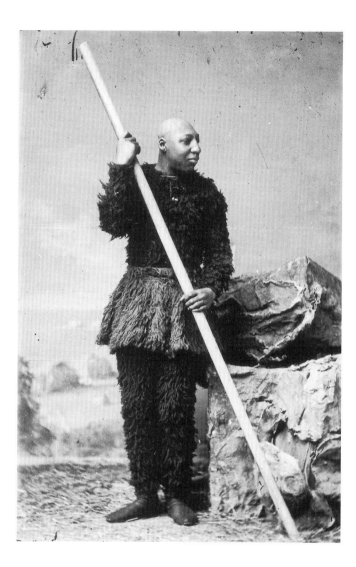

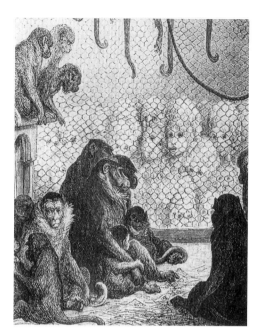

117. Mathew Brady, *Photograph of William Henry Johnson,* c. 1870, Meserve Collection, National Portrait Gallery, Smithsonian Institution, Washington D.C. / Art Resource, NY.

118. Gustave Doré, *The Monkey House,* 1872.

gain pleasure from the performing of tricks, and develop close rapport with their trainers. It is probably the case that the "wilder" the animal, the more oppressive are the acts of training.

Complimenting the rise of the circus, museum, and "freak show" was the transformation of zoos from elite possessions to public spectacle during the nineteenth century.[39] The international industry of displaying living animals in popular zoos was accompanied by a burgeoning business in traveling shows, often in association with circuses or fairs. The demand for animals supported a substantial and generally unhappy trade in "exotics." The Hagenbeck of Hamburg, operating though the major port town, spanned the full range of the business, from hunting, through export and import, to virtually every kind of exhibition and show. At the peak of the Hagenbeck business, they were supplying as many as twelve thousand rhesus monkeys a year.[40] The somewhat unnerving experience of reciprocal staring in a monkey house became a centerpiece of the zoo experience. The underlying ambiguity of the observer and the observed is neatly encapsulated in Gustave Doré's woodcut in 1872 (fig. 118). Carl Hagenbeck was a noted animal "tamer," pioneering methods

that eschewed the red-hot irons that were the standby of earlier performers, while retaining the ubiquitous whip. The taming of the big cats testified simultaneously to human sovereignty over even the most menacing realms of the animal kingdom and to the mental ability of animals to learn simple human tricks, often of a comic kind. At the more risible end of the business, chimps became the star performers, and the ever-popular tea party became the stock setting for lively displays of what was taken for cheerful naughtiness.

A good idea of the air of the itinerant spectacles can be gained from Paul Meyerheim's 1864 painting of the *Menagerie of Herman and Wilhelm Van Aaken* (fig. 119). Typically, following the wondrous parade of the beasts through town, curious locals would be enticed into a canvas enclosure within which the living exhibits were displayed along aisles smelling of straw and excreta. Meyerheim's painting confirms the anthropomorphizing tendencies that were always prominent in the audience reaction. The pendulous lip of the Herculean barker, standing triumphantly on the box of his "python," is satirized in the comic expression of the Bactrian camel beside his elbow, while the bright-eyed man with a luxuriant beard, standing on the left of the

119. Paul Meyerheim, *Menagerie of Herman and Wilhelm Van Aaken,* 1864, Collection of Inge and Werner Kourist, Stiftung Stadtmuseum, Berlin.

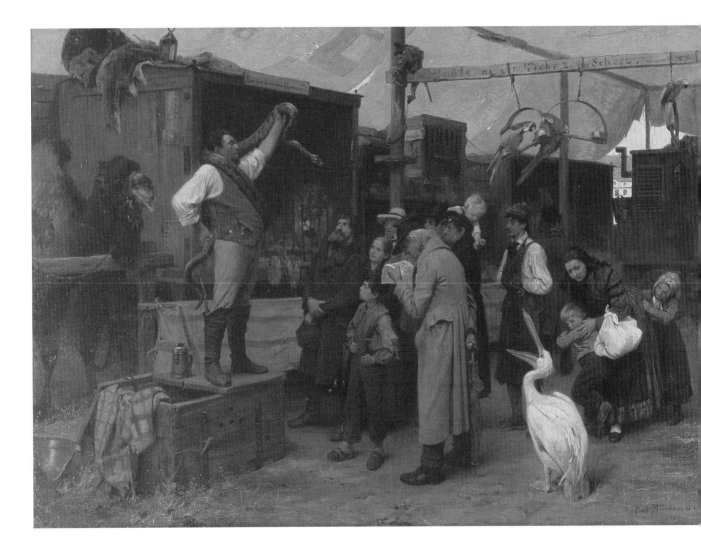

group of onlookers, is tellingly juxtaposed with the maned lion in its wheeled cage. The two colorful parrots conduct a squawking family argument, while the pelican provides its own commentary as the kind of narrator who was a stock in trade for academic painters telling a story.

The entrepreneurs of popular animal shows, fixed or itinerant, regularly broadcast the educational value of their exhibits, echoing the better-founded claims of some of the zoological gardens, in which scientific research was genuinely conducted. In all these contexts, the boundaries between the ethnographical and the zoological were fluid. In the fifty years on either side of 1900, traveling shows of such exotic races as Laplanders, Nubians, Sinhalese, and Eskimos featured prominently in zoological gardens as well as in circuses and side-shows. If a crocodile could be accompanied by a "negro" in a leopard skin, so much the better for the spectacle. In 1878 a group of Eskimos were put on parade in the Berlin zoo, complete with huskies, sledges, kayaks, and deerskin shelters (in lieu of igloos).[41] Fantasies on exotic architectural styles—Indian pagodas, Egyptian temples, Arab mosques, Siamese palaces, and suchlike—were commonly used in the design of permanent housing for imported species in zoological gardens, just as they featured in the staging of botanical gardens. The staging of the more popular shows was eternally opportunistic, exploiting such generalized concepts as paradise (in the prelapsarian sense), the prehistoric primitive, the unredeemed pagan, and the untamed jungle. Human exhibits served vividly to give these conceptual frameworks a greater sense of historical and geographical reality.

All in all, the great parade of animal-centered spectacles during the period 1750 to 1850 exploited a complex nexus of ideas and assumptions about the exotic and strange, embracing a continuous spectrum from the scientific to the sensational, and from the educational to the crudely exploitative. The collective effect was to gnaw at the tidy boundaries between human and animal societies that had comforted earlier generations.

WILDLIFE

Stories of the behavior of animals in their environments had been a conspicuous feature of natural history books in the succession from Gesner, and indeed in their ancient sources, such as Pliny. Buffon, as we have seen, went out of his way to collect evidence about animal habits. As the creation myth broke down, so a more dynamic view was emerging of the interaction of fauna and flora with their changing environments and with each other. The kind of interaction of animals with their environment that we find in animal art in the Romantic era—commencing as early as the 1760s with George Stubbs in England—was permeated by conflict and the struggle for existence.

In the first half of the next century, Georges Cuvier's hugely influential *La règne animal,* first published in 1817 and widely translated, played a key role in the reconceptualizing of the relationship of the parts of nature. Abandoning the linear chain

of being, he envisaged four large groupings of types of bodily organization: vertebrates, mollusks, articulates (insects, etc.), and radiates (with basically circular forms). Cuvier derived these body types from his unrivalled studies of comparative anatomy he was conducting at the Jardin des Plantes in Paris. Each type granted its possessors a certain set of advantages within their particular settings. Within each type, the potentially infinite variations on the basic pattern indicated precise adaptation to particular ways of life. The environmental contexts had undergone large-scale changes, as Buffon had argued, and differently adapted species appeared at various stages in the long span of the history of the earth. They were subject to catastrophes that rendered some of them extinct. The morphological relationships between the related body types could better be envisaged as a tree rather than a chain, but Cuvier's branching system was not a device to indicate the temporal translation of one species into another. The tree carried no evolutionary implications for Cuvier, but was a way to represent the orderly system of God's logical Creation.

Cuvier's view of genuses and species as holistically adapted to their particular habitats involved the dynamic interaction of all the animate and inanimate elements in the environment. Life was a perpetual struggle, within the context of the complex and fluctuating interrelationships between all the factors that bore in upon the life of each organism. The interactions of the dynamic parts involved laws that stood outside the organisms themselves:

> Natural history has . . . a principle on which to reason, which is peculiar to it . . . ; it is that of the conditions of *existence,* commonly termed *final causes*. As nothing can exist without the concurrence of these conditions which render existence possible, the component parts of each must be so arranged as to render possible the whole living being, not only with regard to itself, but to its surrounding relations; and the analysis of these conditions frequently conducts to General laws, as demonstrable as those derived from calculations and experiment.[42]

In our post-Darwinian world, it takes an effort not to see Cuvier's system, with its struggle for survival, adaptation, and successive extinctions as prefiguring the tenets of natural selection. But his conceptual framework demonstrates the coexistence of tensive concepts in the early nineteenth century: it is possible to harbor ideas of temporal change and dynamic interaction, together with a fully developed sense of comparative anatomy, and at the same time accept the fixed integrity of God's serial creation of species. The species was the fixed concept, around which other notions were forced to orbit.

Whether Cuvier's view was evolutionary or not made no difference to artists' portrayals of animals in his dynamic vein. To see the striking way that his vision took root in the artistic characterizations, we do not need to leave Cuvier's beloved Jardin des Plantes. Antoine Louis Barye, the greatest of all the French *animaliers*—the "school" of sculptors who specialized in bronzes of powerfully characterized creatures—was invited to witness Cuvier's dissection of a lion at the Jardin in

1829. He was accompanied by no lesser pioneer of Romanticism than Eugène Delacroix, whose turbulent pictures of exotic hunts became part of his stock-in-trade (figs. 120 and 121). The sketches by Delacroix show that Cuvier set the lion in a menacing posture, exploiting the lifelike mode commonly adopted for *écorché* statues of humans. Barye was particularly concerned to measure the animal's dimensions. Delacroix's first pictorial response seems to have come in a fiery painting of a *Lion and Tiger* (fig. 122) in which the essential wildness of the competing beasts is incontestably apparent.[43] The critic, Théophile Gautier, a great enthusiast for Delacroix's ferocious hunts, described the artist himself as endowed with "tawny, feline eyes, with thick, arched brows, and a face of wild and disconcerting beauty; yet he could be as soft as velvet, and could

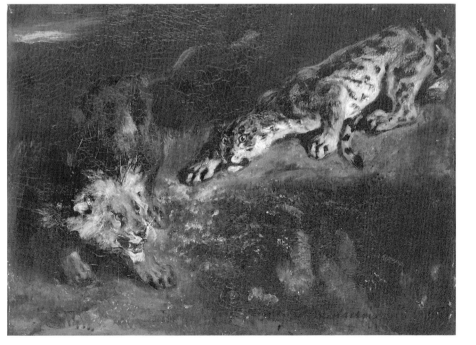

120. Antoine Louis Barye, *Écorché Lion,* 1829, Cabinet des Dessins, Musée du Louvre, Paris. École Nationale Supérieure des Beaux-Arts.

121. Eugène Delacroix, *Écorché Lion,* 1829, Cabinet des Dessins, Musée du Louvre, Paris. Photograph: Réunion des Musées Nationaux / Art Resource, NY.

122. Eugène Delacroix, *Lion and Tiger,* 1829, National Gallery, Prague © National Gallery in Prague, 2005.

be stroked and caressed like one of those tigers whose lithe and awesome grace he excelled in painting."[44]

Barye, in keeping with his specialized interest in the morphology of animals, which had already lead him to make studies in Cuvier's Musée d'Anatomie Comparée, noted the chief measurements of the lion's body, not least for proportional purposes. A versatile painter, draughtsman, and sculptor, Barye's most notable achievement was to raise the genre of animal art to a newly heroic level, in emulation of classical narratives of humans in action and ancient figure sculpture. A major tool was the forceful characterization of the essential natures and emotions of his protagonists—Leonardo's *il concetto dell' anima*—in a way that exploited the animals' physiognomic and pathognomic in relation to those of humans. A central notion in the kind of comparative anatomy exemplified in Cuvier's Musée (fig. 123) was to disclose the commonality of mammalian body plans (not least their skeletal frameworks), and Barye would have found strong anatomical support for his sense of the commonality of expressive action between animals and humans. It comes as no surprise that his monumental bronze of a *Lion Crushing a Serpent* in 1836 (fig. 124) should openly endow the beast with a fiercely imperial air.[45] Sometimes characterized as the "Lion of the Zodiac," it alludes to the propitious astrological timing of the July

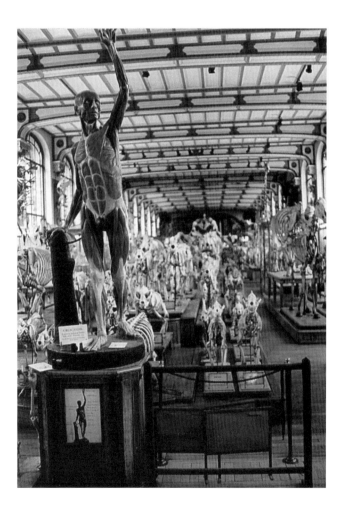

123. Albert Gaudry, *Parade of Skeletons and Écorché Man,* 1898, Gallery of Comparative Anatomy, Jardin des Plantes, Paris.

OPPOSITE

124. Antoine Louis Barye, *Lion Crushing a Serpent,* 1836, Musée du Louvre, Paris. Photograph: Réunion des Musées Nationaux / Art Resource, NY.

Revolution in 1830 that swept Louis-Philippe to the throne. Barye's numerous smaller bronzes were widely marketed by his firm Barye & Cie, becoming all the rage in well-to-do homes and feeding the same appetite for animal exotica that encouraged the rise of zoological gardens, menageries, and the circus. Appropriately, he was appointed master of Zoological Drawing at the Musée d'Histoire Naturelle in 1854.

Cuvier's writings reached a wide international audience. The illustrator of one of the popular English editions of *The Animal Kingdom* was Thomas Landseer, whose brother Edwin assumed a dominant position in the world of animal art in nineteenth-century Britain. Thomas's illustrations often convey an appropriately characterful vision of the species that played particular roles in their niches within animal society. Thomas's *Orang Outang* (fig. 125) is characterized in keeping with one of the eye-witness accounts quoted in the English edition of 1827, which describes

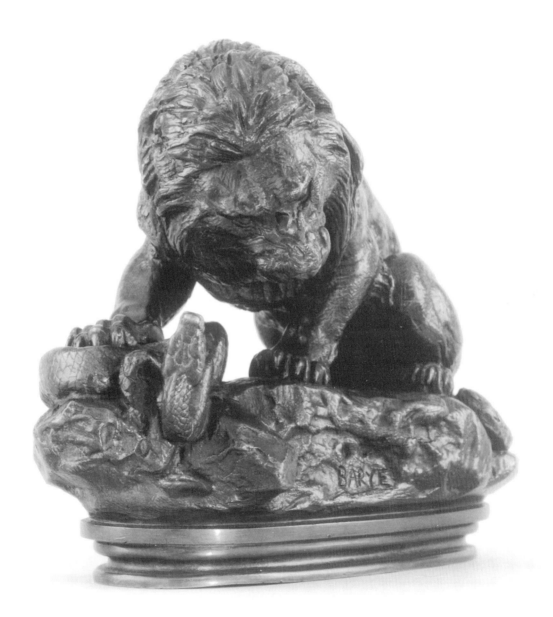

the animal as manifesting "gravity, approaching to melancholy and mildness . . . sometimes strongly expressed in his countenance, and seen in the characteristics of his disposition."[46] Yet Cuvier himself is at pains to stress he does not accept the legends of the orangutan's essentially human attributes: "those wonderful wild men of the woods have lost much of their marvellous charm when subjected to the examination of attentive and judicious naturalists."[47]

It was Thomas Landseer's brother Edwin, who was to give the newly dynamic vision of animals in their special contexts its fullest artistic expression in Britain. Almost inevitably, in an art that had to stand alongside grand history painting in the Academy, anthropomorphizing came to the fore, not infrequently with doses of portentous

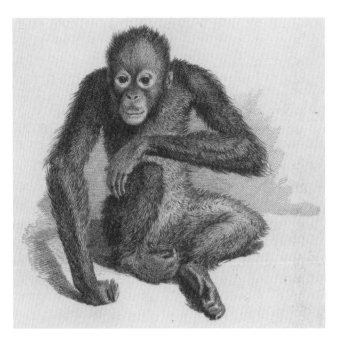

125. Thomas Landseer, etching *Orang Outang,* 1824, from Baron Georges Leopold de Cuvier's *The Animal Kingdom arranged in conformity with its organization, by the Baron Cuvier, with additional descriptions of all the species Names, and of many not before Noticed, by Edward Griffith and others,* London, 1827–35, The Bodleian Library, University of Oxford. 189 e.266, vol. 2.

OPPOSITE

126. Edwin Landseer, *Monarch of the Glen,* 1851. United Distillers and Vintners / Bridgeman Art Library.

symbolism and allegory. With engaging portrayals of humanized dogs and subjects drawn from hunting, Edwin worked variations on traditional narrative themes, as in his *Cat's Paw* (c. 1824), derived from a popular fable, in which a cunning monkey seizes the paw of an agonized cat to extract chestnuts from a hot fire. He was a keen student of animal anatomy, dissecting (amongst others) the corpse of a lion. Edwin Landseer's most spectacularly famous images were the huge bronze lions at the base of Nelson's column in Trafalgar Square, and the large painting of the *Monarch of the Glen* (fig. 126). Originally intended for a decorative scheme in the refreshment room in the House of Lords, the *Monarch* was exhibited in 1851 as an independent picture.[48] Disseminated like his other major inventions in a grand print by Thomas (and now proudly owned by a whiskey company), the image of the majestic stag exemplifies his anthropomorphizing tendencies at the highest level. With a regal set of twelve-point antlers and commandingly aristocratic eye, the great stag is indisputably lord of his romantic Scottish domain, and is supremely adapted to the particular demands of the Highland environment of mountains and glens. We also know, of course, that he was renowned as a quarry fit for the greatest human monarch.

In Britain as in France, animal art and illustration enjoyed a huge vogue in the mid-nineteenth century. The leading specialist animal illustrator in Britain—equally at home in the artistic and zoological arenas—was Joseph Wolf, whom we have encountered in chapter 2 as one of the illustrators of Darwin's *The Expression of the Emotions in Man and in Animals.* Born and educated in Germany, Wolf moved to London in 1848, enjoying a highly successful career for fifty years.[49] He collaborated internationally with such major naturalists as John Gould, Philip Henry Gosse, Hermann Schlegel, and Daniel Elliot. His great colored lithographs were famed for their exceptional combination of precision and unquenchable vitality. He not only served as the chief illustrator for the *Proceedings of the Royal Zoological Society,* but also

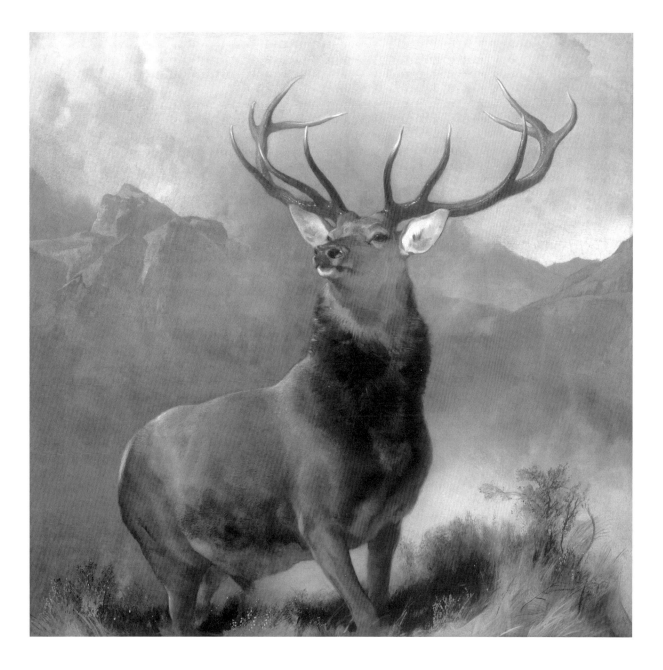

exhibited regularly at the Royal Academy of Art. His set-piece paintings narrate romantic stories of animals in their habitats, not infrequently telling of their struggle for survival in hostile environments. Birds and furry beasts are typically menaced by predators, with Wolf generally evincing sympathy for the prey. He also published a series of popular book illustrations in his storytelling vein, some of which openly fall into the category of animal capers. It is not surprising to find that he illustrated the fables of *Reynard the Fox,* published to accompany an English version of Goethe's text in 1852. He was also a prolific illustrator of such colonial tales as *Shooting Sketches amongst the Kaffirs* (1871).

The apogee of Wolf's popularity as an illustrator came with the twenty grand woodcuts in *The Life and Habits of Wild Animals,* published in 1873. *A Hair-Breadth*

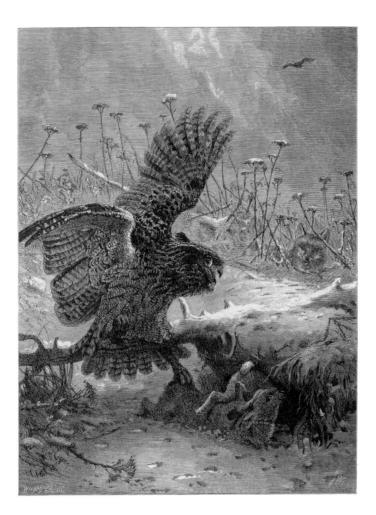

127. Joseph Wolf, *The Hair-Breadth Escape,* from *The Life Habits of Wild Animals,* 1873.

Escape (fig. 127) is typical both of their anthropomorphizing titles and of their up-to-date zoological understanding. The four-way interaction between the harsh winter landscape, the two predators who divert each other's attentions, the terrified rabbits, at least one of which is escaping, is truly Darwinian. The vivid text was written by Elliot, the prominent American naturalist for whom Wolf had previously undertaken five sets of "scientific" illustrations. It is clear that the spectrum of imagery spanning popular tales at one end, and observational science at the other, is wholly continuous within the Victorian zoological enterprise.

The fact that the Romantic characteristics of Wolf's work served Darwin so well helps us to see how the biologist's own mental picture of a nature in full-blooded interaction shares deep affinities with the spirited and visual narratives painted by Stubbs and his immediate successors. When the artists depicted the savage competition between the powerful and the weak and between the armed and the defenseless, they were active participants in forging a vision of nature in interaction that was uncompromisingly dynamic and competitive rather than conventionally fixed. Their imagery played a key role in establishing the visual landscape within which natural selection could be seen as exercising its often violent sway.

Our Animal Cousins

Amongst what I am cautiously calling the preludes to Darwin's great theory, the most immediate involves the way that natural history, or more specifically primatology, was presenting more refined evidence about those apes that are closest to humans. The direct study of primate anatomy meant that such legendary creatures as the "man of the woods" (*Homo sylvestris*) were assuming the flesh and blood of reality and thus radically recasting some of the old questions. The rise of primatology was clearly vital for Darwin because it clarified the nature of those species of apes that most resembled *Homo sapiens*. This theme will provide the focus for our discussion that follows.

Subsequently, I will outline the way in which Darwin himself envisaged our human and prehuman ancestors, and look at how the representation of "primitive peoples" responded to Darwin's revelations of our shared ancestry with primates. None of the new theories and representations made for easy reading or viewing for those who wished to believe in a literal account of Adam and Eve in Genesis, maintaining that humans were God's special creation, made exclusively in his own image. If a godless thought was to be entertained, it was probably less unsettling to think of humans as awesomely wonderful machines invented by a divine clockmaker than just a highly developed form of beast. To be a mere beast is, by implication, to be more messy and unreliable than a machine, the result of the accidents of evolution rather than the deliberate design of an omnipotent deity.

MONKEY BUSINESS

Of all the animals, none exhibit social tendencies more like those of humans than the "higher" apes. Our simian "cousins" have always fascinated us, not least for this reason. Less visual agility is required than with other animals to see them and their behavior in human terms, and at the same time it is harder for us to see ourselves as definitively different from them. They stood over the centuries, for moralists and

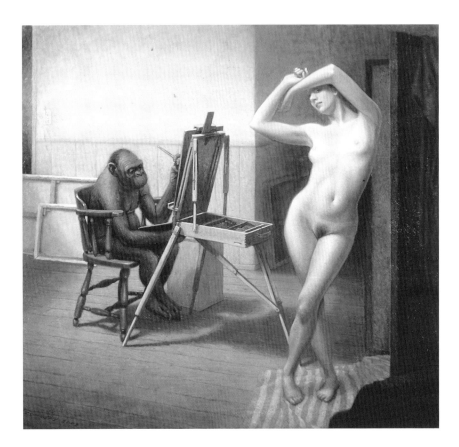

128. Peter Zokosky, *Ape and Model*, 2002. Courtesy of the artist.

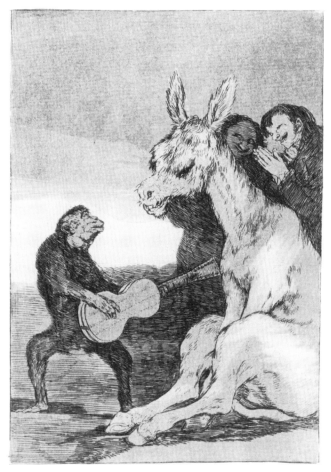

129. Francisco de Goya, *Brabisimo!* from *Los Caprichos*, no. 38, 1799, Davison Art Center, Wesleyan University. Photo: R. J. Phil.

natural historians alike, as a sign that we might be closer to the animals than we care to think. Even the name accorded to the genus of monkeys, *Simia,* signals their closeness, alluding to them as the *Similitudo hominis.* The other side of the coin is our use of the verb "to ape," that is to say, to copy slavishly. We have already seen Potter's image of monkeys falling captive as the result of their insatiable desire to ape human behavior. At a higher level, art or the artist is the ape of nature, the *simia naturae.* Chardin was one of many artists to indulge in gentle self-parody in their portrayal of monkeys as painters (fig. 93). The enduring vitality of this topos is manifest in Peter Zokosky's recent painting of a simian master painting a luscious nude model, who eyes the spectator with a teasingly knowing gaze (fig. 128). In the fourteenth century, Boccaccio's *De genealogia deorum* tells how the sculptor Epimetheus was transformed by Jupiter into an ape, while Filippo Villani describes Giotto's contemporary, Stefano, as the "ape of nature," in a tribute to the painter's mastery of naturalism.[1]

Monkeys, as we have noted, were popular subjects for elaborate automata, performing a variety of human acts—smoking cigarettes and playing music (sometimes in full monkey orchestras). A monkey-musician features in Goya's *Los Caprichos,* strumming lovingly to a smitten ass (fig. 129) while two spectators guffaw and applaud in a way that is both derisory and complicit.[2] "Bravo," says the ironic caption. In Goya's image, monkey music is less the food of high-minded love and more the foreplay that nourishes our animal desires.

The traditional framework at work here and elsewhere is that monkeys were noted for their human attributes, but failed to display the full range of human rationality and moral behavior. They are prefect symbols, in fact, for what happens when we behave in a debased way, giving sway to our animalistic natures. If we indulge in "monkey business," we are not behaving in an orderly and trustworthy manner. Monkeys can always be traduced through their animalistic lack of self-control. Thus the two simians in Pieter Bruegel's picture in Berlin (fig. 130) have surrendered their freedom at the price of a feast of nuts.[3] The specific allusion is to the Dutch expression "a banquet of three hazelnuts," which plays on our propensity to yield to bribes of disproportionate insubstantiality. Monkeys are seen as readily subject to deception. When Galileo wished to argue that it was insufficient for his adversaries to rely upon the immediate impression of what they seemed to see, he admitted that "I am more like the monkey who firmly believed that he saw another monkey in the mirror . . . and discovered his error only after running behind the mirror several times."[4] Whatever human attribute of curiosity, gullibility, shallowness, vanity, and dishonesty might stand in need of symbolic embodiment, the monkey would serve the purpose more than adequately.

What may be regarded as the definitive Renaissance monkey occurs in Dürer's beautiful engraving of a *Madonna and Child* (fig. 131), in which a firmly tethered specimen, observed with all the artist's meticulous sensitivity for living creatures, stands for the sides of our nature that religious observance lets us transcend. This particular monkey, originating from Senegal, had made an earlier appearance in Dürer's panel of Christ and the Doctors in a large 1496 altarpiece devoted to the

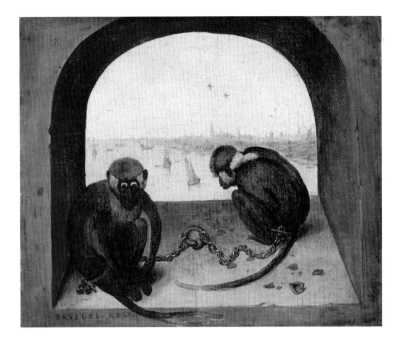

130. Pieter Bruegel, *Two Monkeys*, 1562,
Gemäldegalerie, Berlin. Bildarchiv
Preussischer Kulturbesitz / Art Resource,
NY.

131. Albrecht Dürer, *Madonna and Child*,
engraving, c. 1498, Ashmolean Museum,
Oxford.

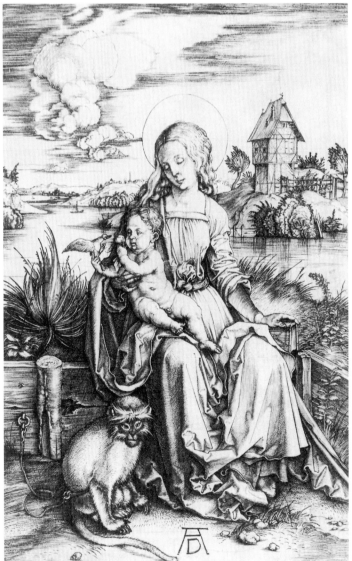

"Sorrows of Mary"; there the monkey is as uncomprehending of Jesus' youthful wisdom as the attendant Rabbis.[5] As it happens, this Senegalese species was colloquially known in German as the "nun-monkey," because of its white-fringed face. On a visit to Antwerp in 1520, Dürer himself purchased "a little seacat," a long-tailed Indian monkey, for the far from trivial sum of five gold florins.[6] What happened to his pet is unknown and we sadly have no surviving depiction of it from the hand of its new master. In Brussels, he drew a baboon, with its dog-like head, an "extraordinary animal" which impressed him with its bulk.

A variety of apes and monkeys became relatively familiar firsthand from the Renaissance onwards, often depicted by skillful illustrators. Imported apes were adequately documented and their behavior in captivity recorded. Others, such as the gorilla and chimpanzee remained more ill defined and elusive. In earlier literature on the wonders of the natural world, varieties of familiar apes, imperfectly known apes, and legendary apelike creatures had existed in an unclear if continuous spectrum alongside races of primitive and diminutive peoples, assorted types of "wild men," and regular human races. This spectrum was not essentially threatening to the status of civilized man, since God had decreed a continuous chain of being in which each link was created separate and entire. Thus, the medieval philosopher Albertus Magnus could regard manlike creatures and pygmies as intermediate types without for a moment countenancing the idea that there was any fluidity across the border that separated humans from nonhumans.[7] The links in the continuous chain were irredeemably distinct in position and value.

As more of the world became conquested in the sixteenth and seventeenth centuries, so more links were defined and more nonhuman primates became available to study, with sometimes unsettling results. By coincidence, one of the progenitors of primatology already enjoyed a prominent presence in the world of art, namely Dr. Nicholas Tulp of Amsterdam, the main protagonist in Rembrandt's famous *Anatomy Lesson* of 1632 (fig. 84).[8] The nature of the demonstration staged by Tulp for the benefit of his fellow surgeons is in keeping with his interest in the relationship of humans to humanlike animals. As we have already noted, he is demonstrating how the wonderful "engineering" of the interpenetrating flexor tendons is crucial for the operation of the human hand as "the instrument of instruments"—as it was characterized in the Aristotelian tradition.[9] The enduring sense of the wonders of our digits featured prominently in the debates on natural theology around 1800, most notably in Charles Bell's *Bridgewater Treatise* on the hand, published in the series of monographs that set out to show how the awesome design of nature testified to God's sovereign purpose.[10] The hand, of all human members, seemed to demonstrate in its engineering and utility the divinely ordained separateness of humans.

Tulp was subsequently to publish his observations on the orangutan in his *Observationum medicae libri tres,* accompanied by an accomplished engraving that became the stock image of the semilegendary humanoid (fig. 132).[11] The actual animal came to be used by successive naturalists as a way of reconciling traditional accounts of the man-apes: the Satyr (based on Pliny), the much illustrated *Homo silvestris* or "Wild

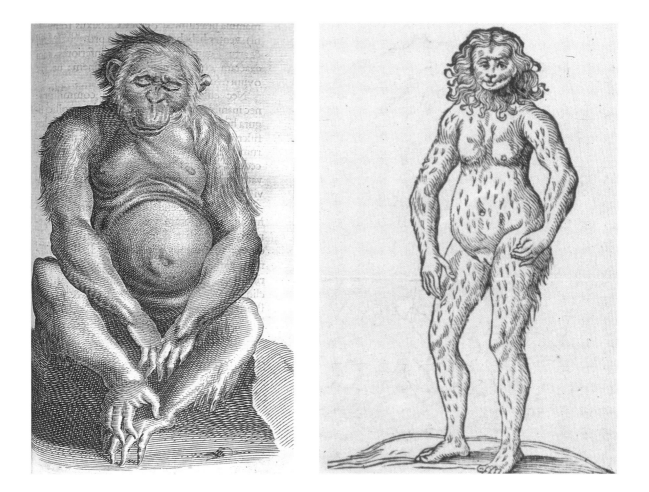

Man of the Woods" (fig. 133), the Pygmy, the Lucifer (a tailed hominoid), the Cyno-cephalus (dog-headed ape), and the subterranean Troglodyte. The reports of An-drew Batten, a British sailor who had been shipwrecked in Africa in the sixteenth century, threw the Pongo and the Engecko (or Jocko), greater and smaller ape-men, into the confusing equation.[12] (The Abominable Snowman, much sought-after in the modern era, stands very much in this tradition.) In Tulp's pioneering image of the orangutan, the beast is seated with the slumped pose and shifty expression of a scolded schoolboy, while prominently displaying the prehensile nature of his big toe, one of the anatomical characteristics that marked out simians from humans.

In 1699 the "Orang" was to be the subject of a full monograph by the English doctor and naturalist, Edward Tyson. As it happens his "Orang" was what we call a chimpanzee, but this misidentification does nothing to lessen the quality of his analysis. His *Orang-Outang, sive homo sylvestris, or THE ANATOMY OF A PYGMIE Com-pared to that of a Monkey, and Ape and a Man* is one of the earliest studies that genuinely warrants the description comparative anatomy. Its full subtitle gives a flavor of his enterprise: "To which is added A PHILOLOGICAL ESSAY Concerning the *Pygmies,* the *Cynocephali,* the *Satyrs* and *Sphynxes* of the ANCIENTS, Wherein it will appear that they are all either APES or MONKEYS, and not MEN as formerly pretended." In fact the Malay name, Orang-outang, means "man of the woods."

132. Nicholas Tulp, *Homo Sylvestris, Orang-outang,* from *Observationum medicae,* 1642. Courtesy of the Provost, Fellows and Scholars of the Queen's College Oxford.

133. Jacob de Bondt, *The Wild Man of the Woods,* from *Historiae naturalis et medicae Indiae orientalis libri sex,* 1658, p. 84.

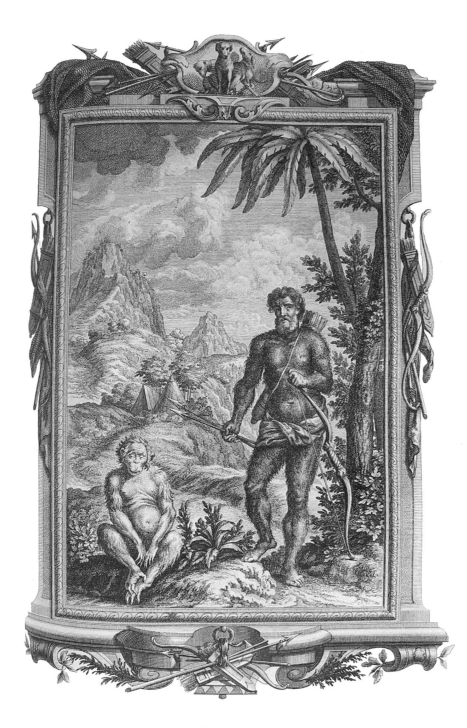

134. Johann Jakob Scheuchzer,
Essau, from *Physica sacra,* 1731.
Courtesy of the Provost, Fellows
and Scholars of the Queen's
College Oxford.

Tyson's purpose, as he testifies in his preface, is better to "observe *Nature's Gradations* in the Formation of *Animal* Bodies" so as to characterize the common and differentiating features of different species, rather than peddling legend. He acknowledges that the "Orang resembles man more closely than any other living creature" but denies categorically that it is a hybrid "product of *mixt* generation."[13] The central thrust of his argument emerges in his dissection of the animal's larynx, the key organ in any distinction between humans and animals with respect to speech. He observes that "the whole structure of this Part [is] exactly as 'tis in *Man*

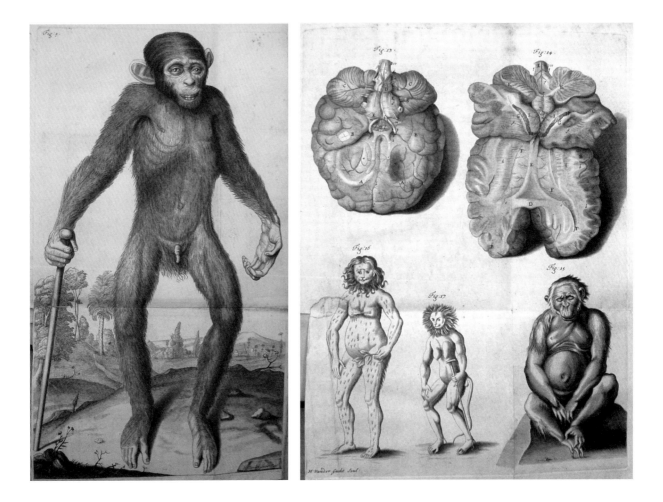

... if there was any further advantage in the forming of *speech*, I can't but think our *Pygmie* had it."[14] The conclusion is that man's higher faculties, resulting from his God-given soul, explains the acquisition of language, not mere anatomical mechanics. Having studied the orangutan's brain, he is able to sustain the Cartesian view that "the *Organs* in *Animal* Bodies are only a regular *Compages* of *Pipes* and *Vessels* for the *Fluids* to pass through, and are passive. But those *Nobler faculties* in the *Mind of Man*, must certainly have a *higher Principle*; and *Matter organised* could never produce them."[15] This creationist separation between humans and animal-machines, which was inviolable in theological terms, was nicely exemplified in 1731 Johann Jakob Scheuchzer's *Physica sacra*, in which Esau, the hirsute man of the Bible, shares his hairiness and his habitat with the ape, but little else (fig. 134).[16] Their irredeemably elevated and lower natures are readily apparent from their postures and demeanor. Scheuchzer's Orang clearly derives from Tulp's precedent.

The fine illustrations in Tyson's own treatise were produced by Willam Cowper (now mainly known for his pirating of Bidloo's magnificent anatomical illustrations for his own book) and Michael Vandergucht. Convincing images of the external appearance of the animal (fig. 135) are followed by depiction of various stages of the dissection performed by Tyson. The brain, whole and dissected (fig. 136), is accom-

135. *External appearance of the Orang*, from Edward Tyson's *Orang-Outang, sive homo sylvestri: or, The anatomy of a pygmie compared with that of a monkey, an ape, and a man*, 1699. London: printed for Thomas Bennet . . . and Daniel Brown. Foyle Special Collections Library, King's College London.

136. *Brain of the Orang*, from Edward Tyson's *Orang-Outang, sive homo sylvestris*, 1699. Foyle Special Collections Library, King's College, London.

panied by three comparative images, the *Homo sylvestris* taken from Jakob de Bondt, a *Cercopithecus* from Gesner, and Tulp's orangutan (fig. 132).

Of all the apes, it was the orangutan—through its established association with the numerous humanoids of legend—that attracted most philosophical attention in the eighteenth century. As we might expect, it is the subject of close attention from Buffon, who provides an unrivalled set of illustrated accounts of simian species, who are characteristically shown using their hands to manipulate objects in a human way and even to make rhetorical gestures (fig. 137). Most typically, monkeys and apes are shown holding branches as clubs or staffs, like primitive warriors or hunters. Looking at the orangutan (fig. 138), which he equates with the Pongo, the Jocko, and the Chimpanzee, Buffon describes a series of indications that captives readily exhibit the civilized instincts of a gentleman or lady: "The orang-outang which I saw, walked always upright . . . Its air was melancholy, its deportment grave, its nature more gentle and very different from that of other apes. I have seen it sit at a table, unfold its napkin, wipe its lips, make use of the spoon and fork to carry its victuals to its mouth . . . It even approached strangers with respect."[17]

The great encyclopedist also noted with approval that the female covered her genitals with due modesty. In the illustration accompanying the 1789 supplement to the original article on the orangutan, the ape is depicted with an extraordinary degree of human self-awareness, speaking directly to the spectator and gesturing communicatively with its free hand (fig. 139). But, in the final analysis, the orangutan remained irredeemably an ape for Buffon—as the most adjacent but utterly discrete link in the great chain of being.

In 1779 the orangutan was, tellingly, the subject of a another monograph, this time by the Dutch physician, anatomist, man of letters, natural philosopher, skilled draughtsman, and student of the arts, Dr. Petrus Camper. On the basis of more detailed anatomical knowledge than even Tyson had obtained, Camper argued that it was the orangutan's anatomical divergences, including the configuration of its vocal chords, that definitively declared its separateness from humankind.[18] The distinction was not, therefore, only a matter of the same instruments being used differently because of superior human mental faculties. Camper's specific studies of various human and simian crania according to the inclination of the facial angle in profile will concern us later when we look at attempts to quantify types of advanced and primitive humans.

It was Camper whom Linnaeus cited when he strove to fit the orangutan and other apes into his grand scheme of universal classification as first laid out in his *Systema naturae* in 1735. His basic taxonomy of animals, disposed them in six categories:

> MAMMALIA, covered with hair, walk on the earth, speaking
> BIRD, covered with feathers, fly in the air, singing
> AMPHIBIA, covered with skin, creep in warm places, hissing
> FISHES, covered with scales, swim in the water, smacking

137. Comte de Buffon (Georges-Louis Leclerc), *Patas Monkey Holding a Pear*, from *Histoire naturelle*, 1749–89, vol. 14, 1766, Foyle Special Collections Library, King's College London.

138. Comte de Buffon (Georges-Louis Leclerc), *Orang-Outang*, from *Histoire naturelle*, 1749–89.

139. Comte de Buffon (Georges-Louis Leclerc), *Orang-Outang*, 1789. Supplement to *Histoire naturalle*, plate 1.

INSECTS, covered with armour, skip on dry ground, buzzing

WORMS, without skin, crawl in moist places, silent.[19]

At the summit of the mammals stood the order of primates, comprised of two genuses, *Homo* and *Simia*. The human species—the most worthy object of our study according to the ancient tag, "Know Thyself"—were six in number:

> Ferens (wild humans, citing nine examples of ferral children, including Peter and
> Memmie)
> Americanus (native Americans or "Indians")
> Europaeus
> Asiaticus
> Afer (from the African subcontinent)
> Monstruousus.[20]

The orangutan is placed decisively amongst the Simia, but Linnaeus faced continued problems in what to do with the obstinate presence of the "Wild Man of the Woods":

> 2. Orang-outang.—2. Simia Satyrus. 1
>
> Has no tail. Is of a rusty brown colour; the hair on the forearms is reversed, or stands upwards; and the buttocks are covered with hair. . . .
>
> Homo sylvestris, or wild man of the woods. . . .—Orang-outang . . .
>
> Inhabits the island of Borneo.—Is about two feet high, and walks mostly erect. . . . The palms of the hands are smooth, and the thumb is shorter than the palm; the feet resemble those of man, except that the great toes are considerably shorter than the other, which are very long.
>
> Much as this species resembles mankind, even possessing the *os hyodies* [the U-shaped bone that supports the muscles of tongue], it must still be referred to the genus of Ape, with which it agrees in wanting the flat round nail of the great toes, and in the structure of the larynx; besides these circumstances it is evident from the direction of the muscles, and from the whole figures of the skeleton that the animal is not designed by nature for an upright posture.[21]

The doctrine that was developed to cope with the apparently small and gradual steps between the various species of ape and humans was "gradation"—a term we have already encountered in Tyson's account of the Orang. The idea involved a minutely graded spectrum of morphological characteristics as revealed by meticulous anatomical studies of closely related species: The principle is that "Nature descends by gradual and imperceptible steps from man down to the least organised beings."[22] This overtly hierarchical system was framed by the Manchester physician and obstetrician Charles White at the very end of the eighteenth century. White's *An Account of the Regular Gradation in man, and in different animals and vegetables, and from the former*

to the latter will, like Camper's craniological researches, concern us again when we look at attempts to use the facial mangle to grade the races of man. For the moment, we will focus on his interests in primates, on which he was notably well read, citing Tyson, Buffon, and Camper amongst others. He is particularly taken with Stephen de Viss's 1769 report published in the *Philosophical Transactions of the Royal Society* (vol. 59) of the "Golok" in Bengal, which de Viss saw as arising from "a mixture with human kind."[23]

The orangutan is, naturally enough, the focus of particular attention for White and he is much impressed by accounts of how they use their hands to work with primitive tools. They "make themselves flints [and] defend themselves with stones and clubs."[24] This evidence was particularly compelling in the light of the long-established belief (given visual realisation in Rembrandt's depiction of Tulp) that the hand was the instrument specific to the intellect of man and served his abilities as a maker of artificial things. The orangutan also exhibits a range of remarkably human characteristics:

> All those who have had opportunities of making observations on the orang-outangs, agree in ascribing to them, not only remarkable docility of disposition, but also actions and affections similar to those observable in human kind. . . . They discover signs of modesty. . . . They have been taught to play on musical instruments, as the pipe and the harp. They have been known to carry off negro boys, girls and even women, with a view to making them subservient to their wants as slaves, or objects of brutal passion; and it has been asserted by some that women have had offspring from such connections.[25]

As a counterpoint to this parade of "advanced" characteristics in an ape, White cites an unpleasant and increasingly standardized litany of observations detrimental to the status of "negroes." In addition to their simian facial features, "the foot of the negro is much flatter" than that of Europeans, and their manner of walking "very much resembles that of the ape."[26] Osteological analyses purport to show how different the African is from the European, and he provides an appendix devoted to Samuel Thomas von Sömmering's "Essay on the Comparative Anatomy of the Negroe and European." The senses of the African race are said to be particularly acute, as is evident in animals, in which respect the beasts may "surpass man in some particular faculties."[27] Negroes do not sweat, but do smell.[28] They are notably susceptible to certain diseases, especially lockjaw.[29] They are (citing Thomas Jefferson) deficient in reason and imagination, those qualities so prized in the Enlightenment.[30] Their difference in their reproductive organs is especially telling: "That the PENIS of the African is larger than that of the European, has, I believe, been shown in every anatomical school in London. Preparations of them are preserved in most anatomical museums; and I have one in mine."[31] On the other hand, notes White, the African has smaller testes than the European, a feature again shared with apes.

Rather than adhering to the monogenist doctrine of the advent of a single species of man, followed by a gradual divergence though external influences, above all

climate, White maintained a polygenist theory, which described the creation of a set of wholly distinct human species. Since the "various species of man were originally created and separated, by marks sufficiently discriminative, it becomes an important object, in general physiology, to trace the lines of distinction."[32] A key point of reference for White was the new science of anthropology, which had effectively been founded by Johann Friedrich Blumenbach, who defined five distinct races: "Caucasian," "Ethiopian," "Mongolian," "Indian" (native American), and "Malay."[33] Although White confessed that the state of available knowledge of human species across the globe was inadequate to paint a complete picture, this does not deter him from declaring with confidence that the Hottentots are "lowest on the scale of humanity."[34]

One of the most potent undercurrents in such a system of judgement is aesthetic, as it overtly had been for Camper, who began with the issue of how to portray "negroes" accurately in art. White is positively rapturous about the physical delights of a well-shaped European. Where, but amongst the European race, can we find perfect realization of physical beauty: "Where that variety of features, and fullness of expression; those long, flowing, graceful ring-lets; that majestic beard, those rosy cheeks, and coral lips? . . . In what other quarter of the globe shall we find the blush that overspreads the soft features of the beautiful women of Europe, that emblem of modesty, of delicate feelings . . . Where, except on the bosom of European woman, two such plump and snow white hemispheres, tipt with vermilion?"[35]

The potentially pernicious nature of White's characterizations, ostensibly based on hard "scientific" evidence, needs no underlining. However, it is only fair to White to cite his opening denunciation of the "pernicious practice of enslaving mankind." He asserts that he is not "desirous of assigning any one superiority over another, except that which naturally arises from superior bodily strength, mental processes and industry, or from the consequences attendant upon living in a state of society."[36] White's position is utterly typical of standard, abolitionist opinion, to be shared in some measure by Darwin, which rejected institutionalized subjugation and intolerance, while recognizing that a natural order of higher and lower types would emerge in course of the development of human societies. In White's scheme of things, whatever the baseness of lowest ranks of humankind, the genus of man remained ultimately separate from that of apes, and he specifically rejected the "degrading notion" that one species could be transformed over time into another.

During the course of the next century, the definitions of both human races and the types of ape were achieved with increasing clarity. The range of simian behavior was observed with increasing precision—at least with respect to their concourse with humans. The studies confirmed that apes were in many respects endowed with human attributes, while dismissing some of the more extreme claims, not least those that had been made on behalf of the orangutan. However, there remained the recurrent problem that animals were subject to close observation by scientists only when they were in captivity. Given the shortage of systematic studies of the behavior of apes in their natural habitats, even such an important study as Robert Hartmann's

Anthropoid Apes (1886) needed to rely a good deal on "travellers' tales" to supplement detailed observations made on captive specimens in zoos.

Orangutans and chimps, the latter increasingly prominent in modern studies of animal learning and language, became the classic points of reference for scientists and satirists alike. Thus we find the speechless Orang hero of Thomas Love Peacock's *Melincourt* (1817), Sir Oran Haut-Ton, successfully purchasing a Baronetcy and entering Parliament, where he did not apprently stand out from his peers. The public image was beginning to indicate that, whether in captivity and in the wild, the "higher" apes were often uncannily like us in their behavior.

SOCIABLE ANIMALS AND MISSING LINKS

When Darwin's theory was disclosed to the public in 1859, it effectively brought back into play a series of traditional stories and Montaignesque observations of bright and socially minded animals. Renewed attention was paid to creatures who established organized "societies' for collaborative endeavor and mutual defense. Victor Espinas's *Des sociétés animales* in 1878 and George Romanes's *Animal Intelligence* in 1882 both exemplify this trend. Romanes confessed that he had to rely upon a good deal of hearsay evidence:

> I have fished the seas of popular literature as well as the rivers of scientific writing. The endless multitude of alleged facts which I have thus been obliged to read, I have found, as may well be imagined, excessively tedious: and as they are for the most part recorded by wholly unknown observers, the labour of reading them would have been useless without some trustworthy principles of selection. The first and most obvious principle that occurred to me was to regard only those facts which stood upon the authority of observers well known as competent; but I soon found that this principle constituted much too close a mesh. Where one of my objects was to determine the upper limit of intelligence reached by this and that class, order, or species of animals, I usually found that the most remarkable instances of the display of intelligence were recorded by persons bearing names more or less unknown to fame. This, of course, is what we might antecedently expect, as it is obvious that the chances must always be greatly against the more intelligent individuals among animals happening to fall under the observation of the more intelligent individuals among men.[37]

Romanes recognized that firsthand observation was preferable when it was possible. A nice example is one of the behavioral experiments he performed with ants.

> I confined one of these under a piece of clay at a little distance from the line [of marching ants], with his head projecting. Several ants passed it, but at last one discovered it and tried to pull it out, but could not. It immediately set off at a great rate, and I thought it had deserted its comrade, but it had only gone for assistance, for in a short time about a dozen ants come hurrying up, evidently fully informed of the circumstances of the case,

for they made directly for their imprisoned comrade and soon set him free. I do not see how this action could be instinctive. It was sympathetic help, such as man only among the higher mammalia shows. The excitement and ardour with which they carried on their unflagging exertions for the rescue of their comrade could not have been greater if they had been human beings.[38]

Romanes was at pains to distinguish between instincts—inbuilt and automatic behaviors akin to those of a Cartesian automaton—and genuinely voluntary actions that could respond flexibly to particular circumstances:

> In an objective sense . . . a mental adjustment is an adjustment of a kind that has not been definitely fixed by heredity as the only adjustment possible in the given circumstances of stimulation. For were there no alternative of adjustment, the case, in an animal at least, would be indistinguishable from one of reflex action. It is, then, adaptive action by a living organism in cases where the inherited machinery of the nervous system does not furnish data for our prevision of what the adaptive action must necessarily be—it is only here that we recognize the objective evidence of mind. The criterion of mind therefore, which I propose . . . is as follows:—Does the organism learn to make new adjustments, or to modify old ones, in accordance with the results of its own individual experience? If it does so, the fact cannot be due merely to reflex action in advance for innovations upon, or alterations of, its machinery during the lifetime of a particular individual.[39]

Although Romanes's compilation may be regarded as one of the last of the traditional kind (and was soon criticized as such), his careful distinction between reflex and adaptive action shows that he was alert to what was to become a key criterion in the observation of animal behavior. It was around this distinction that Ivan Pavlov was to develop his famous notion of the "conditioned reflex." Pavlov's idea, for which he was awarded the Nobel Prize in 1904, arose from his studies of the relationship between salivation and the action of the stomach in dogs.[40] He found that if he rang a bell each time he gave food to his dogs, they would eventually salivate even when no food was present. If no food reward was provided on repeated occasions, the conditioned reflex would eventually be repressed. What Pavlov had observed was a response that lay between the purely inherited and the entirely voluntary. It subsequently proved, as we know, none too difficult to demonstrate that humans were as much subject to "Pavlovian reactions" as the Russian scientist's experimental dogs. Another Darwinian piece in the jigsaw of the human animal was firmly in place.

In 1859, Darwin's own *Origin of Species* had inevitably raised the spectres in fearful minds of the evolutionary continuity of humans and animals, our closeness to apes, and of the continuous evolution of the human species itself.[41] The public controversy very much picked up on our proximity to other primates, and Darwin featured in caricatures as having a simian body and physiognomic characteristics that hinted at his ape origins.

Although the human implications of evolution were not in the forefront of Darwin's epoch-making book, they were to assume prominence a dozen years later in the two volumes of his *The Descent of Man, and Selection in Relation to Sex*. Darwin defined his aims in the first part of the book as "to consider, firstly, whether man, like every other species, is descended from some pre-existing form; secondly, the manner of his development; and thirdly, the value of the differences between the so-called races of man."[42] The last of these he treats in a relatively summary manner, in view of the already extensive literature. Nor does he analyze in detail the relationship between contemporary man and modern apes, not least because "Professor Huxley [in his *Evidence as to Man's Place in Nature* in 1863], in the opinion of most competent judges, has conclusively shewn that in every single visible character man differs less from the higher apes than these do from lower members of the same order of Primates."[43] The most compelling evidence for his use of evolutionary theory to answer his first question arises from comparative anatomy and embryology. "On any other view the similarity of pattern between the hand of a man or monkey, the foot of a horse, the flipper of a seal, the wing of a bat &c., is utterly inexplicable. It is no scientific explanation to assert that they have all been formed on the same plan. . . . No other explanation has ever been given of the marvelous fact that the embryo of a man, dog, seal, bat, reptile &c., can hardly be distinguished from each other."[44] The design of the hand, so long taken to show that man is not an animal, now provides key evidence that he is.

Darwin discounts some of the more elaborate claims for the intellectual skills of apes: "though he [an anthropomorphous ape] could use stones for fighting or for breaking open nuts, yet . . . the thought of fashioning a stone into a tool was quite beyond his scope."[45] Metaphysical reasoning is even further beyond apes' mental reach though they could manifest some aesthetic sensitivity to the visual appeal of "their partners in marriage." They also exhibit some features of sociability and altruism, but not "that disinterested love for all living creatures, the most noble attribute of man."[46] When animals demonstrate cleverness, altruism, and moral qualities, these attributes are used by Darwin to show how they have originated in the evolutionary process and have thus passed to humans.

As far as man's own development is concerned, we have to allow for the gradual evolution of "the several moral and mental faculties." We see just such a process in the "development of every infant," and we can "trace a perfect gradation from the mind of an utter idiot, lower than the lowest animal, to the mind of a Newton."[47] Looking at the bigger picture of the whole "organic scale" on earth, it seems inescapable that "the Simidiae . . . branched off into two great stems, the New World and Old World Monkeys; and from the latter, at a remote period, Man, the wonder and glory of the Universe, proceeded."[48] Darwin admits that "we have given to man a pedigree of prodigious length, but not, it may be said, of noble quality." It was this lack of nobility that many found so unacceptable.

Turning to the unresolved dispute between the monogenists and polygenists, Darwin redefines the grounds for the argument, so that it becomes largely irrelevant.

Additionally, he points out that it is a "hopeless endeavour" to decide on this matter "until some definition of the term 'species' is generally accepted." He writes, "When the races of man diverged at an extremely remote epoch from their common progenitor, they will have differed but little from each other, and been few in number; consequently they will then, as far as their distinguishing characters are concerned, have had less claim to rank as distinct species, than the existing so-called races. Nevertheless such early races would have been ranked by some naturalists as distinct species, so arbitrary is the term."[49] The subsequent divergence—whatever terminology is used—cannot be attributed to "the direct action of the conditions of life" (as Camper had believed), or to the transmission of acquired characteristics (as maintained by Jean-Baptiste Lamarck), but to the operation of "natural selection." The divergences in human types, as observed in such obvious characteristics such as skull shape and skin color, are in reality very small, taken in the context of the whole organization and mental propensities of humankind across the world. Anecdotally, Darwin testifies that "a full-blooded negro with whom I once happened to be intimate" showed "how similar their minds were to ours."[50] This observation, he reports, is supported by archeologists and anthropologists who have demonstrated the development of comparable cultural characteristics and inventive abilities in societies isolated from each other in time and place. All this serves to define the specific nature of modern *Homo sapiens* that has arisen from a definable branch in the evolutionary tree, and to separate the present state of our species from the higher apes as decisively as any Creationist had managed. As we will see in the next chapter, this formulation did not stop the use of Darwin's ideas to stigmatize "primitive" races, together with criminals and the insane (on an individual or collective basis) as surviving residues of a previous evolutionary state or as regressive "throwbacks."

My more immediate concern in the context of this chapter is the doorway Darwin opened to what became a search for the "missing link" between humans and apes—or more properly for the common ancestor of humans and Old World monkeys. The visual characterization of the Darwinian "caveman" drew heavily upon the long-standing tradition of the hairy wildman *Homo silvestris,* but in the wake of Darwin the tradition took a radically new visual turn. The tone was set by his own characterization: "Whether primaeval man, when he possessed very few arts of the rudest kind, and when his language was extremely imperfect, would have deserved to be called man, must depend on the definition which we employ. In a series of forms graduating insensibly from some ape-like creature to man as he now exists, it would be impossible to fix on any definite point when the term 'man' ought to be used."[51] The existence of this primeval "ape-man" has proved no less gripping to our post-Darwinian imaginations than the legendary monstrous races had been to earlier cultures.

Stories about strange races that lived in far-off eras are a common feature of many human societies. In classical antiquity, the myths crystallized around two main poles: one envisaged an idyllic golden age from which moderns had fallen, while the other spoke of barbaric peoples (including giants) who progressed gradually toward

civilized values. Hesiod's *Works and Days* provided the main locus for the former, telling of five successive races, Gold, Silver, Bronze, Heroic, and Iron. Broadly speaking, the pattern was one of degeneration, culminating in the savagery of the Iron Race.

The romantic view that early humans existed in an idyllic "state of nature," uncorrupted by the more pernicious aspects of civilized life, enjoyed a long if not particularly coherent philosophical life. We have already seen Swift's working variations on the theme. Its essence is neatly encapsulated in Jean Bourdichon's Renaissance illumination of *L'Homme sauvage ou L'État de nature* (fig. 140) as the accompanying text explains,

> I live according to what Nature has taught me—
> Free from worry, always joyously.
> For mighty castles, grand palaces I do not care . . .

140. Jean Bourdichon, illumination of *L'Homme sauvage ou L'État de nature*, c. 1500.

I have no need for fancy clothes.

My hairy coat protects me well enough

So that I fear neither heat nor cold.[52]

The genteel vegetarian savage, holding the staff-cum-club that is necessary for defense, gestures toward his rocky habitation. His eyes are raised in a spiritual manner, while his less hairy wife suckles a child with a tenderness surpassed by no Madonna.

The prime alternative was outlined by Lucretius in his great philosophical poem "On Natural Things" (*De rerum naturae*). The first, savagely primitive men were (to quote excerpts from a long and picturesque portrayal),

> built on a framework of bigger and solider bones, fastened through their flesh to stout sinews. They were relatively insensitive to heat and cold, to unaccustomed diet and bodily ailments in general. Through many decades of the sun's cyclic course they lived out their lives in the fashion of wild beasts roaming at large. . . . Thanks to their surpassing strength of hand and foot, they hunted the woodland beasts by hurling stones and wielding ponderous clubs . . . When night overtook them, they flung their jungle-bred limbs naked on the earth like bristly boars, and wrapped themselves round with a coverlet of leaves and branches.[53]

Lucretius was a relatively late discovery in the Renaissance, and even those who were attracted to its message were cautious to embrace its overtly godless tone.[54] Some of the earliest concerted signs of Lucretius's impact can be seen in late fifteenth-century Florentine literature in Medician circles, and his vision of primitive savagery holds center stage in one major series of Florentine decorative paintings, Piero di Cosimo's engaging narratives of the early history of mankind.[55] Piero draws primarily upon Lucretius and the narrative of human progress, which the ancient Roman architect Vitruvius had included in his famed book *On Architecture*. As always, Piero uses his sources in an idiosyncratic way. His scene the *Hunt* (fig. 141), once part of a lost decorative ensemble in a Florentine palace, tells of an almost unbridled savagery mutually perpetrated by man, beast, and man-beasts. The near-naked humans do not act in a conspicuously more civilized way than the cloven-hoofed satyrs. Yet there are some glimmers of hope—much in line with the late-fifteenth-century's author's adaptation of the Lucretius narrative. The rude men (or their wives) have already made rudimentary clothes from animal skins. And in the background, the forest fire from which diminutive animals flee alludes to Vitruvius's story of the discovery of fire, with all the benefits that would accrue. From destruction and fear were to be born the civilizing gift of the flame. It is this more civilized tendency that is apparent in the moving detail of a female centaur cradling her dying partner, lips close to lips, in Piero's *Battle of the Lapiths and Centaurs* (fig. 2).

What is conspicuously shared in the depiction of the primitive races by Bourdichon and Piero is their obviously human bodies and physiognomies. The French artist's humans might be hairy, and Piero's are very stocky, but they were definitely

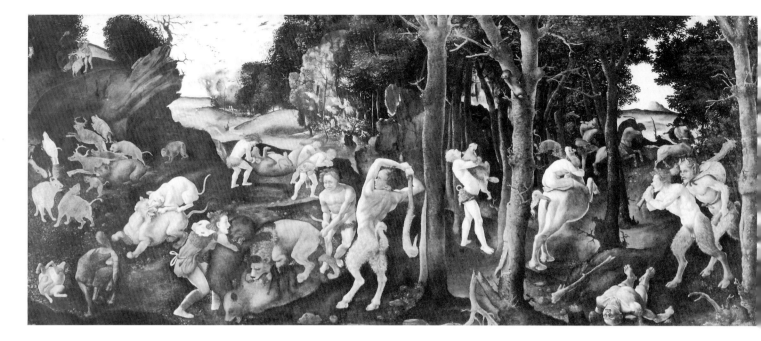

"men." In the wake of Darwin, it is difficult to envisage primeval peoples without endowing them with simian characteristics. But there was no such equation in earlier descriptions. It was true that apelike features could be used to suggest an undesirable character. Giotto endows his Judas with a distinctly "Neanderthal" profile in his *Arrest of Christ* (fig. 142), over five hundred years before the discovery of the remains of "ape-man" in the valley of the river Neander. But simian features were not attributes of "early man," whether of the savage or golden variety. Thus the ancient Picts represented in Theodore de Bry's 1590 *America* (figs. 143 and 144) are anatomically modern while decorating themselves "pict-orially" with decorations that testify to their primitive condition. The man has covered his body with images of monstrous beasts, while the woman is adorned with a less threatening floral display. For de Bry, civilization is a matter of culture, not biology. Thus civilized parts of the world, like Britain, were once populated with races akin to the newly discovered inhabitants of America, the latter being fully formed humans in all but behavior and culture.

Indeed, it was difficult to see how it could be otherwise for anyone who took the Biblical account of God creating the first man with due reverence. Even when it was demonstrated with increasing degrees of conviction during the eighteenth and early nineteenth centuries that humans were relative latecomers on the stage of the world, the special creation of man in the image of God required that the first humans would be essentially like us, even if unclothed. The necessary persistence of this idea for many Christians is witnessed vividly in Louis Figuier's *L'Homme primitif* illustrated by Emile Bayard and published in 1879, eleven years after Darwin's *Origin of the Species*.[56] Compared to his *La Terre avant le déluge* in 1867, Figuier now accepted that our level of civilization had progressed through a long series of epochs, marked by such

142. Giotto di Bondone, *Arrest of Christ*, 1304–6, Scrovegni Chapel, Padua, Italy. Photograph: Scala / Art Resource, NY.

143. Theodore de Bry, *Male Pict,* from *America,* 1590, plate 1, The Bodleian Library, University of Oxford. Reference M93.A00060.

144. Theodore de Bry, *Young Female Pict,* from *America,* 1590, plate 3, The Bodleian Library, University of Oxford. Reference M93.A00060.

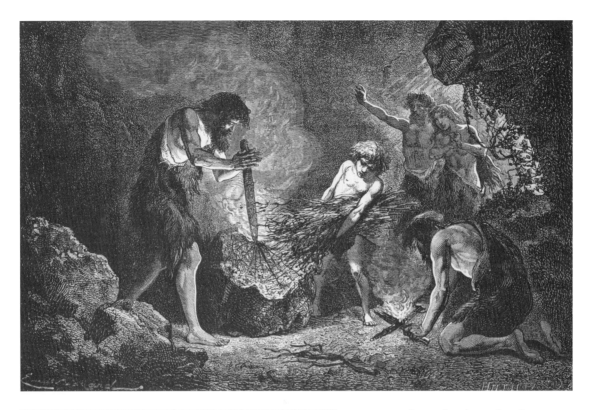

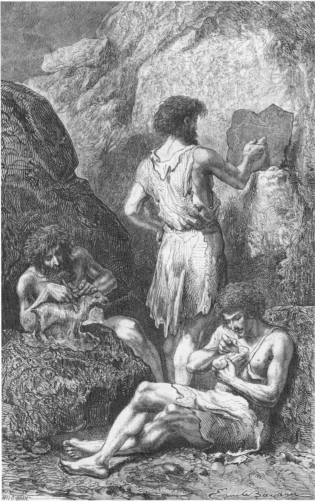

145. Emile Bayard, *Production of Fire,* from Louis Figuier's *L'Homme primitif* (Paris: Hachette, 1870), fig. 7, The Bodleian Library, University of Oxford. Reference M90.E07062.

146. Emile Bayard, *Arts of Drawing and Sculpture during the Reindeer Epoch,* from Louis Figuier's *L'Homme primitif* (Paris: Hachette, 1870), fig. 68, The Bodleian Library, University of Oxford. Reference M90.E07062.

crucial steps as the mastery of fire (fig. 145). In the "Reindeer Epoch" of the Stone Age (fig. 146), Bayard shows ancestral artists using implements of image-making; they paint, engrave, and sculpt with tools similar to those found by archeologists. The primitive peoples sport long hair and bushy beards, and are dressed in animal skins, but they are recognizably the same kind of creatures as Bayard's nineteenth-century contemporaries. They display facial types and body languages derived from contemporary social norms and the conventions of narrative painting.

It was to take a less compromised view of the Darwinian evolution of man to let the ape-man loose in the world of images. The decisive moves were triggered by the accelerating discovery of "fossil men," most notably the series of Neanderthal remains unearthed in 1856 and succeeding years. The first in the field was Pierre Boitard in his *Études Antidiluviennes. Paris avant les hommes* in 1861.[57] Boitard's *Fossil Man* (fig. 147) resolutely displays his profile in all its simian glory. His ape-like feet are clearly emphasized and his hairiness is fully evident in the traditional manner—though one thing the fossil record did not tell Boitard or anyone else is whether the early men were hairy or smooth.

A more scientifically substantial contribution was made by Ernst Haeckel, the mighty German Darwinian, whose *Natürliche Schöpfungsgeschichte* was praised by Darwin himself as an authoritative account of the "genealogy of man."[58] Haeckel

147. *Fossil Man*, from Pierre Boitard's *Études Antidiluviennes. Paris avant les hommes,* 1861, Berlin Staatsbibliothek.

supposed the existence of an ancestor whom he named *Pithecanthropus alalus,* the "speechless ape-man," and vividly described: "The form of their skull was probably very long, with slanting teeth; their hair woolly; the colour of their skin dark, of a brownish tint. The hair covering the whole body was probably thicker than in any of the still living human species; their arms comparatively longer and stronger; their legs, on the other hand, knock-kneed, shorter and thinner, with entirely undeveloped calves."[59] It is noticeable how key elements in this description depended not on the paleontological record but upon preconceptions based on traditional images of primitive peoples of past and present eras. Indeed, Haeckel was all too prepared to look at "primitive peoples" of his own time as little removed from his hypothetical ape-man. He followed Darwin in recognizing that "man is separated from the other animals by quantitative not qualitative differences." However, "if one must draw a sharp boundary . . . it has to be drawn between the most highly developed and civilised man on one hand, and the rudest savages on the other, and the latter have to be classed with the animals."[60] At the summit of Haeckel's ascending order of human types stood the supremely organized German race.

148. *Pithecanthropus,* from Henri du Cleuziot's *La Création de l'homme et les premiers âges de huma-nité,* 1887, p. 89. Image courtesy of the American Museum of Natural History Library.

149. After Gabriel von Max, *Pithecanthropus Alalus* by Franz Haeckel, from Ernst Haeckel's *Natürliche Schöpfungsgeschichte* (Berlin: Georg Reimer, 1898), plate 29, The Bodelian Library, University of Oxford. 18911 d.74(vi).

Unsurprisingly, Haeckel's vivid conception of the "missing link" attracted illustrators. In 1887, Haeckel's *Pithecanthropus* was granted visual reality in Henri du Cleuziot's *La Création de l'homme et les premiers âges de humanité* (fig. 148). The image conspicuously shares more with Buffon's humanoid apes than with Figuier's Herculean cave dwellers. Successive discoveries of fossil remains of early man inevitably triggered visual reconstructions, ranging from sober illustrations in specialist journals, though museum models, to popular imagery in magazines, books, and works of art. The popular and the scientific often slid together. Inspired by the discovery of fragmentary remains of a "missing link" on Java in 1891, Gabriel von Max painted a striking image of the primitive family, which he proudly presented to Haeckel. The evolutionist responded by illustrating it in the 1898 edition of his *Natürliche Schöpfungsgeschichte* (fig. 149), the treatise earlier admired by Darwin. Max's imagery sets a tone that became ubiquitous in the depiction of "cave-men," not least in their air of down-and-out melancholy. It is as if the early peoples were languishing self-consciously in their base condition, waiting for the long years to pass before their heirs could lay claim to the title of civilized humans.

150. Léon-Maxime Faivre, *Deux mères,* 1888, Musée du Louvre, Paris. Photograph: Réunion des Musées Nationaux / Art Resource, NY.

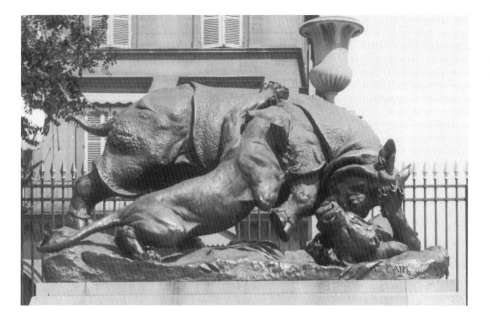

151. Auguste-Nicolas Cain, *Rhinocerous & Tiger,* c. 1882, Paris, Tuileries. Image courtesy of the Conway Library, Courtauld Institute of Art.

A number of painters and sculptors operating in the realm of "high art" at the Paris Salon exploited the dramatic and romantic potential inherent in such savage lives. The primitive life of perpetual strife with cave-dwelling bears and other menacing beasts was now seen in the context of the survival of the fittest. At the French Academy, Fernand Cormon and Paul Jamin cultivated a stirring line of history paintings of prehistory.[51] Léon-Maxime Faivre's *Deux mères,* exhibited at the Salon of 1888 (fig. 150), is an accomplished example of this subgenre. The Amazonian mother, protectively gasping her progeny like an animated version of Charity, is threatened by the shadowy presence of a mother bear with cubs, in keeping with the prehistorians' established idea that humans and bears competed directly for the best caves. Yet, Faivre's painted image of the two females acknowledged by implication that the human mother and bear share the same maternal instincts that serve to protect the continuity of their species. Auguste-Nicolas Cain, the son of a butcher who rose to become a serious successor to Barye as an *animalier,* produced monumental sculptures of big cats and other grandly wild animals that played conspicuous roles in the later sculptural adornments of the Louvre and Tuileries (fig. 151). The great beasts are savage, but in the service of their own society and the survival of their kind. The implication is that modern man would have similar recourse to heroic violence in the face of the greatest physical threats to his existence.

But, whatever we might need to share with the fighting animals, humankind had evolutionarily "ascended" to a higher plane. The inexorable triumph of man in the competition between humans and bears was depicted by Emmanuel Fremiet in a relief in the Jardin des Plantes in Paris (fig. 152), where, as official draftsman of animals, he had succeeded Barye as what we would call "artist in residence." One adult bear, presumably the mother, has been mortally wounded, while a cub is dragged off by the scruff of its neck. The heroic man strides victoriously toward the rising sun of the new age.

That the genre of "cave-man art" did not attain sustained prominence is probably due more to the decline of such large-scale, heroic narrative art in the academies rather than to its limited potential. Indeed, its considerable scope came to be realized the realms of the popular museum display and the cinema. The box-office success of films dealing with the primeval past of an earth, not infrequently populated anachronistically by humans and dinosaurs, shows that a form of science fiction that looks backwards rather than forwards has a considerable potential to engage our imaginations. The poster for *One Million Years BC* in 1966—"this is the way it was!"—parades Raquel Welch in a risqué bikini tailored from animal skin, against an anachronistic backdrop of a savage dinosaur laying waste to puny men (fig. 153). This vision of "primitive" sexuality is no less potentially arousing as an "exotic" display than that of Jane Fonda performing a galactic striptease in the futuristic world of *Barbarella*.

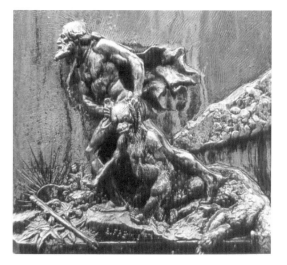

152. Emmanuel Fremiet, *Man and Bear,* c. 1900, Jardin des Plantes, Paris.

153. Movie poster for *One Million Years BC,* 1966. Courtesy of the British Film Institute.

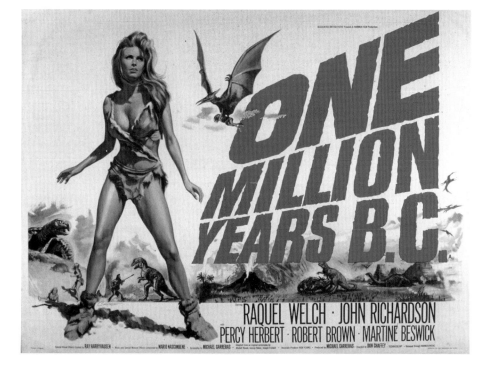

Art and Atavism

To understand what has been happening in many of the incidents we have studied, particularly those from the earlier period, we need to bear in mind a definition of "science" that is far more elastic than that which prevails today. In the light of our modern stereotype of science—characterized as a rigorously inductive exercise in which disinterested observation and systematic experiment provide data for logical analyses (ideally mathematical) and for subsequent retesting and modification—it is easy to be patronizing, dismissive, or downright scathing about earlier endeavors that now seem wrong in their results and misguided in their method. Physiognomy of the Aristotelian kind all too readily looks like a "pseudo-science," as does phrenology, the discipline of cranial analysis that we are about to encounter. The work of Charles White, which parades a series of "objective" reports from medical science and anthropology, seems not only questionable in terms of "good science" but also objectionable in human terms, because it violates values that now prevail in many areas of "civilized" society (in theory at least) and to which I personally subscribe.

However, if we define science in a way that is more true to its actual historical practice, now and in the past, we may look at the so-called pseudosciences in a rather different light. The definition I should like to proffer runs as follows. Science is any set of coherently held beliefs that draws upon systematically assembled evidence from the world as initially perceived by our senses, and builds explanatory models for the causes behind the observed effects, such that the relationship between the observations and the models is in critical dialogue. This definition does not prescribe the nature of the gathering of evidence, nor does it determine what is deemed to be valid evidence. It permits the kind of acceptance of received wisdom that necessarily characterizes any complex endeavor, and accommodates the fitting of scientific knowledge into wider belief systems. It does not automatically privilege quantitative methods of analysis. It also allows a more flexible, complex, and creative interchange between the processes of theoretical modeling, observation, and

hands-on testing than pertains in the rigidly empirical view of scientific method. This definition also facilitates a more ready understanding of how science is a socially embedded activity, since the definition of evidence, the nature of evidence gathering and model building can vary according to norms prevailing in particular places and at particular times. As it happens, I think this more elastic definition is more realistic to the way that most modern sciences actually proceed—particularly those that deal with complex systems that are resistant to traditional mathematical techniques—whatever the public rhetoric that surrounds the infallibility of scientific truth. None if this is to denigrate the achievements of modern science as arbitrary—seeing science as a purely social construct that has no claim to a high level of truth content and explanatory power—but it is to recognize that science is, for all its rigorous principles, a very human activity that has a long and various history in varied contexts.

Looking back from this standpoint at detailed theses, like that of White, or at grand theories such as the doctrine of the four humors, it is easier to see how they assumed cogency over longer or shorter periods of time, and how observations were made to "fit"—not because the observers were dishonest or venal, but because observation is necessarily a partial and directed business if we are not to be overwhelmed with the multitudinous variety and teeming ambiguity of what is presented to us in the external world. One of the central jobs of science over the ages has been to scrutinize the "fit," however comfortable that fit might seem to be and however much its critical scrutiny might involve overturning both accepted observations and cherished models.

Making these remarks at this point seems timely, both in light of the kinds of science paraded in previous chapters, and with respect to the forthcoming subject of phrenology, which has had a retrospective ride of almost unparalleled roughness when set against the firm scientific foundations that its founders strove to establish.

The topics that feature in this chapter exist within a vast spectrum of nineteenth-century sciences, including anthropology, ethnography, psychology, archeology, paleontology, zoology, eugenics, criminology, and medicine, and involve huge bodies of primary and secondary literature. The themes I have selected from this daunting array consciously play toward visual ideas that we have seen in earlier periods, and will provide some signal examples of the general drift in the interpretation of the human animal.

BUMPS ON HEADS

The advent of a completely new science is a rare event. There is some justification in so describing phrenology, the science of cranial features and mental faculties founded by Franz Joseph Gall and furthered by his disciple, collaborator, and proselytiser, Johann Caspar Spurzheim. To be sure, physiognomy had brought the overall shape of the head into the equation of reading character, and Lavater had typically provided readings of an extraordinarily detailed if unsubstantiated kind. But no one had

used a variety of systematically assembled evidence from developmental biology, comparative anatomy and social observation to propose an explanatory framework for the way in which the detailed structure of human crania was directly related to the cerebral characteristics—the mental "capacities"—that lay within. I have expressed Gall and Spurzheim's ideas in terms of the relationship between outer and inner features to avoid the retrospective mistake of defining phrenology (as originally conceived) as a way of predicting human character and behavior from the bumps on own our heads.[1] This later definition was, however, to prevail when phrenology entered the distorting lens of the popular domain in nineteenth-century society.

Gall was a scientist of impeccable credentials, having studied medicine in Vienna and establishing himself as an authority on the anatomy and the physiology of the nervous system. Cranioscopy (or "organology") the science he conceived and began to broadcast during the 1790s, immediately attracted avid attention, both approbatory and critical. Gall was dogged simultaneously by antagonism from established science and the religious authorities and assailed by vulgar popularization throughout his career. With his works banned by imperial decree, Gall fled permanently to Paris in 1807. Spurzheim entered the scene as Gall's assistant and dissector in 1804. It was Spurzheim, as a peripatetic lecturer, who did much to spread the word about "phrenology" (a term coined by Thomas Forster in 1815, and which Gall never liked). The younger man traveled within Europe and to Britain and America as a kind of missionary for the new doctrine.

It was in Paris that the two men embarked on their *magnum opus,* published between 1810 and 1819 in four volumes with an atlas of illustrations. Their *Anatomie et physiologie du système nerveux général, et du cerveau en particulier, avec des observations sur la possibilitié de reconnaître plusieurs dispositions intellectuelles et morales de l'homme et des animaux, par la configuration de leurs têtes* parades huge quantities of learning and state-of-the-art research, of which their system of cranioscopy was just one part, albeit the one they considered their most original contribution. Of more widespread impact, above all in Britain and America where phrenology "took" with particular vigour, was Spurzheim's *The Physiognomical System of Drs. Gall and Spurzheim; founded on an Anatomical and Physiological Examination of the Nervous System in General, and of the Brain in Particular; indicating the Dispositions and Manifestations of the Mind* published in London in 1815, after a severe rift with his master. As a compact encapsulation of their researches (albeit of 581 pages), Spurzheim's single-volume publication will serve our present purposes well.

Worried, as was his mentor, about the popular traducing of their ideas on a widespread basis, Spurzheim declares at the very outset

This system is commonly considered as one according to which it is possible to discover the particular actions of individuals: It is treated as an art of prognostication. Such, however, is not the aim of our enquiries: we never treat of determinate actions: we consider only the faculties man is endowed with, the organic parts, by means of which these faculties are manifested, and the general indications which they present. The object of this

new psychological system, therefore, is to examine the structures, the functions and the external indications of the nervous system in general, and of the brain in particular. Thus does this science especially contribute to the knowledge of human nature.[2]

He then proceeds in an orderly manner through a series of accumulative topics, which compose an impressive list. He opens with the anatomy of the brain (fig. 154) and nervous system as whole. Then follows an outline of neurophysiology, the senses and their organs, the functions of the brain, its diseases, the plurality of the cerebral organs, the issue of brain size, embryology, and development. He examines the ways to determine the organs of the brain and methods of research, the various faculties, pathognomics, psychology, the organization of the mind, and innate faculties (described as "the basis of anthropology").[3] He assesses external influences (society, climate, education, etc.), geniuses among animals and men, moral and philosophical considerations, and the criminal and medical implications of brain science. This vast range of material reaches far beyond medicine and into philosophy and virtually every aspect of the human sciences. The more philosophically oriented questions toward the end of the book were more characteristic of Spurzheim than Gall, who distrusted overtly speculative thought.

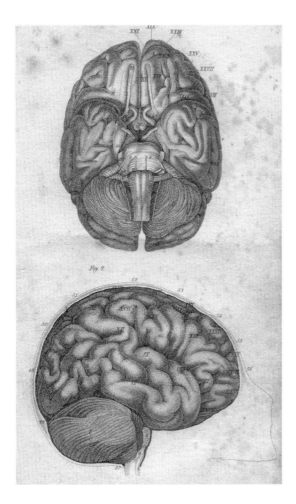

154. *Anatomy of the Brain*, from Johann Caspar Spurzheim's *The Physiognomical System of Drs. Gall and Spurzheim*, 1815.

The centerpiece of Spurzheim's book is his listing and definition of the faculties (numbered here to correspond to the diagrams he supplies at the start, fig. 155). They are grouped taxonomically into orders, genuses, and (by implication) into species:

Order I Feelings

Genus I Propensities

I amativeness, II philoprogeniveness, III inhabitiveness, IV adhesiveness, V combativeness, VI destructiveness, VII constructiveness, VIII covetiveness, IX secretiveness.

Genus II Sentiments

X self-esteem, XI love of approbation, XII cautiousness, XIII benevolence in man / meekness in animals,

Sentiments proper to mankind:

XIV veneration, XV hope, XVI ideality, XVII conscientiousness, XVIII firmness,

Order II Intellect

Genus I knowing faculties

XIX individuality, XX form, XXI size, XXII weight and movements, XXIII coloring, XXIV locality, XXV order, XXVI time, XXVII number, XXVIII tune, XXIX language (natural and artificial signs).

Genus II Reflecting faculties

XXX comparison, XXXI, causality, XXXII wit, XXXIII imitation.

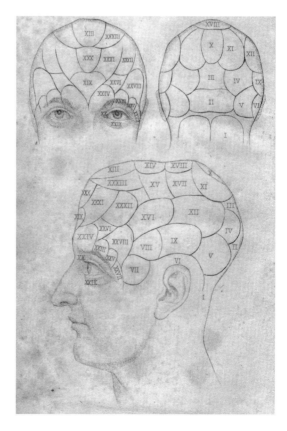

155. *Faculties of the Brain,* from Johann Caspar Spurzheim's *The Physiognomical System of Drs. Gall and Spurzheim,* 1815.

Lest this enumeration and the assigning of particular faculties to externally expressed areas in the brain seem arbitrary, Gall and Spurzheim were at pains to proclaim their systematic, empirical methods. The development of the brains in animals and humans showed clearly that the skull shape responded to areas of the brain that were developed to lesser and greater degrees. They argue that there is, "throughout all nature, a general law that the properties of bodies act with an energy proportional to their size."[4] The specific allocation of particular faculties to particular locations was based on a two-pronged observational strategy, to be conducted on as large a scale as possible: "When, for instance, he [Dr. Gall] observed any mechanician, musician, sculptor, draughtsman or mathematician, endowed with his peculiar faculty from birth, he examined their heads in order to discover a corresponding development of some cerebral part."[5] If the head of any individual presented any protuberance, which was evidently the result of cerebral development, Gall claimed to be acquainted with the talents or dominant character of the person.[6]

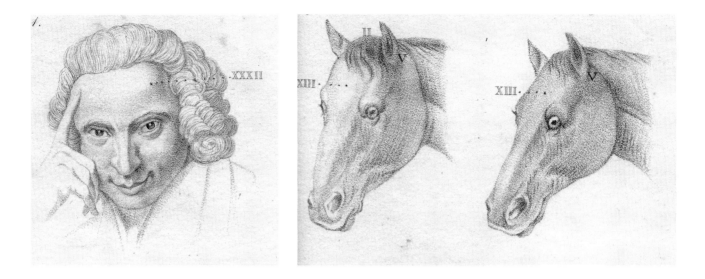

However, when we come to look at the system in operation, as applied to the observations of particular individuals, the results do not seem to differ substantially in quality from those of Lavater. Taking the example of the "organ of wit" (no. XXXII on the diagram), we learn that persons "like Voltaire, Sterne [who is illustrated from Reynolds's portrait (fig. 156)], Piron, John Paul &c., have the superior external parts of the forehead elevated."[7] Animal faculties yield to the same kind of analysis. With respect to the "organ of combativeness" (no. V), Spurzheim observes that "courageous animals have the head between and behind the ears very large [fig. 157]. This is an unfailing sign to distinguish or recognise, if a horse be shy and timid, or bold and sure. The same difference is observed in game cocks and game hens, in comparison with domestic fowls. Horse jockies, and those who are fond of fighting cocks, have long made this observation."[8] In the illustrated examples of horses and dogs, the configuration of the "organ of cautiousness" (no. XIII) presumably confirms the diagnosis.

Particularly relevant in our present endeavor is the fact that Gall and Spurzheim consider the enduring questions of whether man is distinct from the beasts, and the role of innate attributes in relation to culture and education. They come down firmly on the side of those who believe that humans, like animals, draw their primary attributes, general and individual, from innate characteristics: "Without denying the importance of external circumstances as exciting powers, we still think that the primitive and most important cause is overlooked, and that it exists in the innate organisation. It is the same as that of the distinctive labours of animals. Man invents and cultivates sciences and arts in the same way as the beaver builds its hut and as the nightingale sings."[9] Spurzheim, who was particularly engaged with the philosophical issues, expresses much sympathy with Condillac's stance. And like his French predecessor, he pays due attention to the cases of feral children, though adopting a more overtly medical approach: "It is asserted that savages who are found in woods, destitute of all human faculties, resemble beasts solely because they have received no education; but this objection is refuted, as soon as the condition of these pretended

156. After Joshua Reynolds, *Laurence Sterne,* from Johann Caspar Spurzheim's *The Physiognomical System of Drs. Gall and Spurzheim,* 1815.

157. *Horse's Head,* from Johann Caspar Spurzheim's *The Physiognomical System of Drs. Gall and Spurzheim,* 1815.

savages is known. These unfortunate creatures may be referred to two classes: ordinarily they are wretched persons of defective organisation, with heads too large being increased in size by dropsy of the brain; and when this is not the case they have heads too small and deformed."[10] Amongst the examples he cites Dr. Itard's Victor: "the pretended savage of Aveyron, who is kept in the Institution of the Deaf and Dumb at Paris, is an idiot in a high degree [supporting Phillipe Pinel's diagnosis]: his forehead is very small and much compressed in the superior region."[11] Just such a head is illustrated amongst the plates at the end of the book (fig. 158). On the other hand, a normal "individual who has escaped in infancy," when systematically introduced back into society, "will soon imitate the manners and receive the instruction of others. The girl of Champaigne [Memmie] proves this assertion."[12]

158. *Head with Low Forehead,* from Johann Caspar Spurzheim's *The Physiognomical System of Drs. Gall and Spurzheim,* 1815.

The upshot is that humans have an innate disposition for education and civilization, courtesy of those higher faculties that are "proper to mankind" and are either absent or expressed in a limited manner in animals. At the same time, there are many shared attributes, above all those that relate to the biological fitness of the organisms for individual and collective survival. Gall and Spurzheim are convinced that the proper scientific study of anatomy and physiology of the brain and nervous system, down to the smallest components of the "molecules" that compose things, will provide rational definition of the attributes of animals and humans. They are not, however, hard materialists, since they fully accept that man's highest qualities are driven by an immaterial substance (i.e., soul) that is part of God's great scheme of things. Theirs is very much an Enlightenment enterprise, in which knowledge is an unconditionally good thing. They cite with approval Pascal's dictum: "If it is dangerous to make man see too much how he is like the beasts, without showing him enough of his grandeur, just as it is to make him see his grandeur without showing him enough of his beast-like qualities, it is even more dangerous to let him ignore one or the other."[13]

The systematic nature of Gall's phrenology contributed to its role in the development of nineteenth-century scientific thought. To cite just one example, Thomas Forster's *Observations on the Natural History of Swallows* cited phreonological evidence in relation to the tendency of the birds to wander over long distances.[14] On the other hand, the potential for phrenology to be used in a simplistically predictive manner led to its eventually falling into bad odor. Partly with the connivance of Spurzheim and his more serious followers, phrenology entered the realm of popular fad, bowdlerized into a series of crude prescriptions, much as was to happen to Freudian psychology a century later. Phrenological societies sprang up in many centers, varying in quality and levels of scientific understanding. One of the first and best was that in Edinburgh, where Spurzheim disputatiously lectured in 1817. His keenest Scottish follower, George Combe, began immediately to write articles and books in support of the doctrine, publishing his *Essays on Phrenology* in 1819. With his brother Andrew, he was one of the founders of the Edinburgh Phreno-

logical Society in 1820. The fact that Andrew Combe was to become physician to Queen Victoria underlines the inroads that phrenology made into the higher strata of professional medicine. The Edinburgh Society, as recommended by Gall himself, built up a large databank of casts of the heads of the famous and infamous as the basis for systematic comparisons through sight and touch.[15] Gall's own head was one of the prized exemplars (fig. 159).

Almost inevitably, a popular tool that promised diagnostic reading of the configurations of crania had an impact on artists alert to the help that the sciences of character could afford. Indeed, the first volume of the *Phrenological Journal & Miscellany* published a craniological reconstruction of Iago, the sower of discord in Shakespeare's *Othello,* as an implicit demonstration of how phrenology could serve art.[16] Amongst the artists who seem to have adopted phrenological formulas, none was more thorough than William Powell Frith, the popular Victorian painter of famous scenes teeming with worthy and disreputable characters, such as *The Railway Station* in 1862 and *Derby Day* in 1858.[17] Frith did not necessarily need to assume high levels of phrenological knowledge on behalf the many spectators of his canvases. He would expect his viewers to respond instinctively to his own informed characterizations of the diverse ethnic and psychological constitutions of the assorted types of humankind paraded in his pictures.

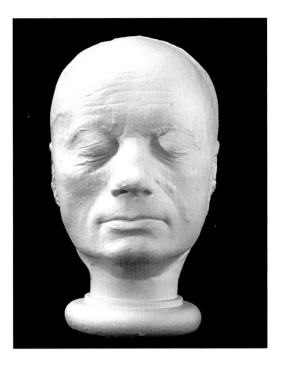

159. *Life Mask of Dr. Gall,* 1828, Edinburgh University. Courtesy of the William Ramsay Henderson Trust.

The ultimate fate of the fashionable science espoused by followers and popularizers like the Combes was that it eventually foundered for want of any fully convincing evidence other than the bumps for their very precise localization of such a mixed set of faculties. It is this evidence that modern neurology has produced through its techniques of brain scanning, albeit with faculties denoting mental processes rather than a fixed set of behavioral attributes, and disassociated from external bumps. The behavioral dimension has been annexed by the largely antagonistic disciplines of psychology and genomics, one emphasizing nurture and the other nature. At least this confirms that the issues raised by Gall are matters of genuine scientific moment and can yield to systematic investigation, though he drew his prime evidence for individualization from the wrong features of our makeup.

INCLINED TO BE SAVAGE

One dimension that was absent from phrenology, and which presented it with a severe disadvantage in the competitive environment of nineteenth-century science, was quantification. Indeed, Gall and Spurzheim denied any simple connection between brain size and intelligence (either in itself or relative to body mass) and they correctly noted that it is very difficult to come up with any accurate measure of *size*

for such a complex and furrowed and partially hollow organ as the brain. However, it was with the measuring systems that the bigger future of craniology resided.

The first sustained attempt to define the varieties of heads on a precisely measurable basis centered on the "facial angle," that is to say the inclination of a straight line drawn along the main features as shown in profile. This angle traced the all-important relationship between the slope of the forehead and the most prominent features of the jaws and chin. It was this angle that became the basis for the characterization of the "prognathous" type, with receding forehead and protruding jaws. It was to become the key sign of "primitive," "degenerate," or "regressive" characteristics, largely because of the supposed affinities of the prognathous profile with the configuration of the heads of apes. In due course, it came to stand at the center of some extremely unpleasant racial theories. Looking at the eighteenth-century origins of the technique, it is easy to tar it retrospectively with the same unpleasant brush, but the initial arrangements of different types of heads in sequence according to facial angle did not carry the immediate implications that they do today, in our post-Darwinian era. This is true above all of the influential Dutch man of medicine and letters, Petrus Camper, who is the inventor of the method.[18]

The springing-off point for Camper was Albrecht Dürer, even if he castigates the "great master" for having "laid the foundation of a bad taste."[19] In his drawings and *Four Books on Human Proportion* (1528), Dürer had worked to establish a proportional system that was capable of embracing an extraordinarily wide variety of human types, not just the ideal form and a few adjacent variants.[20] For the head he took the standard kinds of proportional divisions, used by Leonardo amongst others, and subjected them to various kinds of systematic manipulation or "transformation" (to use the geometrical term), using procedures that include differential stretching and skewing. In one of his drawings in the Dresden Sketchbook, a specifically African physiognomy is constructed (fig. 160). This was the kind of head that would have served his practical purposes as a painter when he needed to characterize one of the three kings in the *Adoration* as African. It also testifies more generally to Dürer's open-minded curiosity about the exotic. He was, after all, the author of the most appreciative of all the artists' reactions to the marvelous artifacts arriving in Europe as the result of the conquest of the Americas.[21] What we cannot do is to assume that such a facial type would have been automatically regarded as "primitive," as it tended to be in the later eras

160. Albrecht Dürer, *Studies of Heads and St. Peter,* c. 1526. Dresden, Saxon State Library, fol. 101v.

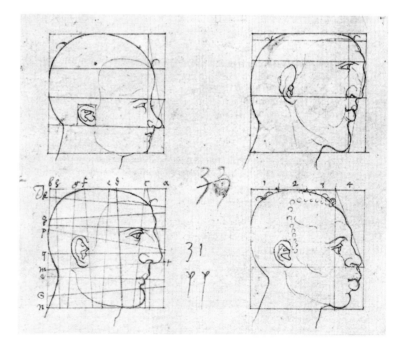

ART AND ATAVISM 219

of world empire. In fact, as we have seen, the ubiquitous sign of "primitive races" of humans in Dürer's era was extensive bodily hair.

The facial angle had played a role in Charles Le Brun's efforts in the French Academy to provide grammatical formulas for the characterization of the fixed and mobile signs of animal heads, but, as we saw, this particular aspect of his teaching was little known and poorly understood. It remained for Camper in the eighteenth century to combine the potential of Dürer's system with the rising science of primatology. Camper's researches, which we encountered in the previous chapter, provide part of the essential context for the proper understanding of his much-illustrated

161. Sequence of the first four crania in profile, from *The Works of the Late Professor Camper on the Connection between the Science of Anatomy and the Arts of drawing, Painting, Statuary,* 1820, plate 1.

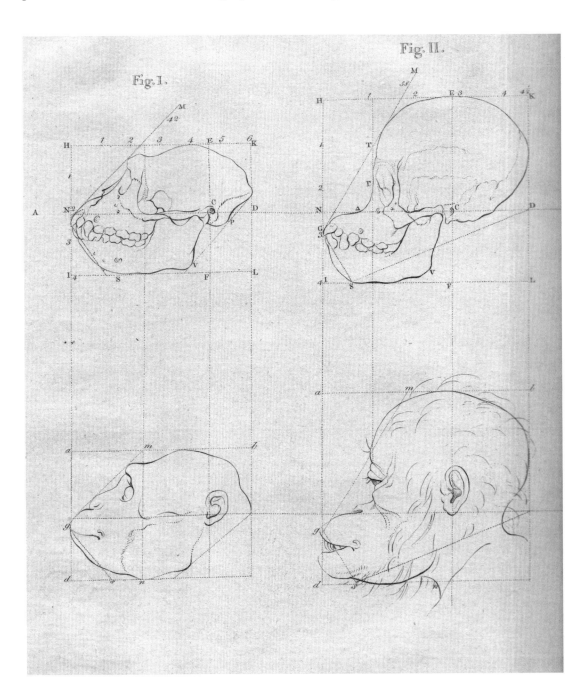

sequence of crania, ranging from a *Simia caudata* (tailed monkey) to the Apollo Belvedere, via a "Negro" and "Calmuck." The plates were first published in his *Dissertation sur les variétés naturelles qui caractérisent la physionomie des hommes* in 1791, and became widely known through the much reprinted *The Works of the Late Professor Camper on the Connection between the Science of Anatomy and the Arts of Drawing, Painting and Statuary* (fig. 161). Camper's purpose is primarily directed toward the ends of art, since he aspires to rectify artists' customarily inaccurate characterization of different racial types, but he does provide a broader outline of his views on the "natural history" of man. Taking his cue from Buffon, he looks to explain the varieties observable within

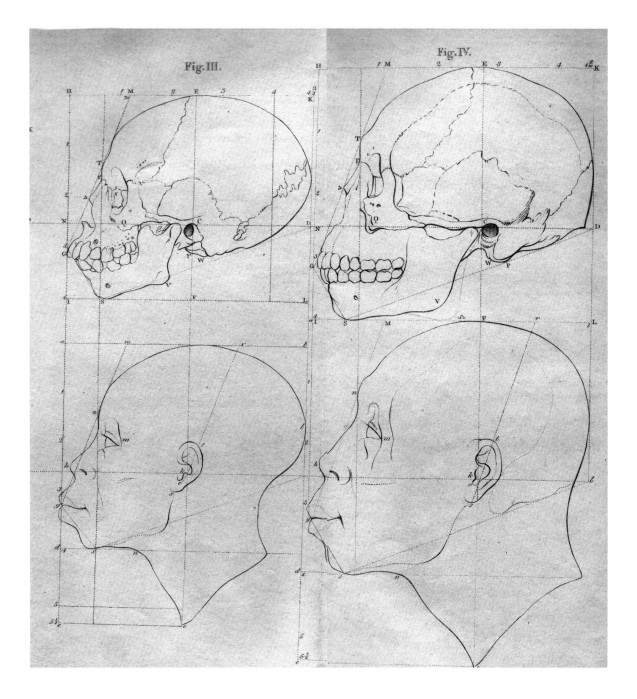

the human species on the grounds of climate, food, manners, and customs, that is to say on the basis of variations induced by circumstance into the many human types descended from Adam and Eve. The best way to do justice to what his arguments are about and, as importantly, what they are not about, is to let him speak for himself.

The arguments center on his fold-out plates of elegantly drawn heads and crania, systematically surveyed from the front and from the side. They record data from crania in his collection, using an elaborate measuring frame of his own devising. He records the key facial angles:

> 42° in the *simia caudata;*
> 58° in a small *orang-outang;*
> 70° in a young Negro [publicly dissected by Camper in Amsterdam in 1758];
> 70° in a Calmuck;
> 80° in the European.

The 80° angle can be exceeded "by the rules of art alone," as exemplified by the ideal beauty of the Apollo Belvedere, which sets the standard from which the various human and simian heads depart to greater or lesser degrees. For example,

> The Calmucks, compared with ourselves, and more particularly with the most celebrated figures of antiquity, are deemed the ugliest of the inhabitants of the earth. Their faces are flat and very broad from one cheek-bone to the other; the eyes are near to each other; the lips are thick, and the uppermost lip is long. They resemble the inhabitant of Siam, as described by Loubière, whose faces are broad across the cheeks, while foreheads and chin terminate in a point; so that their form is more rhomboidal than oval.[22]

The sequence, in which he acknowledges that the Negro and Calmuck "begin to resemble some species of monkey," corresponds to the way that he actually displayed crania his own collection: "It is amusing to contemplate an arrangement of these, placed in a regular succession: apes, orangs, negroes, the skull of a Hottentot, Madagascar, Celebese, Chinese, Moguller, Calmuck, and divers Europeans, in order that those differences might become the more obvious which I have described."[23] He is aware that "the assemblage of craniums . . . may perhaps excite surprise," not least because,

> the striking resemblance between the race of Monkies and of Blacks, particularly on a superficial view, has induced some philosophers to conjecture that the race of blacks originated from the commerce of the whites with orangs and pongos; or that these monsters, by gradual improvements, finally become men.
>
> This is not the place to attempt a full confutation of so extravagant a notion. I must refer the reader to a physiological dissertation concerning the orangutan, published in the year 1782. I shall simply observe at present, that the whole generation of apes, from the largest to the smallest, are quadrupeds, not formed to walk erect; and that from the

very construction of the larynx, they are incapable of speech. Further: They have a great similarity with the canine species, particularly respecting the organs of generation. The diversities observable in these parts, seem to mark the boundaries which the Creator has placed between the various classes of animals.[24]

The separate, monogenetic creation of a single species, followed by the dynamic generation of races over time, is the absolute that dictates his views:

> No man who contemplates the whole human race as it is now spread over the face of the earth, without a predilection for hypothesis, can doubt of its having descended from a single pair, that were formed by the immediate hand of God, long after the world itself had passed through numberless changes. From this pair all the habitable parts of the earth were gradually propagated. The difference of colour is not an objection of moment. This frequently varies, while the contexture of the skin is uniformly similar in all men . . . I have in my collection of natural curiosities, several specimens of the skins of moors, Italians, and of the fairest Dutch women, in which the *membrana reticularis* is to a great or less degree of a dusky hue; so that no difference exists, whichever of the propositions be advanced.[25]

The technical study of skins of various colors was becoming a significant subject of study for those concerned with the races of man, including Camper's fellow countryman, the great anatomist, Albinus.

In all of this, there is not—despite assumptions made to the contrary when Campus's sequences are discussed in much of the historical literature—the slightest indication that he is concerned with anything other than aesthetic ranking. The facial angle is not paraded as a sign of either intelligence or of different races of humans being closer or more remote from apes in moral character. However, once his observations were drawn into a more broadly diagnostic arena, they all too readily began to assume such implications.

How this could happen can be seen very clearly in Charles White's *An Account of the Regular Gradation in Man, and in Different Animals*. As in his more general statements on the position of human races in relation to apes, White's knowledge of contemporary scholarship on craniology is not in doubt. He directly cites John Hunter's "Remarks on the Gradation of Skulls" and quotes Lavater on the lessons to be learnt from "Ethnographic skulls."[26] The kind of detrimental observations he made about African anatomy become even more cogent, in his eyes, when he turns to the structure of the head. The Negro's chin "is less than in the European" and "falls back as in the ape," just as can be observed in inbred upper classes in Britain (popularly known as "chinless wonders").[27] Using a sequence that extends Camper's sets of progressively inclined facial angles, he lays out rows of thirty-two cranial profiles (fig. 162), descending from the noble Apollo Belvedere to the stupid snipe, with the "Golok" (for which he had no skull) acting as an intermediate link between men and apes.

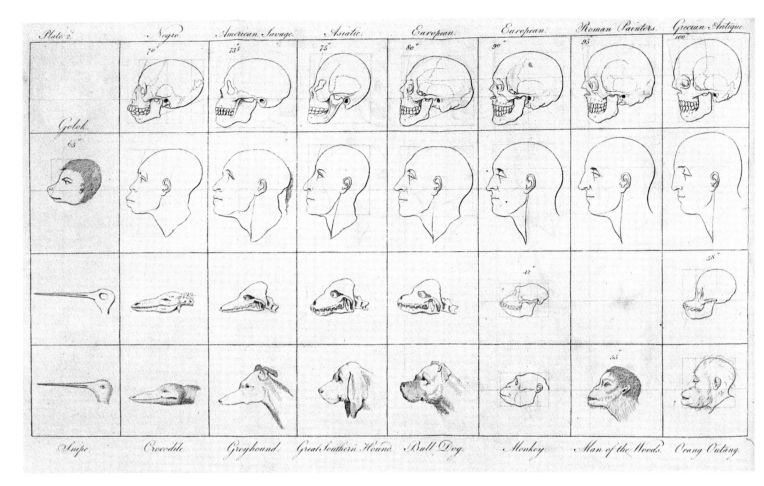

White may be at the extreme end of the gradation business, but he does accurately represent the kind of radical rewriting of the creation story that was occurring in Europe and America around 1800. There were important voices raised in doubt. For example, Spurzheim pointed out that Camper's facial angle is "inapplicable to all the lateral and posterior parts" and cannot be taken as an adequate characterization of the brain.[28] He also noted that "we know of negroes whose jaw-bones are extremely prominent, but who manifest great intellectual faculties because their foreheads are much developed."[29] However, the attractions of systems that promised the kind of quantitative methods that phrenology lacked, helped to ensure that craniological measurement came to be regarded as more "scientific" than the subjective reading of bumps.

Camper's ideas were to be taken up and transformed in the climate of the early 1800s, when the rising sciences of anthropology, ethnography, and eugenics were growing to early maturity. This was particularly the case in Paris, where such disputatious luminaries of the natural and human sciences as Georges Cuvier and Geoffroy de Saint-Hilaire were laying the foundations for the comparative study of human and animal morphologies in the context of the fossil record. Cuvier was one of those who keenly studied Saartje Baartman, the "Hottentot Venus," seen here in

162. *Sequence of Cranial Profiles,* from Charles White's *An Account of the Regular Gradation in Man, and in Different Animals,* 1800.

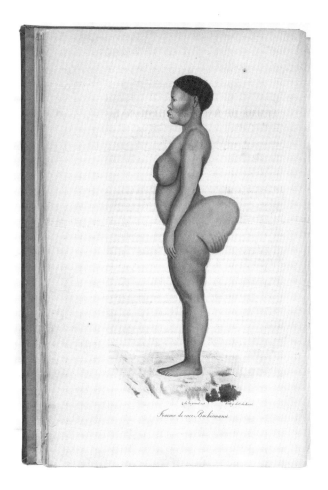

Saint-Hilaire's illustration (fig. 163) who became a celebrity of scientific curiosity in Paris and London. Cuvier recorded that,

> She had a way of pouting her lips exactly like what we have observed in the orang-outang. Her movements had something abrupt and fantastical about them, reminding one of those of the ape. Her lips were monstrously large. Her ear was like that of many apes, being small, the tagus weak, and the external border almost obliterated behind. These are animal characters. I have never seen a human head more like an ape than of this woman.[30]

In 1816 Cuvier performed on autopsy on Baartman concluding that Hottentots were indeed part of the human species, but that they exhibited discernible anatomical variations from Europeans, not least a certain hypertrophy of the vulva indicated a high level of sexuality.[31] Baartman's sexual organs are still preserved in the Musée de l'Homme. She was in fact a member of the San or Bushmen, whose women exhibit a genetic variation in their nymphae and labias, which form an apron over their vulvas, and typically possess large buttocks—characteristics which have nothing to do with enhanced sexuality, "animalistic" or otherwise.

163. *The Hottentot Venus,* Étienne Goeffroy de Saint-Hilaire and Frédéric Cuvier, *Femme de Race Bochismann, Histoire Naturelle des Mammifères,* Paris, 1824. Image courtesy of the General Research Division, The New York Public Library, Astor, Lenox and Tilden Foundations.

It was in the Cuverian succession that Paul Broca embarked upon his great campaigns of anthropological measurement, and founded his Société d'Anthropologie in Paris in 1859. At the heart of Broca's enterprise was his desire to "find some information relevant to the intellectual value of the various human races."[32] His general thesis was that "there is a remarkable relationship between the development of intelligence and the volume of the brain."[33] He was also firmly of the opinion that the Camperian facial angle provided a significant sign: "a prognathous face, more or less black colour of the skin, woolly hair and intellectual and social inferiority are often associated."[34] In the face of anthropologists' demands for minutely accurate data, instrument makers were more than ready to devise ever more ingenious craniometers to record excruciatingly precise measurements of the facial angle or any other dimension that might conceivably facilitate the arrangement of crania according to graded scales (fig. 164). However, when Broca's own prodigious campaign, conducted with notable rigor, eventually disclosed data to suggest that "Eskimos, Lapps, Malays, Tartars and several other peoples of the Mongolian type" possessed larger brains than Europeans, he concluded brain size alone would not suffice as an infallible measure of intellectual capacity.[35] The premise was that Europeans were demonstrably the most intelligent race, as the level of civilization incontrovertibly showed, and if the theory and data suggested otherwise, either or both must be revised. Broca sought, with at least some sense of growing anxiety, for alternative measurements that should be sifted and tabulated to sustain his governing premise of the superiority of modern Caucasians.

This should not be taken to mean that Broca was knowingly dishonest. Stephen Jay Gould has reexamined his data to show how they were gathered and handled on the basis of certain premises that "add up."[36] The French scientist's craniometry may have been misguided, but it was conducted with assiduity and care, and it encouraged many throughout Europe and America to join in. Nor should we forget that Broca, like Gall, was a significant researcher into the anatomy and physiology of the brain. It was Broca who used his observations of the asymmetry of the brain to lay down the basis of the right-brain left-brain duality that prevails today. He advocated the superior nature of the left brain, which controlled the right side of the body, while the right brain was assigned to the "sinister" left side. Localizing the higher faculties, including reason, morality, and language acquisition, in the left hemisphere, Broca accordingly relegated the right to the governance of the faculties that we predominantly share with animals.

164. Paul Broca, *Craniometer,* c. 1870, designed and used by Paul Broca, A658588, Science Museum, London. Image courtesy of the Science and Society Picture Library, London.

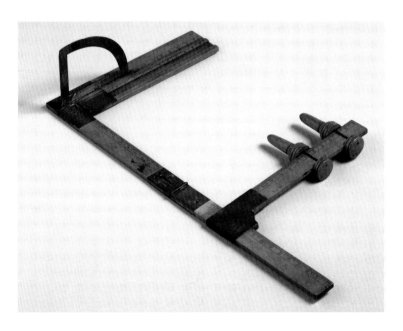

What Broca's great endeavors show is that any investigator of the essential nature of human beings is entering a perilous field in which cultural values inevitably color everyone's ways of looking. In this respect, one of the most telling episodes in the story of culturally based ordering of races arose when the European theories encountered American realities. Louis Agassiz, the great Swiss biologist and follower of Cuvier who arrived in Philadelphia in 1846 before moving to Harvard to found the Museum of Comparative Zoology, was persuaded by the revulsion he felt at the appearance of "negroes" (whom he had never previously encountered "in the flesh") that they could not belong to the same species as the noble and beautiful Caucasians. He wrote to his mother that "I experience pity at the sight of this degraded and degenerate race, and their lot inspired compassion in me in thinking that they are really men."[37] Their "animalistic" demeanor was in contrast to "the indomitable, courageous, proud Indian": "in how very different a light he stands by the side of the submissive, obsequious Negro, or by the side of the tricky, cunning and cowardly Mongolian! Are not these facts indications that the different races do not rank upon one level in nature?"[38] Like so many fundamentally humane people, at least in their dealings with particular people, Agassiz was instinctively compelled to transform a level of aesthetic and social revulsion and attraction into a "rationalized" system of anthropological values.

The exemption of Native Americans, the "Indians," from Agassiz's stigmatizing of non-Europeans had a long history. Though despised and feared by many settlers and their descendants, Rousseau's characterization of Indians as "noble savages" enjoyed a substantial following. James Fenimore Cooper's *The Last of the Mohicans,* first published in 1826, set the naturally masculine, warlike valor of Magua against the feminized refinements that beset polite society. Named "Le Renard Subtil" by the Canadians, the pure-blooded Mohican exhibits the fabled cunning of Reynard the Fox: "Has he not seen that the woods were filled with outlying parties of the enemies, and that the serpent could not steal through them without being seen? Then, did he not loose his path, to blind the eyes of the Hurons? Did not he pretend to go back to his tribe, who had treated him ill and driven him from their wigwams, like a dog? . . . Does not Reynard mean to turn like a fox in his footsteps?"[39] When, at the end of the book, the elegy for the dead Magua is delivered by a girl of the Delawares, "selected for the task by her rank and qualifications," natural analogies abound: The girl

commenced by modest allusions to the qualities of the deceased warrior, embellishing her expressions with those oriental images, that the Indians have probably brought with them from the extremes of the other continent, and which form, of themselves, a link to connect the ancient histories of the two worlds, she called him the "panther of his tribe," and described him as one whose moccasin left no trail on the dews; whose bound was like the leap of a young fawn; whose eye was brighter than a star in the dark night; and whose voice, in battle, was loud as the thunder of the Manitto.[40]

Cooper is alluding to the ethnographical theory that the natives of America had descended distantly from the Oriental race, not least because their "language has the richness and sententious fullness of the Chinese."[41]

The response of painters to Cooper's highly pictorial vision was immediate. Of the Hudson River School of landscapists who took up the theme, Thomas Cole was the first in the lists with a number of versions of his 1827 picture, *Scene from "The Last of the Mohican." Cora Kneeling at the Feet of Tamenund* (fig. 165). In a setting of savage sublimity, Cora, beautiful daughter of Colonel Munro and a West Indian Creole (from whom she inherited a quotient of "negro blood"), throws herself on the mercy of the chief. The remnants of his tribe are gathered in a circle on the natural "altar" on which the sacrificial dénouement of the novel is to be acted out—culminating in the deaths of Cora and Le Renard Subtil. Whatever romance might attach to the life of the Indian, viewers of Cole's paintings, like those who read Cooper's novel, knew that the natural wilderness was increasingly surrendering to the colonizers. The sublime nature of the remoter tracts of the continent was no longer the preserve of the savages, whether noble or barbaric.

165. Thomas Cole, *Cora Kneeling at the Feet of Tamenund,* 1827, Wadsworth Atheneum Museum of Art, Hartford, Connecticut. Bequest of Alfred Smith.

Amongst the races that were not subject to the romantic exemption sometimes granted the "Indian," the Mongols came in for particularly harsh treatment. This is vividly manifested by the characterization of the congenital disease of "Mongolism" by Dr. John Down in his 1886 paper "Observations on an Ethnic Classification of Idiots." Claiming that idiots displayed common anatomical characteristics with "lower" races, he attempted a taxonomy of European retards in terms of racial type: Ethiopian, Malay, and Mongol. The last category was particularly significant, since "a very large number of congenital idiots are typical Mongols."[42] As a caring doctor of liberal persuasions who was genuinely concerned with the disadvantaged, Down made a careful description of the features of a child with what is now called Down's syndrome. His conclusions were, however, much at odds with what would be permissible in modern medicine: "the boy's aspect is such that it is difficult to realise that he is the child of Europeans, but so frequently are these characters presented, that there can be no doubt that these ethnic features are the result of degeneration."[43]

In our present context, Louis Agassiz's most notable entanglement was with the Philadelphia physician, Samuel George Morton, who was a Camperian student of craniology on a scale far beyond that of his Dutch predecessor. Inspired by the phrenological theories of Gall and Spurzheim to believe that the configuration of the cranium provided accurate measures of the relative mental "capacities" of different creatures and different types of mankind, he built up a huge collection of crania and undertook an exhaustive program of craniological measurement. In addition to multiple measures of linear dimensions using specially designed instruments, he used mustard seed and lead shot to calibrate the internal volumes of series of skulls. In his successive publications in 1839 and 1844 on *Crania Americana* (on Native Americans) and *Crania Aegyptiaca* (on skulls from Egyptian tombs), he provided sets of striking illustrations (fig. 166) and assembled enormous banks of data to demonstrate that the desirable and undesirable characteristics of various races could be correlated with

166. John Collins, *Skull of an Araucanian Indian,* from Samuel George Morton's *Crania Americana,* 1839, The Bodleian Library, University of Oxford. 02.E02479.

brain shape and size.[44] In the case of the "Indians" (one of Blumenthal's races), who provided the primary focus for Morton's researches, his cranial analyses revealed to his satisfaction why they demonstrated unsuitability for civilization and no capacity for abstract reasoning. The standard catalog of lower races, such as the Mongols, are given their expected beatings, and the Hottentot women are singled out as "even more repulsive in appearance than the men."[45] However, the resulting gradation of human species, ascending from bestial to noble, did nothing to shake Morton's belief that each individual species of humans must be considered in its own right as a "primordial organic form," immune from significant transformation.

Agassiz, for his part, was well aware of the temporal progression of the appearance and disappearance of different species on earth as represented by the fossil record, but could not countenance Darwin's full theory of evolution, which he continued to combat fervently until his death in 1873. It was the conviction that one species could not transform itself into another that ultimately placed strict limits on what could be meant by an "intermediate link" in the pre-Darwin era. The links in the great chain of being were discrete and fixed, even for someone who did not believe in a single, unitary creation of humankind. One link could simply not evolve over time into another.

It is interesting and perhaps surprising to find that Camper's method of characterizing skulls—without any of the later connotations—still featured in the

167. François Sallé, *The Anatomy Lesson of Dr. Duval at the École des Beaux Arts,* oil on canvas, 218 × 299 cm, purchased 1888. Collection: Art Gallery of New South Wales, Adelaide. Photo: Jenni Carter for AGNSW.

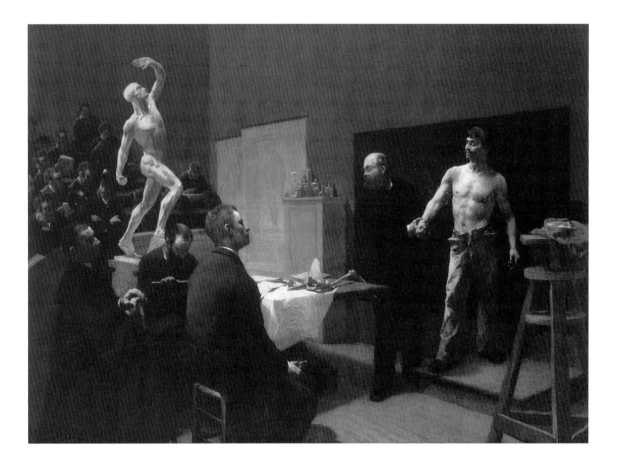

teaching at the École des Beaux Arts in the final quarter of the nineteenth century. Mathias Duval, who was shown splendidly in action as professor of anatomy at the École in François Sallé's painting in 1888 (fig. 167), described and illustrated Camper's description of facial angles in the book of his lectures. No conclusion is drawn. Nor is any value imputed to his observation about arm length in relation to height:

> Man having arms horizontal is enclosed within a square. This shows that the span of arms is equal to the height. This statement is true for a man of the Caucasian race of middle height, but it is not so for the yellow races, in whom the span of the arm is greater than the height. If from man we pass on to the superior monkeys, called anthropoid (chimpanzee, Gorilla, &c.), we find that the span of the arms in these becomes more and more extended as compared to the height, until it becomes almost double.[46]

As director of the Anthropological Laboratory at the École des Haut Études, Duval would have been well aware of the range of interpretations applied to such observations. He makes highly critical remarks about the physiognomical theories of Lavater and the late eighteenth-century anatomist Jean-Joseph Sue—particularly the latter's elaborate animal parallels, observing that "this delicate analysis" is "a pure affair of sentiment," which is "always very uncertain and admitting of philosophical developments which would carry us far beyond the domain of anatomy."[47] Instead Duval contents himself with the reproduction of line drawings from Duchenne's photographs, which meet the standards of empirical truth that he is at pains to emphasize.

However, looking at Sallé's large painting, it is hard not to see a meaningful contrast between the impressive dome of the professor's bald pate, and the head of the working-class subject of study, whose muscled arm he grips. The model's high cheekbones, sharp nose and complexion stand in marked contrast to Duval's more obviously standard European features, which happily approximate those of Socrates in Roman busts. The profile of the attentive student in the foreground boasts a facial angle of which even the Apollo Belvedere would have been proud. Even if Duval was at pains to describe and not to interpret, putting his teaching into visual practice inevitably brings a series of values into play, whether they are those of the subject, artist, or spectator—and whether they are conscious or instinctive.

Not the least striking feature to have emerged from this selective overview of the issue of facial angle and craniological measurement is the extent to which Western notions of beauty, founded on the Greek ideal, plays a key role in conditioning a whole range of visual judgments made about racial types and their relationships to animals, most especially apes. So ingrained was the idea that the classical canons of beauty were irredeemably associated with moral and intellectual value, that racial stigma, scientific thesis, and visual norms of an aesthetic kind cannot be readily teased apart. This is as true even of those texts, like Broca's, that parade serried ranks of numbers rather than pictorial illustrations.

THROWBACKS:
THE STRANGE CASE OF LOMBROSO AND THE STIGMATA

There is a lengthy roll call of nineteenth-century authors who attempted to explain the behavior of those who transgressed social norms through the concept of "degeneration." The theory ran as follows: those who were mad and bad manifested a congenital condition in which their dominant traits were "primitive" or atavistic; their physical appearance bore signs of their condition; and they typically exhibited a deficit in those moral virtues that make us behave in a civilized manner. The regression could be defined "temporally" in relation to a residue left from our ancient ancestors or more traditionally with respect to our innately animalistic propensities. The notion that it was possible for people (individually or collectively) to revert to the uncivilized state of our rude progenitors did not, in itself, depend on an evolutionary theory. All that was needed was a belief in the kind of long-term sequence that Buffon or Democritus had advocated. However, once the evolutionary genie was out of the bottle—once it could be shown that our ancestors were apelike—the interpretation of degeneration as a kind of regression to a past state of existence still embedded deep within us became compelling. The advocates include a series of major and influential authors in a number of disciplines, extending from Phillipe Pinel, a major pioneer of neuroanatomy who worked at the prestigious Parisian mental hospital of the Salpêtrière around 1800 (fig. 168), to the long-lived Francis Galton, cousin of Darwin, polymathic man of science, and founder of eugenics who remained active after 1900.[48] E. Ray Lankester was prominent amongst the establishment naturalists of the Victorian era, and studied the evolutionary regression of organisms in his *Degeneration: A Chapter in Darwinism* in 1880, providing proponents of degeneration in the human species with a respectable base in biological science. *Degeneration* was also the title for the widely read book on the correlation between physical and moral regression published by the Hungarian author Max Nordau in 1893. Nordau was scathing about psychologists' definitions of separate kinds of "monomanias" and "phobias," preferring to see all mental enfeeblement and physical defects as manifestations of a single degenerative condition. For opponents of Darwin, the apparent openness of his theory and its mechanisms to such ideas made it all the more suspect.

We are fortunate that one major writer will serve in our present context to represent the post-Darwinian world of regression in its most developed form. Cesare Lombroso's scientific theories and popular writings gained huge currency. His book *The Criminal Man* was translated into many European languages and ran into several editions after its initial publication in Italian in 1876. Not least, from our present point of view, he was in the forefront of the search for morphological signs that aligned criminal humans with the animal relatives. His underpinning was Darwinian. Like Broca, Lombroso also splendidly exemplifies how an intensively designed and avidly conducted scientific enterprise in the human sciences can define and see the evidence it wants to see in the way it wishes.

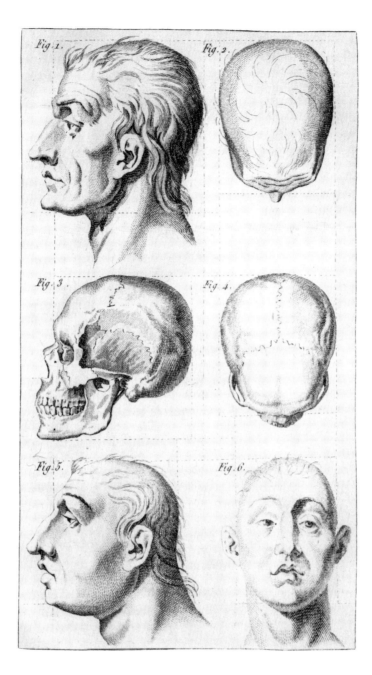

168. Phillipe Pinel, *Traité médico-philosophique sur l'aliénation mentale,* 1801, plate 2, Max Planck Institute for the History of Science, Berlin.

Lombroso benefited from an international education in three of the leading centers of medicine and psychology: Padua, Vienna, and Paris. He returned to Italy in 1862 to pursue a distinguished academic career in Pavia and Turin. It was in Turin that he essentially founded the science of criminal anthropology. All his major efforts in criminology were directed toward discerning of signs of innate characteristics that betrayed the nature of the "born criminal." Unlike Gall and Spurzheim's science of phrenology, the Lombrosian method openly claimed that it was predictive of human behavior and could be used for forensic detection.

As recorded in the popular monograph by his daughter in 1911 that summarized his theories, the key moment came in 1870 when Lombroso was examining the skull

of a notorious murderer, a kind of Italian Jack the Ripper. Lombroso experienced something like a vision on the road to Damascus:

> At the sight of that skull [Vihella, fig. 169], I seemed to see all of a sudden, lighted up as a vast plain under a flaming sky, the problem of the nature of the criminal—an atavistic being who reproduces in his person the ferocious instincts of primitive humanity and the inferior animals. Thus were explained anatomically the enormous jaws, high cheek bones, prominent maxillary arches, solitary lines in the palms, extreme size of the orbits, handle-shaped ears found in criminals, savages and apes, insensibility to pain, extremely acute sight, tattooing, excessive idleness, love of orgies, and irresponsible craving of evil for its own sake, the desire wantonly to extinguish life in the victim, to mutilate the corpse, tear its flesh and drink its blood.[49]

He described the tell-tale anatomical sign that had triggered his revelation with the detachment of a professional anatomist: "Where the internal occipital crest or ridge is found in normal individuals" he noticed, as his daughter describes, "a small hollow, which he called *median occipital fossa.* . . . the vermis was enlarged that it almost formed a small, intermediate cerebellum like that found in the lower types of apes, rodents and birds." On this basis, he began to study the recurrence of this feature in many categories of skulls. He reported, for example, that it was also found in 40 percent of the Aymara tribe in Bolivia and Peru. Above all, it was "prevalent in criminals."

He progressively identified and undertook extensive surveys of other visual signs, avidly measuring and listing any feature that might be pressed into service. Unstable piles of data were aggregated, resting on shaky premises. With remarkable precision, he reported that 45.7 percent of criminals are prognathous.[50] Their skulls are thicker, and the face predominates over the cranium. The chin "is often small and receding, as in children, or else excessively long, short and flat, as in apes."[51] Their common configuration of prominent canine teeth and flattened palette aligned them with rodents—indicating, by implication, that they were "rats."[52] "The span of the

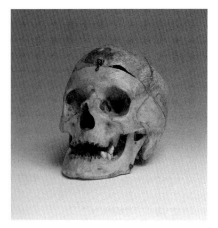

169. Cesare Lombroso, *Sectioned Skull of Vihella,* c. 1870, Museo di Antropologia Criminale Cesare Lombroso, University of Turin.

arms exceeds the total height, an ape-like character"—violating the proportional system that held sway in Western art and in its ancient prototypes.[53] "The foot is often flat, as in negroes."[54] In his study of the Dinka people of the Upper Nile, he recorded that their noses are "not only flattened, but trilobed, resembling that of monkeys," confirming their savage nature.[55] The criminal and primitive brain is said to be smaller than average. The signs even extend to the cellular level. Examining the cortical strata of criminal and normal individuals, he declares that "in born criminals and epileptics there is a prevalence of large, pyramidal and polymorphous cells, whereas in normal individuals small, triangular and star-shaped cells predominate."[56]

This litany of uncivilized features, or "stigmata," does not differ in principle from the characteristics we have already seen used to mark "primitive" peoples. There are some new features, based on the latest science, but many of the characteristics are familiar enough. For example, the tattooing of bodies with "ideographic hieroglyphs" can be recognized as having a precedent in the savage Picts, amongst others.

> Some of those pointed bones which have been used by modern savages in tattooing themselves have been found in the prehistoric grottoes of Avignac, and in the ancient tombs of Egypt. The Assyrians, according to Lucian, and the Dacians, according to Pliny, covered their whole bodies with figures. The Phoenicians and the Jews traced lines which they called "signs of God" on their foreheads and their hands. This usage was so widespread among the Britons that their name (from *Brith*, painting), like that of the Picts and Pictons, seems to have been derived from it. See Caesar.[57]

There follows a long list of modern savages from every corner of the world who decorate their bodies. If anything the criminals were worse than their ancestors and wild contemporaries, since they "showed obscenity of design and position and furnished also a remarkable proof of their insensibility to pain characteristic of criminals, the parts being tattooed being the most sensitive of the whole body, and therefore left untouched even by savages."[58]

The literally bloodthirsty apogee of atavistic behavior by the blood-drinkers and cannibals drew upon dark myths of vampires, Satanist rituals, Jewish malefactors, and tales of white men stewed in black men's pots. It is hardly surprising that when Bram Stoker in 1897 came to describe his fanged Count Dracula he did so in Lombrosian terms—"aquiline, with high bridge of the thin nose and peculiarly arched nostrils, . . . His eyebrows were very massive, almost meeting over the nose. . . . The mouth . . . was fixed and rather cruel-looking, with peculiarly sharp white teeth; these protruded over the lips, . . . his ears were pale and at the tops extremely pointed."[59] Not least, of course, the count's canine (or dog) teeth could be extruded at will to penetrate the pale necks of his nourishing victims. When Professor Van Helsing wishes to demonstrate that the deceased but undead Lucy has been vampirized, he "pulled back the dead lips" to reveal that the "canine teeth" were "even sharper than before."[60] We will encounter the aristocratic bloodsucker again in the postscript.

Lombroso seized avidly upon support from other authors and researchers. He was pleased to be able to quote Hippolyte Taine, when the French positivist praised Lombroso in fulsome terms: "you have shown us fierce and lubricious orang-utangs with human faces. It is evident that they cannot act otherwise . . . there is all the more reason for destroying them when it has been proved that they will always remain orang-utangs."[61] He was equally pleased with the data that purported to demonstrate how the feet of prostitutes are often prehensile like those of apes: "these observations show admirably that the morphology of the prostitute is more abnormal that even that of the criminal, especially for atavistic anomalies, because the prehensile foot is atavistic."[62] In very real sense, the modern criminal was the equivalent of the apelike caveman and cavewoman. Their constitutions were irredeemably savage and animalistic.

A remarkable visual manifestation of the way that Lombrosan theories of innate atavism insinuated themselves into popular consciousness is provided by Edgar Degas' sculpture of the *Little Dancer, 14 Years Old* (fig. 170). After various delays, it was displayed in 1881 inside a museum-style vitrine, which had specifically been supplied by the artist. The critics were generally disturbed by what they saw as the violation of several aesthetic norms.[63] Its highly original use of color and real materials (paralleled by polychrome anatomical and ethnographic sculpture rather than standard "Fine Art" exhibits) immediately placed the dancer in an odd category of object.

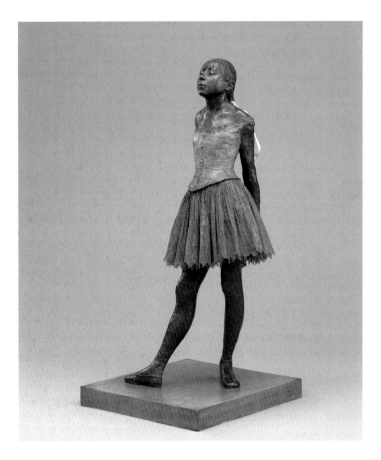

170 . Edgar Degas, *Little Dancer, 14 Years Old,* 1881, Museum of Fine Arts, Boston. Photograph © 2004 Museum of Fine Arts, Boston.

Even more worrying for those who picked up the references were the clear signs or "stigmata" that betrayed the "primitive" traits of the young woman. With their viewing attuned by Lombrosian notions, they were able to recognize the prognathous inclinations in her profile and the "degenerate" cast of her forehead. Degas himself took steps to ensure that the anthropological point should not be missed. The *Little Dancer* was displayed alongside his own pastel sketches of criminals in profile. This is not to say that his sculpture is simply illustrative. Looking at what we instinctively feel is the sensitivity of his portrayal and what we recognize as the beauty of the piece, it becomes difficult to think that Degas intended his work to convey crude stigmatization.

The human subtlety of our reading of character in such a complex work of art presents an open rather than closed field of interpretation. Degas, for his part, knew that he was placing his sculpture in a very different conceptual context for viewing than that for an illustration in a criminological text or sculpture in the Musée de l'Homme. If there is a context that now sits comfortably with his much-loved image, it lies more with the long tradition of the "noble savage," still very much current in the later nineteenth century, not least in the subsequent work of Gauguin in the South Seas. It may well be that the girl's constitution lent her dancer's body a more unfettered physicality than was available to corseted Parisian ladies of impeccable breeding. But perhaps the criminals' heads exhibited by Degas indicate that this is too romantic a reading of the "primitive" dancer. The frankly animalistic world created by Stravinsky and Nijinsky at the Ballet Russe is not so far away.

Lombroso's own illustrations were able to make extensive use of the new tool of photography. The photographic image, compared to drawn representations, was widely seen as giving a "perfect and faithful record"—to quote Hugh Welch Diamond, the English pioneer of photography of the insane.[64] As a compliment to the banks of numerical data obtained through craniometry, extensive sets of photographs could be assembled to detail facial characteristics that were shared by particular classes of peoples and differentiated them from other classes. French ethnographers had proved themselves to be eager users of photographic records, not least of the kind of Hottentot women that had attracted so much attention.[65] In Britian, Galton used photography in a notably innovative way to make composites of overlaid images to define all kinds of classes—from racial groups to families, from the lower to the higher, and from those susceptible to particular diseases to the insane and criminals (the last with the official assistance of the Home Office). Lombroso used artists to portray some notorious individuals, but he found it far more effective to collect photographs whenever he could. Photographs not only laid claim to superior levels of objectivity, but could also be produced in numbers impossible with hand-drawn images. His surviving collection in Turin contains many boxes of labeled photographic portraits. When he believed that he had gathered what appeared to be a coherent group, he laid them out as galleries and trees of serial images (figs. 171 and 172). Staring at the faces *en masse,* an alert viewer would be expected with Lombroso's guidance to recognize the "stigmata" that served to identify the

GLI ANTROPOLOGI CRIMINALISTI

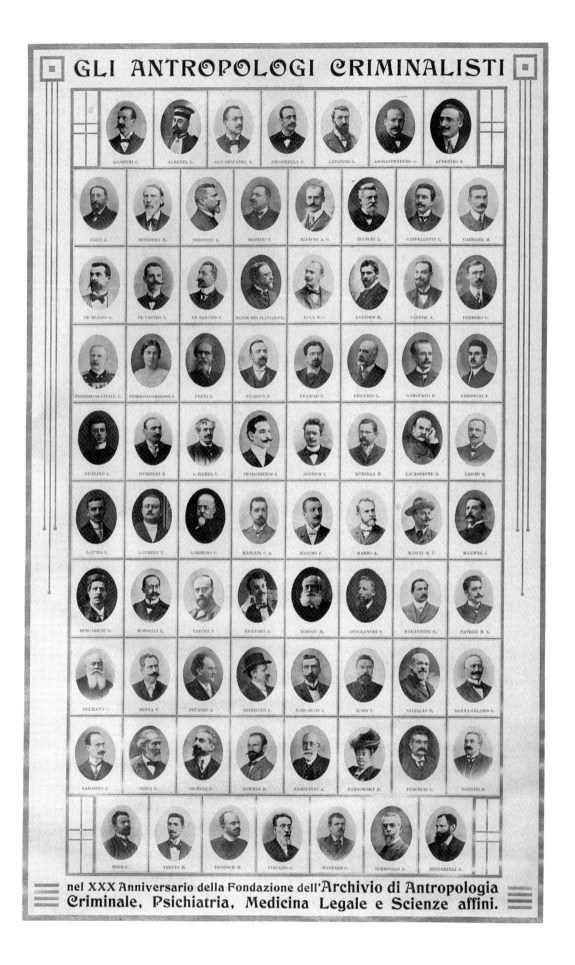

nel XXX Anniversario della Fondazione dell'Archivio di Antropologia Criminale, Psichiatria, Medicina Legale e Scienze affini.

shared characteristics. Once we could identify a particular stigma, we should be able to recognize it in real life. We should be equipped to detect someone who is innately criminal, just as we should be able to see the civilized qualities of Lombroso and his fellow "Crimial Anthropologists."

Lombroso's convictions that the criminal was born not made, and that such a congenital condition should be detectable through signs, were locked into a set of social, educational and political values. His views could readily serve the cause of those who advocated widespread use of capital punishment and even systematic extermination. Some extreme cases were beyond education, and even beyond the correctives of punishment. This is not to say that Lombroso himself advocated inhumane treatment of those condemned by fate to behave in a criminal manner. Atavistic individuals could not, after all, help their behavior. Society needed to be protected from them, and it was undesirable that they should be allowed to pass on their flaws to offspring, but they were deserving of pity for their debased state.

His data and methods of analysis came under sustained and often well-founded attacks from those who could not accept his package of values, and he progressively modified his arguments to accommodate criticism. Not least he accepted an expanded role for social factors, and he recognized that only a portion of those with criminal records were "born" to the job, so to say. However, his fundamental premise that there was indeed a definable class of atavistic persons remained untouched. We can see, with hindsight, that the Lombrosian episode in criminology is just one example

OPPOSITE

171. Cesare Lombroso, *Photographic Gallery of Criminal Anthropologists*.

TOP

172. Cesare Lombroso, *Album of Criminals,* no. 2, c. 1870, Museo di Antropologia Criminale Cesare Lombroso, University of Turin.

of the age-old disputes about the primacy of nature or nurture, and about the educational perfectibility of humans individually and collectively. For a Lombrosian, the belief was that once an animal (or caveman), always an animal (or caveman).

Whatever our own stance on these issues—whether we incline to the nature or nurture pole, or acrobatically combine elements from both in relation to particular issues—we are unlikely to subscribe overtly and consciously to the kind of scientifically defined "stigmata" in which Lombroso placed such confidence. However, such ideas lurk just below the surface of our beliefs, as expressed in popular myth and at a deeper instinctual level. As mentioned in the introduction, I recall my father telling me as a child that men with large amounts of bodily hair were of "low mentality." He was not a hairy man, and neither (as I was happy to observe at the time) am I. He also said that people whose eyebrows joined in the middle were untrustworthy—although I did observe that one of my classmates at school, who boasted a fine ledge of more or less continuous eyebrows, seemed to be one of the more virtuous boys amongst my group of hooligans.

Compared to such cultural formulas, instinctive stigmatization is very much another matter, because it is both deeply ingrained and difficult to recognize (particularly in one's own reactions). We know that we rush to snap judgments on the basis of someone's appearance, reacting both to the total ensemble and to specific features. We possess an apparently insatiable desire to put a face to a name, particularly of the famous, and we exhibit a heightened fascination with the faces of criminals. When Dr. Harold Shipman, Britain's most prolific serial killer, was convicted in February 2000, the newspapers carried full frontal photographs of his face, some focusing in on his eyes as windows of the soul (fig. 173). Shipman was convicted of killing 15 of his patients during the course of attending their homes as a General Practitioner in a provincial town near Manchester, and subsequent inquiries have raised the number of his probable victims to as many as 250. In British courts, where cameras of any kind are forbidden, specialist artists are employed to provide a picture of the accused and guilty persons, as if the faces of miscreants somehow tells us something, particularly in the context of those of judges, barristers, lawyers, and members of the law enforcement agencies (fig. 174). Shipman's appearance, grey bearded and bespectacled, is unremarkable. No one could or did tell in advance by looking at him. He remained a trusted family doctor in the community. But now we were invited to look into his eyes for some sign that the "evil" attributed to him is indeed discernible. All we need to do is to look hard enough and with discernment. Was there, behind that benign exterior, some sign of the basilisk stare of the harbinger of death? When the subsequent inquiry published its report some two years later, a further set of newspaper pictures extended the earlier invitation to see the "evil" in Shipman, but no answer seemed forthcoming.

The rhetoric of condemnation surrounding Shipman was largely devoid of the animalistic metaphors that commonly feature in the categorization of "evil" people. He could be described in general terms as a "monster," but the nature of his crimes, conducted quietly by a clever and solicitous doctor with a hypodermic

173. "Dr. Harold Shipman—the eyes of a killer," from the *Guardian,* February 1, 2000.

174. Elizabeth Cook, *Dr. Shipman in Court,* from the *Guardian,* February 1, 2000.

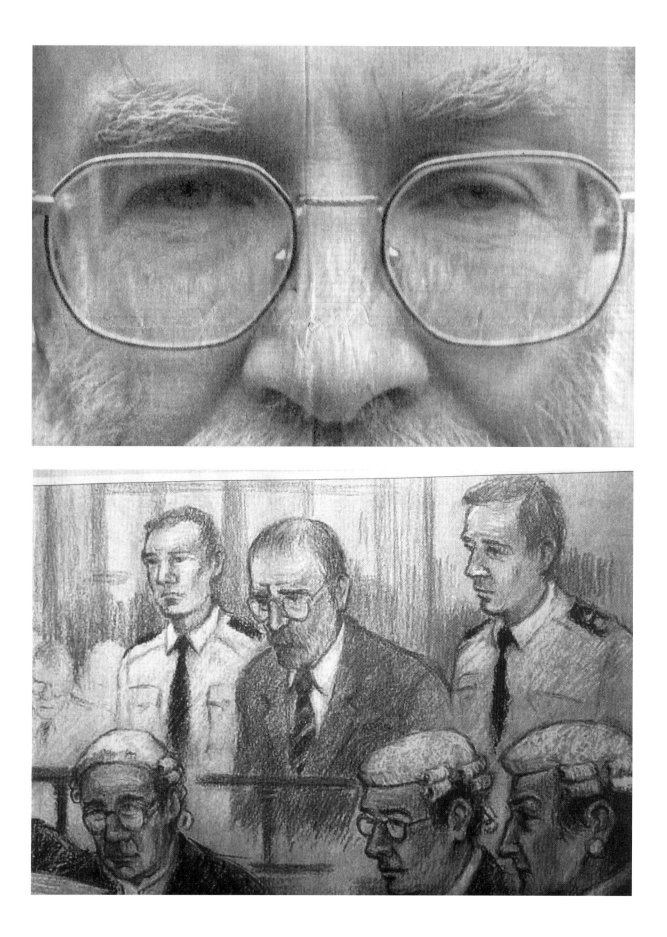

syringe, somehow does not fit easily with the conventions of bestial behavior. His crimes, the motives for which are still unclear, were too "intellectual" or "cold" to be those of an "animal." Other malefactors, above all terrorists amongst the modern pantheon of hate-figures, routinely excite the full range of animal metaphors from politicians and other commentators. It always helps if an available photograph of them renders them with a bestial appearance. One of the problems with the standard pictures of Osama bin Laden, held responsible for the aerial attacks in New York and Washington in September 2001, is that they conform for the Western viewer more to the stock image of an ancient divine or even Christ himself, than to our preconceived image of an "evil" man.

On Thursday, August 20, 2003, the *Times* in London carried a front-page picture of a stocky, bearded, bespectacled man cradling two children in his arms, his daughter and his son. Against a cheery background of nursery wallpaper, he smiles openly and beguilingly at the camera. He is someone we would like to know. The article accompanying the photograph begins, "There is no trace of evil in the beaming face of the proud father balancing his two young children in his arms. Yet Raed Abdel Malik Misk, a religious scholar, was yesterday identified as the suicide bomber who snuffed out the lives of Jewish children barely old enough to walk." Later in the article, Prime Minister Arial Sharon of Israel is reported as telling "his Cabinet colleagues that the perpetrators of the bombing were animals."

The reporter based in Hebron, Robert Tate, exhibits stock discomfort in failing to find any visible sign of how this man could be responsible for the "Massacre of the Children." This failure casts a subtly underlying doubt on whether we have really understood the Palestinians in their conflict with Israel. He would, like the majority of his readers, be more comfortable if the happy father betrayed some physiognomic sign of the "bestial" tendency that lead him to commit such an act.

However, often the "Lombosian tendency" fails to deliver; we find it enduringly hard not to expect it to deliver what we want.

A LITERARY-CINEMATIC POSTSCRIPT 🦎

In the modern era we know better, of course. We know where we stand with respect to animals in the long march of evolution. We are busy defining that quotient in the human genome that determines why we are humans rather than animals (minute as it happens). We are separated from chimpanzees by 0.6 percent (not 6.0 percent!) of our genetic material. Population genetics has mapped, across time and space, our lines of descent from the "first humans," the evolutionary Adams and Eves. The tool- and language-using capacities of primates have been researched intensively. And so on.

But the big questions of the nature of animals and humans remain essentially untouched by all this learning. Are animals conscious—either in their own way or in our sense (whatever that might be)? Do they have rights? Are we just superior animals—or rather self-deluding animals with a unique capacity to intervene in our universe, for good or for ill? Will we all, animals and humans, be surpassed by computational machinery? In the face of modern materialism, vast numbers of adherents to world religions still believe in the reality of our higher souls. And, at an instinctive level, as I have signaled at various points, the human animal and the animal human remain deeply embedded in our automatic reactions to characters in the world around us and to images of those characters.

I have no intention, on grounds of either competence or feasibility, of reviewing the vast stock of post-1900 material, even in its visual manifestations. However, in a personal footnote following this postscript, I will signal my own stance on the relationship between "us" and "them." Here I will limit myself to four literary exemplars that have exercised a special impact on the twentieth-century imagination, above all because of their direct transformation into film and more general transfusion into the world of shared imagery in the popular media.[1] My closing intention is to seek their help in opening up thoughts in a suggestive way for the reader, rather than to round things up tidily.

Two of the four luminaries of the human animal in its popular dimensions are involved with the world of "wild boys." They are Rudyard Kipling, author of *The Jungle Books,* published in 1894 and 1895, and Edgar Rice Burroughs, whose long string of Tarzan stories were initiated with *Tarzan of the Apes* in 1912. Kipling's wolf-boy, Mowgli, like Burroughs's jungle-Hercules, provided comfort to those who were haunted by the spectre of our apelike natures, since both heroes innately behaved in the jungle according to fundamentally human values of the highest kind, allying these with a kind of natural law. The other literary fonts very much involve the other side of the coin. They are Bram Stoker's bloodcurdling chronicles of *Dracula* of 1897, and Robert Louis Stevenson's 1886 story of the "animal within," *The Strange Case of Dr. Jekyll and Mr. Hyde,* the most overtly "scientific" and "modern" of all.

THE MAN-CUB

Kipling, supreme painter of word-pictures in colonial India, hardly presents a coherent stance toward the relative states of humans and animals. Rather, the humanized animal and animalized human appear on the stage to perform roles that serve the author's current purpose and intended readership, without pretending to philosophical consistency. In this, Kipling's agile ambivalence is characteristic of much of British colonial rule in India, and of the imperial attitude to nature in general. Stereotype and insight, prejudice and humanity coexist in a way that is typical of most (perhaps all) of us, but it becomes heightened in the colonial situation. As Kipling's father wrote, with respect to Western characterization of Indian races: "We ought, perhaps, to distrust most of the compendious phrases which presume to label our complex and paradoxical humanity with qualities and virtues, like drugs in a drawer."[2] In his journalistic reports, Rudyard Kipling vividly bears witness to both sides of the coin of the human animal. In Peshawar on March 28, 1885, he records how he ran the gauntlet of an assembly of many "varieties of the turbulent Afghan race."

> As an Englishman passes, they will turn to scowl upon him, and in many cases to spit fluently on the ground after he has passed. One burly big-paunched ruffian, with a shaven head and a neck creased and dimpled with rolls of fat, is especially zealous in this religious rite. . . . As an unconscious compensation to the outraged Kaffir, he poses himself magnificently on—degrading instance of civilisation—a culvert, turning a very bull's head and throat to the light. . . . The main road teems with magnificent scoundrels and handsome ruffians; all giving the onlooker the impression of wild beasts held back from murder and violence, and chafing against the restraint.[3]

Then in Simla on May 12, Kipling flips the coin to its other side in a knowingly Darwinian manner. His bungalow invaded by a "deputation" of monkeys:

> The leader of the gang has established himself on my dressing table, and investigates the brushes there. The flatsides would do splendidly to keep the babies in order. He tucks a

brush under each arm, and strikes out for the open country. . . . Then he sits down to scratch and cuff an intrusive hobbledehoy across the back. Darwin's theory is correct after all. This is no monkey, but an irascible old gentleman with a short temper. . . . If the doctrines of transmigration and evolution be true, the brush stealer, in a few millions of years, may grace the Legislative Council of London on the Hill [in Simla]. He is very, very solemn, and has broad and vigorous ideas on the subject of "appropriation."[4]

For *The Jungle Books,* Kipling turned to sources that stand very much within the kinds of tradition we have encountered. His zoological knowledge is drawn chiefly from Robert Armitage Sterndale's *Mammalia of India and Ceylon* (1884), and the same author's more popular picture-book, *Denizens of the Jungle: A Series of Sketches of Wild Animals, Illustrating Their Forms and Attitudes* (1884), the first plate of which unfortunately characterizes Gond Hunters and monkeys in echoing postures (fig. 175). Rudyard's own father, the artist and author, John Lockwood Kipling, who provided illustrations for various editions of his son's stories, wrote on his own behalf about *Beast and Man in India. A popular sketch of Indian animals in their relations with people* in 1891. J. L. Kipling had moved to India in 1865 as teacher in the Jeejebhoy School of Art in Bombay, and became principal of the Mayo School of Industrial Art at Lahore, where he also served as curator at the Central Museum. He became a specialist in "Indian-style" decorative schemes, in collaboration with his pupil, Bhai Ram Singh—most famously creating the Durbar Room for Queen Victoria in Osborne House on the Isle of Wight. Amongst the indigenous art of India, John Lockwood believed that "in architecture alone it can be said to claim the highest distinction."[5]

175. *Gond Hunters and Monkeys,* from Robert Armitage Sterndale's *Denizens of the Jungle: A Series of Sketches of Wild Animals, Illustrating their Forms and Attitudes* (Calcutta, 1886), The Bodleian Library, University of Oxford. Reference 18971 b.1.

John Lockwood Kipling's *Beast and Man* deals successively with those domestic, semidomestic, and trained animals with which people enjoyed the closest concourse. He is unfailingly observant (if often patronizing) not only of the interactions between animals and men, but also of the religious attitudes and folklore that underlie the customs that Indians follow in their treatment of beasts. His effective illustrations range from fully pictorial engravings in the Western mode to line transcriptions of Indian imagery. His account and illustration of the langur monkey (fig. 176) will serve to give the flavor of his accounts.

The tall, long-tailed, black faced, white-whiskered *langur (Presbytes illiger)*, clad in an overcoat of silver-grey . . . has a face that reminds one of Mr. Joel Harris's "Uncle Remus," and is, in his way, a king of the jungle, nor is he so frequently met in confinement as his own brother [the Macaque]. In some part of India troops of langurs come bounding with a mighty air of interest and curiosity to see the railway trains pass, their long tails uplifted like notes of interrogation; but frequently, when fairly perched on a wall or tree alongside, they seem to forget all about it, and avert their heads as you go by with an affectation of languid indifference. This may be a mark of the superiority of the monkey mind, or a sign that some threads were dropped when its fabric was woven.[6]

Kipling *père* maintains that India is "probably the cradle of wolf-child stories, which are here universally believed and supported by a cloud of testimony, including

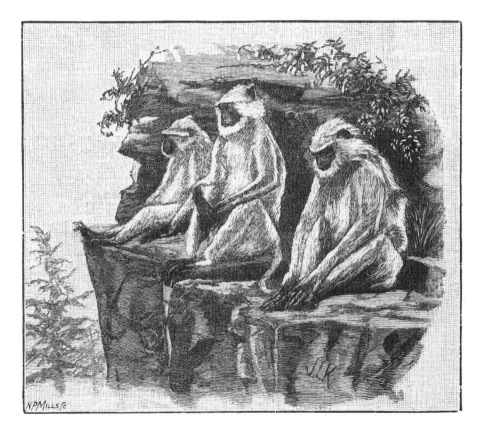

176. John Lockwood Kipling, *Langur Monkeys,* from *Beast and Man in India: A popular sketch of Indian animals in their relations with the people* (London: MacMillan & Co., 1891), The Bodleian Library, University of Oxford. Reference 247434d.3.

in the famous Lucknow case of a wolf boy, the evidence of European witnesses."[7] However, he pours cold water on the legends, reminding us that "though the wolf is probably the parent of all dogs, he is . . . a wild beast." Rudyard himself first signaled his involvement with this wolverine theme in his story "In the Rukh" published in *Many Inventions* in 1893. He probably also looked to the detailed review by Sir William Henry Sleeman, *An Account of Wolves Nurturing Children in Their Dens. By an Indian Official*. Sleeman's pamphlet first appeared in 1852 and was prestigiously republished in the *Zoologist* in 1888; his accounts paint the kind of savage picture of feral children with which we are familiar. The first boy he describes was mute, untamable, and animalistic: "when any raw meat was offered, he seized it with avidity, and put it in the ground under his hands, like a dog."[8] Kipling's sources, on the other hand, are thoroughly transmuted. Sterndale's accounts of the behavior of the animals, standing distantly in the tradition of Gesner, are consistently transformed into character traits recognizable in human society. Sleeman's precedents are turned upside down by Kipling in such a way that Mowgli the wolf-child manifests an innate humanness that is expressed more perfectly in the jungle than in human society.

From the first, in Kipling's story, the foundling "man-cub" shows no fear of the wolves, and fits in with unselfconscious naturalness. Mowgli is first encountered

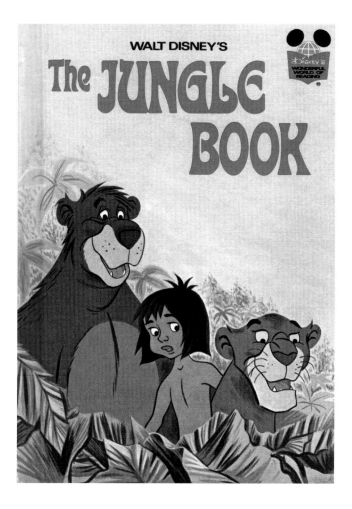

177. *Mowgli with Baloo and Bagheera,* from the cover of *The Jungle Book,* New York: Random House, 1974.

by his wolf-parents as "a naked brown baby who could just walk—as soft and as dimpled a little atom as ever came to a wolf's cave at night. He looked up into Father Wolf's face, and laughed."[9] Disney later transformed this affectionate picture into Mowgli's film persona of endearing innocence (fig. 177). The growing child is progressively induced into the "Law of the Jungle," which "never orders anything without a reason."[10] Baloo, the tutorial bear, explains that the "Law," "which is by far the oldest law in the world—has arranged for almost every kind of accident that may befall the Jungle People, till now its code as prefect as time and custom can make it. . . . the Law was like the Giant Creeper dropped across everyone's back and no one could escape."[11] The natural order had over the long ages determined the hierarchies of animals, predators and prey, large and small, higher and lower. In one circumstance, that of extreme drought, only one rule prevailed, that of the Water Truce: "the reason for this is that drinking comes before eating."[12] At any source of water that is still functioning, "all hunting stops, while the Jungle People go there for their needs . . . starved and weary, to the shrunken river—tiger, bear, deer, buffalo and pig together."[13] Darwinian survival becomes not of the fittest but of anyone at all, and predation ceases.

Representations of Mowgli in Baloo's company vary considerably. J. L. Kipling's designs for his son's books, billed as "decorations," take the form of inset illuminations rather than narrative illustrations in the normal sense. The first page of "How Fear Came" (fig. 178) shows an emaciated Mowgli with Baloo and the Black Panther at the edge of the diminished water hole within an "Indian frame" adorned with death skulls. Below the Law of the Jungle is symbolized by a fictive "relief carving" of an elephant's head surmounted the scales of justice. Other illustrators provided images that were more overtly concerned with telling the story. The painted frontispiece of "The water cannot live long" supplied by Stuart Tresilian for the 1932 edition of Kipling's *Animal Stories* exhibits a clear affinity with pictures of "cave men." It exudes an air of naturalism, with its animal portraits and leathery portrayal of Mowgli as a wolf-boy (fig. 179). It is nicely consistent with Kipling's account of the drought-ravaged jungle, which is tough and evocative. The author certainly had not endowed the more mature Mowgli with a comforting appearance: "His naked hide made him seem more lean and wretched than any of his fellows. His hair was bleached to tow colour by the sun; his ribs stood out like the ribs of a basket, and the lumps on his knees and ankles, where he was used to track on all fours, gave his shrunken limbs the look of knotted grass stems."[14] By contrast, Mowgli in the animated film by Disney is a cute, sun-tanned waif, while the podgy Baloo exhibits all the amiable cuddliness of Yogi Bear's favorite uncle.

One of the key lessons Mowgli learns from Baloo concerns the lawlessness of the *Bandar-log,* or "monkey-people" (identifiable as the gray apes or langurs described by Rudyard's father): "They have no law. They are outcaste. They have no speech of their own, but use stolen words. . . . They are without leaders. They have no remembrance. They boast and chatter and pretend that they are a great people about to do great affairs in the jungle, but the falling of a nut turns their minds to laughter

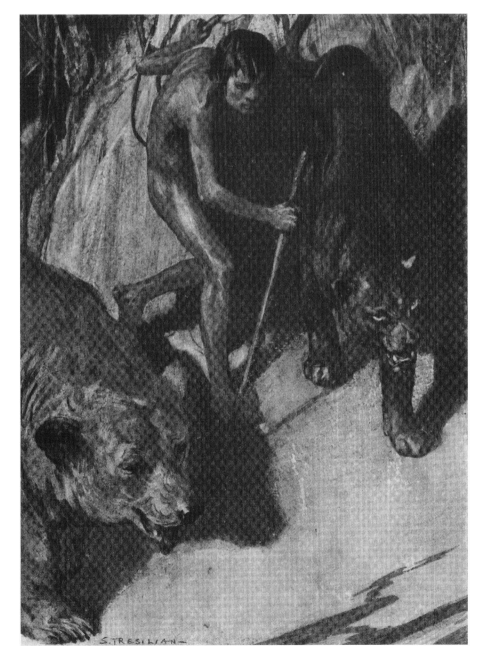

178. J. L. Kipling, *How Fear Came to the Jungle,* from *The Second Jungle Book,* 1895, The Bodleian Library, University of Oxford. Reference Walpole e.402.

179. Stuart Tresilian, *The Water Cannot Live Long,* from Rudyard Kipling's *Animal Stories* (London: MacMillan, 1932). The Bodleian Library, University of Oxford. Reference 25325 d.49.

and all is forgotten. We of the jungle have no dealings with them."[15] They are the imitative apes of humankind, easily deluded, like Brueghel's and Potter's monkeys, reflecting our vices back to ourselves in nature's mirror. In a way, the monkey-people prepare Mowgli for his encounter with human society. When Mowgli eventually appears in the village he is readily recognized as a wolf-child, but unlike Peter the Wild Boy and Sleeman's later examples, he rapidly learns "man's talk" and grasps the social rules.

Throughout the Mowgli stories, animals speak their language, and have their law, incomprehensible to humans—a point of view recalling that of Montaigne. Oddly, Kipling's animals are accorded a strange kind of archaic English with simple grammatical constructions like learners. Humans speak their language and have their laws, incomprehensible to animals. Mowgli alone speaks both and knows both. In the final analysis, he finds the unnatural law and devious artificiality of human behavior unbearable given his deeply ingrained instincts for natural law. Kipling's moral intent in all this, should one be sought, is probably closest to Swift, in that the unworthy aspects of human society are thrown into relief by looking at it through eyes untainted by its iniquities. Kipling's subversion is of the anecdotal variety, accessible not least to a younger readership, with little of the biting satire of Swift or Orwell. It has none of the threatening polar inversion of humans and animals in Pierre Boulle's *Planet of the Apes,* published in 1963, which was also transformed into a film of enduring potency.

ME TARZAN

Edgar Rice Burrough's creation, the jungle-nurtured Lord Greystoke, also known as Tarzan, enjoyed an enormous vogue for more than half a century after his debut in *Tarzan of the Apes* in 1912. More than two-dozen adventures followed, to say nothing of Tarzan stories written by other authors. The books spawned a series of mightily popular films. There is some sense of the inherent values embedded in Rice's social assumptions that have become increasingly unfashionable, though the Disney studio produced a lavish, animated version in 1999.

The story of Tarzan as a feral child begins with John Clayton, Lord Greystoke, and his pregnant wife, Alice, as they travel to Africa. After a mutiny on board their ship, they are cast adrift and washed up on a shore distant from any civilization. Having survived the terrors of the wild for some time in a makeshift shelter, Greystoke carelessly leaves himself open to attack from a "man-brute":

> It was approaching through the jungle in a semi-erect position, now and then placing the backs of its closed fists upon the ground—a great anthropoid ape, and, as it advanced, it emitted deep guttural growls and an occasional low barking sound. Clayton was at some distance from the cabin, having come to fell a particularly perfect tree for his building operations. . . . He knew that, armed only with an axe, his chances with this ferocious monster were small indeed. . . . With an ugly snarl, he [the ape] closed upon

his defenceless victim, but ere his fangs had reached the throat they thirsted for, there was a sharp report and a bullet entered the ape's back between his shoulders.[16]

The saving volley was fired by his wife, who that same night gave birth to a little son—"in the tiny cabin beside the primeval forest, while a leopard screamed before the door, and the deep notes of a lion's roar sounded from beyond the ridge."[17] But the balance of her mind was permanently disturbed by the trauma: "though she lived for a year after her baby was born, she was never again outside the cabin, nor did she ever fully realise that she was not in England."[18]

Lord Greystoke himself finally meets his end at the hands of the greatest ape of all, who leads a band of simian ruffians into the humans' home: "Kerchak was a huge king ape, weighing perhaps three hundred and fifty pounds. His forehead was extremely low and receding, his eyes bloodshot, small and close set to his coarse, flat nose; his ears large and thin, but smaller than most of his kind. His awful temper and his mighty strength made him supreme among the little tribe into which he had been born some twenty years before."[19] After Greystoke succumbs to this fearsome beast, there remained their son, tiny and vulnerable. Through some basic instinct, Kala, a resolute female ape, whose own child had died in a terrible fall, seized the baby from its cradle and protected it from the marauding males:

> High up among the branches of a mighty tree she hugged the shrieking infant to her bosom, and soon the instinct that was as dominant in this fierce female as it had been in the breast of his tender and beautiful mother—the instinct of mother love—reached out to the tiny man-child's half-formed understanding, and he became quiet. . . . Then hunger closed the gap between them, and the son of an English lord and an English lady nursed at the breast of Kala, the great ape.[20]

As the apes moved off, after their murderous raid on the Greystokes' lair,

> The other young rode upon their mothers' backs; their little arms tightly clasping the hairy necks before them, while their legs were locked beneath their mothers' armpits. Not so with Kala; she held the small form of the little Lord Greystoke tightly to her breast, where the dainty hands clutched the long black hair which covered that portion of her body. She had seen one child fall from her back to a terrible death, and she would take no further chances with this.[21]

The young lord, taking after his father as a fine specimen of an English gentleman, develops into a magnificent youth, handsome, graceful, and agile, inferior to none of his ape-family in airborne acrobatics. There are a number of carefully staged incidents in his developing consciousness of himself. One involves his own appearance, and involves a level of perceptual and conceptual subtlety toward which Burroughs does not always aspire:

It was on a sultry day of the dry season that he and one of his cousins had gone down to the bank to drink. As they leaned over, both little faces were mirrored on the placid pool; the fierce and terrible features of the ape beside those of the aristocratic scion of an old English house. Tarzan was appalled. It had been bad enough to be hairless, but to own such a countenance! He wondered that the other apes could look at him at all. That tiny slit of a mouth and those puny white teeth! How they looked beside the mighty lips and powerful fangs of his more fortunate brothers. And the little pinched nose of his; so thin was it that it looked half starved. He turned red as he compared it with the beautiful broad nostrils of his companion. Such a generous nose! Why it spread half across his face! It certainly must be fine to be so handsome, thought poor little Tarzan. But when he saw his own eyes; ah, that was the final blow—a brown spot, a grey circle and then blank whiteness! Frightful! not even the snakes had such hideous eyes as he.[22]

The crucial step in his human awareness comes with his discovery of the lair of his father and mother, replete with their personal possessions and paraphernalia, including books and photographs. He is introduced to images of humans. Unlike the apes, who could make nothing of the human possessions, including the knife and gun (which had terrified and bemused even the mighty Kerchak), Tarzan's inherited instincts and latent intellect draw him into the task of deciphering the visual and verbal signs left by his parents.

He progressed very, very slowly, for it was a hard and laborious task which he had set himself without knowing it—a task which might seem to you or me impossible—learning to read without having the slightest knowledge of letters or written language, or the faintest idea that such things existed. He did not accomplish it in a day, or in a week, or in a month, or in a year; but slowly, very slowly, he learned after he had grasped the possibilities which lay in those little bugs [letters], so that by the time he was fifteen he knew the various combinations of letters which stood for every pictured figure in the little primer and in one or two of the picture books.[23]

He also begins to teach himself how to write, and, as by-product, to count: "copying the bugs taught him another thing—their number; and though he could not count as we understand it, yet he had an idea of quantity, the base of his calculations being the number of fingers upon one of his hands."[24]

The third step comes with his first encounter with a living human, a "Negro" who lived in cleared land at the edge of the jungle: "Tarzan looked with wonder upon the strange creature beneath him—so like him in form and yet so different in face and color. His books had portrayed the NEGRO, but how different had been the dull, dead print to this sleek thing of ebony, pulsing with life. As the man stood there with taut drawn bow Tarzan recognized him not so much the NEGRO as the ARCHER of his picture book—A stands for Archer."[25] Tarzan decides to track this new creature: "Lord Greystoke wiped his greasy fingers upon his naked thighs and took up the trail of Kulonga, the son of Mbonga, the king; while in far-off London

another Lord Greystoke, the younger brother of the real Lord Greystoke's father, sent back his chops to the club's CHEF because they were underdone, and when he had finished his repast he dipped his finger-ends into a silver bowl of scented water and dried them upon a piece of snowy damask."[26]

Burroughs had already made it clear that Tarzan's taste for raw meat was truer to the natural omnivorous instincts of man: "Tarzan, more than the apes, craved and needed flesh. Descended from a race of meat eaters, never in his life, he thought, had he once satisfied his appetite for animal food; and so now his agile little body wormed its way far into the mass of struggling, rending apes in an endeavour to obtain a share which his strength would have been unequal to the task of winning for him."[27]

Tarzan, through Burroughs's anthropological eyes, inspects his new quarry, the Negro prince: "He examined and admired the tattooing on the forehead and breast. He marvelled at the sharp filed teeth. He investigated and appropriated the feathered headdress, and then he prepared to get down to business, for Tarzan of the Apes was hungry, and here was meat; meat of the kill, which jungle ethics permitted him to eat. How may we judge him, by what standards, this ape-man with the heart and head and body of an English gentleman, and the training of a wild beast?"[28] Burroughs answers his own question, by implication, when Tarzan observes the savage viciousness of the natives in the village from which his victim had come. "He saw that these people were more wicked than his own apes, and as savage and cruel as Sabor, herself. Tarzan began to hold his own kind in low esteem."[29]

Through a compound of nurture in nature and infallible inheritance, Tarzan represented true manhood, the realization of a moral and aesthetic ideal. He is a masterpiece of romantic primitivism.

The young Lord Greystoke was indeed a strange and war-like figure, his mass of black hair falling to his shoulders behind. . . . His straight and perfect figure, muscled as the best of the ancient Roman gladiators must have been muscled, and yet with the soft and sinuous curves of a Greek god, told at a glance the wondrous combination of enormous strength with suppleness and speed. A personification, was Tarzan of the Apes, of the primitive man, the hunter, the warrior. With the noble poise of his handsome head upon those broad shoulders, and the fire of life and intelligence in those fine, clear eyes, he might have typified some demigod of a wild and warlike bygone people of his ancient forest.[30]

Burroughs had been much occupied with the theme of the continued existence of primitive peoples in his novels of *The Land that Time Forgot* and *The People that Time Forgot,* which both involve accidental survivals from earlier evolutionary eras.

The climactic step in Tarzan's voyage of self-discovery comes in his encounter with Caucasians on a jungle expedition. The party includes (necessarily for the story) his ennobled cousin, and the delectable Jane Porter. She is the daughter of the splendidly named Professor Archimedes Q. Porter, who typically prefaces his

academic utterances with strings of "Tut, tut, tut." Tarzan, as a red-blooded young Englishman of healthy instincts,

> was not particularly interested in the men, however, so he sought the other window. There was the girl. How beautiful her features! How delicate her snowy skin! She was writing at Tarzan's own table beneath the window. Upon a pile of grasses at the far side of the room lay the Negress asleep. For an hour Tarzan feasted his eyes upon her while she wrote. . . . At length she [Jane] arose, leaving her manuscript upon the table. She went to the bed upon which had been spread several layers of soft grasses. These she re-arranged. Then she loosened the soft mass of golden hair which crowned her head. Like a shimmering waterfall turned to burnished metal by a dying sun it fell about her oval face; in waving lines, below her waist it tumbled.[31]

Almost inevitably, Jane is borne off by an enormous ape, gallantly pursued by Tarzan. Trembling, like a pale princess awaiting her Renaissance St. George, she witnesses the ensuring combat: "Jane—her lithe, young form flattened against the trunk of a great tree, her hands tight pressed against her rising and falling bosom, and her eyes wide with mingled horror, fascination, fear, and admiration—watched the primordial ape battle with the primeval man for possession of a woman—for her."[32] The victorious Tarzan seizes his trophy and transports her aloft. Vital juices are stirring:

> Tarzan of the Apes had felt a warm, lithe form close pressed to his. Hot, sweet breath against his cheek and mouth had fanned a new flame to life within his breast, and perfect lips had clung to his in burning kisses that had seared a deep brand into his soul—a brand which marked a new Tarzan. Again he laid his hand upon her arm. Again she repulsed him. And then Tarzan of the Apes did just what his first ancestor would have done. He took his woman in his arms and carried her into the jungle.[33]

Chapter 20, which immediately follows this titillating account, is simply entitled "Heredity." The hereditary factors that assert themselves belong both to Tarzan, as a natural lord, and Jane, as a female of the species.

> Jane, wondering that she felt no fear, began to realize that in many respects she had never felt more secure in her whole life than now as she lay in the arms of this strong, wild creature, being borne, God alone knew where or to what fate, deeper and deeper into the savage fastness of the untamed forest. . . . Jane reeled and would have fallen, had not Tarzan, dropping his burden, caught her in his arms. She did not lose consciousness, but she clung tightly to him, shuddering and trembling like a frightened deer. Tarzan of the Apes stroked her soft hair and tried to comfort and quiet her as Kala had him, when, as a little ape, he had been frightened by Sabor, the lioness, or Histah, the snake. Once he pressed his lips lightly upon her forehead, and she did not move, but closed her eyes and sighed.[34]

Tarzan, for his part, was utterly transformed: "contact with this girl for half a day had left a very different Tarzan from the one on whom the morning's sun had risen. Now, in every fiber of his being, heredity spoke louder than training."

Tarzan's subsequent induction into human (Caucasian) society and the very final revelation that he is the true Lord Greystoke come as something of an anti-climax after this vivid manifestation of primal instincts in the jungle. The pulses of both Burroughs and Tarzan quicken when he is in the wild—a theme that persists throughout the many Tarzan stories. Even after his rehabilitation as an English lord, he remains more at home in the jungle. As Burroughs later reports in *Tarzan and the Jewell of Opar*,

> his civilization was at best but an outward veneer which he gladly peeled off with his un-comfortable European clothes whenever any reasonable pretext presented itself. It was a woman's love which kept Tarzan even to the semblance of civilization—a condition for which familiarity had bred contempt. He hated the shams and the hypocrisies of it and with the clear vision of an unspoiled mind he had penetrated to the rotten core of the heart of the thing—the cowardly greed for peace and ease and the safe-guarding of property rights. That the fine things of life—art, music and literature—had thriven upon such enervating ideals he strenuously denied, insisting, rather, that they had en-dured in spite of civilization.
>
> "Show me the fat, opulent coward," he was wont to say, "who ever originated a beautiful ideal. In the clash of arms, in the battle for survival, amid hunger and death and danger, in the face of God as manifested in the display of Nature's most terrific forces, is born all that is finest and best in the human heart and mind."[35]

The primitive is lauded—at least as expressed in the natural-born lord. "At last the call of the milk of the savage mother that had suckled him in infancy rose to an insis-tent demand—he craved the hot blood of a fresh kill and his muscles yearned to pit themselves against the savage jungle in the battle for existence that had been his sole birthright for the first twenty years of his life."[36]

Tarzan stands as the twentieth century's supreme popular representative of the strain of romantic primitivism, appealing to contemporary American mores—and through these to Britain and other European cultures—as the eugenic male ideal of inherited martial and moral virtue. He provided reassurance that our primi-tive selves and rude human ancestors need not be seen as apelike savages, but as inherently noble. It was possible to maintain that, once Darwin's *Homo sapiens* had emerged, the species became wholly distinct in habit, mind, and body from the apes that developed in parallel from the common ancestral kind. Burroughs's ultimate separation between human stock, at least of the prime kind, and species of animal conformed to an ideal that Camper amongst others had striven to sustain. In spite of common perceptions to the contrary, it could be reconciled without too much difficulty with Darwin's views. But such romantic primitivism came increasingly to be submerged by a tide that was flowing in the opposite direction. In combination

with Mendelian genetics, "hard" Darwinism was increasingly to adopt a biological rather than spiritual definition of the human species and its relationship to hominid ancestors.

THE VAMPIRE COUNT AND HIS HANDMAIDS

In a remarkable picture by that most renowned of late Victorian painters, Sir Edward Burne-Jones, Merlin reclines languidly inert, ensnared in a hawthorn bush and drained of his magician's vital juices by the temptress, Vivien (or Nimue) (fig. 180). Tennyson's *Idylls of the Kings* sets the scene:

> A storm was coming, but the winds were still
> And in the wild woods of Broceliande
> Before an oak, so hollow, huge and old . . .
> At Merlin's feet the wily Vivien lay
> . . . lissome-limbed, she
> Writhed towards him, slided up his knee and sat,
> Behind his ankle twined her hollow feet
> Together, curved an arm about his neck,
> Clung like a snake.

The serpentine Vivien possesses in full measure the duplicitous graces of face and body that prevent her victim from seeing her in her "true form"—just as the serpent of Genesis had beguiled Eve into tempting Adam with the fateful fruit. Painted in the last decade of the nineteenth century, Burne-Jones's picture inhabits the same world as Bram Stoker's *Dracula,* which was published in 1897. The kind of sexual tension exuded by Burne-Jones's painting marked Stoker's personal contribution to the story of the human animal. (And as it happens, Kipling's mother was Lady Burne Jones's sister.)

The prime witness in the early stages of Bram Stoker's narrative is a young man of marriageable age and intentions, Jonathan Harker. Toward the start of his enforced stay in the count's threatening fortress, he is approached by three sensuous women, two dark and one fair—"as fair as can be, with great, wavy masses of golden hair and eyes like pale sapphires."[37] This very paragon of Pre-Raphaelite beauty makes the first move:

> The fair girl went on her knees, and bent over me, fairly gloating. There was a deliberate voluptuousness that was both thrilling and repulsive, and as she arched her neck, she actually licked her lips like an animal, till I could see in the moonlight the moisture shining on the scarlet lips and on the red tongue as it lapped the white sharp teeth. . . . I could feel the soft, shivering touch of the lips on the hypersensitive skin of my throat, and the hard dents of two sharp teeth, pausing there. I closed my eyes in a languorous ecstasy and waited—waited with a beating heart.[38]

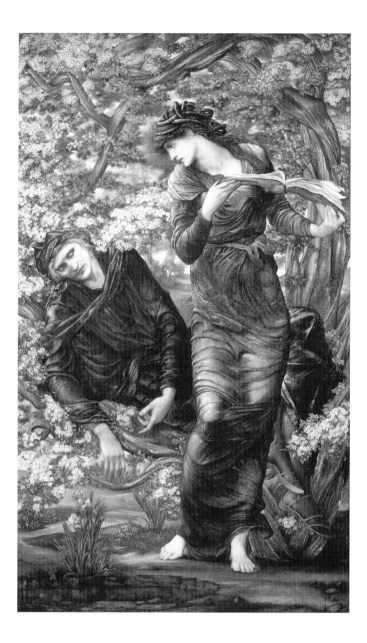

180. Edward Burne-Jones, *The Beguiling of Merlin,* 1874, National Museums Liverpool (Lady Lever Art Gallery).

To Harker's immediate disappointment—but to the benefit of his longer-term "cleanliness"—the count wrenched the blonde seductress from her compliant victim. A clear case of *morsus interruptus*.

The specter of the bloodsucking vampire had long stalked the waking and sleeping consciousness of different world cultures. The European literary vogue was effectively initiated by Dr. John Polidori's *The Vampire: A Tale* in 1819, which had been generated by the same literary circumstances as had occasioned Mary Shelley's *Frankenstein.* When Byron was staying with the Shelleys in Geneva in 1816, he issued a challenge to compose a "ghost story." Byron's own effort did not progress beyond his "Fragment," which was to form the basis for the shortish story by Polidori, who had been Byron's physician and traveling companion in 1816. The myth of the vampire prospered in nineteenth-century Gothic fiction. Even Leonardo's *Mona Lisa* was

drawn into dark web of the undead in Walter Pater's famous evocation, first published in 1869: "She is older than the rocks amongst which she sits; like the vampire she has been dead many times, and learned the secrets of the grave."[39]

Long before Van Helsing—the intense and learned Dutch professor in Stoker's compelling story—had identified Count Dracula as a vampire, his inhuman qualities had been visually manifest. He loomed up in the hours of darkness in his black clothes and enveloping cape as a batlike creature of Hecate. From the first, the count manifested an undisguised affinity with feared denizens of the dark forest:

> There seemed a strange stillness over every thing; but as I listened I heard as if down in the valley the howling of many wolves. The Count's eyes gleamed, and he said:—
>
> "listen to them—the children of the night. What music they make!"[40]

Stoker's text, cast in the form of journal entries by the innocent protagonists, is replete with detailed physical descriptions that tap the reader's familiarity with sources of the kind we have already encountered. The Count's face, unsurprisingly, comes in for detailed scrutiny by Harker:

> His face was a strong—a very strong aquiline, with the high bridge of the thin nose and peculiarly arched nostrils, with lofty dome forehead, and with hair growing scantily around the temples, but profusely elsewhere. His eye-brows were very massive, almost meeting over the nose, and with bushy hair that seemed to curl in its own profusion. The mouth, so far as I could see it under the heavy moustache, was fixed and rather cruel-looking, with peculiarly sharp white teeth; these protruded over the lips, whose remarkable ruddiness showed astonishing virility in a man of his years. For the rest, his ears were pale and at the tops extremely pointed; the chin was broad and strong, and the cheeks firm though thin. The general effect was one of extraordinary pallor.[41]

Bela Lugosi's personification of the bloodsucking count in Tod Browning's 1931 film evokes the general physiognomic air of this description without following the precise details in a literal way (fig. 181).

Hands are also a tell-tale sign, partly because they are visible but more importantly because of their traditional status as tools of the intellect: "Hitherto I had noticed the back of his hands as they lay on his knees in the firelight, and they had seemed rather white and fine, but seeing them now close to me, I could not but notice that they were rather coarse—broad, with squat fingers. Strange to say, there were hairs in the centre of the palm. The nails were long and fine and cut to a sharp point."[42] The hairy palms, shared by the lower dog-types in Kipling's stories, are particularly telling.

After an orgy of bloodlust, the sleeping count presents a repellent image to Harker: "it seemed as if the whole awful creature were simply gorged with blood; he lay like a filthy leech, exhausted by his repletion."[43] Poor, pale Lucy, who had fantasized about women simultaneously enjoying three or four husbands, was vampirized in

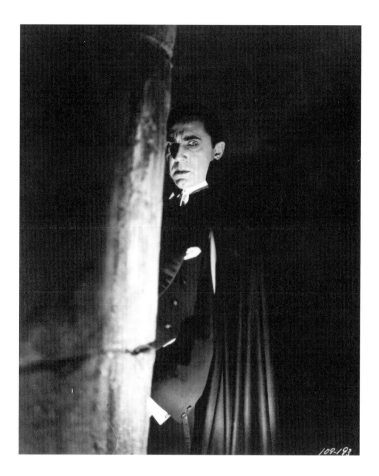

181. Béla Lugosi as Count Dracula, from *Dracula,* directed by Tod Browning, 1931. Courtesy of the British Film Institute.

her white nightclothes in a black churchyard. Thereafter she takes up new her mission as a bloodsucker with animalistic fervor, as Dr. Seward's diary recounts: "She drew back with an angry snarl, such a cat gives when taken unawares. . . . Her eyes blazed with an unholy light, and the face became wreathed in a voluptuous smile. The lovely, blood-stained mouth grew to an open square, as in the passion masks of the Greeks and Japanese. If ever a face meant death—if looks could kill—we saw it at that moment."[44] This reference to archaic and primitive masks taps into the cultural knowledge of "primitive" expressions as conveyed through "specimens" in British Collections (fig. 182). Seward, as a doctor working in an asylum, had earlier exercised his diagnostic skills on Renfield, an early victim:

R. M. Renfield, aetat 59.—Sanguine temperament; great physical strength; morbidly excitable; periods of gloom ending in some fixed idea I cannot make out. I presume that the sanguine temperament itself and the disturbing influence end in a mentally accomplished finish; a potentially dangerous man, probably dangerous if unselfish. In selfish men caution is as secure an armour for their foes as for themselves. What I think on this point is, when self is the fixed point on the centripetal force is balanced with the centrifugal; when duty, a cause, etc. is the fixed point, the latter force is paramount, and only accident or a series of accidents can balance it.[45]

These obscure case notes were recorded on the doctor's phonograph—a signal of his comfort with the new technologies of objective record.

As the denouement approaches and understanding of vampires accumulates under the intellectual orchestration of the Dutch professor, the "so clever lady," Mrs. Harker, is encouraged by Van Helsing to disclose her insights:

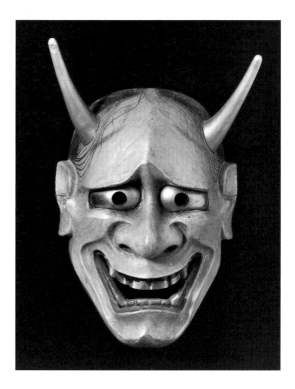

> "Now you shall speak. Tell us two dry men of science what you see with those so bright eyes." He took her hand and held it whilst she spoke. His finger and thumb closed on her pulse, as I thought instinctively and unconsciously as she spoke:-
>
> "The Count is a criminal and of criminal type. Nordau and Lombroso would so classify him, and *qua* criminal he is of imperfectly formed mind. Thus in difficulty he has to seek recourse in habit."[46]

Stoker clearly expected his readers to pick up Mrs. Harker's references to Nordau's *Degeneration,* and Lombroso's *Criminal Man.* By reverting to type, the count can be relied upon to return, animal-like, to his lair. It is this innate habit that permits his hunting down and ensures his convulsive end.

As I am writing this, the annual street fair is being set up in Woodstock near Oxford, where I live. One of the shows is entitled "From Dusk Till Dawn." At either end of the scary ride are grotesquely vampirish faces of a man and a woman (fig. 183). The "monsters" liberally scattered across the backcloth to the carts (fig. 184) are vulgar cousins of Stoker's Dracula and Lucy, stoking the inferno of horror with the volatile fuel of sexual promise. The connotation of such imagery is now a cultural commonplace all over the world.

182. Japanese mask, pre-nineteenth century, Pitt Rivers Museum, University of Oxford.

THE BEAST WITHIN

The fear that our evolutionary past had left an indelible deposit of the animal in our innermost being is the intellectual and emotional engine that drives Robert Louis Stevenson's *The Strange Case of Dr. Jekyll and Mr Hyde.*[47] Once our bestial genie is out of the bottle, released by the cocktail of the doctor's potions, it cannot be contained. In the face of the inevitable consequences of our biological ancestry, deeply embedded in our natures, the platitudes of religion and brittle conventions of polite society seem impotent.

Cast like Stoker's *Dracula* as a series of reports rather than a conventional narrative, *The Strange Case* affects the air of a series of documentary accounts. It assumes

the guise of a set of case notes assembled from various sources that are to be evaluated. The reader assumes the role of a diagnostician who attempts to build up a picture of a patient. The climax comes with Dr. Jekyll's own learned and self-incriminating testimony.

There is no doubt that Stevenson was well informed about mental disease and criminality. Although he does not cite sources, there are clear signs of his having turned to some of the latest authorities. These include James Cowles Prichard, author of the *Treatise on Insanity and Other Disorders Affecting the Mind,* in 1835, Francis Galton, whose *Inquiries into Human Faculty* involved the quest to define what marked out variance and deviance in human inherited traits, and Richard von Krafft Ebing, the Viennese psychologist, whose *Psychopatia Sexualis* was translated into English in 1892. Perhaps the most direct source was the writings of the highly regarded Henry Maudsley. In his *Responsibility for Mental Disease* in 1874, Maudsley asserted that "a distinct criminal class of beings constitutes a morbid variety of mankind, marked by peculiar low physical and mental characteristics, not seldom deformed, with badly shaped, angular heads; are stupid, sullen, sluggish, deficient in vital energy, and sometime afflicted with epilepsy."[48]

Epilepsy was one of the stigmata described by Lombroso. Perhaps even more resonant was Maudsley's paper on "Remarks on Crime and Criminals," published in *Journal of Mental Science* two years after Stevenson's tale. The psychologist argues that human moral sentiments and convictions "are the latest and highest products of mental evolution; being the least stable, therefore they are the first to disappear in mental degeneration, which is a literal sense an *unkinding* or undoing of mind; and when they are stripped off the primitive and more stable passions are exposed— naked and not ashamed, just as they were in the premoral ages of animal and human life on earth."[49]

One year before *The Strange Case,* Stevenson had published *Olalla,* another of his Christmas shockers. It centered on atavistic regression. The narrator journeys to a remote *residencia* in Spain to recover from war wounds. Looking at the living representatives of the noble but decayed family who were his hosts, he discerns that "the family blood had been impoverished, perhaps from long inbreeding. . . . The intelligence (that more precious heirloom) was degenerate; the treasure of ancestral memory ran low."[50] The beautiful but blankly inert mother was "the last representative of an ancient stock, degenerate in both parts and fortune."[51] Looking at a yellowed portrait on the wall of his room, he realizes that "to love such a woman were to sign and seal one's own sentence in degeneration."[52]

The exception is the lovely and vital daughter, Olalla, who exhibits no sign of atavistic decay. She is as "active as a deer. . . . The thrill of her young life, strung like a wild animal's, had entered in me."[53] The wounded visitor and the lovely young lady fall precipitately in love. But their idyll is broken by a hideous incident. The narrator cuts his hand on the broken glass of a window. At the sight of the blood, Olalla's previously indolent mother surges toward the young man in an insatiable

183. Female face, in the fairground ride "From Dusk Till Dawn," 2002. Photo courtesy of the author.

frenzy. In an instant, "my hand was at her mouth, and she had bitten me to the bone. . . . I beat her back and she sprang at me again and again, with bestial cries."[54] Olalla knows that she must renounce her love, since the taint of which lurks within her (like a latent Mendelian trait), waiting to erupt in the next generation. Respect for eugenic principles forbids their union.

Compared to this story of the passive degeneration of an ancient bloodline, reminiscent of Edgar Allen Poe's *Fall of the House of Usher,* the story of Jekyll and Hyde involves the most up-to-date interventionist science. The premise is "the thorough and primitive duality of man," which the doctor takes as an established fact.[55] Jekyll, sitting in Regent's Park before one of the unbidden regressions that occur with increasing frequency, even without the transformative elixir, describes how "I sat in the sun on a bench; the animal within me licking the chops of memory."[56] His experimental concoction aims to separate the human and the animal so that each can live without the fetters of the other. The aims can be achieved by

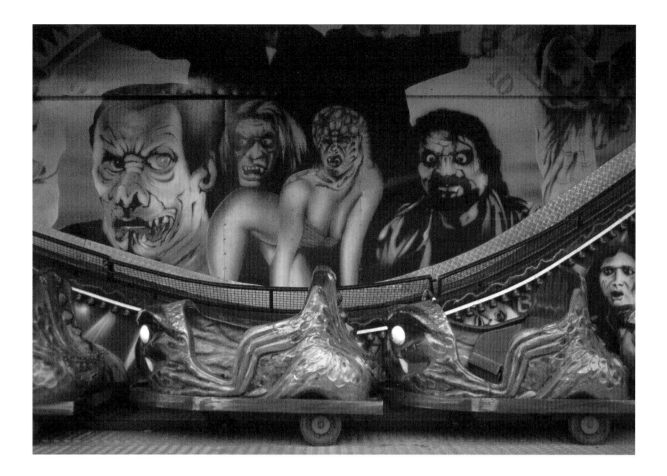

184. Backdrop in the fairground ride, "From Dusk Till Dawn," 2002. Photo courtesy of the author.

intervening chemically in the body of the subject, which in this case is, heroically, himself.

His success surpasses his expectations. Although everyone who encounters Mr. Hyde, observing him from without, finds him repellent in one way or other, the inside view of the soul liberated from its veneer of rationality and civilization is quite different. Jekyll finds delight in the liberation:

> There was something strange in my sensations, something indescribably new and, from its very novelty, incredibly sweet. I felt younger, lighter, happier in body; within I was conscious of a heady recklessness, a current of disordered sensual images running like a mill race in my fancy, a solution of the bonds of obligation, an unknown but not an innocent freedom of the soul. I knew myself in this first breath of this new life to be wicked, tenfold more wicked, sold a slave to my original evil, and the thought, in that moment, braced and delighted me like wine.[57]

Looked at through his new eyes, even his transformed appearance evokes pleasure: "Evil . . . had left on that body an imprint of deformity and decay. And yet when I looked upon that ugly idol in the glass, I was conscious of no repugnance, rather of a leap of welcome. This, too, was myself. It seemed natural and human."[58]

From the viewpoint of the others, Hyde looks utterly different. Stevenson's witnesses log up a series of signs, not of the blatant sort that tend to be employed in the films, but the forensic kind that Lombroso or Nordau would diagnose. Utterson, the lawyer, cannot put his finger on what makes Hyde repellent:

> He is not easy to describe. There is something wrong with his appearance; something displeasing, something downright detestable. I never saw a man so disliked, but I scarce know why. He must be deformed somewhere; he gives a strong feeling of deformity, although I couldn't specify the point. He's an extraordinary-looking man, and yet I really can name nothing out of the way. No sir, I can make no hand of it; I can't describe him. And it's not for want of memory, for I declare I can see him at this moment.[59]

Dr. Lanyon is fired by medical curiosity about the origin of such a person. He can see signs of Hyde's degenerate traits in his runtish figure, incongruously garbed in good quality clothes designed for Jekyll's more statuesque figure. However, even Lanyon finds it difficult to put the effect into words: "There was something abnormal and misbegotten in the very essence of the creature that now faced me—something seizing, surprising and revolting."[60]

It is Dr. Jekyll alone who has acquired the knowledge (the product of obsessive research) and possesses the forensic skills to make the complete diagnosis. The procedure very much conforms to that of the paradigm of the observing and analysis of evidence established as canonical practice in British nineteenth-century professional science. Conan Doyle's Sherlock Holmes functions in just this way, accumulating minutely scrupulous and significant observations of the kind that Dr. Watson should be trained to acknowledge, but is too plodding to accomplish on his own behalf. There is at least some sense that Holmes's addiction provided him with a chemically induced hyper-receptivity, just as Jekyll's ecstasy as Hyde is reminiscent of drug-induced euphoria.

A good example of Jekyll's ready skill in diagnostic observation is provided by the description of what happened to his hand—as always a signal instrument—on the occasion of his fist spontaneous regression. Jekyll awakes and stares in shock at his hand. "Now the hand of Henry Jekyll . . . was professional in shape and size: it was large, firm, white and comely. But the hand which I now saw, clearly enough, in the yellow light of a mid-London morning, lying half shut on the bed clothes, was lean, corded, knuckly, of a dusky pallor and thickly shaded with a smart growth of hair. It was the hand of Edward Hyde."[61] It is strikingly like the hand of Jonathan Swift's bestial Yahoo.

From the first, Stevenson's story exercised a peculiar grip. It played into age-old perceptions of man's thinly suppressed animalistic tendencies, and vividly exploited the post-Darwinian climate of ideas. Its impact was made even more intense by the way in which life seemed to imitate art. Two years after its publication, London was horrified by the hideous series of the Whitechapel murders of prostitutes, perpetrated by the so-called Jack the Ripper, who has never been convincingly identified.

The reports contributed to a profile of the murderer, whose skills of evisceration suggested that he had the kind of medical knowledge possessed by Jekyll. It became increasingly assumed that the police were dealing with what we would now call a Jekyll-and-Hyde character, rather than somebody who looked and lived most obviously like a primitive specimen.

The films of Stevenson's novella (fig. 185) almost inevitably need to exploit more blatant signs of Hyde's transformation into a beast than his text, which leaves the reader free to paint his or her own pictures. The author could be confident as to the kind of sources that his readers would have used for inspiration. The filmic narratives have also resorted to more obvious sequences of narrative events, rather than the scattered reports from differently equipped witnesses that Stevenson exploits to build up suspense. What the films have accomplished, in a way that only the mass visual media can, is to establish iconic images. We have little difficulty in summoning up the bestial visage that emerges from beneath the doctor's cultivated countenance, and the lumbering gate of the apish figure who shambles along the fetid and fog-shrouded alleys of London's subindustrial hinterland.

Of the four authors in this postscript, it is Stevenson who seems to carry the day at the start of the second millennium AD. All four, in their different ways, bear witness to the thinness of the civilized skin that holds back humans from animalistic behavior. Only Stoker does not dwell on the falsity of much of what passed as civilized society. They have all struck repeated chords in popular consciousness over the last one hundred years. But it is the skepticism of the scientifically and legally minded Stevenson, the Edinburgh Scot who is a grandchild of the Enlightenment, which seems most in tune with our modern sense of how much we are animals at heart.

185. Spencer Tracy in *Transformation from Dr. Jekyll to Mr. Hyde,* from *The Strange Case of Dr. Jekyll and Mr. Hyde,* directed by Victor Flemming, 1941. Courtesy of the British Film Institute.

A PERSONAL FOOTNOTE 🦋

I offer the thoughts that follow with considerable reticence, since I will be stray-ing into territories in which I am unread and unversed. I am also aware that the formulations I offer have a density that is out of keeping with what I hope has been the accessibility of the main text. However, I am conscious in a book on such a load-ed subject that my personal stances on the various questions cannot but have colored every aspect of my choice of examples and analysis. I should let the reader know where I stand. The central question is clear: "can humans simply be considered as particular kinds of animal?"[1]

Any answer that has recourse to a divine or immortal soul does not, for me, pres-ent a valid option, since it is predicated on theological premises in which I cannot believe. I also, like Antonio Damasio, reject the hard dualism of body and mind (or soul) proffered by Descartes.[2] This means that any answer must center on whether something different in kind rather than degree occurred during the course of our evolution from our animal ancestors. It also seems to me that the central issue is the nature of our kind of consciousness and its relationship to any form of consciousness that we might impute to animals (and even, potentially, to thinking machines).

CONSCIOUSNESS AND COMPLEXITY

A great part of the problem is that the categories and vocabulary we have built up through introspection over many centuries does not serve us well in an era when brain sciences are being rewritten, not least through novel scanning techniques such as Functional Magnetic Resonance Imaging (fig. 186).[3] The localizations of men-tal processes being disclosed by neurologists do not mesh comfortably with the old "faculties" to which we still adhere in our everyday thought and in much of our academic discourse. It seems highly unlikely that such great, traditional entities as "imagination" and "intellect" are each readily identifiable with a specific, single pro-cessing center in the brain. Although it may be possible, for instance, to demonstrate

186. Marta de Menezes, *Functional Portrait of Martin Kemp*, 2001.

specific locations and links for the imaginative ability to think metaphorically, it is highly unlikely that all those abilities that we have traditionally grouped together in the big bag we call imagination sit in one neatly identifiable region or in closely linked regions of the brain. Imagination is not just one kind of thing, but the product of simultaneous networking performed in a multitude of permutations. Likewise with intellect. And it is unlikely that the processes we regard as intellectual and imaginative are definitively separable in some kind of tidy way.

It seems that we have, through age-old self-reflection, grouped together facets of our mental capacities that combine to do the same or related kinds of thing, as distinct from sets of other things. They are aggregates that have been intuited from a composite of different neurological processes occurring to all effects and purposes

simultaneously in different locations in the brain. They are rather like "strange attractors" in chaos theory. In a complex system in which the outcomes of a process with multiple variables are not precisely predictable, but subject to laws of probability, it is possible to map the behavior of the phenomenon on a graph with two or three coordinates.[4] The resulting configuration, which defines the parameters for the probabilities, is a strange attractor. A typical form for an attractor is a fat band, the outer boundaries of which denote the limits that constrain even the extreme manifestations of the phenomenon; in other words all the probable outcomes reside within the bounds of the strange attractor. When we observe such a phenomenon (say water squirting in a parabola from a hosepipe and breaking into a scattering of drops), we can sense intuitively that there is a "shape" or general pattern to its behavior, even though the next move in the system and the precise nature of the eventual outcome are unpredictable (e.g., whether a drop will fall on a particular spot at a particular moment). We can, likewise, sense that there are general shapes to types of brain activity, which we can recognize on the basis of the shared experience of being in our minds and bodies. We have been able to accord enduring names to these shapes. Thus, imagination and intellect may be regarded as the intuitively sensed shapes of sets of brain functions which act in a way that is analogous to complex systems in dynamics. Indeed, during normal mental activity the faculties localized by neuroscience do not operate separately but are always simultaneously in dynamic interaction with other faculties in a way that undermines any staightforward attempt to apply neuroscience to complex, socially embedded activities. The old mental entities still exhibit considerable power in categorizing the complex aggregates of localized activities.

However, to describe imagination and intellect as if they are "things," as we are bound to do implicitly in any analysis of them, is in the final analysis misleading. A strange attractor is not a thing with a real existence; it is a formal way of characterizing certain properties of a complex system. Likewise with imagination. Consciousness falls within the embrace of the same strictures about its "thingness." Our particular kind of consciousness seems to be a collective precipitate of many different kinds of levels of complexity in our brain. The difference from animals is one of levels and degrees if characterized in terms of neurological processes. But a decisive change occurred at a certain compound level of complexity into what effectively operates as another kind of system. Sets of differences of degree in complex interaction come to operate collectively as a difference in kind. Some "higher" animals, such as anthropoid apes and dolphins, clearly have systems of notable complexity in some aspects of brain activity, but not in the enmeshed totality that lies behind our heightened and potentially troubling levels of self-consciousness. Our human system is characterized by a heightened sense of self and of conscious agents outside ourselves. It manifests the ability to live in and identify with multiple collectives (like being both a motorist and a pedestrian). It can aspire to understand and strive to master all kinds of inanimate and animate action at a distance, predictable and unpredictable. A computer may well in the future be able to achieve the cluster of

processes that results in consciousness, but not to generate the messy kind of lived consciousness accumulated by an individual human in his or her body over the vagaries of collective and individual human existence. As it happens, I think the archaeological and paleontological record has allowed us to highlight with reasonable precision when the decisive cluster of mental attributes came into conduction with such a profound effect.

TOOLS, WORDS, AND IMAGES

A key observation with respect to our "cultures of consciousness" is that the Neanderthals made tools, but did not apparently make images as representations (and from what we know of them would make it surprising if they had done). The Cro-Magnons, however, made tools and images.[5] The key period of the advent of the Cro-Magnons can be dated to around 40,000 years ago. There is some evidence, if disputed, that meaningful mark-making originated much earlier, perhaps over 200,000 years ago, but we do not have sufficient evidence or context to make much sense of such isolated earlier episodes. The value of the Neanderthal to Cro-Magnon "switch" is that we can at least formulate some kind of hypothesis about the cultural context. I think it is not the image-making capacities in themselves that are significant, but the cluster of abilities to which figurative image-making integrally belongs.

When we look at their tool-making in isolation from the cluster, we can see that the difference between the tool-making capacities of the Neanderthals and Cro-Magnons was considerable. Neanderthals made an extensive range of tools, and their range of "technologies" have been enumerated. The Cro-Magnons far surpassed them. To my mind, the key difference between the Neanderthals and their successors lies not in their number of tools, nor in their inventiveness or the fineness of manufacture, nor even in their ornamentation, but in the fact that the later and ultimately more successful inventors went beyond what I am calling "direct tools." A direct tool is made to achieve directly the end in view, as when a simple stone axe is used to chop something. An "indirect" or "intermediate" tool stands within a chain of processes that lead from the starting point to the end, but does not alone achieve that end. An indirect tool is inherent neither in the starting point nor the finishing point. An example is a bone needle. To invent a needle a series of conditions and suppositions need to come into play:

1. that there is perceived need to join two pieces of hide, cloth, or other substance together;

2. that this can be done using a thin, continuous strip, such as a thong or thread, to tie them together in an orderly and progressive manner;

3. that there needs to be some way to make the thread or thong do what it does not naturally do, that is to say passing readily through small, tight holes;

4. that something stiff and fine is needed to draw the thong or thread tightly though

5. that an "eye" is needed, just large enough to hold the thong but not so large as to cause the "needle" to fatten considerably, with attendant disadvantages;

6. that a series of regular holes of appropriate size should be pierced sufficiently close to the edges of the materials to be joined, but not so close to the edges or to each other as to tear;

7. that a looping progress for the thread will result in the most secure yet flexible joint, and so on.

The reader can doubtless add more conditions and suppositions if the joining is to be achieved with maximum efficacy and even to look good.

In short, the needle stands in the middle of a conceptualized process in which an intricate set of conditions has to be *visualized* or pictured in advance in a cognitively more complex way than the making of a flint axe, which is in essence a one-step tool of the kind used by some animals. The fact that the flint axe may be more elaborately fashioned than the stick used by a monkey to extract termites is a difference of degree not of kind. The direct tool works in the conceptual framework such that to achieve the end Z, I need to make the tool A, given the starting point Y. The intermediate tool stands in the conceptual framework that to achieve Z (the act of joining) given a starting point of Y (two items to be joined), I need to make B (the needle) so that I can use A (the thread), which I have conceived will do the job. The intermediate tool B does not survive in the finished product, and is not inherent in starting point Y. There is a kind of grammar of action involved beyond that of a single object and subject joined by a verb. It involves a double condition: "If I want to do this, then I first have to make something else that will do the intermediate job."

A comparable example is the bow and arrow, a device that seems in retrospect to be obvious, like so many indirect tools when viewed with hindsight. The more basic act of throwing a sharp-ended stick in the form of a spear relies upon a simple set of experiences, which may result in considerable experiential refinement (knowing what wood to use, of what length and diameter, and where it can best be gripped to travel with maximum effect when released by the throwing hand, etc.). By contrast we can see that a bow and arrow—without going through the elaborate enumeration of conditions we adduced for the needle—is very sophisticated in its sense of using a compound setup to use human power in an amplified manner. There must be an intuition at work that the drawn bow acquires some kind of sense of embedded or latent power, even if this is conceived in a way that shares little with Western physics from Aristotle onwards. This mode of conception seems to me to require forms of structured thought, involving logic, reflective memory and imagination(!). It corresponds to (but is not caused by) a language based on a grammar of some complexity. It involves a sophisticated conceptualization that is at once verbal and visual while being precisely neither. An absolutely integral and integrated role for visual thinking in relation to verbal processing is a prerequisite for this kind of invention.

It also seems to me that the dynamic kind of internal verbal-cum-visual "picturing" that can envisage a needle (a sharp, fine object with a hole at one end) or the latent power in a drawn bow is strongly akin to the capacity to make something that stands *indirectly* for something else; that is to say to shape a piece of clay so that it becomes a bison. Thus, I want to achieve Z (such as implicit mastery over a bison), given the starting point Y (that the bison is not available), I need to take B (the clay) to shape it into A (the surrogate bison). The surrogate exhibits some degree of resemblance, but necessarily stands simultaneously as a symbol in relation to the real thing. The parallel with the needle is not precise, since the clay bison stands in for the real one, but the envisaging of an indirect or intermediate agent is shared. Perhaps it is closer to the envisaging of the power in a drawn bow, which will be implicitly imputed to some kind of unseen agency. The making and possession of the clay bison imputes an unseen power that is somehow embedded in the image. I do not think the distinction is between functional and nonfunctional, since the making of the bison deeply fulfils a particular kind of function. Nor do I think the distinction is literally between symbolic and nonsymbolic thinking, in which the verbal is conventionally given priority over the visual. The clay bison in effect becomes the real bison through acts of resemblance, conceptualization, and symbolizing. If this interpretation is anywhere near correct, it places the making of the bison at least as close in its essential nature to the invention of a bow and arrow as to the framing of a word for bison. The use of rudimentary language and image making is likely to predate the Cro-Magnons by a substantial span of years. What is crucial in the abilities I have been discussing is not language in itself but the level of sophistication within the linguistic structures which enable us to communicate complex relationships between entities and between series of acts, and not least to forecast their consequences. This does not mean that some kind of image making cannot occur outside such a context, rather it implies that advanced imaginative visualization is integral to a nexus of fictive abilities.

I think there are a number of things that go with the propensities we have been describing. A key factor is the envisaging of unknown agencies (as when a Neanderthal hypothetically looked at the two pieces of hide sewn together by a Cro-Magnon but did not know how it was done). Even more remarkable is the intuition of the power in a drawn bow. This conception of invisible and apparently immaterial power opens the way toward the conception of spirits and divinities. Another key factor is the conceptualizing of action at a distance, as when the moon moves the tidal oceans. The complex of propensities opens the way to a level of speculative and reflective consciousness that passes beyond me and that other thing, and extends to a network of known and potentially unknown (and unknowable) conditions and agencies that determine what will happen between me and that other thing. It involves the conceptualizing of alternative futures for any action or sets of actions, known or unknown, rather than a single predictive explanation. The archetypal manifestation of plurally predictive visualization involving alternative scenarios is

playing chess. The conjunction of abilities allows for the envisaging of how long-distance trade can operate by a form of contract. It permits division of labor in a productive process, with intermediate agents acting between material and outcome. It is essential for predictive agriculture, not least the systematic improvement in stock from what we call selective breeding. In social terms, the essential conditions are laid down for complex and flexible societies in which regulation and free adaptation are precariously balanced.

Of this summary and incomplete list of propensities, I am not pointing to any one as causative, or even as fundamental. Whether word came before image or image before word is a nonquestion in this framework. I think the abilities are all manifestations or symptoms of the nature of the particular kinds of conjunctions of mental processes, which tipped the balance in human development. It seems significant that the tools of the intermediate kind, such as those made from bone, bear some of the earliest images that survive. The fundamental propensities are not toolmaking, or art, or language, but an envisaging capacity that conceptualizes potentialities, consequences, and surrogates in terms of various tools, images, and languages at the level of thought that is proto- (or supra-) verbal and proto- (or supra-) visual, in the sense that it is definable as neither in terms of separable capacities. The chronological precedents and localization of various kinds of visual and verbal attribute is not decisive in this theory. What is crucial is the moment of ineffable complexity in which the compound set of proclivities is precipitated in such a way as to result in an overarching difference in kind.

The precipitation of this moment can, as in any system in a critical, poised condition, arise from some tiny increment of change. This is why the fashionable emphasis upon the small quotient of the genetic material of DNA that separates us from even quite lowly animals is less striking than it is generally seen. To take an analogy, the difference between an object just floating in water and decisively sinking can be a very small difference in specific gravity. As the increment that tips a critical system over the edge, utterly transforming it, the 0.6 percent that separates us from chimps is more than enough.

Yes, we are animals. But the conjunction of mental and bodily powers we have developed has crucially granted us a capacity to think and act differently in kind from animals. History tells us that we can use these powers for good or for ill. This is not to say that there are things separable in practice as "human powers" from "animal instincts"; we are wholes in which every facet of our natures is ever-present and potentially acts integrally with every other in every circumstance. It may seem that we can at moments become truly "human" or truly "bestial," but in effect we are both all the time since there is no nonporous boundary.

Any evolved form has its ancestral entities it evolved from embedded within it, but the ancestors do not retrospectively have the later creature embedded within them. Thus we are human animals but animals are not human. That is not a value judgment, just a statement of fact.

THE LAST VISUAL WORD

An unexpected but potent commentary on the primitive centrality of the visual image of the human animal is provided by the Danish expressionist artist Asger Jorn, author of savage images of human angst. His picture of a beginning proves a fitting image with which to end. Within the scrawls of tangled color in his violent canvas, *In the Beginning Was the Image* (fig. 187), we can just discern masklike faces, nightmarish in their primitive ferocity. He exploits our irresistible desire to transform even the slightest hints of human features into a face. The title knowingly inverts the biblical dictum, "In the beginning was the word." Jorn is insinuating the idea that our visual reactions to such basic images are more primeval than the invention of language. In a twentieth-century echo of Pascal's aphorism, which stands at the head of this book, he elliptically declared, "it is not the human animal we should describe, but ourselves as human animals."[6]

187. Asger Jorn, *In the Beginning Was the Image,* 1965, private collection, Arken Museum of Modern Art, Denmark. Image from Silkeborg Kunstmuseum; courtesy of the Jorn family / Artists Rights Society (ARS), NY / COPY-DAN, Copenhagen.

NOTES

INTRODUCTION

1. George Orwell, *Animal Farm* (Orlando: Plume, 1975), pp. 4–5.

2. Ibid., p. 100.

3. Ibid., p. 101.

4. William Golding, *Lord of the Flies* (New York: Perigee, 1954), p. 204. Quoted in the notes by Edmund L. Epstein.

5. Ibid., p. 181.

CHAPTER I

1. Hippocrates, *The Nature of Man*, trans. H. S. Jones (Cambridge, MA: Harvard University Press, 1998), iv, pp. 11–12.

2. Ibid., vii, p. 19.

3. Ibid., ix, pp. 25–26.

4. Julie Hansen and Suzanne Porter, *The Physician's Art: Representations of Art and Medicine* (Durham, NC: Duke University Medical Center Library and Museum of Art, 1999), pp. 48–49.

5. William Martin Conway, ed. and trans., *The Literary Remains of Albrecht Dürer* (Cambridge: Cambridge University Press, 1889), p. 135.

6. Raymond Klibansky, Erwin Panofsky, and Fritz Saxl, *Saturn and Melancholy* (New York: Basic Books, 1964), p. 33. For the meaning of the images see Karl Arndt and Bernd Moeller, *Albrecht Dürers "Vier Apostel"* (Göttingen: Vandenhoeck and Ruprecht, 2003).

7. Klibansky et al., *Saturn and Melancholy*, p. 363.

8. Ibid., p. 59.

9. Ibid., p. 357.

10. Colin Eisler, *Dürer's Animals* (Washington: Smithsonian Institution Press, 1991).

11. For the *St. Jerome* and *Melencolia I*, see Erwin Panofsky, *The Life and Art of Albrecht Dürer* (Princeton, NJ: Princeton University Press, 1955), pp. 154–71.

12. Aristotle, *Aristotle Minor Works*, trans. W. S. Hett (London: William Heinemann, 1936), p. 85.

13. Ibid., p. 105.

14. Ibid., p. 91.

15. Ibid., p. 93.

16. Ibid.

17. Ibid., p. 99.

18. Ibid., p. 103.

19. Ibid., pp. 111–13.

20. Ibid., p. 113.

21. Ibid., pp. 120–29.

22. Windsor, Royal Library, no. 19037v. See Kenneth D. Keele and Carlo Pedretti, *Corpus of the Anatomical Studies in the Collection of Her Majesty the Queen at Windsor Castle* (London: Johnson Reprint Co.; Harcourt Brace Jovanovich, 1978–1980).

23. Milan, Biblioteca Ambrosiana, Codice atlantico, 270rc. See Martin Kemp and Margaret Walker, eds. and trans., *Leonardo on Painting: An Anthology of Writings* (New Haven: Yale University Press, 1989), pp. 256–57.

24. Martin Kemp, "Ogni dipintore dipinge se: A Neoplatonic Echo in Leonardo's Art Theory?" in *Cultural Aspects of the Italian Renaissance: Essays in Honour of Paul Oskar Kristeller*, ed. C. H. Clough (Manchester: Manchester University Press, 1976), pp. 311–23.

25. Rome, Vatican, Codex Urbinas, 109r–v. See Kemp and Walker, *Leonardo on Painting*, p. 147.

26. Rome, Vatican, Codex Urbinas, 109r–v.

27. Rome, Vatican, Codex Urbinas, 60v. See Kemp and Walker, *Leonardo on Painting*, p. 144.

28. John Pope-Hennessy, *Italian Renaissance Sculpture*, 3rd ed. (Oxford: Phaidon, 1986), pp. 255–56.

29. John Pope-Hennessy, *Italian High Renaissance and Baroque Sculpture*, 3rd ed. (Oxford: Phaidon, 1986), pp. 370–71.

30. Ibid., p. 370.

31. Ibid., p. 366.

32. Giambattista della Porta, *De Humana physiognomia*, vol. III (Vici Aequensis: Josephus Cacchius, 1586).

33. Giambattista della Porta, *Magiae naturalis*, vol. II (Naples: Matthiam Cancer, 1558), p. xii.

34. Jennifer Montagu, *The Expression of the Passions. The Origin and Influence of Charles le Brun's Conférence sur l'expression générale et pariculière* (New Haven: Yale University Press, 1994).

35. Ibid., p. 23.

36. Ibid., pp. 23–24.

CHAPTER 2

1. Charles Le Brun, introduction to *Conférence de Monsieur Le Brun . . . Sur l'expression générale & particulière* (Paris: Picart le Rom, 1694). Also see Jennifer Montagu's reconstructed version of Le Brun's text in *The Expression of the Passions*, p. 126.

2. Etienne Binet, *Essay des merveilles de nature et des plus nobles artifices, par René François*, 2nd ed. (Rouen, 1622), p. 444.

3. Charles Avery, *Bernini: Genius of the Baroque* (London: Thames and Hudson, 1997), pp. 66, 74.

4. H. Perry Chapman, *Rembrandt's Self-Portraits: A Study in Seventeenth-Century Identity* (Princeton, NJ: Princeton University Press, 1990), figs. 9–12.

5. David Hockney, *Secret Knowledge. Rediscovering the Lost Techniques of the Old Masters* (London: Thames and Hudson, 2001), pp. 164–71.

6. The best compact account remains Rudolf Wittkower, *Born under Saturn: The Character and Conduct of Artists: A Documented History from Antiquity to the French Revolution* (London: Weidenfeld and Nicolson, 1963), pp. 124–32. See also the exhibition catalog *Franz Xaver Messerschmidt,* ed. Michael Krapf (Vienna: Osterreichische Galerie Belvedere, Hatje Cantz, 2003).

7. Wittkower, *Born under Saturn*, p. 126.

8. Ronald Paulson, *Hogarth's Graphic Works*, 3rd ed. (London: Print Room, 1989), pp. 79–80.

9. Ibid., p. 82.

10. Fiona Haslam, *From Hogarth to Rowlandson: Medicine in Art in Eighteenth Century Britain* (Liverpool: Liverpool University Press, 1996), pp. 29–51.

11. Ibid., pp. 132–43.

12. William Hogarth, *Analysis of Beauty . . . with an Essay on Comic Painting by Francis Grose* (London: Mercier, n.d.), p. 202.

13. Ibid., p. 204.

14. Ibid., p. 206.

15. Fiona Haslam, *From Hogarth to Rowlandson*, pp. 52–66.

16. For Parsons, see ibid., pp. 11, 158; and Shearer West, *The Image of the Actor. Verbal and Visual Representation in the Age of Garrick and Kemble* (London: Pinter, 1991), pp. 93–100.

17. Hogarth, *Analysis of Beauty . . . with an Essay on Comic Painting*, pp. 203–4.

18. Paulson, *Hogarth's Graphic Works*, pp. 83–85.

19. West, *The Image of the Actor*, p. 93.

20. Hogarth, *Analysis of Beauty . . . with an Essay on Comic Painting*, pp. 203–4.

21. West, *The Image of the Actor*, pp. 101–4.

22. Tomas Harris, *Goya Engravings and Lithographs*, vol. 2 (Oxford: Bruno Cassirer, 1964), p. 89.

23. Ibid., p. 84.

24. Johann Caspar Lavater, *Essays on Physiognomy, Designed to Promote the Knowledge and Love of Mankind,* 5 vols. (London: John Murray, 1789), 1:128, 123, 65.

25. Johann Caspar Lavater, *Physiognomische Fragmente zur Beförderung Menschenkenntniss und Menschenliebe*, vol. 2 (Leipzig: Weidmanns Erben und Reich, 1775–78), p. 110.

26. Ibid., p. 133.

27. Lavater, *Essays on Physiognomy*, p. 133; see Martin Kemp and Marina Wallace, *Spectacular Bodies: The Art and Science of the Human Body from Leonardo to Now*, exhibition catalog, Hayward Gallery, London (Berkeley and London: University of California Press, 2000), p. 107.

28. Lavater, *Essays on Physiognomy*, 2:200.

29. Ibid., 1:259–61.

30. Ibid., 2:2.

31. Ibid., 3:310.

32. Ibid., 3:207.

33. Lavater, *Physiognomische Fragmente*, p. 113.

34. Ibid., p. 101.

35. Ibid., p. 135.

36. Ibid., p. 137.

37. Ibid., p. 135.

38. Ibid., p. 137.

39. Ibid., p. 106.

40. Ibid., p. 102.

41. Loys Delteil, *Honoré Daumier*, vol. 2 (Paris: Chez l'Auteur, 1925), no. 567.

42. Honoré de Balzac, *La Comédie humaine*, vol. 1 (London: H. S. Nichols, 1896), p. v.

43. Delteil, *Honoré Daumier*, vol. 2, nos. 329 and 335.

44. Ibid., no. 1243.

45. Guillaume-Benjamin Duchenne de Boulogne, *Méchanisme de la physionomie humaine ou analyse electro-physiologique de l'expression des passions* (Paris: J.-B. Ballière, 1876). See also *The Mechanism of Human Facial Expression,* ed. and trans. R. Andrew Cuthbertson (Cambridge: Cambridge University Press, 1990). All references are made to this edition.

46. Duchenne, *Méchanisme*, p. xxx.

47. Ibid., p. 15.

48. Ibid., p. xii.

49. Ibid., pp. 42–43, 49.

50. Ibid., pp. ix, 55–56, 132.

51. Ibid., plate 77.

52. Charles Darwin, *The Expression of the Emotions in Man and Animals* (London: John Murray, 1872), pp. 12–13.

53. Ibid., p. 376.

54. Ibid., pp. 29–30.

55. Ibid., p. 5.

56. Ibid., p. 17.

57. Ibid., p. 155.

58. Karl Schulze-Hagen and Armin Geus, eds., *Joseph Wolf (1820–1899): Tiermaler / Joseph Wolf (1820–1899): Animal Painter* (Marburg an der Lahn: Basilisken-Presse, 2000).

59. *The Portable Darwin*, ed. Duncan Porter and Peter Graham (London: Penguin, 1993), p. 478.

60. Ibid., p. 479.

61. Sergei Eisenstein, *S. M. Eisenstein Selected Works*, ed. Richard Taylor, trans. William Powell, vol. 3 (London: British Film Institute, 1996), p. 350.

62. Simon Baron-Cohen, *The Essential Difference: Men, Women and the Extreme Male Brain* (London: Allen Lane Science, 2003).

63. Paul Ekman and Erika Rosenberg, eds., *What the Face Reveals: Basic and Applied Studies of Spontaneous Expression Using the Facial Action Coding System (FACS)* (Oxford: Oxford University Press, 1997).

CHAPTER 3

1. Leonardo texts in MS H (9v, 12r, 51v), Institut de France, in Jean Paul Richter, *The Literary Works of Leonardo da Vinci*, rev. ed., 2 vols. (Phaidon: Oxford, 1970) II, nos. 1229, 1234, and 1265; to be used in conjunction with the *Commentary* by C. Pedretti, 2 vols. (Phaidon: Oxford 1977).

2. Leonardo text H¹ 11r, in Richter, *The Literary Works of Leonardo da Vinci*, 1232.

3. Luca Landucci (with anonymous continuation), *A Florentine Diary from 1450–1516* (New York: Books for Libraries Press, 1927), entries for Nov. 11 and 12, 1487; June 25 and 27, 1514; and Feb. 27, 1539.

4. John Pope-Hennessy, *Donatello Sculptor* (New York: Abbeville Press, 1993), p. 62.

5. Charles Avery, *Giambologna. The Complete Sculpture* (Oxford: Phaidon, 1987), p. 59.

6. Ibid., p. 47–48.

7. Martin Kemp, "Navis Ecclesiae: An Ambrosian Metaphor in Leonardo's Allegory of the 1515 Concordat," *Bibliothèque d'Humanisme et Renaissance* 43 (1981): 257–68.

8. Josephine Jungic, "Savonarolan Prophecy in Leonardo's Allegory with Wolf and Eagle," *Journal of the Warburg and Courtald Institutes* 60 (1997): 253–60.

9. Kemp and Walker, *Leonardo on Painting*, p. 224.

10. Erwin Panofsky, *The Life and Art of Albrecht Dürer* (Princeton, NJ: Princeton University Press, 1971), pp. 141–44.

11. Ibid., p. 87.

12. Sharon Fermor, *Piero di Cosimo. Fiction, Invention and Fanstasia* (London: Reaktion, 1993), pp. 49–51 and pl. 5; and now Dennis Geronimus, *Pierodi Cosimo* (New Haven: Yale University Press, 2006) for the story of the mourning of Procris from Niccolo da Coreggio.

13. Werner Schade, *Die Malerfamilie Cranach* (Dresden: Verlag der Kunst, 1974), p. 61.

14. Ulisse Aldrovandi, *Opera omnia,* 13 vols. (Bologna: Franciscum de Franciscis Senensem, 1599–62), and Ulisse Aldrovandi, *Monstrorum historia* (Bologna: Nicolai Tebaldini, 1642).

15. The account that follows is based on the fine catalog entry by Edwin Buijsen in *Paulus Potter. Paintings, Drawings and Etchings*, ed. Amy Walsh, Edwin Buijsen, and Ben Broos (The Hague: Mauritshuis, 1995), pp. 127–35.

16. Genesis 9:2–3.

17. René Descartes, *Discourse on Method and Related Writings*, trans. Desmond Clarke (London:

Penguin, 1999), p. 40. For the role of automata in such debates, see D. J. de Solla Price, "Automata and the Origins of Mechanism and Mechanistic Philosophy," *Technology and Culture* 5 (1964): 19, and Silvio Bedini, "The Role of Automata in the History of Technology," *Technology and Culture* 5 (1964): 24–42.

18. Leonardo, Windsor 19001r.

19. Martin Kemp, "The Handyworke of the Incomprehensible Creator," in *Writing on Hands: Memory and Knowledge in Early Modern Europe,* ed. C. R. Sherman and P. M. Lukehart (Washington, D.C.: Dickinson College and Folger Shakespeare Library, 2000), pp. 22–27.

20. Leonora Cohen Rosenfield, *From Beast Machine to Man Machine: Animal Soul in French Letters from Descartes to La Mettrie* (New York: Oxford University Press, 1941).

21. Aram Vatanian, *La Mettrie's "L'Homme machine": A Study in the Origins of an Idea* (Princeton, NJ: Princeton University Press, 1960); and Kathleen Wellman, *La Mettrie, Medicine, Philosophy, and Enlightenment* (Durham, NC: Duke University Press, 1992). The translations that follow are based on La Mettrie's *Man a Machine; and, Man a Plant,* trans. Richard Watson and Maya Rybalka, with an introduction by Justin Leiber (Indianapolis: Hackett, 1994). See also Julien Offray de La Mettrie, *Machine Man and Other Writings*, ed. and trans. Ann Thomson (Cambridge: Cambridge University Press, 1996).

22. *Man a Machine*, p. 69.

23. Ibid, p. 69.

24. Ibid, p. 69.

25. Ibid., p. 62.

26. Ibid, p. 61.

27. Ibid, p. 62.

28. Ibid., p. 75.

29. Ibid., p. 28.

30. Ibid., p. 75.

31. Ibid. p. 49.

32. Ibid., p. 53.

33. Ibid., p. 51.

34. For a subtle discussion of the background to Montaigne's views and their later history, see George Boas, *The Happy Beast in French Thought of the Seventeenth Century* (Baltimore: Johns Hopkins Press, 1933).

35. Michel Eyquem Seigneur de Montaigne, *An Apology for Raymond Secord*, trans. Michael Andrew Screech (London: Penguin, 1993), pp. 16–17.

36. Ibid., p. 17.

37. Ibid., p. 38.

38. Ibid., p. 31.

39. Ibid., p. 33.

40. Charles Avery, *Bernini Genius of the Baroque* (London: Thames and Hudson, 1997), pp. 190–92.

41. An old yet valuable overview is provided by Conrad William Cooke, *Automata Old and New* (London: Chiswick Press, 1893). See also Alfred Chapius and Edmund Droz, *Automata: A Historical and Technological Study,* trans. Alec Reid (London: Batsford, 1958). For "clockwork" mechanisms see, more recently, K. Morris and O. Mayr, *The Clockwork Universe,* exhibition catalog (Washington, D.C.: Smithsonian Institution, 1980); and O. Mayer, *Authority, Liberty and Automatic Machinery in Early Modern Europe* (Baltimore: Johns Hopkins University Press, 1986).

42. Aage Gerhardt Drachmann, *Ktesibios, Philon, & Heron: A Study in Ancient Pneumatics* (Copenhagen: E. Munksgaard, 1948).

43. Hans Hahnloser, *Villard de Honnecourt: Kritische Gesamtausgabe des Bauhüttenbuches ms. Fr. 19093 der Pariser Nationalbibliothek* (Graz: Akademische Druck- und Verlagsanstalt, 1992).

44. Conrad William Cooke, *Automata Old and New* (London: Chiswick Press, 1893), p. 50.

45. Paolo Galluzzi, *The Art of Invention. Leonardo and the Renaissance Engineers* (Florence:

Giunti, 1999).

46. Oliver Impey and Arthur Macgregor, eds., *The Origins of Museums: The Cabinet of Curiosities in Sixteenth- and Seventeenth-century Europe* (London: House of Stratus, 2001).

47. Salomon de Caus, *Les Raisons des forces mouvantes, avec diverses machines tant utilles que puissantes aus quelles sont adioints plusieurs dessings de grotes et fontaines* (Frankfurt: En la boutique de Ian Norton, 1615). See Jurgis Baltrusaitis and W. J. Strachan, *Anamorphic Art* (Cambridge: Chadwyck-Healey Ltd. 1976), pp. 64–66.

48. Francis Bacon, *New Atlantis: A Work Unfinished* (London: J. H. for William Lee, 1627).

49. Gaby Wood, *Living Dolls* (London: Faber and Faber, 2003), pp. 15–54, for a nice account of Vaucanson's automata.

50. Reported in the *Mercure de France* (April 1738), p. 739 and cited in André Doyon and Lucien Liaigre, *Jacques Vaucanson. Mecanicien de Génie* (Paris: Presses Universitaires, 1966), p. 52.

51. Jacques de Vaucanson, *Le Mécanisme du fluteur automate* (Paris, 1738) was translated into English as *An Account of the Mechanics of an Automaton, or, Image Playing on the German Flute* (London: T. Parker, 1742), p. 23. All references are to the English translation.

52. Ibid., p. 20.

53. Ibid., p. 10.

54. For this and other examples of expensive automata, see Chapuis and Droz, *Automata*.

55. Sarah Kane, "The Silver Swan: The Biography of a Curiosity," *Things* 5 (Winter 1996–97): pp. 39–57.

56. James Cox, *A Descriptive catalogue of the several superb and magnificent pieces of mechanism and jewelry* (London: Cox, 1772).

57. Philip Conisbee, *Chardin* (Oxford: Phaidon, 1986), p. 175.

58. Ibid., pp. 14–16.

59. Tom Standage, *The Mechanical Turk: The True Story of the Chess-playing Machine That Fooled the World* (London: Allen Lane, 2002).

60. Ibid., p. 46.

61. Wolfgang von Kempelen, *Mechanismus der menschlichen Sprache: nebst der Beschreibung seiner sprechenden Maschine* (Vienna: Bei J. V. Degen 1791).

62. As recorded in the *Register of Arts and Sciences* 1 (1824): 3–6.

63. Joseph Needham, *Man a Machine: In Answer to a Romantical and Unscientific Treatise Written by Sig. Eugenio Rignano & Entitled "Man Not a Machine"* (London: Kegan Paul, Trench, 1927).

CHAPTER 4

1. Comte de Buffon (Georges-Louis Leclerc), *Natural History, general and particular, by the count de Buffon [and others] translated with notes and observations, by W. Smellie,* vol. II (London, 1791), p. 68.

2. Leonora Cohen Rosenfield, *From Beast Machine to Man Machine. Animal Soul in French Letters from Descartes to La Mettrie* (New York: Oxford University Press, 1941), p. 54.

3. Steven M. Adler, *Arnauld and the Cartesian Philosophy of Ideas* (Manchester: Manchester University Press, 1989). I am grateful to Linda Whiteley for this reference and other clarifications.

4. Nicholas Fontaine, "Mémoires pour servira l'histoire de Port-Royal," in Maurice Catel, *Les Écrivains de Porte-Royal* (Paris: Flammarion, 1962), p. 300.

5. Jean de La Fontaine, *Fables choisies, mises en vers,* 4 vols. (Paris, 1755–59), 1:xv.

6. M. de Vigneul Marvile, *Mélanges d'histoire et de literature,* vol. II (Rotterdam: Chez Elie Yvans, 1700), p. 354.

7. Jean de La Fontaine, *Discours à Madame de La Sablière (sur l'ame des animaux),* ed. Henri Busson and Ferdinand Gohin (Paris: E. Droz, 1938); and Russell Ganim, "Scientific Verses: Subversion of Cartesian Theory and Practice in the 'Discours à Madame de La Sablière,'" in *Refiguring La Fontaine: Tercentenary Essays,* ed. Anne L. Biberick (Charlotesville: Rockville Press, 1996), pp. 101–25.

8. Jean de La Fontaine, *The Fables,* trans. Elizur Wright (London: George Bell and Sons, 1882), pp. 248–49.

9. Jean de La Fontaine, *Life of Aesop* in *Fables from La Fontaine*, trans. Kitty Muggeridge (London: Colline, 1973), p. 15.

10. Ibid., p. 249.

11. Ibid., p. 250.

12. Ibid.

13. Ibid., pp. 250–51.

14. Hal Opperman, *J. B. Oudry, 1686–1755* (Fort Worth, TX: Kimbell Art Museum, 1982); *J.-B. Oudry, 1686–1755: Galeries nationales du Grand palais, Paris, 1er octobre janvier 1983* (Paris: Ministère de la Culture, Éditions de la Réunion des Musées Nationaux, 1982); and Vincent Droguet, Xavier Salmon, and Danielle Véron-Denise, *Animaux d'Oudry. Collection des ducs de Mecklembourg-Schwerin*, exhibition catalog (Musée National des Châteaux de Versailles et Trianon, 2003).

15. La Fontaine, *The Fables*, p. 251.

16. Ibid., pp. 251–52.

17. Ibid., p. 252.

18. Ibid., pp. 252–53.

19. Ibid., p. 329.

20. Ibid., p. 331.

21. Ibid., p. 254.

22. Ibid., p. 255.

23. Ibid., p. 256.

24. For the Cartesian and post-Montaigne debates, see George Boas, *The Happy Beast in French Thought of the Seventeenth Century* (Baltimore: Johns Hopkins University Press, 1933).

25. François Bernier, *Abrégé de la philosophie de Gassendi* (Lyon: Chez Anisson, Posuel & Rigaud, 1684).

26. See particularly Marin Cureau de la Chambre's *Caractères des Passions*, the second edition of which was published in 1645 with his *Quelle est la connaissance des Bestes*.

27. Hal Opperman, *J. B. Oudry, 1686–1755* (Fort Worth, TX: Kimbell Art Museum, 1982), pp. 146–51.

28. Jean de La Fontaine, *Fables choisies, mises en vers*, vol. I (Paris, 1755–59), p. iii.

29. Opperman, *J .B. Oudry,* p. 61.

30. Drouget et al., *Animaux d' Oudry,* p. 141

31. Jean de La Fontaine, *Fables*, vol. I, p. v.

32. Ibid.

33. Marquis de Girardin, "L'Édition des Fables dite d'Oudry," *Bulletin du bibliophile* (1913): 285.

34. Ibid., p. 220.

35. The review in the *Mercure* is bound in with the copy of the Monentault edition of La Fontaine's *Fables* held in the Bibliothèque Nationale in Paris.

36. Opperman, *J. B. Oudry*, pp. 165–66.

37. Hal Opperman, *Jean-Baptiste Oudry* (New York: Garland Press, 1977), pp. 112–13.

38. For a general account of Buffon's works and life, see Jacques Roger, *Buffon. A Life in Natural History*, ed. L. Pearce Williams and trans. Sarah Bonnefoi (Ithaca, NY: Cornell University Press, 1997).

39. Buffon, *Natural History,* vol. II, pp. 1–2.

40. Ibid., vol. V, pp. 68, 70–71.

41. Ibid., vol. VII, pp. 109–10.

42. Ibid., vol. V, pp. 22–25.

43. Ibid., pp. 26–27.

44. Ibid., p. 70.

45. Ibid., vol. II, p. 2.

46. Ibid.

47. Joseph Adrien Lelarge de Lignac, *Lettres à un Amériquain sur l'Histoire naturelle, générale et particulière de Monsieur de Buffon* (Hamburg, 1751).

CHAPTER 5

1. Michael Newton, *Savage Girls and Wild Boys: A History of Feral Children* (London: Faber and Faber, 2002).

2. Daniel Defoe, *Mere Nature Delineated: or, a Body Without a Soul* (London: T. Warner, 1726).

3. Ibid., p. 61.

4. Ibid., pp. 38–39.

5. Daniel Defoe, *The Adventures of Robinson Crusoe* (London: T. Fisher Unwin, n.d.), p. 144.

6. Newton, *Savage Girls and Wild Boys*, p. 35.

7. Jonathan Swift, *Correspondence*, ed. Harold Williams, vol. III (Oxford: Clarendon Press, 1963), p. 128.

8. Jonathan Swift, *Gulliver's Travels*, ed. Robert Demaria (London: Penguin, 2001), p. 207.

9. Ibid., p. 203.

10. Newton, *Savage Girls and Wild Boys*, p. 53–63.

11. James Burnett, preface to *An Account of a Savage Girl, Caught Wild in the Woods of Champagne*, by Mme Hecquet, trans. William Robertson (Edinburgh: A. Kincaid and J. Bell, 1768), pp. xvi–xviii.

12. Ibid., pp. 54–55.

13. Etienne Bonnot de Condillac, *Essay on the Origin of Human Knowledge*, ed. and trans. Hans Aarsleff (Cambridge: Cambridge University Press, 2001).

14. Ibid., p. 88, citing Christian Wolff, *Psychologia rationalis: methodo scientifica pertractata, qua ea, quæ De anima humana indubia experientiæ fide innotescunt, per essentiam et naturam animæ explicantur, et ad intimiorem naturæ ejusque autoris cognitionem profutura proponuntur* (Verona: Typis Dionysii Ramanzini bibliopolæ apud S. Thomam, 1740).

15. Condillac, *Essay on the Origin of Human Knowledge*, p. 89.

16. Ibid., pp. 36–37.

17. Ibid., p. 39.

18. Ibid., p. 40.

19. Marius Kwint, "Astely's Amphitheatre and the Early Circus in England, 1768–1830," D.Phil diss., Oxford University, 1995. See also Marius Kwint, "The Legitimization of the Circus in Late Georgian England," *Past and Present* 174 (2002): 71–111; and "The Circus and Nature in Late Georgian England," in *Histories of Leisure*, ed. Rudy Koshar (Oxford: Berg Publishers, 2002), pp. 45–60.

20. Kwint, "The Circus and Nature in Late Georgian England," p. 50.

21. Ibid., p. 48.

22. Ibid., p. 54.

23. Ibid., p. 55.

24. Sarah Trimmer, *Fabulous Histories Designed for the Instruction of Children* (London: T. Longman, 1788), p. 71, in Keith Thomas, *Man and the Natural World. Changing Attitudes in England 1500–1800* (London: Allen Lane, 1983), p. 92.

25. Arthur H. Saxon, *Enter Foot and Horse: A History of Hippodrama in England and France* (New Haven: Yale University Press, 1968).

26. Kwint, "The Legitimization of the Circus in Late Georgian England," p. 89.

27. Kwint, "The Circus and Nature in Late Georgian England," p. 49.

28. *Lord Byron. The Major Works*, ed. Jerome J. McGann (Oxford: Clarendon Press, 1986), p. 355.

29. Ibid., 361.

30. Stephen Bann, introduction to *Frankenstein, Creation and Monstrosity*, ed. S. Bann (Lon-

don: Reaktion, 1994), pp. 7–13.

31. Ibid., pp. 10–11.

32. Charles Waterton, *Essays on Natural History, Chiefly Ornithology* (London: Longman, Orme, Brown, Green & Longmans, 1838), pp. 278–79.

33. Hariet Ritvo, *The Platypus and the Mermaid and Other Figments of the Classifying Imagination* (Cambridge: Harvard University Press, 1998), p. 125. For displays and illustrations of "mutant" human bodies, see Armand Marie Leroi, *Mutants. On the Form, Varieties and Errors of the Human Body* (London: Harper Collins, 2003).

34. For Barnum's enterprise, see Robert Bogdan, *Freak Show: Presenting Human Oddities for Amusement and Profit* (Chicago: University of Chicago Press, 1988), pp. 32–35.

35. Ibid., pp. 135–42.

36. Ibid., p. 136.

37. Ibid., pp. 136–37.

38. Ibid., p. 137.

39. Eric Baratay and Elizabeth Harduoin-Fugier, *Zoo: A History of Zoological Gardens in the West* (London: Reaktion Books, 2002); and Daniel Hahn, *The Tower Menagerie: Being the True Story of the Royal Collection of Wild Beasts* (New York: Simon and Schuster, 2003).

40. Ibid., p. 222.

41. Ibid., p. 129.

42. Georges Cuvier, *The animal kingdom, arranged according to its organization, serving as a foundation for the natural history of animals, and an introduction to comparative anatomy* (London: Henry G. Bohn, 1863), pp. 2–3.

43. Lee Johnston, *The Paintings of Eugène Delacroix: A Critical Catalogue*, vol. I (Oxford: Clarendon Press, 1981–89), p. 55.

44. Kenneth Clark, *Animals and Men. Their Relationship as Reflected in Western Art from Prehistory to the Present Day* (London: Thames and Hudson, 1977), p. 154.

45. Michel Poletti and Alain Richarme, *Barye catalogue raisonné des sculptures* (Paris: Gallimard, 2000), pp. 172–79.

46. Georges Cuvier, *The Animal Kingdom . . . with Additional Descriptions by Edward Griffith* (London: Whittaker, 1827), p. 238.

47. Ibid., p. 244.

48. Richard Ormond, *Sir Edward Landseer* (London: Thames and Hudson, 1982), pp. 174–75.

49. Schulze-Hagen and Geus, *Joseph Wolf (1820–1899): Tiermaler* .

CHAPTER 6

1. H. W. Janson, *Apes and Ape Lore in the Middle Ages and the Renaissance* (London: Warburg Institute, University of London, 1952); Giovanni Boccaccio, *In Defense of Poetry*, ed. Jeremiah Reedy (Toronto: Centre for Medieval Studies, 1978), and *Croniche di Giovanni, Matteo e Filippo Villani,* vol. II (Trieste, 1858), p. 450.

2. Alfonso E. Perez Sanchez and Julian Gallego, *Goya: The Complete Etchings and Lithographs* (Munich: Prestel-Verlag, 1995), p. 55.

3. Janson, *Apes and Ape Lore in the Middle Ages and the Renaissance*, pp. 155–57.

4. Martin Kemp, *The Science of Art* (New Haven: Yale University Press, 1991), p. 96.

5. Colin Eisler, *Dürer's Animals* (Washington, D.C.: Smithsonian Institution Press, 1991), plate 25.

6. Ibid., p. 262.

7. Janson, *Apes and Ape Lore in the Middle Ages and the Renaissance*, p. 85.

8. William Schupbach, *The Paradox of Rembrandt's 'Anatomy of Dr. Tulp'* (London: Wellcome Institute for the History of Medicine, 1982).

9. Kemp, "The Handyworke of the Incomprehensible Creator," pp. 22–27.

10. David Knight, *Science and Spirituality: The Volatile Connection* (London: Routledge, 2004).

11. For a review of images of the Orang, see Giulio Barsanti, Simonetta Gori-Savellini, Patrizia Guarnieri, and Claudio Pogliano, eds., *Misura d'uomo* (Florence: Istituto e Museo di Storia della Scienza, 1986), pp. 12–20.

12. Newton, *Savage Girls and Wild Boys*, p. 87.

13. Edward Tyson, *Orang-Outang, sive homo sylvestris, or THE ANATOMY OF A PYGMIE Compared to that of a Monkey, and Ape and a Man* (London: T. Bennet, 1699).

14. Ibid., p. 51.

15. Ibid., p. 55.

16. Stephanie Moser, *Ancestral Images: The Iconography of Human Origins* (Stroud: Sutton, 1998), pp. 110–14.

17. Buffon, *Natural History,* vol. I, p. 325.

18. Petrus Camper, *Histoire naturelle de l'orang-outang, et de quelques autres singes* (Haarlem: Van der Plaats, 1779).

19. Carolus Linnaeus, *The Animal Kingdom or Zoological System of the Celebrated Sir Charles Linnaeus,* trans. Robert Kerr, vol. I (London: J. Murray, and R. Faulder, 1792), p. 32.

20. Ibid., pp. 44–45.

21. Ibid., p. 86.

22. Charles White, *An Account of the Regular Gradation in Man, and in Different Animals and Vegetables, and from the Former to the Latter* (London: C. Dilly, 1799), p. 10.

23. Ibid., p. 32.

24. Ibid., p. 33.

25. Ibid., pp. 33–34.

26. Ibid., pp. 42, 79–80.

27. Ibid., p. 35.

28. Ibid., p. 59.

29. Ibid., pp. 79–80.

30. Ibid., pp. 66–67.

31. Ibid., p. 61.

32. Ibid., p. 125.

33. Johann Friedrich Blumenbach, *De generis humani varietate nativa* (Göttingen: Vandenhoeck, 1777).

34. Charles White, *An Account of the Regular Gradation in Man,* p. 134.

35. Ibid., p. 185.

36. Ibid., p. iii.

37. George Romanes, *Animal Intelligence* (London: Kegan Paul, Trench, 1882), pp. vii–viii.

38. Ibid., p. 48.

39. Ibid., p. 4.

40. Ivan Petrovich Pavlov, *Lectures on Conditioned Reflexes: Twenty-five Years of Objective Study of the Higher Nervous Activity (Behaviour) of Animals,* trans. W. Horsley Gantt and G. Volborth (New York: Liveright, 1928).

41. James Secord, *Victorian Sensation* (Chicago: Chicago Univerisity Press, 2000).

42. Charles Darwin, *The Descent of Man, and Selection in Relation to Sex* (1871; Princeton: Princeton University Press, 1981), pp. 2–3.

43. Ibid., p. 3.

44. Ibid, pp. 31–32

45. Darwin, *The Descent of Man,* pp. 104–5

46. Ibid., p. 105

47. Ibid., p. 106

48. Ibid., p. 203

49. Ibid., pp. 229–30

50. Ibid., p. 232

51. Ibid., p. 235

52. Moser, *Ancestral Images*, pp. 50.

53. Lucretius, *De rerum naturae*, V, 922–30, and 963–69; *On the Nature of the Universe*, trans. Ronald Latham (London: Penguin Books, 1961), pp. 199–200.

54. Alison Brown, "Lucretius and the Epicureans in the Social and Political Context of Renaissance Florence," *I Tatti Studies* 9 (2001): pp. 11–62. I am grateful to Dennis Geronimus for sharing his unpublished discussion of Piero's paintings.

55. Sharon Fermor, *Piero di Cosimo: Fiction, Invention and Fantasia* (London: Reaktion Books, 1993).

56. Moser, *Ancestral Images*, pp. 120–32.

57. Pierre Boitard, *Études antidiluviennes* (Paris: Passard, 1861).

58. Darwin, *Descent of Man*, pp. 4 and 203.

59. Ernst Haeckel, *The History of Creation: or, The development of the earth and its inhabitants by the action of natural causes* (London: Murray, 1876), p. 282.

60. Haeckel, *The History of Creation*, p. 365.

61. Moser, *Ancestral Images*, pp. 150–53.

CHAPTER 7

1. For the characterization of phrenology as a science, see John van der Wyhe, *Phrenology and the Origins of Victorian Scientific Naturalism* (London: Ashgate, 2004), which arrived too late to be taken into full account in this study.

2. Johann Spurzheim, *The Physiognomical System of Drs. Gall and Spurzheim; founded on an Anatomical and Physiological Examination of the Nervous System in General, and of the Brain in Particular; Indicating the Dispositions and Manifestations of the Mind* (London: Baldwin, Craddock and Joy, 1815), p. 1.

3. Ibid., p. 485.

4. Ibid., p. 205.

5. Ibid., p. 259.

6. Ibid., p. 262.

7. Ibid., p. 391.

8. Ibid., p. 302.

9. Ibid., p. 543.

10. Ibid., pp. 463–64.

11. Ibid., p. 464.

12. Ibid., p. 465.

13. Franz Joseph Gall and Johann Spurzheim, *Anatomie et physiologie du système nerveux général, et du cerveau en particulier, avec des observations sur la possibilité de reconnoitre plusieurs dispositions intellectuelles et morales de l'homme et des animaux, par la configuration de leurs têtes*, vol. II (Paris: F. Schoell, 1810–19), p. 5.

14. Thomas Forster, *Observations on the Natural History of Swallows*, 6th ed. (London: Underwood, 1817), pp. xiii and 32. I am grateful to David Knight for this reference.

15. M. H. Kaufman, *Death Masks and Life Masks of the Famous and Infamous* (Edinburgh: Scotland's Cultural Heritage, 1988).

16. *Phrenological Journal and Miscellany* (1823–24), p. 402. David Knight drew my attention to this nice reference.

17. Kemp and Wallace, *Spectacular Bodies*, pp. 116–17, citing Mary Gerrard's analysis of Frith's paintings.

18. For a broader assembly of material on this question, see particularly Giulio Barsanti, Simonetta Gori-Savellini, Patrizia Guarnieri, and Claudio Pogliano, eds., *Misura d'uomo* (Florence: Istituto e Museo di Storia della Scienza, 1986), and Stephen Jay Gould, *The Mismeasure of*

Man (London: Penguin, 1992). For Camper see Miriam Claude Meijer, *Race and Aesthetics in the Anthropology of Petrus Camper (1722–1789)* (Amsterdam: Rodopi, 1999).

19. Petrus Camper, *Dissertation sur les variétés naturelles qui caractérisent la physionomie des hommes* (1791), trans. in *The Works of the late Professor Camper on the Connection between the the Science of Anatomy and the Arts of Drawing, Painting, Statuary &c. &c.*, ed. T. Cogan (London: Herane, 1820), p. 5.

20. Walter Strauss, *The Human Figure by Albrecht Dürer: The Complete Dresden Sketchbook* (New York: Dover, 1972), no. 116.

21. Jay Levenson, ed., *Circa 1492: Art in the Age of Exploration* (New Haven: Yale University Press, 1991), pp. 115–19.

22. Petrus Camper, *The Works of the late Professor Camper*, p. 18.

23. Ibid., p. 50.

24. Ibid., p. 32.

25. Ibid., p. 16.

26. Charles White, *An Account of the Regular Gradation in Man, and in Different Animals and Vegetables, and from the Former to the Latter* (London: C. Dilly, 1799), p. 15.

27. Ibid., p. 43

28. Gall and Spurzheim, *Anatomie et physiologie du système nerveux*, vol. II, p. 197.

29. Ibid., p. 199.

30. Paul Topinard, *Anthropology* (London: Chapman and Hall, 1878), pp. 493–94.

31. Antoinette le Normand-Romain, ed., *La sculpture ethnographique: de la Vénus hottentote à la Tehura de Gauguin* (Paris: Éditions de la Réunion des Musées, 1994), p. 10.

32. Paul Broca, "Sur le volume et la forme du cerveau suivant les individus et suivant les races," *Bulletin de la Société d'Anthropologie* II (1861): 139.

33. Ibid., p. 188.

34. Paul Broca, "Anthropologie" in *Dictionnaire encyclopédique médicales*, ed. A. Dechambre (Paris: Masson, 1866), p. 280.

35. Paul Broca, "Sur les crânes de la caverne de 'Homme-Mort,'" *Revue d'Anthropologie* II (1873), p. 38.

36. See the balanced account in Gould, *The Mismeasure of Man*, pp. 81–132.

37. Agassiz's letter to his mother of December 1846, quoted in ibid., pp. 44–45.

38. Louis Agassiz, "The Diversity of the Origin of the Human Races," *Christian Examiner* 41:144.

39. James Fenimore Cooper, *The Last of the Mohicans* (New York: Penguin Books, 1986), p. 95.

40. Ibid., p. 342.

41. Ibid., p. 5.

42. John Down, "Observations on an Ethnic Classification of Idiots," *London Hospital Reports* (1866), p. 260; see Gould, *The Mismeasure of Man*, pp. 134–35.

43. Down, "Observations on an Ethnic Classification of Idiots," p. 261.

44. Gould, *The Mismeasure of Man*, pp. 50–69.

45. Samuel Morton, *Crania Americana* (Philadelphia: Collins, 1839), p. 90.

46. Mathias Duval, *Artistic Anatomy*, trans. Frederick Fenton (London: Cassel, 1891), p. 283.

47. Ibid., p. 281.

48. Nicholas Gillham, *A Life of Sir Francis Galton* (Oxford: Oxford University Press, 1992).

49. Gina Lombroso, *Criminal Man According to the Classification of Cesare Lombroso* (New York: Puttnam, 1913), p. 6. Subsequent quotes from are from this edition unless otherwise noted.

50. Ibid., p. 12.

51. Ibid., p. 17.

52. Ibid., p. 16.

53. Ibid., p. 7.

54. Ibid., p. 20.

55. Gould, *The Mismeasure of Man*, p. 125.

56. Gina Lombroso, *Criminal Man According to the Classification of Cesar Lombroso*, p. 12.

57. Cesare Lombroso, "The Savage Origin of Tatooing," *Popular Science Monthly* (April 1896): 797.

58. Gina Lombroso, *Criminal Man According to the Classification of Cesar Lombroso*, p. 47.

59. Bram Stoker, *Dracula*, ed. Maurice Hindle (London: Penguin Books, 1993), p. 28.

60. Ibid., p. 258.

61. Cesare Lombroso, *Crime, Its Causes and Its Remedies*, trans. Henry P. Horton (London: W. Heinemann, 1911), p. 428.

62. Gould, *The Mismeasure of Man*, p. 129.

63. Anthea Callen, *The Spectacular Body: Science, Method and Meaning in the Work of Degas* (New Haven: Yale University Press, 1995), and Richard Kendall, *Degas and the Little Dancer* (New Haven: Yale University Press, 1998).

64. Martin Kemp, "'A Perfect and Faithful Record': Mind and Body in Photography before 1900," in *Beauty of Another Order*, ed. Ann Thomas (New Haven: Yale University Press, 1997), pp. 120–49.

65. Gen Doy, "More than Meets the Eye . . . Representations of Black Women in Mid-Nineteenth-Century French Photography," *Women's International Forum* 21 (1998): 305–19.

POSTSCRIPT

1. Christopher Frayling, *Nightmare: the Birth of Horror* (London: BBC Books, 1996).

2. John Lockwood Kipling, *Beast and Man in India* (London: Macmillan, 1892), p. 2.

3. Thomas Pinney, ed., *Kipling's India: Uncollected Sketches 1884–88* (New York: Schocken Books, 1986), pp. 83–84. I owe this picturesque source to Kajri Jain.

4. Ibid., pp. 106–7.

5. John Lockwood Kipling, *Beast and Man in India*, p. 320.

6. Ibid., pp. 57–58.

7. Ibid., p. 281.

8. William Sleeman, "Wolves Nurturing Children in Their Dens," *Zoologist* 12 (1888): 87–98.

9. Ruyard Kipling, *The Jungle Books*, ed. Daniel Karlin (Harmondsworth: Penguin, 2000), p. 38.

10. Ibid., p. 37.

11. Ibid., p. 173.

12. Ibid., p. 174.

13. Ibid., pp. 175–76.

14. Ibid., p. 111.

15. Ibid., p. 159.

16. Edgar Rice Burroughs, *Tarzan of the Apes* (London: Methuen and Co. Ltd, 1912), p. 24.

17. Ibid., p. 26.

18. Ibid.

19. Ibid., p. 30.

20. Ibid., p. 33.

21. Ibid., pp. 35–36.

22. Ibid., p. 39.

23. Ibid., p. 54.

24. Ibid., p. 55.

25. Ibid., p. 76.

26. Ibid., p. 77.

27. Ibid., p. 79.

28. Ibid., p. 80.

29. Ibid., p. 90.

30. Ibid., p. 106.

31. Ibid., p. 154.

32. Ibid., p. 171.

33. Ibid., p. 172.

34. Ibid., pp. 179, 181.

35. Edgar Rice Burroughs, *Tarzan and the Jewell of Opar* (London: Methuen & Co. Ltd, 1919), pp. 13–14.

36. Ibid., p. 14.

37. Bram Stoker, *Dracula*, p. 53.

38. Ibid., p. 54.

39. Walter Pater, *The Renaissance. Studies in Art and Poetry*, ed. Donald Hill (1873; Berkeley: University of California Press, 1980), pp. 98–99.

40. Ibid., p. 29.

41. Ibid., p. 28.

42. Ibid., p. 28.

43. Ibid., p. 71.

44. Ibid., pp. 271–72.

45. Ibid., p. 83.

46. Ibid., p. 439.

47. Robert Mighall, introduction to Robert Louis Stevenson, *The Strange Case of Dr. Jekyll and Mr. Hyde and Other Tales of Terror* (London: Penguin, 2002), pp. 29–30.

48. Henry Maudsley, *Responsibility in Mental Disease*, 2nd ed. (London: H. S. King & Co., 1874), pp. 29–30.

49. Henry Maudsley, "Remarks on Crime and Criminals," *Journal of Mental Science* 34 (1888): 162.

50. Robert Louis Stevenson, *The Strange Case of Dr. Jekyll and Mr. Hyde*, p. 108.

51. Ibid., p. 96.

52. Ibid., p. 102.

53. Ibid., p. 116.

54. Ibid., p. 124.

55. Ibid., p. 56.

56. Ibid., p. 66.

57. Ibid., p. 57.

58. Ibid., p. 58.

59. Ibid., p. 10.

60. Ibid., p. 52.

61. Ibid., p. 61.

A PERSONAL FOOTNOTE

1. For elegantly skeptical reviews of this much debated question, see John Gray, *Straw Dogs: Thoughts on Humans and Other Animals* (Cambridge: Granta, 2004); and Felipe Fernánadez-Armesto, *So You Think You're Human?* (Oxford: Oxford University Press, 2004). See also Raimond Gaita, *The Philosopher's Dog* (London: Routledge, 2003) for a Wittgensteinian approach; and, for a Fontainean view of farm animals, Jeffrey Masson, *The Pig Who Sang to the Moon* (London: Cape, 2003).

2. Antonio Damasio, *Descartes' Error: Emotion, Reason and the Human Brain* (London: Picador, 1995).

3. See Richard Buxton, *Introduction to Functional Magnetic Resonance Imaging* (Cambridge: Cambridge University Press, 2002); Stefano Cappa, *Cognitive Neurology. An Introduction* (London: Imperial College Press, 1991); and F. Clifford Rees, ed., *Neurology and the Arts* (London, Imperial College, 2004).

4. For introductions to chaos theory, see Ian Stewart, *Does God Play Dice: The New Mathematics of Chaos* (Oxford: Blackwells, 1992); James Gleick, *Chaos: Making a New Science* (Penguin, 1988); Mitchell Wardrop, *Complexity. The Emerging Science at the Edge of Order and Chaos* (New York: Simon and Schuster, 1992); and Jeffrey Carver, *Strange Attractors* (New York: Tor Books, 1996).

5. For a telling review, see Ian Tattersal, *Monkey in the Mirror: Essays in the Science of What Makes Us Human* (New York: Harcourt, 2003), though I am placing less emphasis upon the primacy of the symbolic power of language.

6. *Asger Jorn. A Retrospective*, exhibition catalog (Arken: Arken Museum of Modern Art, 2002), p. 74.

Note: Books are listed in the editions used. References to monographs on artists are gener-
ally to be found in the notes and are only included here if they contain a general discussion
related to the theme of this book.

Adler, Steven M. *Arnauld and the Cartesian Philosophy of Ideas*. Manchester: Manchester University
 Press, 1989.

Agassiz, Louis. "The Diversity of the Origin of the Human Races." *Christian Examiner* 49 (1850):
 110–45.

Aldrovandi, Ulisse. *Opera omnia*. 13 vols. Bologna: Franciscum de Franciscis Senensem, 1599–62.

———. *Monstrorum historia*. Bologna: Nicolai Tebaldini, 1642.

Baltrusaitis, Jurgis, and W. J. Strachan. *Anamorphic Art*. Cambridge: Chadwyck-Healey, 1976.

Bann, Stephen, ed. *Frankenstein, Creation and Monstrosity*. London: Reaktion, 1994.

Baratay, Eric, and Elizabeth Harduoin-Fugier. *Zoo: A History of Zoological Gardens in the West*.
 London: Reaktion Books, 2002.

Baron-Cohen, Simon. *The Essential Difference: Men, Women and the Extreme Male Brain*. London:
 Allen Lane Science, 2003.

Barsanti, Giulio, Simonetta Gori-Savellini, Patrizia Guarnieri, and Claudio Pogliano, eds. *Misura
 d'uomo*. Florence: Istituto e Museo di Storia della Scienza, 1986.

Bedini, Silvio. "The Role of Automata in the History of Technology." *Technology and Culture* 5
 (1964): 24–42.

Bindman, David. *Ape to Apollo: Aesthetics and the Idea of Race in the Eighteenth Century*. London:
 Reaktion, 2002.

Boas, George. *The Happy Beast in French Thought of the Seventeenth Century*. Baltimore: Johns
 Hopkins University Press, 1933.

Bogdan, Robert. *Freak Show: Presenting Human Oddities for Amusement and Profit*. Chicago:
 University of Chicago Press, 1988.

Boitard, Pierre. *Études antidiluviennes*. Paris: Passard, 1861.

Bonderson, Jan. *The Cat Orchestra and the Elephant Butler*. London: Tempus, 2007.

Bowler, Peter. *The Fontana History of the Environmental Sciences*. London: Fontana, 1992.

Broca, Paul. "Anthropologie." In *Dictionnaire encyclopédique des sciences médicales,* edited by A.
 Dechambre. Paris: Masson, 1866, pp. 276–300.

———. "Sur les crânes de la caverne de 'Homme-Mort.'" *Revue d'Anthropologie* II (1873): 1–53.

———. "Sur le volume et la forme du cerveau suivant les individus et suivant les races." *Bulletin Société d'Anthropologie* II (1861): 139–207, 301–21, 441–46.

Brown, Alison. "Lucretius and the Epicureans in the Social and Political Context of Renaissance Florence." *I Tatti Studies* 9 (2001): 11–62.

Buffon, Georges-Louis Leclerc (Comte de Buffon). *Natural History, general and particular, by the count de Buffon [and others] translated with notes and observations, by W. Smellie.* London, 1791.

Burnett, James. Preface to *An Account of a Savage Girl, Caught Wild in the Woods of Champagne,* by Mme Hecquet. Translated by William Robertson. Edinburgh: A. Kincaid and J. Bell, 1768.

Burroughs, Edgar Rice. *Tarzan of the Apes.* London: Methuen, 1912.

———. *Tarzan and the Jewell of Opar.* London: Methuen, 1919.

Callen, Anthea. *The Spectacular Body: Science, Method and Meaning in the Work of Degas.* New Haven: Yale University Press, 1995.

de Caus, Salomon. *Les raisons des forces mouvantes, avec diverses machines tant utilles que puisisantes aus quelles sont adioints plusieurs dessings de grotes et fontaines.* Frankfurt: En la boutique de Ian Norton, 1615.

Camper, Petrus. *Dissertation sur les variétés naturelles qui caractérisent la physiomomie des hommes.* 1791. In *The Works of the late Professor Camper on the Connection between the Science of Anatomy and the Arts of Drawing, Painting, Statuary &c., &c.* Edited by T. Cogan. London: Herane, 1820.

———. *Histoire naturelle de l'orang-outang, et de quelques autres singes.* Haarlem: Van der Plaats, 1779.

Chapuis, Alfred. *Automata: A Historical and Technological Study.* London: Batsford, 1958.

———. "L'horloger Vaucher et l'affaire du collier." *Journal Suisse d'horlogerie et de Bijouterie* (1945).

Clark, Kenneth. *Animals and Men: Their Relationship as Reflected in Western Art from Prehistory to the Present Day.* London: Thames and Hudson, 1977.

Condillac, Etienne Bonnot de. *Essay on the Origin of Human Knowledge.* Translated and edited by Hans Aarsleff. Cambridge: Cambridge University Press, 2001.

Cooke, Conrad William. *Automata Old and New.* London: Chiswick Press, 1893.

Cooper, James Fenimore. *The Last of the Mohicans.* 1826. Edited by Richard Slotkin. New York and London: Penguin, 1986.

Cox, James. *A descriptive catalogue of the several superb and magnificent pieces of mechanism and jewelry.* London: Cox, 1772.

Cuvier, Georges. *The animal kingdom, arranged according to its organization, serving as a foundation for the natural history of animals, and an introduction to comparative anatomy.* London: Henry G. Bohn, 1863.

———. *The Animal Kingdom . . . with Additional Descriptions by Edward Griffith.* London: Whittaker, 1827.

Damasio, Antonio. *Descartes' Error: Emotion, Reason and the Human Brain.* London: Picador, 1995.

Darwin, Charles. *The Descent of Man, and Selection in Relation to Sex.* 1871. Princeton: Princeton University Press, 1981.

———. *The Expression of the Emotions in Man and Animals.* London: John Murray, 1872.

———. *The Portable Darwin.* Edited by Duncan Porter and Peter Graham. London: Penguin, 1993.

Debus, Allen. *Man and Nature in the Renaissance.* Cambridge: Cambridge University Press, 1978.

Defoe, Daniel. *Mere Nature Delineated; or, A Body Without a Soul.* London: T. Warner, 1726.

della Porta, Giambattista. *De Humana physiognomia.* Vol. III. Vici Aequensis: Josephus Cacchius, 1586.

———. *Magiae naturalis.* Vol. II. Naples: Matthiam Cancer, 1558.

Descartes, René. *Discourse on Method and Related Writings.* Translated by Desmond Clarke. London: Penguin, 1999.

Diamond, Jared. *The Rise and Fall of the Third Chimpanzee.* London: Radius, 1991.

Down, John. "Observations on an Ethnic Classification of Idiots." *London Hospital Reports,* 1866.

Doy, Gen. "More than Meets the Eye . . . Representations of Black Women in Mid-Nineteenth-Century French Photography." *Women's International Forum* 21 (1998): 305–19.

Droguet, Vincent, Xavier Salmon, and Danièle Véron-Denise. *Animaux d'Oudry: Collection des ducs de Mecklembourg-Schwerin*. Exhibition catalog. Musée National des Châteaux de Versailles et Trianon, 2003.

Duchenne de Boulogne, Guillaume-Benjamin. *Mécanisme de la physionomie humaine ou analyse électro-physiologique de l'expression des passions*. Paris: J.-B. Baillière, 1876.

———. *The Mechanism of Human Facial Expression*. Translated and edited by R. Andrew Cuthbertson. Cambridge: Cambridge University Press, 1990.

Dürer, Albrecht. *The Literary Remains of Albrecht Dürer*. Translated and edited by William Martin Conway. Cambridge: Cambridge University Press, 1889.

Duval, Mathias. *Artistic Anatomy*. Translated by Frederick Fenton. London: Cassel, 1891.

Eisler, Colin. *Dürer's Animals*. Washington, D.C: Smithsonian Institution Press, 1991.

Ekman, Paul, and Erika Rosenberg, eds. *What the Face Reveals: Basic and Applied Studies of Spontaneous Expression Using the Facial Action Coding System (FACS)*. Oxford: Oxford University Press, 1997.

Fermor, Sharon. *Piero di Cosimo: Fiction, Invention and Fantasia*. London: Reaktion, 1993.

Fernández-Armesto, Felipe. *So You Think You're Human?* Oxford: Oxford University Press, 2004.

Frayling, Christopher. *Nightmare: The Birth of Horror*. London: BBC Books, 1996.

Fudge, Erica. *Perceiving Animals: Humans and Beasts in Early Modern English Culture*. Chicago: University of Illinois Press, 2002.

Gaita, Raimond. *The Philosopher's Dog*. London: Routledge, 2003.

Gall, Franz Joseph, and Johann Spurzheim. *Anatomie et physiologie du système nerveux en général, et du cerveau en particulier, avec des observations sur la possibilité de reconnoitre plusieurs dispositions intellectuelles et morales de l'homme et des animaux, par la configuration de leurs têtes,* vol. II (1812). Paris: F. Schoell, 1810–19.

Ganim, Russell. "Scientific Verses: Subversion of Cartesian Theory and Practice in the 'Discours à Madame de La Sablière.'" In *Refiguring La Fontaine: Tercentenary Essays,* edited by Anne L. Birberick. Charlottesville: Rookwood Press, 1996.

Gillham, Nicholas. *A Life of Sir Francis Galton*. Oxford: Oxford University Press, 1992.

Girardin, Marquis de. "L'Édition des Fables dite d'Oudry de la Fontaine," *Bulletin du bibliophile* (1913): 217–36, 277–92, 330–47, 386–98.

Gould, Stephen Jay. *The Mismeasure of Man*. London: Penguin, 1992.

Gray, John. *Straw Dogs: Thoughts on Humans and Other Animals*. Cambridge: Granta, 2004.

Haeckel, Ernst. *The history of Creation; or, The development of the earth and its inhabitants by the action of natural causes*. London: Murray, 1876.

Hahn, Daniel. *The Tower Menagerie: Being the True Story of the Royal Collection of Wild Beasts*. New York: Simon and Schuster, 2003.

Hansen, Julie, and Suzanne Porter. *The Physician's Art: Representations of Art and Medicine*. Durham, NC: Duke University Medical Center Library and Museum of Art, 1999.

Haslam, Fiona. *From Hogarth to Rowlandson: Medicine in Art in Eighteenth Century Britain*. Liverpool: Liverpool University Press, 1996.

Hippocrates. *The Nature of Man*. Translated by H. S. Jones. Cambridge, MA: Harvard University Press, 1998.

Hoeneger, F. David. "How Plants and Animals Were Studied in the Mid-Sixteenth Century." In *Science and the Arts in the Renaissance,* edited by John Shirely and F. David Hoeneger, pp. 130–48. Washington, D.C.: Folger Books, 1985.

Hogarth, William. *Analysis of Beauty . . . with an Essay on Comic Painting by Francis Grose*. London: Mercier, n.d.

Impey, Oliver, and Arthur Macgregor, eds. *The Origins of Museums: The Cabinet of Curiosities in Sixteenth- and Seventeenth-Century Europe*. London: House of Stratus, 2001.

Janson, Horst. *Apes and Ape Lore in the Middle Ages and the Renaissance*. London: University of London, Warburg Institute, 1952.

Jungic, Josephine. "Savonarolan Prophecy in Leonardo's Allegory with Wolf and Eagle." *Journal of the Warburg and Courtauld Institutes* 60 (1997): 253–60.

Kane, Sarah. "The Silver Swan: The Biography of a Curiosity." *Things* 5 (Winter 1996–97): 39–57.

Kaufman, M. H. *Death Masks and Life Masks of the Famous and Infamous*. Edinburgh: Scotland's Cultural Heritage, 1988.

Keele, Kenneth D., and Carlo Pedretti. *Corpus of the Anatomical Studies in the Collection of Her Majesty the Queen at Windsor Castle*. Johnson Reprint. London: Harcourt Brace Jovanovich, 1978–1980.

Kemp, Martin. "'A Perfect and Faithful Record': Mind and Body in Photography before 1900." In *Beauty of Another Order,* edited by Ann Thomas, pp. 120–49. New Haven: Yale University Press, 1997.

———. "Navis Ecclesiae: An Ambrosian Metaphor in Leonardo's Allegory of the 1515 Concordat." *Bibliothèque d'Humanisme et Renaissance* 43 (1981): 257–68.

———. "The Handyworke of the Incomprehensible Creator." In *Writing on Hands: Memory and Knowledge in Early Modern Europe,* edited by C. R. Sherman and P. M. Lukehart. Washington, D.C.: Dickinson College and Folger Shakespeare Library, 2000.

———. *The Science of Art*. New Haven: Yale University Press, 1991.

Kemp, Martin, and Margaret Walker, eds. and trans. *Leonardo on Painting: An Anthology of Writings*. New Haven: Yale University Press, 1989.

Kemp, Martin, and Marina Wallace. *Spectacular Bodies: The Art and Science of the Human Body from Leonardo to Now*. Exhibition catalog. London: Hayward Gallery; Berkeley: University of California Press, 2000.

Kempelen, Wolfgang von. *Mechanismus der menschlichen Sprache: nebst der Beschreibung seiner sprechenden Maschine*. Vienna: Bei J. V. Degen, 1791.

Kendall, Richard. *Degas and the Little Dancer*. New Haven: Yale University Press, 1998.

Kipling, John Lockwood. *Beast and Man in India*. London: Macmillan, 1892.

Kipling, Rudyard. *The Jungle Books*. Edited by Daniel Karlin. Harmondsworth: Penguin, 2000.

———. *Kipling's India: Uncollected Sketches 1884–88*. Edited by Thomas Pinney. New York: Schocken Books, 1986.

Knight, David. *Science and Spirituality: The Volatile Connection*. London: Routledge, 2004.

———. *Zoological Illustration: An Essay Towards a History of Printed Zoological Pictures*. Folkestone, UK: Dawson/Archon Books, 1977.

Klibansky, Raymond, Erwin Panofsky, and Fritz Saxl. *Saturn and Melancholy*. New York: Basic Books, 1964.

Krapf, Michael, ed. *Franz Xaver Messerschmidt*. Vienna: Osterreichische Galerie Belvedere, Hatje Cantz, 2003.

Kwakkelstein, Michael. *Leonardo da Vinci as a Physiognomist: Theory and Drawing Practice*. Leiden: Primavera Press, 1994.

Kwint, Marius. "*Astely's Amphitheatre and the Early Circus in England, 1768–1830.*" D. Phil. diss., Oxford University, 1995.

———. "The Circus and Nature in Late Georgian England." In *Histories of Leisure,* edited by Rudy Koshar. Oxford: Berg Publishers, 2002.

———. "The Legitimization of the Circus in Late Georgian England." *Past and Present* 174 (2002): 72–115.

La Fontaine, Jean de. *Discours à Madame de La Sablière (sur l'âme des animaux)*. Edited by Henri Busson and Ferdinand Gohin. Paris: E. Droz, 1938.

———. *Fables Choisies, mises en vers*. 4 vols. Paris, 1755–59. Translated as *The Fables* by Elizur Wright. London: George Bell and Sons, 1882.

———. *Life of Aesop*. In *Fables from La Fontaine,* translated by Kitty Muggeridge. London: Collins, 1973.

La Mettrie, Julien Offray de. *Man a Machine; and Man a Plant.* Translated by Richard Watson and Maya Rybalka. Indianapolis: Hackett, 1994.

Lavater, Johann Caspar. *Essays on Physiognomy, Designed to Promote the Knowledge and Love of Mankind.* 5 vols. London: John Murray, 1789.

———. *Physiognomische Fragmente zur Beförderung der Menschenkenntnis und Menschenliebe.* Vol. II. Leipzig: Weidmanns Erben und Reich, 1775–78.

Liaigre, Lucien. *Jacques Vaucanson: Mécanicien de Génie.* Paris: Presses Universitaires, 1966.

Le Brun, Charles. Introduction to *Conférence de Monsieur Le Brun. . . . Sur l'expression genenrale & particuliere.* Paris: Picart le Rom, 1694.

———. *Conférence . . . sur L'Expression Générale et Particulière des Passions.* Verona: Carattoni, 1761.

Leroi, Armand Marie. *Mutants: On the Form, Varieties and Errors of the Human Body.* London: Harper Collins, 2003.

Linnaeus, Carolus. *The Animal Kingdom or Zoological System of the Celebrated Sir Charles Linnaeus. Class I: Mammalia. . . .* Translated by Johann Friedrich Gmelin. London: J. Murray and R. Faulder, 1792.

Lombroso, Cesare. *Crime, Its Causes and Its Remedies.* Translated by Henry P. Horton. London: W. Heinemann, 1911.

———. *L'Homme criminal.* Paris: Alacan, 1887.

———. "The Savage Origin of Tattooing." *Popular Science Monthly* (April 1896): 793–803.

Lombroso, Gina. *Criminal Man According to the Classification of Cesare Lombroso.* New York: Putnam, 1913.

Lucretius. *On the Nature of the Universe.* Translated by Ronald Latham. London: Penguin Books, 1961.

Masson, Jeffrey. *The Pig Who Sang to the Moon.* London: Cape, 2003.

Maudsley, Henry. "Remarks on Crime and Criminals." *Journal of Mental Science* 34 (1888): 159–67.

———. *Responsibility in Mental Disease.* 2nd ed. London: H. S. King, 1874.

Mayer, O. *Authority, Liberty and Automatic Machinery in Early Modern Europe.* Baltimore: Johns Hopkins University Press, 1986.

Meijer, Miriam Claude. *Race and Aesthetics in the Anthropology of Petrus Camper (1722–1789).* Amsterdam: Rodopi, 1999.

Montagu, Jennifer. *The Expression of the Passions: The Origin and Influence of Charles Le Brun's conférence sur l'expression générale et pariculière.* New Haven: Yale University Press, 1994.

Montaigne, Michel Eyquem Seigneur de. *An Apology for Raymond Sebond.* Translated by Michael Andrew Screech. London: Penguin, 1993.

Morris, K., and O. Mayer. *The Clockwork Universe.* Exhibition catalog. Washington, D.C.: Smithsonian Institution, 1980.

Morton, Samuel. *Crania Americana.* Philadelphia: Collins, 1839.

Moser, Stephanie. *Ancestral Images: The Iconography of Human Origins.* Stroud, UK: Sutton, 1998.

Needham, Joseph. *Man a Machine: In Answer to a Romantical and Unscientific Treatise Written by Sig. Eugenio Rignano & Entitled "Man Not a Machine."* London: Kegan Paul, Trench, 1927.

Newton, Michael. *Savage Girls and Wild Boys: A History of Feral Children.* London: Faber and Faber, 2002.

Normand-Romain, Antoinette le, ed. *La sculpture ethnographique: de la Vénus hottentote à la Tehura de Gauguin.* Paris: Éditions de la Réunion des Musées Nationaux, 1994.

Opperman, Hal. *J. B. Oudry, 1686–1755.* Fort Worth, TX: Kimbell Art Museum, 1982.

———. *J.-B. Oudry, 1686–1755: Galeries nationales du Grand palais, Paris, 1er octobre 1982–janvier 1983.* Paris: Ministère de la Culture, Éditions de la Réunion des Musées Nationaux, 1982.

———. *Jean-Baptiste Oudry.* New York: Garland Press, 1977.

Panofsky, Erwin. *The Life and Art of Albrecht Dürer*. Princeton: Princeton University Press, 1955.

Paulson, Ronald. *Hogarth's Graphic Works*. 3rd ed. London: Print Room, 1989.

Pavlov, Ivan Petrovich. *Lectures on Conditioned Reflexes: Twenty-five Years of Objective Study of the Higher Nervous Activity (Behaviour) of Animals*. Translated by W. Horsley Gantt and G. Volborth. New York: Liveright, 1928.

Paulus Potter: Paintings, Drawings and Etchings. Edited by Amy Walsh, Edwin Buijsen, and Ben Broos. The Hague: Mauritshuis, 1995.

Richter, Jean Paul. *The Literary Works of Leonardo da Vinci*. 2 vols. Revised edition with commentary by C. Pedretti. Oxford: Phaidon, 1970.

Ritvo, Harriet. *The Platypus and the Mermaid and other Figments of the Classifying Imagination*. Cambridge, MA: Harvard University Press, 1998.

Roger, Jacques. *Buffon: A Life in Natural History*. Edited by L. Pearce Williams and translated by Sarah Bonnefoi. Ithaca: Cornell University Press, 1997.

Romanes, George. *Animal Intelligence*. London: Kegan Paul, Trench, 1882.

Rosenfield, Leonora Cohen. *From Beast Machine to Man Machine: Animal Soul in French Letters from Descartes to La Mettrie*. New York: Oxford University Press, 1941.

Rudwick, Martin. *Scenes from Deep Time: Early Pictorial Representations of the Prehistoric World*. Chicago: University of Chicago Press, 1992.

Saxon, Arthur H. *Enter Foot and Horse: A History of Hippodrama in England and France*. New Haven: Yale University Press, 1968.

Schaffer, Simon. "Babbage's Dancer and the Impresarios of Mechanism" In *Cultural Babbage*, edited by Frances Spufford and Jenny Uglow. London: Faber, 1996.

Schupbach, William. *The Paradox of Rembrandt's 'Anatomy of Dr. Tulp.'* London: Wellcome Institute for the History of Medicine, 1982.

Schulze-Hagen, Karl, and Armin Geus, eds. *Joseph Wolf (1820–1899): Tiermaler / Joseph Wolf (1820–1899): Animal Painter*. Marburg an der Lahn: Basilisken-Presse, 2000.

Secord, James. *Victorian Sensation*. Chicago: University of Chicago Press, 2000.

Sleeman, Sir William Henry. "An Account of Wolves Nurturing Children in the Dens. By an Indian Official." 1852. *Zoologist* XII (1888): 87–98.

Solla Price, D. J. de. "Automata and the Origins of Mechanism and Mechanistic Philosophy." *Technology and Culture* 5 (1964): 9–23.

Spurzheim, Johann. *The Physiognomical System of Drs. Gall and Spurzheim; founded on an Anatomical and Physiological Examination of the Nervous System in General, and of the Brain in Particular; Indicating the Dispositions and Manifestations of the Mind*. London: Baldwin, Craddock and Joy, 1815.

Standage, Tom. *The Mechanical Turk: The True Story of the Chess-playing Machine that Fooled the World*. London: Allen Lane/Penguin Press, 2002.

Sterndale, Robert. *Denizens of the Jungle: a Series of Sketches of Wild Animals, Illustrating their Forms and Attitudes*. Calcutta, 1886.

———. *Mammalia of India and Ceylon*. Calcutta, 1884.

Stevenson, Robert Louis. *The Strange Case of Dr. Jekyll and Mr. Hyde and Other Tales of Terror*. With introduction and essay on "Diagnosing Jekyll" by Robert Mighall. London: Penguin, 2002.

Stoker, Bram. *Dracula*. Introduction by Maurice Hindle. London: Penguin, 1993.

Swift, Jonathan. *Correspondence*. Vol. 3. Edited by Harold Williams. Oxford: Clarendon Press, 1963.

———. *Gulliver's Travels*. 1726. Introduction by Robert Demaria, Jr. London: Penguin, 2001.

Tattersal, Ian. *Monkey in the Mirror: Essays in the Science of What Makes Us Human*. New York: Harcourt, 2003.

Thomas, Keith. *Man and the Natural World: Changing Attitudes in England 1500–1800*. London: Allen Lane, 1983.

Topinard, Paul. *Anthropology*. London: Chapman and Hall, 1878.

Tyson, Edward. *Orang-Outang, sive homo sylvestris, or THE ANATOMY OF A PYGMIE Compared to that of a Monkey, and Ape and a Man*. London: T. Bennet, 1699.

Vatanian, Aram. *La Mettire's "L'Homme machine": A Study in the Origins of an Idea*. Princeton: Princeton University Press, 1960.

Vaucanson, Jacques de. *Le mécanisme du fluteur automate*. 1738. Translated as *An Account of the Mechanics of an Automaton, or, Image playing on the German Flute*. London: T. Parker, 1742.

Waterton, Charles. *Essays on Natural History, chiefly Ornithology*. London: Longman, Orme, Brown, Green & Longmans, 1838.

Wellman, Kathleen. *La Mettrie, Medicine, Philosophy, and Enlightenment*. Durham, NC: Duke University Press, 1992.

West, Shearer. *The Image of the Actor: Verbal and Visual Representation in the Age of Garrick and Kemble*. London: Pinter, 1991.

White, Charles. *An Account of the Regular Gradation in Man, and in Different Animals and Vegetables, and from the Former to the Latter*. London: C. Dilly, 1799.

Wittkower, Rudolf. *Born under Saturn: The Character and Conduct of Artists: A Documented History from Antiquity to the French Revolution*. London: Weidenfeld & Nicolson, 1963.

Wood, Gaby. *Living Dolls*. London: Faber and Faber, 2003.

Wyhe, John van der. *Phrenology and the Origins of Victorian Scientific Naturalism*. London: Ashgate, 2004.

INDEX

Note: Italicized page numbers indicate illustrations.

cats, large and small: characteristics as-
signed to, 2, 5, 34, 39, 45; depictions of,
45, 46, 49, 50, 79, 88–89, 90, 143, 144,
208; hunting of, 102, 103; in Kipling's
Jungle Books, 247, 248, 249; Montaigne
on, 113; sacredness of, 3; trained for
circus, 174. *See also* lions
cattle, cows, calves, 2, 3, 39
Caucasian people: Africans compared to,
194–95, 199, 223; in Burroughs's *Tar-
zan,* 253–55; characteristics assigned to,
227; class values and appearance of, 231;
crania of, 221, 222; others' brains larger
than, 226
Caus, Salomon de, 118
Cellini, Benvenuto, 44–45, 96
centaurs, 8, 8, 99, 201
chain of being hierarchy: of God, 7, 8, 187;
language in, 163; primates in, 187, 191;
as stable and fixed, 230
Chardin, Jean-Siméon, 122–23, 185
Charivari, Le (newspaper), 73, 74
chess player automaton, 123–25
chickens, 216
childbirth, 22, 23
children: animal drawings of, 83; emotions
of, 80–81; storybooks for, 1–2, 245–49.
See also wild children
chimpanzees: human closeness to, 243, 256,
273; misidentification of, 188; as scien-
tific point of reference, 196; trained for
circus, 174
Chodowiecki, Daniel Nikolaus, 68
choleric people: characteristics of, 11–12,
17, 20; depictions of, 41, 42, 44–45, 47,
50–51, 95–96
Christianity: animal symbols of apostles
in, 6; Creation story and, 202, 205;
dualism in, 104–6, 108
Christian Ludwig II (duke of Mecklen-
burg-Schwerin), 139
circuses: context of, 122; elite commentary
on, 165, 166; human exhibits of, 171; as
"prelude" to Darwin, 157; trained ani-
mals for, 164–65, 172–73; transgressive
nature of, 13; visual legacy of, 167–69;
wild animals for, 165, 167. *See also* freak
shows
civilization: of horses, 161; state of nature
before, 200–201; veneer of, 6–7, 265
Clark, Kenneth, 41
Cleuziot, Henri du, 192, 206, 207
clockworks: analogy of body to, 109,
125–26; mechanics of, 116
clothing: temperaments correlated with,
30, 31
Cochin (royal censor), 142
Cochin, Charles-Nicolas, 142

cockerels, 6, 67, 68, 216
Cole, Thomas, 228
Collings, Samuel, 165, 166
Collins, John, 229
color: temperaments correlated with, 30, 31
Combe, Andrew, 217–18
Combe, George, 217–18
Concordat of 1515, 97
Condillac, Étienne Bonnot de, 79, 158,
163–64, 216
consciousness: animals as devoid of, 105–6;
complexities of, 267–70; of self, in
Burroughs's *Tarzan,* 251–54
constitutions of bodies and minds: ani-
mals' role in, 34–37; definition of, 14;
early text on, 31; four elements in, 11,
18–19, 20; print series depicting, 22–28;
reciprocity of soul and body in, 37–40,
41, 48. *See also* humors (bodily); patho-
gnomics; physiognomics
Cook, Elizabeth, 241
Cooper, James Fenimore, 227–28
Cormon, Fernand, 208
Cosimo, Piero di, 8, 99, 201–2
Cowper, William, 190
Cox, James, 121–22
Coysevox (sculptor), 119
Cranach, Lucas, 35, 36, 37, 99
crania and skulls: of Araucanian Indian,
229; Camper's work on, 219, 220–23;
casts of, 218; comparisons of, 224; of
criminals, 234–35; exhibit of, 234; intel-
ligence and size of, 213, 226–27, 229–30;
Morton's illustrations of, 229–30; tool
for measuring, 226; White's gradation
of, 223–24. *See also* faces/heads; facial
types
craniology, 219, 220–21
craniometer, 226
cranioscopy, 213
criminal anthropology: Degas's *Little Danc-
er* in context of, 236–37; founding of,
233; photography's use in, 237–39, 260
criminals: Degas's sketches of, 237; eyes
of, 241; murderer's profile and, 264–65;
photographs of, 237–39, 260; physical
characteristics (stigmata) of, 233–42,
261, 263–64
criminology, 14, 232
crocodiles, 3
Cro-Magnons: tools and images of, 270–72
crows, 2
Crusoe, Robinson (character), 160
Cureau de la Chambre, Marin, 48, 50, 138
Cuvier, Frédéric, 225
Cuvier, Georges: comparative anatomy
studies of, 176–79; on Hottentot Venus,
224–25; natural history ideas of, 73,

157–58, 175–76; on orangutans, 180;
works: *Animal Kingdom,* 175–76, 179,
180

Damasio, Antonio, 267
Dante, 8
Darwin, Charles: abolitionism and,
195; animal art reflective of, 180–82;
balanced approach of, 83; on Bell's
anatomy, 76; caricatures of, 197; degen-
eration concept and, 232; expression
studies of, 78–82, 180; on Haeckel's
work, 205–6; on human and prehuman
ancestors, 183; human-animal trangres-
sions and, 13; on human races, 198–99;
Kipling on, 245; mentioned, 89; op-
position to, 230, 232; "preludes" to,
157–58, 183; on primeval "ape-man,"
199, 202; scientific boundaries of, 6;
story elements of, 1; works: *Biographi-
cal Sketch of an Infant,* 80–81; *Descent of
Man,* 198; *Expression of the Emotions,*
78–80, 81, 180; *Origin of the Species,* 172,
196, 197. *See also* evolutionary theory
Darwin, William, 80–81
Daumier, Honoré, 73–76
death, 98, 165
deer, 38
Defoe, Daniel: animalistic children and, 13;
Burnett compared with, 162; on wild
child, 158–60; works: *Mere NATURE
Delineated,* 159
Degas, Edgar, 236–37
degeneration: concept of, 6, 232; in
Stevenson's Jekyll/Hyde, 263–64; in
Stevenson's *Olalla,* 261–62
deities: depictions of, 45, 47, 102; particular
animals as, 3; powers of, 100. *See also*
God
Delacroix, Eugene, 177–78
Democritus, 232
demons, 3, 35, 98
Descartes, René: on animals and machines,
48, 105–8, 111, 112, 267; on automata,
106, 123, 127; influences on, 118; La
Fontaine's response to, 12, 111, 130–38;
Montaigne's alternative to, 12, 112–15;
on passions, 48, 53
despair, 54, 55
devils, 3, 35, 98
Diamond, Hugh Welch, 237
Diana (deity), 100, 102
Dinka people, 235
diseases and conditions: autism, 158;
Down's syndrome, 229; epilepsy, 235,
261; external signs of, 20; in *Four Sea-
sons* series, 24, 25; humors correlated
with, 19; insanity, 11, 77, 232, 233, 237,

on, 213–14. *See also* crania and skulls; faces/heads

physiognomics: animalization in, 6; appropriate application of, 56–58; early vs. current attitudes toward, 211; in heroic animal depictions, 178–79; of horses, 164–65; Leonardo on, 40–41; reciprocity of soul and body in, 37–40, 41, 48; reinstatement and revitalization of, 48, 50, 60–76; scientific impulse in, 13; sculptors' conveying of, 43–45; in Stoker's *Dracula*, 258; temperaments correlated with, 20, 31; treatises on, 37, 40, 45–46, 213, 214, 215, 216, 217. *See also* humors (bodily)

Physiologus (collection), 87–88

Piccinino, Giovanni, 158, *159*

Pict people, 202, *203*, 235

pigs: characteristics assigned to, 5, 20, 39; in Golding's *Lord of the Flies*, 7; line's illumination of, 63; in Orwell's *Animal Farm*, 4, 5; as surrogates for humans, 7; trained for circus, 165; Vesalius's depiction of, 104, *105*

pineal gland, 53–54, 105–6

Pinel, Phillipe, 217, 232, *233*

Pisano, Giovanni, 158, *159*

Pithecanthropus, 192, 206

planetary pendulum, 109

Planet of the Apes (film), 250

planets: temperaments correlated with, *20–21, 29, 31*

plants, 32

Plato, 58, 105, 138

Pliny, 87, 93, 115

Poe, Edgar Allan, 125, 262

Poelenburch, Cornelis van, *101–2*

Polidori, John, 257

political allegories: Leonardo's animal story as, 97–98; Potter's *Life of the Hunter* as, 103–4; taxidermy fantasies as, 169

polygenist theory, 195, 198–99

Porta, Giambattista della, 45–46, 116, 143

Porter, Roy, 11

Potter, Paulus: on animals, 115, 185; hunting scenes of, 101–4

Prichard, James Cowles, 261

primates: as artists, *123, 184,* 185; Buffon's illustrations of, 172; classification of, 193; crania of, *220–21, 224*; gradation of, 193–94, 195, 223–24, 230; human characteristics of, 194–96; humans separated from, 72, 191, 193; imported to Renaissance Europe, 187; prognathous type of, 219, 226, 234, 237. *See also* apes; chimpanzees; human(s); missing link; monkeys; orangutans

primatology: Dürer's proportional system

linked to, 220–21; emergence of, 13; pioneers of, 106; as "prelude" to Darwin, 183

primitivism: in Burroughs's *Tarzan,* 253–56; Darwin's evolution concept and, 183; emergence of, 13; freak show exhibits and, 170–72; masks associated with, 259, *260*; regression to, 261, 262–63. *See also* atavism

prognathous type, 219, 226, 234, 237

prostitutes, 8, 236, 264–65

psychology: autism and, 158; fantasy in medieval, 98; Nordau's view of, 232; popularization of, 217; systematization of, 14

rabbits: characteristics assigned to, 34; controversy concerning, 60, *61*; depiction of, *182*; humans separated from, 72; hunting of, 102. *See also* hares

race(s): animal characteristics and, 5, 6, 170–72; culturally based ordering of, 226–29; Darwin on, 198–99; Germans as, 206; myths about strange, distant, 199–200; number of, 195; primeval or primitive, 199–209; systematic measurements and, 13–14; traveling shows and, 175; visual judgments of, 231; White's comparison of, 194–95

rage, *42, 43,* 80

Ralph, Benjamin, *65*

Ramelli, Agostino, 117–18

Ramus, Peter, 116

Raphael, 65, 68, *83*

rats, 136–37, 234

ravens, 136–37

reason and rationality: absence of, 185, 230; of animals, debated, 105–6, 138–39; liberation from, in Stevenson's Jekyll/ Hyde, 263–64; sensation blurred with, 162; "sleep of," 58, 67–68

Regiomontanus (Johann Müller), 116

regression, 261, 262–63

Rejlander, Oscar, 79, *80*

Rembrandt Harmensz van Rijn: Duchenne in context of, 77; extreme expressions depicted by, 56, 57–58; style of, 68; works: *Anatomy Lesson,* 106, *108, 187*; self-portraits, 57–58

reptiles, 2, 3

Reynolds, Joshua, *216*

rhinocerous, *208*

Richard the Lionheart (Richard I, king of England), 6

Rignano, Eugenio, 126

Robertson, William, 162

Romanes, George, 196–97

Rome: founders of, 2, 158; obelisk in, *114,*

115

Rousseau, Jean-Jacques, 227

Royal Academy of Art (London), 181

Royal Circus (London), 165

Royal Ethnographic Society (London), 172

Royal Zoological Society (London), 180

Rubens, Peter Paul, 43

Rudolf II, 117

Sablière, Madame de La, 130–38

SAD (Seasonally Affective Disorder), 27

Saint-Hilaire, Étienne Goeffroy de, 224–25

Sallé, François, *230–31*

Salpêtrière (Paris), 77, 232, *233*

sanguine people, 17, 20

Saturn (planet): Agrippa's account of melancholy of, 32–34; temperaments associated with, 20–21, 29, 31

satyrs: depictions of, *8,* 98, 99, *99,* 201, *202*; in encyclopedia, 93, *94*

Savonarola, Girolamo, 40, 97

Savonarola, Michele, 40

Scheuchzer, Johann Jakob, *189, 190*

Schlegel, Hermann, 180

science: adaptability of, 14; art history's focus compared with, 81–82; boundaries redrawn in, 6, 157–58; definition of, 211–12; development of, 224–25; imagery of, 10–11; interventionist type of, 262–63; key biological issues in, 146–47; physiognomics as, 68; systematization of, 13–14, 76. *See also* methodologies; neuroscience; zoology

scorn, *64*

scorpions, 5

Scot, Michael, 40

sea and water creatures, 2, 88. *See also specific types*

Seasonally Affective Disorder (SAD), 27

seasons: elements correlated with, 18–19, *20*; print series depicting, *22–28*

Sebond, Raymond, 113

self-control: absence of, 185

self-portraits: expressions in, *57–58*

Seneca, 70, *71*

September 11, 2001, terrorist attacks, 242

Sève, Jacques Eustache de, 152–53

sexuality: animal terms for, 7–8; of beasts and humans, 45; in Burroughs's *Tarzan,* 254–56; primitive visions of, 209; satyr as symbol of, 98–99; in Stoker's *Dracula,* 256–60

Sforza, Ludovico, 90

Shakespeare, William, 218

sharks, 2

Sharon, Ariel, 242

sheep, lambs, rams, 2, 20, 38

Shelley, Mary, 10, 125, 257